M000285721

A
Nietzschean
Defense
of Democracy

A Nietzschean Defense of Democracy

An Experiment in Postmodern Politics

LAWRENCE J. HATAB

OPEN COURT

Chicago and La Salle, Illinois

OPEN COURT and the above logo are registered in the U.S. Patent and Trademark Office.

© 1995 by Open Court Publishing Company

First printing 1995

All rights reserved. No part of this publication may be reproduced, stored in a retrieval system, or transmitted, in any form or by any means, electronic, mechanical, photocopying, recording, or otherwise, without the prior written permission of the publisher, Open Court Publishing Company, 315 Fifth Street, P.O. Box 599, Peru, Illinois 61354-0599.

Printed and bound in the United States of America

Library of Congress Cataloging-in-Publication Data

Hatab, Lawrence J., 1946–
 A Nietzschean defense of democracy : an experiment in postmodern politics / Lawrence J. Hatab.
 p. cm.
 Includes bibliographical references and index.
 ISBN 0–8126–9295–0 (alk. paper). — ISBN 0–8126–9296–9 (pbk. : alk. paper)
 1. Nietzsche, Friedrich Wilhelm, 1844–1900—Contributions in political science. 2. Democracy. 3. Postmodernism—Political aspects.
JC233.N52H37 1995
921.8—dc20 95-25147
 CIP

For my father,
George A. Hatab

Alles Glück auf Erden,
Freunde, gibt der Kampf!
Ja, um Freund zu werden,
Braucht es Pulverdampf!

All happiness on earth,
My friends, comes from conflict.
Even becoming a friend
Needs gunsmoke!

<div align="right">–THE GAY SCIENCE, PRELUDE, 41</div>

Contents

Abbreviations x

Preface xiii

Introduction 1

1. A Primer on Nietzsche and Postmodernism 5

 Nietzsche 5
 Postmodernism 13

2. Nietzsche Contra Democracy: Deconstructing
 Equality 22

 Master and Slave 24
 Anti-egalitarianism 27
 Anti-liberalism 29
 Aristocraticism 39
 Hermeneutical Complications 42
 Nietzsche and Politics 51

3. Nietzsche Contra Nietzsche: Democracy Without
 Equality 55

 Defining Democracy 55
 Equality in Question 57
 The Greek Agōn 61
 Perspectivism 64
 Suspicion 70
 Postmodern Democracy 76

4. Agonistic Democracy 78

 Hermeneutical Differences 78

Democracy as Agonistic Praxis 83
Order and Conflict 86
The Range of Political Agonistics 87
Legal Agonistics 89
Nonprocedural Agonistics 91
Subgroup Tensions 92

5. Democracy, Excellence, and Merit 94

Equality and Freedom 96
Contemporary Egalitarianism 98
Redescribing Equality 106
Merit and Mediocrity 108
Apportional Justice 111
Meritocracy Without Essential Superiority 116
Political Equality as Fair Competition 119
Aristocratic Elements in Representative Democracy 122
Education and Excellence 129
How Far Should Democracy Extend? 133
Nietzsche's Creators and Politics 137
Creativity and Normalcy 141

6. Perspectivism, Truth, and Politics 145

Perspectivism and Truth in Nietzsche 145
Truth as Contextual, Agonistic Pluralism 158
Perspectivism and Democracy 162
Perspectivism, Reason, and Political Practice 164

7. Ethics and Politics Without Foundations 174

Ethics and Nietzsche's Thought 175
Agonistic Ethics 180
Distinguishing the Ethical and the Political 185
Metanarratives and Democratic Politics 193
Politics and Teleology 201

8. Selfhood, Rights, and Justice 203

Human Existence and the Political Sphere 203
The Unstable Self 207

Rights 213
Respect and Freedom 217
Justice and the Political Process 223
Economic Justice 226
A Last Word: Democracy and Political Radicalism 230

Notes 237

Bibliography 303

Index 313

Abbreviations for Nietzsche's Works

Numbers in citations refer to section numbers in the text, unless indicated otherwise. On occasion I have slightly modified published translations.

A *The Antichrist*, in *The Portable Nietzsche*. Edited and translated by Walter Kaufmann. New York: Viking Press, 1954.

BGE *Beyond Good and Evil*, in *Basic Writings of Nietzsche*. Edited and translated by Walter Kaufmann. New York: Random House, 1966.

BT *The Birth of Tragedy*, in *Basic Writings*.

D *Daybreak*. Translated by R. J. Hollingdale. Cambridge: Cambridge University Press, 1982.

EH *Ecce Homo*, in *Basic Writings*. The four main chapters will be indicated by roman numerals, with book titles in chapter III abbreviated accordingly.

GS *The Gay Science*. Translated by Walter Kaufmann. New York: Random House, 1974.

GM *On the Genealogy of Morals*, in *Basic Writings*.

HAH *Human, All Too Human*. Translated by R. J. Hollingdale. New York: Cambridge University Press, 1986.

KSA *Sämtliche Werke: Kritische Studienausgabe*. Edited by G. Colli and M. Montinari. Berlin: Walter de Gruyter, 1967.

OTL *On Truth and Lies in an Extramoral Sense*, in *Philosophy and Truth*. Edited and translated by J. Daniel Breazeale. Atlantic Highlands, NJ: Humanities Press, 1979.

TI *Twilight of the Idols,* in *The Portable Nietzsche.* The chapters
will be numbered in sequence by arabic numerals.

WP *The Will to Power.* Translated by Walter Kaufmann and R. J.
Hollingdale. New York: Random House, 1967.

WS *The Wanderer and His Shadow,* Part II of *Human, All Too
Human.*

Z *Thus Spoke Zarathustra,* in *The Portable Nietzsche.* The four
parts will be indicated by roman numerals, the sections by
arabic numerals according to Kaufmann's scheme on pp.
112–14.

Preface

The idea for this project had been brewing for a while. Years ago when I was working on my last book,[1] I was orchestrating various elements of ancient Greek culture and Nietzsche's interpretation of the Greeks. All at once several ideas converged in a clash that gave me pause: the Greek experience of democracy as an open contest of speeches, Plato's repudiation of democracy, Nietzsche's critique of Plato, Nietzsche's affirmation of contention, and Nietzsche's repudiation of democracy. Something is wrong here, I thought. But political questions were not my focus at the time, so I put this interesting problem aside.

Provocative developments in social and political thought and reconsiderations of Nietzsche's political views later caught my attention and the problem came back to life, leading to an article[2] and its expansion into the present book. The motivation for this study came from a dilemma that is surely not mine alone: I have been significantly influenced by Nietzsche and consider myself to be a fellow traveler; I also believe in democracy as the only viable political system; but Nietzsche was a severe opponent of democracy. It seems to me that there is a disparity here that calls for the following resolution: Either Nietzsche has a problem or I do. This book was written in the hope that the problem is not mine.

Assuming that we can*not* depoliticize Nietzsche (to be argued later) and that political questions are essential to one's view of life, then it seems that Nietzsche enthusiasts who also affirm democracy face the following choices: 1) Surrender their allegiance to Nietzsche and challenge his politics with standard arguments for democracy; or 2) Give up their allegiance to democracy; or 3) Challenge Nietzsche's politics on his own terms, that is to say, defend democracy from within Nietzsche's thought, without distorting the texts or transforming Nietzsche into a new creature. It is this last option that I have chosen, and the clues for executing it emerged out of the dissonance I noticed when working on the Greeks.

I think that my analysis not only contributes to Nietzsche studies, it also evokes important questions for democratic theory. Current political developments (especially in Eastern Europe) and contemporary intellectual controversies make a reexamination of democracy timely but also more complex and difficult. As the emerging democracies try to build their political systems after the collapse of communism, implementation problems and the reverberations of decades of debate in European thought over competing radical doctrines force us to reflect anew on the nature of democracy. Do old ideals still work? Do they need rethinking? Can such rethinking help us understand the problems of the emerging democracies more effectively than traditional assumptions can?

In the contest of political rhetoric, it is clear that democracy has won the day. Very few theorists, if any, seriously propose nondemocratic systems, and even patently undemocratic regimes want to *call* themselves democracies. Even though the actual practice of democracy around the world is not predominant, the rhetorical victory does provide the opportunity for internal criticism that can unmask societies that only pretend to be democratic. Despite democracy's comfortable rhetorical status, however, it is still important to ask the question: Why democracy? One reason is that many traditional assumptions in democratic theory are in question today. Another reason is that addressing the *Why?* opens up issues

regarding *what* democracy is and *how* it operates that are not always evident or obvious. Finally, political education needs these questions to generate better understanding and commitment in the face of difficulties that are inevitable in democratic societies.[3]

There has been a great resurgence recently in questions surrounding democracy and political philosophy. I hope that my study can make a contribution. I should add, however, that my work has a limited focus. I am primarily interested in Nietzsche's thought in relation to democratic practice. There will be a number of significant issues in political philosophy and democratic theory that will not be addressed or that will be given only thin or passing treatment. Within the limits of my topic, I will not be able to provide adequate answers to many important questions. I see this study as an experiment meant to provoke and stimulate a more detailed treatment of the many issues involved.

I want to thank the following individuals for their comments, criticisms, suggestions, and support in the course of my project: Martha Bailey, Phil Cafaro, Daniel Conway, Bernard Dauenhauer, Bruce Detwiler, Lewis Ford, Dana Heller, David James, Harry Jones, John McCumber, Richard Rorty, Lawrence Schmidt, Gary Shapiro, Howard Swartz, and Bruce Umbaugh. Thanks also to the staff at Open Court—especially Kerri Mommer—for their early faith in this project, and to Elaine Dawson at Old Dominion University for her exemplary work in producing the text. Special thanks to my wife Chelsy for her empathy, love, and companionship.

Introduction

Defending democracy by way of Nietzsche's thought would seem to be adventurous at best, oxymoronic at worst. Nietzsche considered democracy to be a political consequence of Western moral and metaphysical doctrines that could no longer sustain themselves. In particular, he assailed notions of equality, rationality, emancipation, and human rights that were born in the Enlightenment and that informed various modern political projects. Nietzsche proposed a politics of power and domination, an aristocratic cultural order meant to generate and support higher types of creative individuals and to counter the leveling tendencies of democratic sentiments.

Nietzsche's thought has had an enormous influence on contemporary discourse in many different disciplines, and he has come to be recognized as a prime source of "postmodernism," which represents a multifaceted critique of various philosophical, scientific, moral, and cultural paradigms inherited from the Enlightenment. The problem is this: Most people who are influenced directly or indirectly by Nietzsche's challenge to modernism do not denounce democracy, but they have not confronted the fact that, for Nietzsche, the critique of modernity and the critique of democracy imply each other.[1] Enthusiasts have tended to follow one

of two paths regarding Nietzsche's political thought: Either they cover over or deflect Nietzsche's antidemocratic passages by interpreting them in nonpolitical terms, or they ignore Nietzsche's problematic politics and simply follow the other lines of his thinking. But such paths conceal a significant problem: Postmodern thought does imply a serious challenge to democratic theory and Nietzsche's critique is a telling indication of this. To take one instance of the problem, postmodern discourse wants to stress "difference" and yet this casts suspicion on the longstanding democratic ideal of "equality." Very few postmodern writers advocate a nondemocratic political system, and yet Nietzsche considered democracy to be incompatible with what we now call postmodern thought.[2] This is a dilemma that faces postmodern political discourse. How can we preserve a democratic polity when much of its philosophical foundation seems suspect?

The present study is meant to address this dilemma by complementing contemporary efforts to rethink democracy freed from its modernist moorings and by attempting to resolve certain anomalies plaguing these postmodern projects.[3] In following Nietzsche's important contributions to philosophy, we cannot hide or ignore Nietzsche's antidemocratic argument and its potent challenge to traditional political principles. But I would like to show that democracy *is* compatible with Nietzsche's thought, that democracy can be redescribed in a Nietzschean manner. This would accomplish two things: 1) If a central postmodern thinker who is also a severe critic of democracy can be converted on his own terms, this can provide a fairly solid intellectual defense of democracy—by sustaining democracy while not ignoring, in fact by incorporating, significant criticisms of traditional political theory. 2) Democratic politics will be revised in postmodern terms, thereby revealing a profile of democracy that is quite different from classic assumptions, and that can consequently sidestep many enduring problems haunting those assumptions: e.g., Are human beings actually equal in any way? Is there such a thing as a "common good"? Can reason truly rule human discourse? Are there "natural rights"? Democracy need not be tied to traditional postulates such as those expressed in

the Enlightenment project. In fact, it is my contention that a Nietzschean, postmodern approach to democracy can better clarify what does happen and what should happen in a democratic society, and why we should want to live in one.[4]

A central question for my project, of course, is the meaning of Nietzsche's political remarks. Positions on this question have been located at, or have moved somewhere between, two extremes. One side interprets political passages as metaphors for something nonpolitical, as iconoclastic disruptions meant to foster creativity, individuality, excellence, or philosophical insight.[5] The other side takes Nietzsche at his words and sees in the texts a quasi-fascist aristocraticism.[6] I locate myself between these extremes in the following way: Nietzsche's bombastic political claims should not always be read literally, since they enact a cryptic ambiguity and rhetorical play that must be recognized in Nietzsche's style; and Nietzsche did call himself "anti-political" (EH I,3). On the other hand, we cannot sanitize Nietzsche and ignore a persistent pattern of antidemocratic thinking in his writings. I believe that neither extreme is entirely wrong, that some kind of mediated view is required.[7] This is more than hermeneutical positioning, however. It spotlights a deep discord and perhaps some incoherence within Nietzsche's thinking itself. I have been struck by this dissonance and I want to work with it. My contention is that whatever political views Nietzsche did entertain, he should have preferred democracy to any other political arrangement—and this in the spirit of his own thinking.[8]

After a primer on Nietzsche and postmodernism (chapter 1), I will analyze Nietzsche's critique of democracy and modernist political theory, and consider various angles on Nietzsche's political thought (chapter 2). Then I will attempt a deconstruction of Nietzsche's critique by identifying three Nietzschean themes that can fit a democratic setting and its political practices (chapter 3). These themes are as follows: 1) Nietzsche's interest in the ancient Greek *agōn* (contest) and the role that contention plays in his thought. 2) Nietzsche's critique of truth foundations and his embrace of perspectivism. 3) Nietzsche's suspicion of cognitive and

moral justifications for power and authority. In the light of these notions, democracy will be redescribed as an ungrounded, continual contest, without having to depend on such problematic notions as a universal "human nature," a "common good," and especially human "equality." Democracy can then be redescribed in agonistic terms (chapter 4). My proposal is that a substantive sense of equality is unnecessary in democracy, and the use of egalitarian rhetoric in political theory and elsewhere should be criticized to make room for differences, excellence, and, it turns out, democratic practice itself (chapter 5). Despite this disavowal of egalitarianism, we can utilize a critique of foundationalism to preserve and defend, *in a different way*, democratic politics (chapter 6). I will then consider questions pertaining to ethics and politics (chapter 7), and finally take up a reexamination of human nature, rights, and justice in the light of my analysis (chapter 8).

In effect, my defense of democracy amounts to a *via negativa* in that democracy wins by default, as the only political arrangement that is appropriate for an ungrounded, postmodern atmosphere. I am also adopting what could loosely be called a phenomenological and pragmatic approach in that I am focusing more on what *happens* in democracy, more on political practices and procedures, than on political theory and its philosophical infrastructure; in this way I hope to compensate for the frequent absence in political theory of attention to concrete details of political life. Accordingly, my emphasis will be different from some other treatments of Nietzsche and political thought. I am applying a Nietzschean orientation to political *practice* rather than the usual array of standard political writers and models (although these certainly will be addressed). I think that a pragmatic approach opens up new angles for political philosophy that can provide different answers to old questions.[9] It should be clear that my project is not simply a work of Nietzsche interpretation. The payoff is a philosophical defense of democracy in a postmodern milieu. And in keeping with the spirit of this milieu, nothing like a demonstrative "justification" is imagined, but simply a response to the concrete question: Why should one want to live in a democratic society?

1

A Primer on Nietzsche and Postmodernism

Nietzsche[1]

Nietzsche's thought can be understood as a subversion of classic priorities in the Western philosophical tradition, from Plato up through the Modern period. Those priorities were the result of dividing reality up into various binary oppositions and then promoting one side over, or to the exclusion of, the other side: for example, being over becoming, immutability over change, eternity over time, universals over particulars, necessity over contingency, identity over difference, reason over passion, spirit over body, order over strife, good over evil, truth over appearance—all of this in the service of providing fixed foundations that can supersede or resolve the negative conditions and forces of disorder that challenge human existence.

Nietzsche has often been interpreted as proposing the reversal of these priorities, promoting the demoted side over, or to the exclusion of, the other side. This is not accurate, despite the fact that Nietzsche's rhetoric often suggests as much for polemical purposes. Nietzsche rejects the *opposition* of the two sides, an opposition that permits the *exclusion* of threatening or unmanageable elements that characterize the demoted side. Such preferential

opposition is exchanged for a sense of *mixture*, where the conditions in question are not exclusive of each other and cannot be ordered hierarchically (*BGE* 2; *WP* 881). Consequently, such philosophical distinctions have to be redescribed by retrieving and emphasizing that which had been devalued in the tradition.

In restoring legitimacy to becoming, time, passion, strife, etc., Nietzsche sees himself as offering a kind of existential naturalism.[2] The finite limit-conditions of earthly existence become the measure of reality, to counter various attempts in philosophy and religion to "correct" lived experience by means of a rational, spiritual, or moral "transcendence" that would effect a transformation of an originally flawed condition.

> The criteria which have been bestowed on the "true being" of things are the criteria of not-being, of *naught*; the "true world" has been constructed out of contradiction to the actual (*wirklichen*) world. (*TI* 3,6)

Nietzsche's diagnosis of the philosophical tradition goes beyond a conceptual critique; the path to fundamental problems is to be found in psychology (*BGE* 23). Nietzsche suggests that weakness in the face of life is the source of the preferential oppositions; it is an *aversion* to the negativity implied in the demoted conditions that lies at the heart of religious, philosophical, and moral systems.

> To invent fables about a world "other" than this one has no meaning at all, unless an instinct of slander, detraction, and suspicion against life has gained the upper hand in us. . . . Any distinction between a "true" and an "apparent" world . . . is only a suggestion of decadence, a symptom of the *decline of life*. (*TI* 3,6)[3]

Consequently a certain kind of strength is required to affirm life and rethink the nature of things in ways that are more appropriate for, and reflective of, the finite conditions of life. Fixed foundations have to be exchanged for more open categories. Various themes throughout Nietzsche's writings enact this combination of critique and reevaluation.

Prephilosophical tragedy. In *The Birth of Tragedy*, Nietzsche analyzes Greek tragedy as a reconciliation between Apollonian and Dionysian forces, between an aesthetic power of individuation and an ecstatic dissolution of the boundaries of self and order. The

tragic blend of the Apollonian and the Dionysian represented a correlation of form and formlessness, life and death, creation and destruction, that marked the early Greek capacity to affirm a finite existence on its own terms. The advent of Socratic rationalism initiated a turn from this "tragic wisdom" to the suspect philosophical assumptions and methods that Plato and Aristotle bequeathed to the West.[4]

Genealogy. Nietzsche employs genealogical critiques to subvert traditional belief systems. Genealogy shows that cherished doctrines are not eternal, but rather have a history and emerge in contest with counterforces; indeed, they cannot avoid being caught up in conditions they are opposing. Such analysis reveals the complexity of cultural beliefs and subverts the presumed stability and purity of longstanding measures of thought. For example, Nietzsche's quasi-historical genealogy of morals shows that values like neighbor-love, peacefulness, and self-control were simply reversals of power, whereby the weak class of slave types was able to neutralize the domination of the master types, those strong few who were able to win their position in life through their own powers. The valorization of "good" (love) over "evil" (domination) is unmasked and shown to be rooted in many less-than-noble conditions: e.g., resentment (of the master's power), protection (of the self), and cruelty (punishment for transgressions and self-castigation in the attempt to overcome natural drives).[5] In general terms, the master condition represents life-affirming strength and the slave condition represents life-denying weakness. This quasi-historical distinction becomes a catalyst for one of Nietzsche's fundamental distinctions, that between the creator type (those who undermine the established order in the process of meaning-creation) and the herd type (those who conform and prefer conditions of stability and order).

The problem of nihilism. Nietzsche is sometimes thought to be a nihilist, but this too is a mistake. If nihilism connotes the denial of any truth, meaning, or value in the world, it is the Western tradition that turns out to be nihilistic, since it has long judged life conditions to be inadequate and has "annulled" these conditions in favor of rational, spiritual, or moral resolutions. If the loss of traditional

confidences is experienced as nihilistic, this is because traditional structures are still presumed to be the only possible forms of truth, meaning, and value—and so the world seems empty without them (*WP* 12A). Nietzsche sees the challenge to tradition as a momentous choice: either we will collapse into nihilism or we will reinterpret the life-world anew, on its own terms.[6] Throughout his writings, Nietzsche proposes various motifs that offer such a philosophical renewal. Some of those motifs follow.

Perspectivism. As opposed to the presumption of an absolute, objective, fixed, and single standard for knowledge, Nietzsche advocates a pluralized perspectivism: "There is *only* a perspective seeing, *only* a perspective 'knowing'" (*GM* III,12). There are many possible takes on the world and no one take could count as the "correct" one. Moreover, one's perspective can never be separated from one's existential interests; "disinterested" knowledge is a fiction (*BGE* 207; *GM* III,12,26); there is no "drive to knowledge in and for itself" (*HAH* II,26). Perspectivism means that we exchange the connotations of strict knowledge for the more open category of "interpretation" (*GS* 374). Different, even conflicting claims can no longer be ruled out of play. Nietzsche expresses his differential outlook as follows:

> Profound aversion to resting once and for all in any one total view of the world. Enchantment (*Zauber*) of the opposing point of view: refusal to be deprived of the stimulus of the enigmatic. (*WP* 470)

Will to power. Perspectives are not merely different from each other; there is an inevitable element of conflict, since each perspective partly defines itself in contrast to, and must consequently contend with, other perspectives. Will to power depicts in dynamic and existential terms the idea that each affirmation is also a negation, that any assertion of meaning must overcome some "other," some obstacle, some counterforce: "will to power can manifest itself only against resistances" (*WP* 656). Will to power, as I see it, is a provocative metaphor meant to express an interactive force-field, which better captures the conditions of becoming, growth, and achievement that mark the life-world than do the fixed, stable categories of the tradition.[7]

Power is not an "instrument" in the service of knowledge, pleasure, purpose, or even survival; rather, these things are themselves epiphenomena of power, of a drive to master an Other, to create one's meaning in the life-affirming experience of overcoming. Life is "that which must always overcome itself" (Z II,12).[8] According to Nietzsche, any doctrine that would deny the centrality of power in this sense would deny the fuel of its own historical emergence in contest with some Other. It should be added that the notion of contesting forces refers not only to the engagement of self and world and of self and other selves, but also to the dynamic conflict *within* a self. In sum, for Nietzsche, will to power is a primal condition of finite becoming, but it is more than just "change," it is becoming driven by *conflicting* tensions.

Art. Will to power is connected with interpretation and the creation of new meanings (*BGE* 211; *GM* II,12). The metaphor of art is employed by Nietzsche throughout the writings as another countermovement to the notion of objective, fixed truth (*WP* 794). We should call it a metaphor because it is intended in a broader sense than just the arts (*BGE* 291). Art embodies features that suffice for a nonfoundational model of experience that can replace traditional structures. Art is not objective or given because it must be created, brought forth from unformed conditions; art therefore involves an ungrounded process of movement and becoming; art is innovative and therefore in conflict with the given; art gives birth to a plurality of meanings. In such an expansive context we can better understand Nietzsche's strong claim that the world is "a work of art that gives birth to itself" (*WP* 796). Moreover, the higher types of creative individuals are those who serve and enact the process of "aesthetic" forming that gives humanity its meanings, purposes, values, and truths (all of which can now be redescribed in nonfoundationalist terms).

Übermensch. The figure of the *Übermensch* plays an enigmatic role in Nietzsche's thought. Does it reflect the ultimate master type or is it something more anonymous, more a condition than an actual person or type? I have favored the latter view.[9] When the figure is announced (Z P,3) it is connected with the "overcoming"

(*Überwinden*) of the human, and is directly named "the meaning of the earth" (*der Sinn der Erde*), calling us to remain "faithful to the earth." Such a figure can be related to Nietzsche's naturalistic alternative to otherworldly doctrines, an alternative that requires us to affirm the finite conditions of earthly existence. To do this we must get "over" the polar opposition of "human" and "world" that has fostered the self-serving doctrines in the tradition, the attempts to rescue us from finitude. Nietzsche's objection to the very distinction between the "human" and the nonhuman "world" (*GS* 346), together with the various "crossing" motifs in *Thus Spoke Zarathustra* (*über* can mean "across"), suggests, I think, that the *Übermensch* represents a break with tradition that will integrate humanity with the finite conditions of earthly existence. What distinguishes the *Übermensch* from previous examples of higher achievement in history (masters, creators) is the full sweep of its affirmation and the degree to which the rethinking of existence is informed by that affirmation—something expressed in the teaching of eternal recurrence.

Eternal recurrence. According to Nietzsche, time is infinite, the number of world conditions is finite, and when the set runs its course it repeats itself in an identical manner, down to every detail.[10] Eternal recurrence has been variously interpreted as a cosmic theory, a metaphysical principle, an ethical imperative, a metaphor for time, and a test or expression of affirmation. I tend to favor the last version. Affirmation of the finite conditions of life is paramount for Nietzsche. Eternal recurrence can be interpreted as the only formulation that can express genuine affirmation of the life-world by forcing attention on the actual course of life (one must face the affirmation of one's worst moments) and by precluding any alternative formulation that permits us to look away from the course of life toward some other condition, whether it be another world (as in religious salvation) or a better world (as in doctrines of progress or teleology) or nothingness (Schopenhauer's consolation) or even eternal novelty (*WP* 1062). Eternal recurrence is the full expression of life affirmation; but to simply psychologize the notion by discounting literal repetition would be a mistake, because the

motif of repetition is what forces attention to the full task and burden of affirmation. Such affirmation might seem to imply "approval" of everything, so that recurrence would compel us to condone the Holocaust, for example. This is a significant misunderstanding, I think. Eternal recurrence includes my *opposition* to the Holocaust. What is affirmed is the entire *field* of forces in which and out of which my life choices are constituted. So I can affirm an Other *as* an opponent without esteeming it.[11]

The death of God. Nietzsche first delivers this proclamation through the figure of a madman (*GS* 125) who assails a group of nonbelievers for not facing the consequences of God's demise. Since God is the ultimate symbol of transcendence and foundations, his death is to be welcomed; but the impact of this reaches far beyond religion. The notion of God had been the foundation and guarantee for all sorts of cultural constructs in moral, political, philosophical, even scientific, domains. From Plato to the European Enlightenment, a divine mind had been the ultimate stable reference point for origins and for truth. With God gone, all the corollary constructs are lost as well (*TI* 9,5). We have "unchained this earth from its sun," and we are "straying as through an infinite nothing" (*GS* 125). We are left with only an unstable world of becoming, and again the choice is between nihilism and reevaluation.

The death of God is therefore the loss of truth, or at least the condition in which "the will to truth becomes conscious of itself as a *problem*" (*GM* III,27). Nietzsche connects the ascetic ideal (the denigration and denial of natural conditions in pursuit of a redemptive transcendence) with *any* belief in truth, including "secular" belief systems liberated from religion: morality, science, even atheism (*GM* III,23–27). God is no longer the centerpiece of culture, but we still cling to confidence in secular truths that have now lost their pedigree and intellectual legitimacy.

Nietzsche's style. Nietzsche is famous for his untypical philosophical style, to the point where some refuse to call him a philosopher. Instead of the structured format of a treatise, Nietzsche generally wrote in an aphoristic, narrative, or literary style, frequently ambiguous and enigmatic, often polemical, hyperbolic, and

personal in tone. In addition, the texts often exhibit different, even conflicting, positions. For these reasons, many readers think Nietzsche is incoherent and impenetrable. There is, however, a coherence in the texts, but of an unusual sort. Nietzsche's stylistic choices were a deliberate challenge to traditional formats and the presumptions behind them—especially the preference for rationally grounded truth, systematic order, and the pose of impartial objectivity. Nietzsche's presentations were consistent with a different picture of how the mind and language work, and of what texts can accomplish.

Nietzsche admits that his texts are hard to fathom, but he also insists that they be read carefully and that his other texts be kept in mind (*GM* P,8), so that reading Nietzsche properly requires reading the corpus as a whole. Nietzsche also indicates that being "understood" is not always the goal of a writer (*GS* 381); if your audience is a select one, you do not mind if the wrong people are put off. Consequently, "masks" are essential in writing (*BGE* 40) to cull one's readers and to stimulate creative readings.

Finally, even the apparent conflicts in Nietzsche's texts can be accorded with his vision of the world. If life is a field of conflicting forces, an agonistic pluralism where no one perspective can claim sole legitimacy, then a fuller view of things would require openness to various different perspectives (*GM* III,12; *TI* 8,6). What appears contradictory can in fact be a richer wisdom that is sensitive to all types of life (*WP* 259). An agonistic perspectivism lets us see a performative consistency in a conflicted work. There are indeed different "Nietzsches" operating in the texts, but it is possible to view conflicting perspectives as appropriate, useful, or plausible in different contexts, with no overarching structure needed to sort it all out.[12] I might call Nietzsche texts a "palette" of philosophical possibilities.[13] And I freely admit that I will be choosing different shades from that palette to serve my analysis (nothing new in Nietzsche studies). This might seem suspect and loose but I do try to operate under the restraints of appropriateness and plausibility. In any case, hermeneutical openness is in keeping with the spirit of Nietzsche's texts and his sense of the world.[14]

Postmodernism

The term "postmodernism" is typically very difficult to define. Some even argue that this difficulty is appropriate, since in a postmodern atmosphere "definition" is often put in question. A more promising account of the difficulty would recognize that the word has functioned differently in various disciplines and from different perspectives within disciplines, so that there are different "postmodernisms" operating in contemporary discourse.[15] A degree of clarity is possible if one can identify the discipline and perspective in which one is operating. My own use of the term emphasizes the philosophical tradition and selects Nietzsche as the hinge for differentiating the modern from the postmodern. I happen to think that this approach provides a more searching and cogent account of an overly dispersed term, but I grant that there are other versions and that mine is not definitive.

Postmodernism can only be understood in relation to its "predecessor," modernism. In my account modernism is primarily associated with the course of philosophy running from Bacon and Descartes, through the Enlightenment, at least up to Kant, but arguably also through to Hegel and Marx (who might be called late modernists[16]). What was "modern" was initially that which distinguished new thinking, especially in the sciences, from ancient and medieval conceptions. Modern paradigms then forged their own tradition that affected every facet of culture, and therein arose a recognizable "era," modernity. Without claiming that this era can be wrapped up in a neat package or that all thought in this period was following a common course, I will offer some rough generalizations that identify significant aspects of modernism, which will then allow a clearer account of postmodernism.

Critique. From the beginning, modernism was characterized by its challenge to previous systems and especially to all forms of traditionalism and conventionalism. The New Science and faith in human reason generated an atmosphere of critique that put in question established customs, authority structures, and belief systems, and that moved to overturn what could not satisfy new criteria of rational justification.

Rationality. Most thinkers in the modern period thought that the world is ultimately rational and orderly, that the human mind is capable of discovering this order, that human beings are essentially rational, at least in potential, and that reason is the privileged element in the order of human powers.

Subjectism. This term is primarily cognitive in meaning and has a number of corollaries. Rationality requires reflection and arises when the individual "subject" stands back from lived experience and active involvement to discover abstract principles or structures that can order experience. Self-conscious reflection thereby becomes a prerequisite of thinking and a new reference point both for defining human nature and for the "objectification" of nature on the other side of the positing "subject." Descartes' critical stance toward tradition, his withdrawal into his meditations, and his subsequent discovery of a zone of conceptual certainty in the *cogito* embodied much of what has been discussed thus far regarding the modern spirit.

Since the human subject in this sense was thought to apprehend universal truths of reason that supersede empirical contingencies, there was nurtured a kind of universalism based on the belief in, or hope for, a convergence of humanity around commonly apprehended truths. Truth was liberated from association with divine mysteries and privileged authorities; confidence was shifted from such domains to the prospects of a common human project of discovery.

The human subject was also perceived to be *free* in a number of senses. The critical spirit gave the human individual freedom from traditional presumptions and restraints, and the rational subject was considered by many (e.g., Kant) to be *constituted* by freedom in its capacity to transcend the constraints of sensuous nature. Modernist freedom, therefore, was not indiscriminate license, but the freedom that rational *truth* provides in liberating us from confinement to passion, confusion, natural need, and arbitrary belief; accordingly, "freedom" and "order" were not necessarily incompatible in modernism, since both ideas were defined in rational terms.

In sum, modernist thought conceived the human self to be a *free rational individual*, distinct from nature, from tradition, and from other selves. This liberation of the self, however, was still animated by belief in the possibility of rational convergence. Here we approach one of the central legacies of modernism that has not had an entirely smooth course, especially in the political arena. With respect to the correlation of freedom and order mentioned above, political philosophy was marked by a confrontation with the often ambivalent marriage of individuality and collective rationality in the social nexus; and, as we will see, such ambivalence generated conflicted conceptions of the relationship between the individual citizen and the state.[17]

Optimism. Based on the elements delineated above, the modern period was a time of confidence, a belief in the human capacity to progress individually and collectively: Human reason could unlock the secrets of nature; science could foster technological advances and economic prosperity; people could transcend their passions and differences, surrender their superstitions and biases; and all of this could nurture the growth of, and justification for, political liberty. Accordingly, most of modern political theory was animated by the ideal of human emancipation from both natural constraints and institutional oppression.[18]

If we recall Nietzsche as a reference point, the features of postmodernism become clearer as a reaction to the aforementioned elements of modernism. The foremost feature is the ubiquity of *critique*. Postmodernism *shares* the modernist spirit of critique, but turns critique against modernism's own assumptions. Although modernism generated a liberation from tradition, custom, and religious authority, it still confined thought within new boundaries and foundations that are not immune to criticism themselves.[19]

Critique of rationality. Postmodernism subverts the belief that reality and human nature are essentially rational. Science, for example, is only one perspective on the world, and much of scientific reason conceals problematic biases and distortions. Human behavior cannot be and should not be confined by constructs that suppress nonrational forces. Modern technology is

especially singled out as a massive coercive system that sees nature and humanity as resources and objects of control, and that risks environmental and social catastrophe. Modernism's liberation of human reason ironically has unleashed the tyranny of reason's domination of nature and human individuality.[20]

Critique of subjectism. This challenge is connected with the previous critique and concentrates on subverting the picture of a rational, free, individual consciousness as the core of human nature. The paradigm of self-conscious mental reflection inherited from Descartes began to unravel in late modern thought when individual selfhood was described as essentially constituted by social relations (Hegel), material relations (Marx), and unconscious drives (Freud). Postmodernism radicalizes this late modern inheritance into a thoroughgoing contextualism. Any "humanistic" doctrine that reduces the world to human interests or that stems from an ideal of willful self-assertion becomes suspect; equally questionable are rational or romantic individualism and all idealistic and emancipatory ideologies. Human existence is too much caught up in historical, social, natural, and material forces to be fully amenable to such things. And again, the concealed motive of control that is implicated in rational reflection's distance from nature opens up the self-consuming paradox of modernist "freedom."

In this regard, postmodern contextualism illuminates both the value and the dangers of the modern conception of selfhood. In historical context, the free, rational individual was a valuable counterstroke to forces of traditionalism; the liberation of reason, however, generated certain scientific, technological, and social forces that came back to threaten human freedom and individuality. One of the paradoxes of modernism is that rationality can both support and suppress individual freedom. Postmodernism insists that the root metaphysical model of a free, rational, individual subject 1) overdetermines individuality at the expense of context, and 2) in response to this excess, generates rationalized, systemic structures that overdetermine collectivity and order at the expense of individuality. Solutions to social problems stemming from tensions between selfhood and context accordingly should begin

with subverting the modernist model that permits the extreme polarization of individuation and systemic control in the first place. *Critique of totalism.* In the social and political arena, rational universalism has been challenged by a turn to particularism, because human differences are subject to erasure in universalism, and the persistence of the "different" has provoked tyranny on behalf of universality or rationality. Modern subjectism, as indicated earlier, produced ambivalent tensions between individual and collective forces, which generated disruptions and difficulties that spawned oppressive structures in the modern state. As Connolly has suggested, a central feature of modernist thought has been that otherness is experienced as alienation, and that the goal of politics is to overcome otherness in a fully integrated community.[21] It is the postmodern presumption of an ineradicable persistence of otherness that leads to the charge that such modernist aspirations are unwittingly, but inevitably, repressive in their implications. Again, the liberation of the free, rational individual produced a greater tension in the social and political milieu, which prompted the rational capacity to construct systemic controls; this generated various technocratic and bureaucratic regimes and totalitarian models of the state.

Critique of foundationalism. Any attempt to "ground" thinking in metaphysical, rational, or scientific constructs is abandoned in postmodernism in favor of an openness that is willing to put anything and everything in question, that sees limits everywhere, that undermines closure and univocity, that is suspicious of "final things." Postmodernism distrusts traditional confidences and embraces a contingent, historical, plural, conflicted, aesthetic atmosphere. As Jean-François Lyotard has put it in an influential work, postmodernism replaces the model of objective, uniform, rationally ordered knowledge with a plurality of "narratives," and is defined in the end as disbelief in all *meta*narratives.[22]

In many ways, what has come to be called the "linguistic turn" characterizes the nonfoundationalist gestures of postmodernism. The turn has been away from seeking foundations in "reality" or in cognitive structures, and toward an analysis of language, specifi-

cally, the ways in which language informs thought and experience. In these terms, the philosophical openness and pluralism that postmodernism has championed stems from the irreducible variety of language forms and the absence of any freestanding measure in "reality" or the "mind" that could adjudicate different perspectives by means of a baseline truth. Science, for example, is not the "truth" but a particular language game.[23] Even the "subject" becomes a function of language, since the idea of a rational, self-contained, reflective self has been superseded by an emphasis on language as an open, social, and material process that disperses, contextualizes, and situates the self in a fluid network of linguistic activity and media. In the end, nothing in thought can be "essentialized" because all meanings arise in different context-bound relations that mark the various matrixes of language use. Meaning, then, is situational and correlational in that it is contextual, intertextual, and sometimes countertextual. As Lyotard says, there is no metalanguage that can supersede or resolve the plurality and paralogy of language.[24]

It is important to establish that postmodernism should not be taken to mean *anti*modernism. Some caricatures of postmodernism and, to be sure, some postmodern writers, give the impression that the aim is an abandonment of modernist structures. But more responsible treatments do not suggest such a rupture, in part because that would mimic the modernist tendency to "totalize" for the purpose of denial or control. The proper target is the essentialism and metaphysical reductions in the tradition that have promoted a fixed and closed model of thought. So reason, for example, is not the target, but rather a rationalistic closure that privileges reason and insulates it from supposedly irrational forces. The point in postmodernism is that reason is less supreme and more complicated than that. Some writers have even suggested that postmodernism should not be taken as a periodic term coming "after" modernism, but rather as a disruption *within* modernity itself.[25] There is something to this, especially considering the centrality of critique in modernism, but it tends to neutralize or dilute the clear break from modernist assumptions that is evident at certain levels,

especially in a thinker like Nietzsche. In any case, I am comfortable with a quasi-chronological understanding of postmodernism, as long as it is not taken as a new binary opposition. Accordingly, postmodernism represents attention to the limits, dangers, distortions, and divisions within modernist elements, not the purgation of these elements. So, in the spirit of Nietzsche, terms such as reason and freedom can be retained and affirmed if they are given appropriate redescription.

Postmodernism is often interpreted as simply a negative gesture, as disruptive, destructive, and anarchic. Although some writers have encouraged, or done little to forestall, such an interpretation, the more sophisticated discussions have tried to show that a concentration on the "negative" effects simply begs the question of traditional "positive" constructions, and that—as Nietzsche insisted—those constructions themselves are esoterically nihilistic, in the sense that any project that aims to supersede finitude unwittingly aims for the cessation of human existence. The "negativity" of postmodernism, therefore, should not be taken to mean the denial of any sense of truth, order, and meaning, but rather the denial of certain hyperbolic presumptions that in fact distort, conceal, or annul the ways in which truth, order, and meaning unfold in the world. What is "negative" in postmodern thought should be distinguished from something like absence, disintegration, or chaos in the following four ways: Postmodernism speaks to 1) the *limits* of any construction in a field of agonistic interplay and interpenetration; 2) the *potential for innovation* that such a dynamic continually presumes and protects; 3) the *openness to* "difference"; and 4) the irreducible *openness of* "identity." What would seem to be a loss—a world without foundations, essences, definitional precision, or systematic order—turns out to be a gain—a world that is dynamic, creative, complex, and rich. The postmodern alternative certainly makes thinking more difficult and demanding, and it requires more subtlety and caution, but it is not on this account without rigor, shape, or consequence.[26] If I wanted to avoid the controversies surrounding the term "postmodernism" I would propose the term "finitism" as an indication of what I take postmodern thought to be

all about. Finitism names the finite limits that attend all thinking. In doing so, it does not undermine the positive possibilities of thought; rather, it simply indicates that no idea can claim to be stable or universal, since no idea can be divorced from agonistic relations with other ideas or elevated beyond particular contexts and situations. Although an "agonistic contextual finitism" might be able to intercept certain controversies and misunderstandings, nevertheless the term "postmodernism" is with us now, for better or worse, and I will not shy away from aligning my reflections with this notorious signifier.

I want to add, however, that I am refusing to fall prey to a kind of antiessentialist fetish that often plagues postmodern writings, wherein we must constantly be on guard against essentializing our own discourse. Some have even suggested that ironic writing is the only way to produce a nonfoundationalist text, because irony saves a text from closure by being self-subversive. I find such techniques interesting from a stylistic and literary standpoint, but philosophically unnecessary and even obstructive. I am not convinced that a text itself has to *perform* according to conditions discussed in the text. Moreover, language can be flexible; even old philosophical words can be used and taken in nonessentialist ways if properly analyzed and understood. Negative language can function effectively in critiques without creating new fixtures. Prephilosophical meanings can often rescue words that in fact have been pirated by philosophers.[27] A text does not have to disown itself to be "open," and no one should have to "apologize" for writing in the format of a treatise. All the concern about closure in antiessentialist discourse seems to me to be parasitic on an essentialist view of language and texts, as though words as such were traps. This simply is not always so.[28]

Finally, I will not spend too much time on the problem of self-referentiality or "performative contradiction" (Habermas' contention that a critique of reason cannot escape rational criteria, and so has undermined itself[29]). This is not an insignificant question; some writers do fall prey to the problem more than others, and my discussion of Nietzsche's perspectivism will have to confront the issue. In my view, though, critiquing the *limits* of reason is not

susceptible to a charge of performative contradiction, any more than is teaching students to think for themselves, or making laws to limit the law. The critique of an essentialist tradition can be understood as a dialogical offering, admittedly tangled in "complicity" with tradition and certainly the performance of an "argument," but at the same time, if it is taken as a dialogical maneuver simply waiting for assessment and response, such a critique need not be accused of mimicking its target.

It should be clear from this overview how much of postmodern thought is prefigured in, or has stemmed from, Nietzsche's writings.[30] There is debate, however, about the degree to which Nietzsche qualifies as a postmodern thinker, and Nietzsche's name is absent in some treatments of this movement.[31] Nevertheless I think there is no single thinker who embodies more of the modern-postmodern dynamic than Nietzsche. To be sure, one reason why Nietzsche's name has at times been absent or avoided in postmodern circles is because his social and political remarks are so jarring to contemporary sensibilities. This potent and perplexing discordancy is what I want to explore in the next two chapters.

2

Nietzsche Contra Democracy: Deconstructing Equality

Nietzsche assails democracy as a secular, political extension of traditional religious and philosophical frameworks that are now suspect, indeed that have already lost their central role in culture. The most important of these traditional notions is God. Recalling the figure of the madman, Nietzsche's critique of modernity comes to this: Belief in God is no longer considered necessary, in fact it is safe to promote purely secular and scientific models for understanding the world and human culture; but our residual confidence in secular "truths" should be suspect because they arose historically in connection with the concept of God. The Enlightenment did represent a break with religious authority and with political authority that claimed a religious warrant (e.g., the divine right of kings), but most thinkers who were forging new political principles did not display a complete break with religious tradition, since their arguments reflected a blend of scientific rationalism and Judeo-Christian paradigms of morality and theology.[1]

Nietzsche claims that many modern political ideals are rooted in the Christian notion of "the equality of souls before God" (*A* 62); for Nietzsche, "the democratic movement is the heir of the Christian movement" (*BGE* 202). Consider Locke's reflections on natural rights in connection with natural law and divine creation:

The state of nature has a law of nature to govern it which obliges everyone; and reason, which is that law, teaches all mankind who will but consult it that, being all equal and independent, no one ought to harm another in his life, health, liberty, or possessions; for men being all the workmanship of one omnipotent and infinitely wise Maker—all the servants of one sovereign master, sent into the world by his order, and about his business—they are his property whose workmanship they are, made to last during his, not one another's, pleasure; and being furnished with like faculties, sharing all in one community of nature, there cannot be supposed any such subordination among us that may authorize us to destroy another, as if we were made for one another's uses as the inferior ranks of creatures are for ours.[2]

General confirmation of Nietzsche's position can be found in the writings of Hegel. According to Hegel, history is the dialectical development of the idea of freedom, which is first expressed in religious form and then actualized in political institutions. Greco-Roman freedom was limited because only some humans were politically free (some were slaves), and the religious fatalism of that era meant that human interests were ultimately alienated from spiritual power. The Christian image of a single, transcendent, omnipotent, and benevolent God introduced the idea that *all* humans are free, and the Incarnation was the catalyst for the idea of "incorporating" freedom into earthly forms. For Hegel, the French Revolution, with its liberty-equality-fraternity triad, was the political realization of an ideal that first took form in religious imagination. Political developments in this way are the *concrete* expression of religious ideals. Such an account helps explain the ambivalent atmosphere of the Enlightenment—it both was and was not a break with religion. For Hegel, its "secular" movement was in fact the *realization* of a vision that in the past had been located in a transcendent realm and postponed for an afterlife. Hegel saw the modern state as the *embodiment* of the divine idea in history.[3]

At least Hegel perceived the connection between modern movements and religious tradition, but other theorists are not so careful; they think we can separate the notion of God from political principles, or they ignore the issue entirely. Nietzsche agrees with Hegel's analysis but he detects the seeds of self-destruction in a

secular extension of traditional ideals. The turn to the world is the turn to history, change, contingency, flux, and unsettlement. The element of *transcendence* in metaphysical and religious paradigms created the space for their stability and thus our confidence in them. If such paradigms recede, so too should our confidence in their progeny, which confidence is simply a redirection of the old "faith." If democratic political principles are descendants of transcendent constructs that can no longer be sustained in a turn to the natural world, then Nietzsche sees no reason to believe in democracy, and he insists on revising in naturalistic terms the script of democracy's development.

Democracy, like morality, is dismantled in Nietzsche's analysis of master-slave and creator-herd exchanges, in his opposition to any system grounded in reason or a universal human subject, and in his adoption of a decentered field of power plays among competing life forces. In general, Nietzsche repudiates transcendent or rationalistic theories of the state, as in teleological or contract models (see *GM* II,17). Political arrangements are power relations, originally manifested in the dominance and distance of the master, followed by the counter-conquest of slave values.

Master and Slave

According to Nietzsche, democracy is rooted in slave morality. In his genealogical treatment of moral ideals, Nietzsche aims to ruin the pretense of moral purity by suggesting a different look at the historical context out of which certain moral values arose. Values such as neighbor-love, peacefulness, and humility were not derived from some transcendent source, but from the interests and needs of a particular type of human being, weaker peoples suffering at the hands of stronger types. Hierarchical domination was the ruling condition of early human societies.

> To be sure, one should not yield to humanitarian illusions about the origins (*Entstehungsgeschichte*) of an aristocratic society (and thus of the presupposition of this enhancement of the type "man"): truth is hard. Let us admit to ourselves, without trying to be considerate, how

every higher culture on earth so far has *begun*. Human beings whose nature was still natural, barbarians in every terrible sense of the word, men of prey who were still in possession of unbroken strength of will and lust for power, hurled themselves upon weaker, more civilized, more peaceful races, perhaps traders or cattle raisers, or upon mellow old cultures whose last vitality was even then flaring up in splendid fireworks of spirit and corruption. In the beginning, the noble caste was always the barbarian caste. (*BGE* 257)

What has been exclusively called "morality" was originally only a particular kind of morality, one quite different from another kind of morality that reflected the interests of the stronger, master types.

> There are *master morality* and *slave morality*. . . . The moral discrimination of values has originated either among a ruling group whose consciousness of its difference from the ruled group was accompanied by delight—or among the ruled, the slaves and dependents of every degree. (*BGE* 260)[4]

Master and slave morality are distinguished by Nietzsche according to two sets of estimation—good and bad in master morality, and good and evil in slave morality. Master types discover what is good out of their own condition of strength; they experience pleasure and exaltation in their victories and their distance from the powerless. Characteristics such as courage, conquest, aggression, and command that produce the feelings of power are deemed "good"; traits of the weaker class such as cowardice, passivity, humility, and dependence are deemed "bad." Nietzsche finds support for his analysis in the etymology of ancient words for good and bad, which generally connoted "noble" and "base," "superior" and "inferior" (*BGE* 260; *GM* I,5). What is important for Nietzsche here is that good and bad are not absolutes. What is good is good only for the master; what is bad in the slave arouses embarrassment and contempt in the master, but not condemnation or denial. In fact the existence of the slave is essential for maintaining the master's sense of distance, rank, and thus "goodness." The condition of the slave is not esteemed but at the same time it is not annulled, since it provides the master with psychological (and material) benefits. In sum, what is good for the master is something active, immediate, and spontaneous, arising directly out of the master's accomplish-

ment; what is bad is a *secondary* judgment in contrast to an antecedent experience of self-worth.

In relation to master morality, slave morality is constituted by a number of reversals. What the master calls "bad" is deemed good by the slave, and what is good for the master is called "evil" by the slave. The difference between "bad" and "evil" is important for Nietzsche. What is evil is absolutely negative and must be annulled if the good is to endure. Nietzsche traces this different kind of judgment to the existential situation of the slave: The *immediate* condition of the slave is one of powerlessness and subservience; the master is a threat to the very existence and well-being of the slave; in effect the slave lacks agency and so the *initial* evaluation is a negative one—the "evil" of the master is in the foreground, while what is "good," the features of the slave's submission, is a *secondary* judgment.

According to slave morality, anything that opposes, destroys, or conquers is evil and should be eliminated from human intercourse. In master morality, however, strife, opposition, and danger are necessary for the sense of power and accomplishment that are essential for goodness. Harmlessness and security, which are good for the slave, are an embarrassment and encumbrance for the master. Slave morality reverses master morality and recommends humility, selflessness, and kindness as the measure for *all* human beings—but only out of a condition of weakness and as a strategy for self-protection and self-enhancement. Slave morality seeks the simultaneous exaltation of the weak and incapacitation of the strong; but in doing so, slave types find enhancement not through their own agency but through the debilitation of others.

Nietzsche's target here is generally the Judeo-Christian ethic. The stories and exemplars embodying this moral outlook have promoted the ideal of supplanting worldly "power" with "justice" and "love." In the context of cultural history, however, Nietzsche sees in this ideal a disguised form of power, in that it is meant to protect and preserve a certain type of life; even more, the images depicting divine punishment of the wicked suggest to Nietzsche that the slave type has simply *deferred* its own interest in conquest (*GM*

I,15). Both master and slave moralities, therefore, are expressions of will to power. A current distinction in the literature draws from Nietzsche's differentiation of *aktive* and *reaktive* attitudes (*GM* II,11), and stipulates that the master expresses active will to power, while the slave expresses reactive will to power.[5] The slave has no genuine agency and therefore can compensate only by reacting to an external threat and attempting to annul it. For Nietzsche, slave morality is not immediately an affirmation of a good, but a denial of something dangerous and fearful, and he grounds this evaluation-by-negation in the psychological category of resentment.[6]

> The slave revolt in morality begins when *ressentiment* itself becomes creative and gives birth to values: the *ressentiment* of natures that are denied the true reaction, that of deeds, and compensate themselves with an imaginary revenge. While every noble morality develops from a triumphant affirmation of itself, slave morality from the outset says No to what is "outside," what is "different," what is "not itself"; and *this* No is its creative deed. This inversion of the value-positing eye—this *need* to direct one's view outward instead of back to oneself—is of the essence of *ressentiment*: in order to exist, slave morality always first needs a hostile external world; it needs, physiologically speaking, external stimuli in order to act at all—its action is fundamentally reaction. (*GM* I,10)

For Nietzsche, the difference between active and reactive will to power, between affirmation and resentment, is a fundamental issue that bears on all intellectual and cultural topics. The general question is the ability or inability to affirm a finite world of limits, losses, conflicts, and dangers (see *Z* II,20 and *TI* 2,1); but the social arena is a particularly important subject for our study. In effect, Nietzsche is trying to subvert longstanding social values that are animated by notions of universality, equality, harmony, comfort, protection, and the like—seemingly positive notions that Nietzsche insists are connivances of negative attitudes: fear of danger and difference, hatred of suffering, resentment of, and revenge against, excellence, superiority, and domination. In the ascendancy of the slave mentality, Nietzsche sees three lower types of life—the oppressed, the mediocre, and the discontented—retaliating against and subduing three successful types of life—the ruling class,

exceptional individuals, and the highspirited (*WP* 215).

> Moral judgments and condemnations constitute the favorite revenge of the spiritually limited against those less limited—also a sort of compensation for having been ill-favored by nature. (*BGE* 219)[7]

With literal slavery disappearing,[8] Nietzsche tends to designate this condition of weakness and its voluntary perpetuation of the slave attitude as the "herd instinct," which is continually seeking to exercise its own mode of power by enforcing conformity and comfort. In so doing it protects the self-esteem of ordinary humans by neutralizing differences and denigrating excellence. In this light, we can better understand Nietzsche's attack on democratic egalitarianism.

Anti-egalitarianism

> I do not wish to be mixed up and confused with these preachers of equality. For, to *me* justice speaks thus: "Men are not equal." Nor shall they become equal! (*Z* II,7)

Nietzsche's primary political target is egalitarianism, which, like slave morality, gives the appearance of something positive but is in fact a reactive negation. The promotion of political equality is unmasked as the weak majority grabbing power to incapacitate the strong few.[9] Democracy is different from slave morality in one very important respect: Democracy repairs the lack of agency that constituted the slave mentality, because slave values have now been redirected from the more internal realms of religious imagination and moral ideals to the external public realm of political power and cultural institutions (*WP* 215). In democratic politics, the herd instinct actually rules and legislates against hierarchical domination. For Nietzsche, the unfortunate consequence is the hegemony and promulgation of mediocrity and a vapid conformism, which obviates creativity and excellence and portends the aimless contentment, the happy nihilism, of the "last man," who makes everything comfortable, small, and trivial (*Z* P,5). On behalf of excellence and high aspirations, Nietzsche challenges democracy by

promoting rank, distance, and domination. The doctrine of human equality is diagnosed as weakness and decadence, a poison that destroys the natural justice of differentiation.

> "Equality," as a certain factual increase in similarity, which merely finds expression in the theory of "equal rights," is an essential feature of decline. The cleavage between man and man, status and status, the plurality of types, the will to oneself, to stand out—what I call the *pathos of distance*, that is characteristic of every strong age. The strength to withstand tension, the width of the tensions between extremes, becomes ever smaller today; finally the extremes themselves become blurred to the point of similarity. (*TI* 9,37)

> The doctrine of equality! There is no more poisonous poison anywhere: for it seems to be preached by justice itself, whereas it really is the termination of justice. "Equal to the equal, unequal to the unequal"— *that* would be the true slogan of justice; and also its corollary: "Never make equal what is unequal." (*TI* 9,48)[10]

Nietzsche sees equality as a blending that washes out differences, something that offends his constant affirmation of *distinctions*, which requires a demarcational hold against an Other.

Anti-liberalism

Nietzsche is at odds with most modern political formats (see *HAH* I,438–82), but he particularly challenges liberal democratic theories born out of Enlightenment paradigms.[11] It is no wonder that Nietzsche was preoccupied with liberal thought, for its assumptions about human nature, human relations, and citizen-state relations have dominated democratic theory, and the philosophical structures targeted by Nietzsche have been given their most extensive and focused political expression in liberalism. Throughout most of his writings, Nietzsche attacks liberal notions of egalitarianism, individualism, rationalism, optimism, emancipation, and human rights: The vaunted French Revolution is called a "horrible farce" (*BGE* 38) and is traced to resentment (*GM* I,16); humanitarianism is repudiated (*GS* 377); progressivism is associated with fear of suffering and an incapacity to punish (*BGE* 201); a "free society" is

deemed the "degeneration and diminution of man into the perfect herd animal" (*BGE* 203); "equal rights" is diagnosed as a "war on all that is rare, strange, privileged, the higher man" (*BGE* 212; *A* 43); "autonomy" is decoded as the prerequisite for moral responsibility and thus for social control (*GM* II,2); a legal order conceived as a means of preventing human strife is called hostile to life (*GM* II,11); modern political theories and constitutions are judged to be consequences of decadence (*TI* 9,37); universal suffrage is designated as a system whereby inferior types "prescribe themselves as laws for the higher" (*WP* 861–62).

> Liberal institutions cease to be liberal as soon as they are attained: later on there are no worse and no more thorough injurers of freedom than liberal institutions. Their effects are known well enough: they undermine the will to power; they level mountain and valley, and call that morality; they make men small, cowardly, and hedonistic—every time it is the herd animal that triumphs with them. Liberalism: in other words, herd-animalization. (*TI* 9,38)

There are a number of deep currents in Nietzsche's objections to liberalism, and they mainly concern the central modernist categories of equality, freedom, subjectivity, and agency. In liberal theory, equality and freedom seem to have a comfortable association, but a socio-psychological doctrine of equality is ruinous for Nietzsche's peculiar version of freedom, which reflects the *disequilibrium* of a struggle against an opposing force, of a creative overcoming that achieves something in and through this strife.

> For what is freedom? That one has the will to assume responsibility for oneself. That one maintains the distance which separates us. That one becomes more indifferent to difficulties, hardships, privation, even to life itself. That one is prepared to sacrifice human beings for one's cause, not excluding oneself. Freedom means that the manly instincts that delight in war and victory dominate over other instincts, for example, over those of "happiness." The human being who has *become free*—and how much more the *spirit* who has become free—spits on the contemptible type of well-being dreamed of by shopkeepers, Christians, cows, females, Englishmen, and other democrats. The free man is a *warrior*.
> How is freedom measured in individuals and peoples? According to the resistance which must be overcome, according to the exertion

required, to remain on top. The highest type of free men should be sought where the highest resistance is constantly overcome. (*TI* 9,38)

Liberalism conceives freedom politically as state-guaranteed liberty to pursue individual self-interest. The state is born in a "contract" meant to prevent individuals from thwarting each other's interests. Philosophical justifications for political freedom have flowed from a modernist picture of human nature: All human beings share a common general structure as individual subjects grounded in reflective consciousness; each individual has a definable nature, a unified order of needs and faculties that can be discovered by rational examination and actualized by powers of agency that originate in purposive, regulatory reason. Any conflicts in the self can in principle be resolved by the individual's rational deliberation and orchestration, and so happiness is within the reach of people if not constrained by outside forces. With such a picture of human nature, all persons are *entitled* to freedom from social control.[12] One more feature of the modernist paradigm subsequently informs the rhetoric of liberalism: The subject is a discrete, enduring "substance," the unified foundation for attributes and faculties, the site of identity, and the causal source of action. Such a framework of foundational individualism has animated the notion that social and material goods are human "possessions," that we "own" rights and property, for example, which cannot be "taken away" from us.[13]

Nietzsche rejects this modernist model of an individual, unified, substantive, autonomous, rationally ordered human nature. The self is not an enduring substance, not a unified subject that grounds attributes, that stands "behind" activities as a causal source (*BGE* 19–21).[14] Nietzsche's challenge to liberalism's commerce with this model of selfhood is another angle on his anti-egalitarianism. In addition to Christian universalism and scientific rationalism, the idea of an enduring self grounding its attributes created another space for equality by supplying a site that could be distinguished from contingent characteristics and performances (talent, skill, success, failure, etc.). In Nietzsche's outlook, there is no substantive self behind or even distinct from performance.

> There is no "being" behind doing, effecting, becoming; "the doer" is
> merely a fiction added to the deed—the deed is everything. (*GM* I,13)

Consequently, the variations of achievement are irreducible. In this
way, Nietzsche subverts egalitarianism in favor of an economy of
differences.

More than anything, language is what subsidizes these mistaken
models of selfhood, according to Nietzsche. Human experience and
thinking are decentered processes, but the "grammatical habit" of
using subjects and predicates, nouns and verbs, tricks us into
assigning an "I" as the source of thinking (*BGE* 17). Human
experience is much too fluid and complicated to be reducible to
linguistic units (*BGE* 19), and the vaunted philosophical categories
of "subject," "ego," and "consciousness" are nothing more than
linguistic fictions that cover up the dynamics of experience and that
in fact are created to protect us from the precariousness of an
ungrounded process.

Nietzsche (before Freud, and borrowing from Schopenhauer)
dismisses the centrality of consciousness and the longstanding
assumption that the conscious mind defines our identity and
represents our highest nature in its capacity to control instinctive
drives. According to Nietzsche, consciousness is a very late develop-
ment of the human organism and therefore is not preeminently
strong or effective (*GS* 11). If we consider ourselves as animals, we
should be suspicious of the claim that consciousness is necessary
for our operations.

> The problem of consciousness (more precisely, of becoming conscious
> of something) confronts us only when we begin to comprehend how we
> could dispense with it; and now physiology and the history of animals
> place us at the beginning of such comprehension. . . . We could think,
> feel, will, and remember, and we could also "act" in every sense of that
> word, and yet none of all this would have to "enter our consciousness"
> (as one says metaphorically). The whole of life would be possible
> without, as it were, seeing itself in a mirror. For even now, for that
> matter, by far the greatest portion of our life actually takes place
> without this mirror effect; and this is true even of our thinking, feeling,
> and willing life, however offensive this may sound to older philoso-
> phers. (*GS* 354)[15]

Moreover, consciousness is not the opposite of instinct, but rather a refined *expression* of instincts; even the reflective thinking of a philosopher "is secretly guided and forced into certain channels by his instincts" (*BGE* 3).

Since consciousness seems to arise in *internal* reflection, the emphasis on consciousness was also coordinated with atomic individualism, the idea that human beings are discrete individuals and that social relations are secondary to the self-relationship of consciousness. For Nietzsche, however, the notion of an atomic individual is an error (*TI* 9,33; *BGE* 12). "Individuality" is not an eternal property, but a historical development; and even consciousness itself is a social and linguistic construction.

> Today one feels responsible only for that which one wills and does, and one finds one's pride in oneself. All our teachers of law start from this sense of self and pleasure in the individual, as if this had always been the fount of law. But during the longest period of the human past nothing was more terrible than to feel that one stood by oneself. To be alone, to experience things by oneself, neither to obey nor to rule, to be an individual—that was not a pleasure but a punishment; one was sentenced "to individuality" (*verurteilt "zum Individuum"*). (*GS* 117)

> Consciousness is really only a net of communication (*Verbindungsnetz*) between human beings; it is only as such that it had to develop; a solitary human being who lived like a beast of prey would not have needed it. That our actions, thoughts, feelings, and movements enter our own consciousness—at least a part of them—that is the result of a "must" that for a terribly long time lorded it over man. As the most endangered animal, he *needed* help and protection, he needed his peers, he had to learn to express his distress and to make himself understood; and for all of this he needed "consciousness" first of all, he needed to "know" himself what distressed him, he needed to "know" how he felt, he needed to "know" what he thought. For, to say it once more: Man, like every living being, thinks continually without knowing it; the thinking that rises to *consciousness* is only the smallest part of all this— the most superficial and worst part—for only his conscious thinking *takes the form of words, which is to say signs of communication*, and this fact uncovers the origin of consciousness.
>
> In brief, the development of language and the development of consciousness (*not* of reason but merely of the way reason enters consciousness) go hand in hand. Add to this that not only language

serves as a bridge between human beings but also a look, a pressure, a gesture. The emergence of our sense impressions into our consciousness, the ability to fix them and, as it were, exhibit them externally, increased proportionately with the need to communicate them to *others* by means of signs. The human being inventing signs is at the same time the human being who becomes ever more keenly conscious of himself. It was only as a social animal than man acquired self-consciousness—which he is still in the process, more and more. (*GS* 354)[16]

If Nietzsche is right, then even *self*-consciousness, perceived as a kind of internal representation or dialogue, is a function of social relations and the commerce of common signs. Accordingly, even "self-knowledge"—a crucial ingredient in traditional philosophical and political strategies—is in fact only a function of the internalization of socio-linguistic signs that operate by fixing experience into stable and common categories. What is truly "individual," then, is *not* indicated even in self-reflection, because the *instruments* of reflection are constituted by the *omission* of what is unique in experience.

[G]iven the best will in the world to understand ourselves as individually as possible, "to know ourselves," each of us will always succeed in becoming conscious only of what is not individual but "average." . . . Fundamentally, all our actions are altogether incomparably personal, unique, and infinitely individual; there is no doubt of that. But as soon as we translate them into consciousness *they no longer seem to be.* (*GS* 354)[17]

Consequently, "individualism" is disrupted by the fact that most of what we recognize as human is a *social* phenomenon; at the same time, we cannot ultimately *reduce* "human nature" to linguistic and conceptual categories, even when such structures have been appropriated by individuals in their own self-regard, because there are elements of nonconscious experience that elude these structures.[18]

Finally, for Nietzsche the self is not an organized unity, but an arena for an irresolvable contest of differing drives, each seeking mastery (*BGE* 6,36).[19] There is no single subject, but rather a "multiplicity of subjects, whose interplay and struggle is the basis of our thought and our consciousness" (*WP* 490).[20] Nietzsche's

agonistic psychology does not suggest that the self is an utter chaos. He does allow for a shaping of the self, but this requires a difficult and demanding procedure of counter-cropping the drives so that a certain mastery can be achieved. This is one reason why Nietzsche thinks that the modernist promotion of universal freedom is careless.

> "Freedom which I do *not* mean." In times like these, abandonment to one's instincts is one calamity more. Our instincts contradict, disturb, destroy each other; I have already defined what is *modern* as physiological self-contradiction. Rationality in education would require that under iron pressure at least one of these instinct systems be paralyzed to permit another to gain in power, to become strong, to become master. Today the individual first has to be made possible by being pruned (*beschneidet*): possible here means *whole*. The reverse is what happens: the claim for independence, for free development, for *laisser aller* is pressed most hotly by the very people for whom no reins would be too strict. This is true in *politics*, this is true in art. But that is a system of decadence: our modern conception of "freedom" is one more proof of the degeneration of the instincts. (*TI* 9,41)

Nietzsche seems to be saying that only the strong few can be given the freedom of self-direction and self-cultivation; most people, because of their weakness, would disintegrate or cause havoc. Democracy, for Nietzsche, amounts to an oxymoron, an "autonomous herd" (*BGE* 202).

Contrary to modernist optimism about the rational pursuit of happiness, Nietzsche sees the natural and social field of play as much more precarious and demanding. So according to Nietzsche— and this is missed in many interpretations—freedom and creative self-development are not for everyone: "Independence is for the very few; it is a privilege of the strong" (*BGE* 29). Simply being unconstrained is not an appropriate mark of freedom, according to Nietzsche; freedom should only serve the pursuit of great achievement, a pursuit that most people cannot endure.

> You call yourself free? Your dominant thought I want to hear, and not that you have escaped from a yoke. Are you one of those who had the *right* to escape from a yoke? There are some who threw away their last value when they threw away their servitude.

> Free *from* what? As if that mattered to Zarathustra! But your eyes
> should tell me brightly: free *for* what? (*Z* I,17)

That most people are bound by rules and are not free to cut their
own path is not regretted by Nietzsche. The "exception" and the
"rule" are *both* important for human culture, and neither one should
be universalized. Although exceptional types further the species, we
should not forget the importance of the rule in *preserving* the species
(*GS* 55).[21] The exception as such can never become the rule, can
never be a model for all humanity (*GS* 76). Absent this provision,
Nietzsche's promotion of "creative individuals" is easily misunder-
stood. The freedom from constraints is restricted to those who are
capable of high cultural achievement. Nietzsche therefore believes
that freedom is a privilege of rank and should not be generalized to
all individuals.

> My philosophy aims at an ordering of rank: not at an individualistic
> morality. The ideas of the herd should rule in the herd—but not reach
> out beyond it. (*WP* 287)

Such is the background for Nietzsche's rejection of liberal political
theory and the democratic ideals of equality and freedom. His
analysis of the human self and his delineation of human types lead
to a preference for an aristocratic and hierarchical model of culture.

Mark Warren well understands Nietzsche's differences with
liberal modernism,[22] but he thinks it is still possible to find in
Nietzsche's philosophy of power a model of human agency that is
compatible with liberal political ideals. As I am, Warren is trying to
transform Nietzsche on his own terms. There is a great deal to
recommend in his study, but as I see it there are a number of
problems with Warren's interpretation of Nietzsche. He thinks that
the philosophy of power can be separated from hierarchical politics;
will to power can provide a universal model of agency that in
certain ways historicizes and contextualizes a Kantian approach to
agency. According to Warren, will to power should not be read as
domination, but as the process of reflexive self-constitution, the
universally desired experience of the self as an autonomous, free
will.[23] The problem is that this does not accomplish an internal

transformation of Nietzsche. Warren is too much bound by a universal notion of subjectivity reminiscent of tradition to be able to convert Nietzsche on his own terms. Warren recognizes that Nietzsche did not universalize his concept of freedom, but thinks there is nothing stopping *us* from doing it.[24] If Warren were going *beyond* Nietzsche, that would be fine, but he claims to be drawing out the implications of *Nietzsche's* notion of power, and this will not work entirely. First of all, the various Nietzschean challenges to liberal models of selfhood and agency delineated earlier show that Warren is greatly underestimating how *different* Nietzsche's position is from liberal principles of autonomy, freedom, subjectivity, and self-development. One cannot find in Nietzsche's texts nearly enough to accommodate a universal model of free agency along the lines of Warren's proposal.[25] Moreover, *limiting* will to power to self-constitution is a surprising interpretation of the texts, given Nietzsche's persistent promotion of rank and the extent to which domination motifs figure throughout his writings.[26]

One last bit of business in this regard concerns the use of Nietzsche's figure of the "sovereign individual" (*souveraine Individuum*: *GM* II,2). Many commentators assume that the sovereign individual expresses Nietzsche's ideal of a self-creating individual in contrast to the herd; and some, like Warren, think that it is possible to connect this self-creator with a Kantian concept of free agency in the social-political domain.[27] Ansell-Pearson, though disagreeing with Warren, does maintain that the sovereign individual is Nietzsche's supra-moral self-creator.[28] I have yet to be convinced, however, that any of this is accurate. The sovereign individual—in its lone appearance in the context of the genealogy of morals—names, I think, the modernist ideal of subjective autonomy, which, as we have seen, Nietzsche *displaces*. The sovereign individual is the result of a long process of making people calculable, uniform, and morally responsible (*GM* II,2). When this figure is called "supra-moral," the German term is *übersittlich*, which is more like the modernist notion of liberation from custom and tradition (*Sitte*), and therefore it is closer to the modern construction of rational morality (*Moralität*).[29] Later in the same passage, the sovereign

individual is described as claiming power over fate, which does not square with one of Nietzsche's central recommendations, *amor fati* (*EH* II,10). "Autonomy" is something that Nietzsche traces to the inversion of master morality; freedom in this sense means "responsible," "accountable," and therefore "reformable"—all in the service of convincing the strong to "choose" a different kind of behavior (*GM* I,13).[30]

The meaning of freedom in Nietzsche's thought is not at all clear, but it *is* clear that it does not reflect the modernist ideal of "free will." At the same time, Nietzsche does not opt for a mechanistic determinism either.[31] In *BGE* 21, Nietzsche rejects both free will and unfree will—the former because of his dismissal of atomic individualism, and the latter because of his voluntaristic alternative to mechanistic causality.[32] Nietzsche's self-creating individual cannot be associated with autonomy in the strict sense.[33] My reading of this matter is as follows: Nietzsche's dictum, "Become what you are" (*GS* 270,335), is ambiguous regarding the freedom-necessity scale. I think it means that you cannot be free from what you are, but in pursuing your path you can be free from the pressures of others who are trying to keep you from your path (something that can cash out politically). In effect this connects with the atmosphere of eternal recurrence, in the sense of willing to be what you have always been. It may be that the figure of the sovereign individual does foreshadow in some way Nietzsche's creator type, but my point here is that such a connection is quite problematic because of the meaning of "sovereignty," its textual association with morality, and Nietzsche's critique of modernist freedom.

Nietzsche's disruption of liberalism is persistent and vigorous throughout the writings. Accordingly, any attempt to join Nietzsche with aspects of liberal theory is precarious. This makes the project of joining Nietzsche with democracy all the more uncharted, however, since liberalism has played such an important role in democratic theory. I am trying to avoid the pitfalls associated with a liberal appropriation of Nietzsche by accepting much of Nietzsche's critique and finding another route to democracy, indeed by

sidestepping most of the machinery of political "theory" alto-gether—especially its preoccupation with "human nature" and the "self"—and experimenting with a postmodern *via negativa* in relation to democratic *practice*. In this way I hope, for example, to be able to connect democracy with a Nietzschean version of will to power that is more faithful to the texts than something like Warren's attempt.[34]

Given Nietzsche's energetic and forceful critique of traditional political ideals, the question I turn to next is whether Nietzsche's deconstruction of democracy represents a concrete political program, or some encoded cultural vision, or some combination of the two.

Aristocraticism

Much of Nietzsche's language suggests an aristocratic, authoritar-ian political arrangement. The historical precedent of the master-slave relation coupled with the notion of will to power as the fuel of human activities leads easily to an apparent approval of political domination and exploitation.

> We simply do not consider it desirable that a realm of justice and concord (*Eintracht*) should be established on earth . . . we are delighted with all who love, as we do, danger, war, and adventures, who refuse to compromise, to be captured, reconciled and castrated; we count ourselves among conquerors; we think about the necessity for new orders, also for a new slavery—for every strengthening and enhance-ment of the human type also involves a new kind of enslavement. (*GS* 377)

> Here we must beware of superficiality and get to the bottom of the matter, resisting all sentimental weakness: life itself is *essentially* appropriation, injury, overpowering of what is alien and weaker; suppression, hardness, imposition of one's own forms, incorporation and at least, at its mildest, exploitation—but why should one always use those words in which a slanderous intent has been imprinted for ages?
> . . . everywhere people are now raving, even under scientific disguises, about coming conditions of society in which "the exploitive aspect" (*der ausbeuterische Charakter*) will be removed—which sounds to me as if they promised to invent a way of life that would dispense

with all organic functions. "Exploitation" does not belong to a corrupt or imperfect or primitive society: it belongs to the *essence* of what lives, as a basic organic function; it is a consequence of the will to power, which is after all the will of life.

If this should be an innovation as a theory—as a reality it is the *primordial fact* of all history: people ought to be honest with themselves at least that far. (*BGE* 259)[35]

Democratic movements are traced to a kind of "misarchism," a hatred of everything that dominates and wants to rule (*GM* II,12). In contrast, as we have seen, Nietzsche insists that cultural excellence is the result of conquest and hierarchical rule (*BGE* 257; *GM* II,17). The masses are valuable only as a necessary support system for the production of excellence, as the broad base upon which and over which higher individuals can stand.

> The essential characteristic of a good and healthy aristocracy . . . is that it . . . accepts with a good conscience the sacrifice of untold human beings who, *for its sake*, must be reduced and lowered (*herabgedrückt und vermindert*) to incomplete human beings, to slaves, to instruments. Their fundamental faith simply has to be that society must *not* exist for society's sake but only as the foundation and scaffolding on which a choice type of being is able to raise itself to its higher task and to a higher state of *being*. (*BGE* 258)

> A high culture is a pyramid: it can stand only on a broad base (*Boden*); its first presupposition is a strong and soundly consolidated mediocrity. (*A* 57)[36]

Nietzsche's naturalistic bent often dresses his hierarchism in provocative references to biology and race (*GM* I,5; *BGE* 224,251). In addition, modern democracy and socialism are depicted as an assault upon the dominance of an Aryan, master race (*GM* I,5). The development of higher types and races is sometimes discussed in the context of breeding (*Züchtung*).

> From now on there will be more favorable preconditions for more comprehensive forms of dominion, whose like has never yet existed. And even this is not the most important thing; the possibility has been established for the production of international racial unions whose task will be to rear a master race, the future "masters of the earth";—a new, tremendous aristocracy, based on the severest self-legislation, in which

the will of philosophical men of power and artist-tyrants will be made to endure for millennia. (*WP* 960)[37]

There are also chilling references to letting the failures, the sick, and the weak perish or die out in the interests of life.

> The weak and the failures shall perish: first principle of *our* love of man. And they shall even be given every possible assistance (*Und man soll ihnen noch dazu helfen*). (*A* 2)

> To create a new responsibility, that of the physician, for all cases in which the highest interest of life, of ascending life, demands the most inconsiderate pushing down and aside of degenerating life—for example, for the right of procreation, for the right to be born, for the right to live. (*TI* 9,36)

> [L]et us suppose that my attempt to assassinate two millennia of antinature and desecration of man were to succeed. That new party of life which would tackle the greatest of all tasks, the breeding of a higher humanity (*Hoherzüchtung der Menschheit*), including the unsparing annihilation (*schonungslose Vernichtung*) of everything that was degenerating and parasitical, would again make possible that excess of life on earth from which the Dionysian state, too, would have to awaken again. (*EH* III, *BT*,4)[38]

Finally, there are cryptic remarks about a future "great politics" woven with images of impending warfare.

> The time for petty politics (*kleine Politik*) is over: the very next century will bring the fight for the dominion of the earth—the *compulsion* to great politics (*grossen Politik*). (*BGE* 208)

> [W]hen truth enters into a fight with the lies of millennia, we shall have upheavals, a convulsion of earthquakes, a moving of mountains and valleys, the like of which has never been dreamed of. The concept of politics will have merged entirely with a war of spirits; all power structures of the old society will have been exploded—all of them are based on lies: there will be wars the like of which have never been seen on earth. It is only beginning with me that the earth knows *great politics*. (*EH* IV,1)[39]

Passages such as these make it very difficult indeed to sustain the profile of a "kinder and gentler Nietzsche" who is only interested in individual self-creation. In any case, to whatever extent these

aristocratic motifs are meant to assume a concrete political form, it is clear that in the main Nietzsche rejected the guiding criteria of traditional political theory—which conceived the purpose of politics and the state variously as the promotion of prosperity, happiness, human rights, justice, public security, harmony, unity, or emancipation—in favor of a politics dedicated to cultivating and furthering the highest cultural individuals and achievements. Perhaps, as Detwiler has remarked, this dissociation from traditional politics is what clarifies Nietzsche's claim to being "anti-political" (*EH* I,13): it would not have to mean being apolitical or against the political sphere as such, but rather being against existing political models, the idolization of the state (as in Hegelianism), and the notion that culture should be subservient to the state.[40] Be that as it may, for our purposes it is clear that Nietzsche saw democracy and liberalism as forms of cultural decadence and obstacles to a higher politics.[41]

Hermeneutical Complications

Nietzsche's texts are so rich and often ambiguous that a literal political reading might not always succeed. For one thing his genealogical tactic is quite complex. Some writers, like Habermas, think that the genealogy implies a nostalgia for a more noble original condition.[42] Nietzsche, however, does not advocate a return to past situations (*GS* 377; *WP* 953); genealogy is a strategy for critique in the face of hardened convictions (*GM* P,6) and a preparation for something new (*GM* II,24). As we have seen, genealogy opens up a picture of cultural structures that is quite different from traditional assumptions. Attention to concrete historical emergence subverts foundationalist models and transcendent guarantees; and the agonistic mixtures and alterity displayed in this history undermine the clear boundaries of conceptual categories. To this extent genealogy is simply *disruptive* and quite different from the predications of "social and political philosophy."

In particular, Nietzsche's genealogical analysis is not meant to reject or even regret the slave/herd mentality, as much as to redescribe the environment of moral values. In this way, Nietzsche

aims to disarm the highminded pretense of egalitarian thinking by contextualizing it and showing it to be no less interested in power and control than is aristocraticism (*BGE* 51; *GM* I,15). Moreover, slave morality is no less *creative*, according to Nietzsche; the *motive* behind creative forming is what differentiates master and slave (*GM* I,10).

A careful reading of the texts does not support the thesis that Nietzsche's genealogy is exclusively a defense of crude physical power or overt social control. Throughout the writings, the meaning of weakness, strength, and power is polymorphous and far from clear. For instance, Nietzsche calls the values he criticizes necessary for life.

> If the majority of men had not considered the discipline of their minds—their "rationality"—a matter of pride, an obligation, and a virtue, feeling insulted or embarrassed by all fantasies and debaucheries of thought because they saw themselves as friends of "healthy common sense," humanity would have perished long ago! The greatest danger that always hovered over humanity and still hovers over it is the eruption of madness—which means the eruption of arbitrariness of feeling, seeing, and hearing, the enjoyment of the mind's lack of discipline, the joy in human unreason. (*GS* 76)

Morality has been essential for human development in its contest with nature and natural drives (*WP* 403), and for this it deserves gratitude (*WP* 404). The exceptional individual is not the only object of honor for Nietzsche; conditions of the rule are equally important for the species (*GS* 55). The "weakness" of the herd mentality turns out to be a practical advantage, since it has prevailed over the strong.

> The weak prevail over the strong again and again, for they are the great majority—and they are also more intelligent (*klug*). (*TI* 9,14)[43]

Indeed, the higher types of creative individuals that Nietzsche favors are more vulnerable and perish more easily—because of their complexity, in contrast to the simplified order of herd conditions.

> The higher type of man that a man represents, the greater the improbability that he will turn out *well*. The accidental, the law of absurdity in the whole economy of mankind, manifests itself most horribly in its

> destructive effect on the higher men whose complicated conditions of life can only be calculated with great subtlety and difficulty. (*BGE* 62)

> The higher type represents an incomparably greater complexity—a greater sum of coordinated elements; so its disintegration is also incomparably more likely. The "genius" is the sublimest machine there is—consequently the most fragile. (*WP* 684)

Finally, when considering creative types from the perspective of social normalcy and its powers, it is these types that appear weak, incapable, and degenerate. Accordingly, a global view of culture would notice *both* the stability gained through "the union of minds in belief and communal feeling" *and* "the possibility of the attainment of higher goals through the occurrence of degenerate natures" (*HAH* I,224).

In all this we can see that "weak" and "strong" are anything but stable signifiers in Nietzsche's discourse. So it is not at all clear that what Nietzsche calls strength necessarily implies privileged political power over people's lives, especially since he often dissociates his cultural ideals from matters of the state.

> Only where the state ends (*aufhört*), there begins the human being who is not superfluous: there begins the song of necessity, the unique and inimitable tune.
> Where the state *ends*—look there, my brothers! Do you not see it, the rainbow and the bridges of the *Übermensch*? (*Z* I,11)

> Culture and the state—one should not deceive oneself about this—are antagonists: "*Kultur-Staat*" is merely a modern idea. One lives off the other, one lives at the expense of the other. All great ages of culture are ages of political decline: what is great culturally has always been unpolitical, even *anti-political*. (*TI* 8,4)

Creators are more important than the state and they should never be subordinated to political operations and interests (*Z* I,11).

In this context we can begin to see the shortcomings in those who read Nietzsche as a proto-fascist reactionary.[44] Nietzsche frequently advocates the posture of a "good European" to oppose such things as nationalistic ethnocentrism and race hatred (*GS* 377) and "atavistic attacks of fatherlandishness and soil addiction (*Schollenkleberei*)" (*BGE* 241). Walter Kaufmann has given the now

classic critique of the presumed connection between Nietzsche and Nazi ideology, especially by documenting Nietzsche's aversion to antisemitism and his continual criticism of things German.[45] Kaufmann's nonpolitical interpretation of Nietzsche, however, seems one-sided and somewhat evasive.[46] And given some of the passages we have encountered, it would be wrong to utterly segregate Nietzsche's thinking from the rhetoric and vision of National Socialism. Even if it is true that Nietzsche would have abhorred the emergence of Nazism (and I think that he would have), he is not blameless for the uses and abuses of his ideas in the service of fascism.[47] Between 1890 and 1914, many of Nietzsche's ideas and images became current in Germany, so much so that they took on an independent existence, without their source having to be cited.[48] Nietzsche influenced many different movements but his texts gave particular inspiration and philosophical legitimacy to the radical right.[49] The Nazi movement was able to mine Nietzsche's texts to express many of its central ideas: opposition to liberalism, democracy, and communism; martial values of power and heroic struggle; and a biological emphasis on instinct and breeding. When the Nazis came to power, there was already current a climate of ideas inspired by Nietzsche that enabled them to enact a comfortable transition from rhetoric to practice.[50] Even if an author is misinterpreted, no author is blameless if the misinterpretation reaches such extensive proportions.

Nevertheless, the assumption that Nietzsche's thought embraces fascist-style politics *is* suspect. One reason is that the central notion of will to power cannot be restricted to modes of physical, social, or political control. Although human domination is indeed an instance of will to power, there are other forms of power that do not involve domination of other people.[51] As I suggested earlier, will to power should be understood as a creative overcoming in the midst of opposing forces, and as such it can apply to any relational move in the world or in one's own self—that is to say, it names the field of both external and internal creative achievement. Life is a field of overcomings, and any value is going to involve a kind of "violence" against another condition (Z II,12). Even acts of self-sacrifice and

ascetic self-denial involve certain feelings of power that elevate those who accomplish such things (*GS* 13; *BGE* 229). The phenomenon of willing *as such* is a dynamic of ruling: "A man who *wills* commands something within himself that renders obedience," and in doing so he "enjoys an increase of the sensation of power which accompanies all success" (*BGE* 19). To cite an example that best illustrates the subtlety of Nietzsche's power principle, something like pacifism—understood as a struggle with, and overcoming of, violent impulses, as an ennobling ideal that exalts its proponents and that implicitly reproaches a life of violence—the practice of pacifism can be construed as an instance of will to power!

Such a reading does not, of course, rule out political power and domination, but it opens up what I think is the strongest version of nonpolitical interpretations of Nietzsche's genealogy, which I will call the *creativity thesis*. The outline of this thesis is as follows: The kind of artistic, cultural, and intellectual creativity championed by Nietzsche was made possible by the slave mentality. Outwardly thwarted and powerless, the slave turned to the inner realm of imagination. Cultural creativity is the internalization or spiritualization of more overt and brute manifestations of power (the condition of the original master). This greatly expands the possibilities of innovation—since it is not completely bound by external conditions—and so cultural invention is set loose as a contest with existing conditions. Accordingly, cultural creators, like the original master, will be perceived as threats, as destroyers, as evil. In this light, the genealogy of morals is a complex code for understanding the dialectics and dynamics of cultural development.

Let me fill out this thesis by citing texts that help build its features. We have already seen that will to power is connected with creativity, with "spontaneous, aggressive, expansive, form-giving forces that give new interpretations and directions" (*GM* II,12). The slave can exercise will to power only in the inner domain of imagination.

> All instincts that do not discharge themselves outwardly *turn inward*—this is what I call the *internalization* (*Verinnerlichung*) of man: thus it was that man first developed what was later called his "soul." The entire

inner world, originally as thin as if it were stretched between two membranes, expanded and extended itself, acquired depth, breadth, and height, in the same measure as outward discharge was *inhibited*. (*GM* II,16)[52]

The slave mentality is the prerequisite for spiritual cultivation (*BGE* 188); the "weak" represent a positive power of spirit (*TI* 9,14) because their resentment of the strong opens up the possibilities of a higher culture, which is based on "the spiritualization and deepening of cruelty" (*der Vergeistigung und Vertiefung der Grausamkeit*) (*BGE* 229).[53] Such a turn begins to make mankind "an interesting animal," because the most ancient cultural concepts were "incredibly uncouth, coarse, external, narrow, straightforward, and altogether *unsymbolical* in meaning" (*GM* I,6). Now higher culture is possible, since "human history would be altogether too stupid a thing without the spirit that the impotent have introduced into it" (*GM* I,7).

So the master-slave distinction may have clear delineations at first, but it begins to get complicated in the context of cultural creativity and Nietzsche's brand of higher types, who should be understood as an "interpenetration" of master and slave characteristics combined in a "single soul" (*BGE* 260).[54] The conflict between master and slave forces is the most decisive mark of a higher, more spiritual nature (*GM* I,16).[55] As a result, the "evil" that designated the destructive threat of the master is now recapitulated in creative disruptions of established conditions.

The strongest and most evil spirits have so far done the most to advance humanity: again and again they relumed the passions that were going to sleep—and they reawakened again and again the sense of comparison, of contradiction, of the pleasure of what is new, daring, untried; they compelled men to pit opinion against opinion, model against model. Usually by force of arms, by toppling boundary markers, by violating pieties—*but also by means of new religions and moralities* [my emphasis]. In every teacher and preacher of what is *new* we encounter the same "wickedness" that makes conquerors notorious, even if its expression is subtler and it does not immediately set the muscles in motion, and therefore also does not make one that notorious. What is new, however, is always *evil*, being that which wants to conquer and overthrow the old boundary markers and the old pieties. (*GS* 4)

Innovators are the new object of hatred and resentment (*Z* III, 12,26), they are the new "criminals" (*TI* 9,45), the new "cruel ones" (*BGE* 230), the new perpetrators of "war" (*GS* 283).

In sum, cultural creativity is made possible by a dialectic of master and slave characteristics, so that not everything in the latter is "slavish" and not everything in the former is "noble." In the end, therefore, the creator-herd distinction is *not* equivalent to the master-slave distinction; there are overlaps, but the crude domination found in the original condition cannot be considered the primary focus of Nietzsche's analysis of creative types.

There are comparable complications in certain other phenomena supposedly denigrated by Nietzsche, such as bad conscience (resentment turned inward against the self) and the ascetic ideal (the self-destructive denial of nature). Both are conditions of denial that nevertheless also serve culture and have great potential for a higher order (*GM* II,16 and III,27). Specifically, for Nietzsche, these instincts of hatred and denial can perhaps be turned against themselves, where nihilism can be despised and then overcome in the spirit of affirmation. We should notice a general insight operating here: For Nietzsche, *any* development of culture out of natural conditions and any innovation will require a dynamic of discomfort, resistance, and overcoming—a contest with some Other. Nietzsche forces us not only to acknowledge this dynamic but to be wary of its dangers, which are indicated in traditional constructs and their *polarization* of a conflicted field into the oppositions of good and evil, truth and error. The ascetic ideal in the end represents the desire to escape the difficulty of incorporating the Other—*as* other—into one's field of operation. Affirmation, for Nietzsche, is anything but comfortable and pleasant; it means the capacity to take on that difficulty of *contending the Other without wanting to annul it*.[56] The bottom line in Nietzsche's genealogy, then, is that *every* perspective is mixed with its Other.[57] Such a mixture has two components: First, a perspective needs its Other as an *agonistic correlate*, since opposition is part of a perspective's constitution; second, a perspective can never escape a certain *complicity* with elements of its Other. Conflict, therefore, is not simply to be

tolerated; affirming oneself requires the affirmation of conflict, since the self is not something that is first fully formed and then, secondarily, presented to the world for possible relations and conflicts. The self is formed *in* and *through* agonistic relations. So in a way openness toward one's Other is openness toward oneself. This sense of opening-toward rather than closing-off the Other— which is related to the difference between active and reactive will to power—is something that I think can be cashed out as a model for political pluralism, a possibility to be explored in a later chapter.

Given all these hermeneutical possibilities, it would not be presumptuous to suggest that Nietzsche's political categories and recommendations should not be taken literally, that they harbor a hidden meaning—especially since Nietzsche deliberately affirmed the use of masks in philosophy.

> Every profound spirit needs a mask: even more, around every profound spirit a mask is growing continually, owing to the constantly false, namely *shallow* interpretation of every word, every step, every sign of life he gives. (*BGE* 40)[58]

Accordingly, the "rule" of higher types may be a metaphor for something less political, more cultural, or something less social, more internal. There is some truth to this, but as we have seen, the suppression of political implications is just as suspect as a purely literal reading. To focus this issue and to set up a transition to subsequent topics, let us address the question of power in the sphere of human affairs.

We can distinguish two types of human power: 1) *power-for*, which suggests autonomy, the opportunity and capacity for self-development, and 2) *power-over*, which suggests domination, the control of other selves. This distinction helps us clarify a central problem in interpreting the political meaning of Nietzsche's texts. Those who advocate democratic politics are comfortable with the category of power-for, but not power-over. This may be why many commentators favor something like the creativity thesis, since in effect it allows us to decode Nietzsche's power-over motifs as rhetorical masks that harbor patterns of power-for. Some, like Warren, go so far as to say that liberal political ideals can be located

in Nietzsche's thought because his domination rhetoric (even if taken literally) need not be traced to his notion of power, which, if understood as self-constitution, should not be taken to mean power-over, but only power-for. For Warren, Nietzsche's philosophy of power can be separated from his expression of political domination, and therefore can open up possibilities for a liberal appropriation of Nietzsche.[59]

I am ambivalent about such interpretations, and not simply because of doubts about textual exegesis. I too want to find a place for democratic politics in Nietzsche's thought, but I cannot ignore the fact that Nietzsche's texts do suggest that political domination is in some way connected with his philosophy of power. The reason, I think, is because in Nietzsche's estimation, power-for can*not* be separated from power-over. With Nietzsche's agonistic, relational model of selfhood and his rejection of atomistic individuality, it follows that self-expression and self-development never leave the world untouched; something "other" will always be affected. Every form of self-assertion will produce some kind of diminishment in the field of play, a certain "pathos of distance" (*TI* 9,37). I agree with this, but I want to emphasize that power-over need not be limited to crude, direct control of other people's lives (although I think that Nietzsche did accept social control as *part* of the power field). Power-over can have more subtle elements, especially in matters of human excellence, social relations, and even, I will argue, in democratic politics. Such activities can be seen to involve *both* power-for *and* power-over in some form or another.[60] This touches the second reason for my ambivalence about neutralizing Nietzsche's power-over motifs—not simply that this distorts Nietzsche but that it might also distort the nature of democracy. The fixation of democratic theory on individual self-development may cover up elements of democratic politics that ironically can be uncovered by a Nietzschean perspective. In other words, power-for is not a sufficient category for *either* human development *or* democratic practice. We therefore need to incorporate *some* version of Nietzsche's power-over dynamic if we want to better understand such phenomena; and in the bargain, here we find a more effective

strategy for enacting an *internal* conversion of Nietzsche's posture toward democracy. But I am jumping ahead here. Let us return to the hermeneutical task at hand.[61]

Nietzsche and Politics

Even an emphasis on creativity need not deflect Nietzsche's references to political hierarchy, since the impediments to meaning-creation that herd conformity represents can easily lead to a preference for giving creator types social control over the herd. In general terms, we cannot discount or ignore political ramifications, since a careful and honest reading of the texts shows that Nietzsche's thought is not antipolitical in any strict sense; he uses political categories frequently enough and forcefully enough to render purely metaphorical readings suspect.[62]

Cultural superiority is not separable from political superiority (*GM* I,6). Nietzsche's creator category does indeed involve individual self-creation (*GS* 290), but it is also applied to a legislation of values for all humanity. In *BGE* 61, Nietzsche acknowledges that some higher types might prefer to withdraw from the realm of political power, but he describes the higher philosopher as "the man of the most comprehensive responsibility who has the conscience for the overall development of mankind," and as being among "the strong and independent who are prepared and predestined to command and in whom the reason and art of a governing race become incarnate." Genuine philosophers are called "commanders and legislators" (*BGE* 211).[63] Creative individuals who do break away from the social conventions of their time nevertheless "carry the seeds of the future and are the authors of the spiritual colonization and origin of new states and communities" (*Neubildung von Staats- und Gesellschaftsverbänden*) (*GS* 23).[64] Nietzsche occasionally talks about the rule of artist-tyrants and suggests a form of political aestheticism, where the polity is a kind of groundless artwork forged in conflict (*BGE* 208,251; *WP* 960).[65]

Nietzsche was a philosopher of culture, not an advocate of chaos, amorphous freedom, or sheer individualism.[66] Consequently,

an interest in social and political structure would not be alien to his project.[67] At the same time, Nietzsche emphasized the select, creative individuals through whom culture receives its shape and direction. Here we notice one of Nietzsche's basic objections to liberal individualism: it dilutes what he saw as the very purpose of politics and society, namely the production of higher individuals who further the development of culture.[68] In any case, the *juxtaposition* of cultural organization and creative individuals is what lends ambiguity to Nietzsche's avowal of rank. Is it simply an honorific gesture to cultural excellence or is it meant to take some concrete political form?[69]

Regarding Nietzsche's political thought and its relation to democracy, there are a number of possible ways to sort out these issues for the purpose of textual exegesis. Nietzsche's higher types may be political rulers in the direct sense; or they may serve "in conjunction" with a ruling class (*WP* 978); or they may simply use and benefit from aristocratic political arrangements that support their creative work, since cultural production is more important than mere matters of the state.[70] In any case, it seems clear that Nietzsche is advocating a "new aristocracy" (*WP* 953), not the repetition of any past forms (*GS* 356,377). That it is "new" might support some of the anti-domination interpretations, to the point where democracy might even be affirmed as necessary for the masses (as is morality); this would restrict the creator-herd hierarchy to a ranking of cultural importance and honor, where higher types and the democratic herd achieve a kind of mutual recognition and coexistence.[71] At one point Nietzsche seems to say that democratization is inevitable, and that higher types might be able to use democracy as an instrument for creative domination; indeed, creators may become even stronger and richer because of competition with a fortified egalitarianism (*BGE* 242).

More subtly, all these issues might be detypified and depersonalized, so that the moral/democratic "herd" category can reflect the process of socialization (suggested in *GS* 116,354), and the "creator" category can reflect the counter-movement of individuation.[72] If so, each self can be seen as a mixture of socially ordered common

meanings and individualized variations or divergences—with some selves, namely creative types, being simply *more* individuated than others. In this way Nietzsche's "politics" might be seen as minimally ordered, or as simply a theory of human development. We have seen the shortcomings in moves such as this, but the socialization-individuation distinction might provide a useful perspective that can supplement, or run parallel to, political questions. We should not forget, though, that Nietzsche seems to believe that only a select few can become authentically individuated—hence his aristocraticism, whatever form it is meant to take.

After all of this, if the reader is looking for clear answers about which interpretation of Nietzsche's political remarks is the right one, or how we might interpret particular passages properly, I must say that I have no idea how to provide this. I think that all the possibilities described in this chapter are alive in the texts; we can simply acknowledge this and not fall prey to any interpretation that claims exclusivity. My purpose, however, is to go beyond textual exegesis, to work with and against Nietzsche in thinking about democracy.[73] I have no trouble accepting the ranking of cultural achievements along the lines of Nietzsche's creator and herd categories. Nonetheless, must politics be ranked in such a way? I can think of three main options for engaging Nietzsche on this question: 1) Democracy *is* the complete hegemony of mediocrity and weakness, in which case it is hard to withstand Nietzsche's critique and plea for an aristocratic politics. 2) Political democracy as described in the first option can *coexist* with a cultural aristocracy, the excellence of which might even be better catalyzed by resistance from its Other. 3) Democracy is *not* the complete hegemony of mediocrity and weakness, so that distinct aristocratic alternatives or preserves are not needed. This last option is the one that I want to emphasize and explore.

Assuming that Nietzsche's thought is in significant respects antidemocratic, I want to mount a challenge to his critique by redescribing democracy without some of its traditional baggage, to see if democracy can express even some of Nietzsche's own predilections. In general, I think that most traditional assumptions

in democratic theory *are* suspect when seen through the lens of postmodern critique. In particular, Nietzsche's value to us is his convincing assessment of egalitarian mediocrity and the problematic or concealed motives in the psychology of democratic sentiments. Resentment, conformism, and other power plays that suppress creativity and differences *are* a significant threat to cultural and human development; and such herd-like phenomena can and do debase democratic politics. My questions are these: Must democracy necessarily express or stem from what Nietzsche calls smallness or weakness in the face of life? Are the herd mentality and mediocrity intrinsic to democracy? Can the creator-herd problem be disentangled from democratic politics? In short, can democracy be separated from egalitarianism? I want to challenge Nietzsche's political aristocraticism and *at the same time* incorporate his critique of egalitarianism into a redescription of democracy. In other words, I am advancing a twofold argument: 1) Nietzsche was wrong in rejecting democracy, because democracy can be more amenable to his way of thinking than he imagined. 2) Nietzsche nonetheless was right in depicting the flaws of *traditional* democratic theory, and in warning about egalitarian influences in politics.

3

Nietzsche Contra Nietzsche: Democracy Without Equality

Defining Democracy

Before engaging Nietzsche, I want to lay out some basic assumptions and definitions that will inform my analysis. First of all, implicit in my consideration of democracy is a presumption against political anarchism, which in rough terms maintains that a state is not necessary in human affairs, indeed that it is the very machinery of government that corrupts human relations. I am assuming that our life cannot flourish without some form of government, i.e., without political institutions and the elements of coercion that stem from and sustain these institutions.[1] Accordingly, I will not rehearse the question of the legitimacy of government, which among other things animated the "state of nature" gambit in many political theories. Rather, I am pursuing the kind of phenomenological approach conducted by Aristotle, which presupposes certain social and political realities and proceeds to analyze them with an eye toward discerning which form of government would be best.[2]

In this regard I aim to make the case for democracy, but a democracy that is historically and contextually situated, and therefore not necessarily applicable to any and all societies or social arrangements. My emphasis will be on a model of democracy that

55

lends itself to what Dahl calls a modern, dynamic, pluralistic society.[3] Such a setting takes into account the features of a large-scale, heterogeneous, industrial, developing society, which forces us to distinguish contemporary democratic arrangements from other versions (e.g., the direct democracy of the Greek polis, the Italian republican tradition, or the preindustrial nation state). Moreover, I will be emphasizing the kind of democracy that operates in the American system, which is a mixture of constitutionalism, republicanism, and representationalism, and which from an economic standpoint is a blend of free-market and welfare-state principles.

I should indicate that I am postponing a treatment of economic issues until a later chapter. I want to concentrate first on political principles, procedures, and practices that operate in democracy, as distinct from questions of wealth and poverty. This is not to say that politics and economics can ever be separated; indeed some might even argue against drawing analytical lines of distinction between politics and economics. It seems that the bulk of contemporary political theory is focused on economic questions. One likely reason for this is that there has a been a fair amount of consensus about the legitimacy of democratic principles, and so attention has been turned to how economic conditions influence political life. The approach I am taking, however, puts that theoretical consensus in question, and so I want first to reexamine the background of democratic principles, assumptions, and procedures. In the bargain I hope that this background analysis will provide effective preparation and some guidance for a subsequent discussion of economic justice.

In any case, for the purpose of orientation, here are the basic features that identify the form of democratic politics I will be presuming in this chapter and chapters to come:[4]

1. All adult members of society have the right and opportunity to participate in setting the political agenda and reaching collective, binding decisions; such is a definition of citizenship and the extent of suffrage.

2. Political authority is achieved in a procedure of election by citizens.

3. The direct control of the government is in the hands of elected officials.

4. Officials are chosen or removed in periodic, open, fair, and contestable elections that are protected from conditions of violence or coercion.

5. All citizens have a right to the following: free expression and political association, criticism of the government, access to information not controlled by the government, and peaceful protest.

6. The aim of democracy is not the elimination of political conflict but the ordering of conflict through political structures and procedures; the term that Dahl uses for this feature of democracy is "polyarchy."[5]

Equality in Question

My contention is that democracy can be sustained without its traditional banner of human equality. Democracy does require that all citizens be given the same rights; that they all have the same access to, and fair treatment by, the legal system; that they all have the same opportunity for political participation; and that all voices count the same in elections (one person, one vote). Such constructions, however, need not reflect or depend upon any version of substantive "sameness" in human beings or in the outcomes of their lives. We can call these constructions functional and procedural parities that need not imply any kind of substantive or intrinsic equality.

We have already mentioned that traditional democratic theory tended to derive political equality from three main sources that suggest a picture of substantive human equality: 1) The Judeo-Christian notion of souls that are equal in the eyes of one transcendent God; 2) the implications of scientific rationalism, which presumes a common capacity to apprehend universal and demonstrable truths; and 3) a metaphysical model of an enduring, unified self that stands as a "substance" behind its attributes. These three sources, which were usually conjoined in an interrelated complex,

provided a perspective that could transcend and supersede the contingent realm of physical, cultural, and performative differences, and thereby open up conceptual space for equality. If God has the same concern for all human creatures; if abstract, necessary truths take the mind beyond contingencies of sensuous nature to a sphere of enduring, universal principles; if human identity and continuity suggest a stable self behind the changing conditions of experience— then all of this permits us to look past variations of ability, inheritance, fortune, status, and achievement; it thereby supplies ammunition to repudiate social and political hierarchies. Accordingly, in the face of historical inequities and the powerful forces that preserved them, one could make the argument that despite their establishment, such divisions are unjustified because they do not conform with certain truths about human nature.

Of the three sources of equality described above, the one that had the most crucial and direct effect on political movements was scientific rationalism. In the spirit of modernism, scientific rationalism was able to disrupt established religious authority and other traditional forces; secularization and the call for intellectual autonomy were more immediately conclusive for democratic developments. Nevertheless, as we saw in the thought of Hegel, it is still possible to see modern political developments as a correlation of religious, scientific, and philosophical ideas that inform each other in an overall orchestration of themes. Political principles received a great deal of rhetorical strength when couched in the language of esteemed truths and given the kind of intellectual legitimacy that would enable proponents to label opponents as irrational or deviant. Witness the conjunction of rational, religious, and political images in the American Declaration of Independence: the "self-evident" truths that all men are created equal and that the Creator has endowed them with inalienable (i.e., natural) rights that cannot be denied in human relations. The arguments supporting the Constitution given by writers of *The Federalist* papers often used the same rhetoric. For example, the kind of confidence exhibited by Hamilton in paper #31—where natural rights grounded in self-evident truths "command the assent of the mind," and any denial of same would have to be due to a defect, disorder, or prejudice—such

confidence would seem impossible without its appeal to a human "essence" grounded in divine creation.[6]

To rehearse the postmodern opening indicated in Nietzsche's Madman passage, once these traditional foundations become marginal, suspect, or dismantled, the notion of human equality becomes very difficult, if not impossible, to defend. For Nietzsche, the death of God implies the loss of equality and the ascendancy of higher types (Z IV,13,1–2). If we remove the religious reference from the Declaration of Independence (and repair its selective equality) by declaring "all persons are born equal," we see the difficulty of arguing for equality from the standpoint of the natural order. What is universal in the human condition? How are we in any sense the same? We seem to be left with nothing but differing conditions, outlooks, capacities, and outcomes.

I argue that democratic values can be defended without any sense of equality that connotes some positive description or condition of human nature, or that stems from some kind of metaphysical essentialism. In other words, a commitment to democracy need not compel one to espouse any form of substantive egalitarianism. The ambiguities of this question are indeed evident in the history of democracy. The Greeks were able to affirm democracy without a strict egalitarianism, in that they maintained a functional, political sense of equality that was not based on any universal concept of human equality or rights.[7] One indication of this, of course, is that political equality was not extended to all persons in the polis; it was confined to an "in-group" of Athenian citizens that did not include women, slaves, or resident aliens. The citizen population of Athens, for example, never exceeded 15 to 20% of the actual population. Moreover, aristocratic forces and sensibilities were rarely, if ever, absent from Greek politics.[8] Despite the fact that a kind of egalitarianism has indeed operated in various contexts throughout human history and in all sorts of cultures (e.g., in tribal associations), the question is how far equality has been extended (e.g., it might not extend to other tribes). *Universal* egalitarianism is relatively rare in theory, and even then it has not always been cashed out in practice. One reason why universal equality can be seen as ambiguous and problematical is that the

confidence and comfort in traditional egalitarian ideals usually stemmed from an in-group allegiance (e.g., of white males). Once *actual* universal equality is suggested or at hand, egalitarian sentiments often lapse.[9] It is therefore questionable whether the notion of human equality has ever *actually* been affirmed or whether it is ever *likely* to be affirmed in human relations.

I am suggesting that we can sidestep this problem entirely by rethinking democracy without touting the notion of human equality. Perhaps, however, the egalitarianism I have put in question is a straw man. Most contemporary democratic theories are not wedded to a notion of substantive equality. A democratic apologist can agree that equality need not refer to something substantive or intrinsic in human nature, but simply to equal treatment, equal consideration, and equal opportunity for political participation.[10] I have two responses. First, such a revised egalitarianism is subject to the critique stemming from Nietzsche's Madman passage. The rhetoric of equal treatment is historically connected to the rhetoric of substantive equality, as we have seen. If the latter is suspended, is the former still warranted? If we call for equal treatment, the question remains: Why grant this? Traditional rhetoric at least had a ready answer. Suspending substantive equality obligates us to find another answer.

Secondly, it strikes me how durable and esteemed the word "equality" is even when it is no longer intended to mean "sameness." I have not yet been relieved of a Nietzschean suspicion about this. If equality means "letting everyone participate in a fair manner," I can readily accept such a connotation (otherwise I would not be defending democracy). It seems to me, however, that the meaning of the word "equal" is not a necessary condition for fair and open participation, as I will try to argue later. Why are we still so attached to the word "equal"? Is it simply a residual rhetorical habit that a Nietzschean analysis could easily undo? I think not, because there are other meanings that come through in nonsubstantive egalitarian discourse, such as equal respect and equal importance, which can be designated summarily as *equal regard*. Equal regard, in my view, simply transfers egalitarianism from the substantive

nature of persons to an *attitude* toward persons, from "human nature" to demands about how humans ought to view and treat each other. If we recall Nietzsche's genealogical script, however, the issue of equal treatment and regard was the *original arena* of egalitarian developments, which served to elevate the lowly to a point of parity so as to ameliorate the sufferings that stemmed from social inequities. According to Nietzsche, philosophical "theories" about human nature reflected and served *that* psychological dynamic. So equal regard may simply be a *clearer* presentation of the egalitarian doctrine that Nietzsche criticizes, and consequently the problems posed by that critique have not been surmounted. I will have more to say about the question of equal regard in upcoming chapters.

In any case, some aspects of contemporary egalitarian rhetoric are salvageable, in my view. I only want to highlight here the problems facing democratic theory if it maintains a vestigial confidence in equality when its historical foundations have been marginalized or challenged. My approach assumes the postmodern challenge to traditional structures that has been inspired by Nietzsche. This challenge, as I have said, can provide both a postmodern revision of democratic politics and a deconstruction of Nietzsche's critique of democracy. To this end I want to examine three Nietzschean themes that can be shown to fit a democratic setting. Significantly, none of these themes reflects a positive, foundational condition; rather, there is an element of negativity operating in each. The themes are: 1) Nietzsche's interest in the Greek *agōn*, or contest. 2) The absence of objective, absolute knowledge in a nonfoundational atmosphere of perspectivism. 3) The suspicion of power and its pretense of cognitive and moral justification.

The Greek Agōn

Nietzsche stressed and favored the phenomenon of the *agōn*, or contest for excellence, that operated in all Greek cultural pursuits (e.g., in athletics, the arts, oratory, and philosophy). The *agōn* can

be understood as a ritualized expression of an overall world view that characterized so much of Greek myth, poetry, and philosophy: namely, the world seen as an arena for the struggle of opposing forces. We find this agonistic relationship depicted in Hesiod's *Theogony*, in Homer's *Iliad*, in Greek tragedy, and in philosophers such as Anaximander and Heraclitus.[11] In an early text, *Homer's Contest* (1872),[12] Nietzsche argued that the Greek *agōn* represented a *cultivation* of destructive instincts, which did not strive for the annihilation of the Other, but rather an arranged contest that would test skill and performance in a competition. In this way, strife produced excellence, not obliteration, since talent unfolded in a struggle with a competitor (*KSA* 1, p. 787).[13] Accordingly, the Greeks took great pleasure in contests of all sorts, as opportunities for victorious achievement.[14] Nietzsche thought that the Greeks were wise in not falling prey to an ideal of sheer "harmony." An agonistic spirit insured a proliferation of excellence by preventing stagnation, dissimulation, and uniform control; the *agōn* reflected the overall Greek resistance to "domination by one" (*Alleinherrschaft*) and their fear of the danger of unchallenged power (*KSA* 1, p. 789).

Nietzsche recognized the political purposes of the *agōn*, as an educational principle meant to generate excellence in the polis.

> For the ancients the goal of an agonistic education (*agonalen Erziehung*) was the welfare of the whole, of the political society. (*KSA* 1, p. 789)

To be sure, Nietzsche saw the *agōn* as an aristocratic device, where the few talented types would contend for cultural and political status. As we have seen, Nietzsche perceived democratic movements as the degeneration of culture, as the replacement of aristocratic hierarchy with an egalitarian ideal, which considers instincts for victory and contention to be selfish and harmful, which thereby effaces any distinction between better and worse, higher and lower, and which consequently produces a leveling and weakening of culture.[15]

Putting aside for the moment the question of cultural excellence, with respect to politics Nietzsche did not seem to notice any connection between the Greek agonistic spirit and democratic

practice. If we take a genealogical approach, the *emergence* of democracy in Greece shows agonistic elements that I think can add to our understanding of democratic politics. The advent of philosophy and science represented a challenge to traditional paradigms and the select authorities who depended on those paradigms for their political warrants. This challenge, combined with other agonistic habits, generated a preference for giving people an opportunity to contend in open, public discussion, something that nurtured the growth of democracy and came to constitute its procedures.[16]

Democratic practice can be understood agonistically in the following way: Political judgments are not preordained or dictated; outcomes depend upon a contest of speeches, where one view *wins* and other views *lose* in a tabulation of votes; since the results are binding and backed by the coercive power of the government, democratic elections and procedures establish temporary control and subordination—which, however, can always be altered or reversed because of the succession of periodic political contests. Accordingly, if we remember that Nietzsche's concept of power is by no means limited to physical force, we can read something like the will to power into democracy. Democratic elections allow for, and depend upon, peaceful exchanges and transitions of power. Not only is sheer physical force repudiated, but other material machinations of power, such as bribery, are also meant to be displaced by the power of speech to persuade in political discourse; language is the weapon in democratic contests. The binding results, however, produce tangible effects of gain and loss that make political exchanges more than just talk or a game. It is no wonder then that democratic elections and procedures are so often depicted in competitive, even martial, terms: victory and defeat, opponents and allies, battles, strategies, and so on. The urgency of such political contests is that losers must yield to, and live under, the policies of the winner; we notice, therefore, specific configurations of power, of *domination and submission* in democratic politics.[17]

I am not sure why Nietzsche missed this agonistic element in democracy. Indeed, in a note from 1881, Nietzsche speculated that

Greek politicians promoted cultural contests in athletics and the arts to divert competitive instincts *away from* matters of the state, to diminish political strife (*KSA* 9, p. 514).[18] One possible reason for Nietzsche's myopic view of the Greek political scene is that the democratic polis was indeed not as contentious as contemporary versions, even though a contest of speeches remained essential to its operation. In Greek politics there was a comparatively greater degree of homogeneity and consensus about the public good—which of course can be explained by the noninclusive composition of the *demos* in Greek democracy.[19] In any case, the spirit of debate and dispute was not always exercised or encouraged in Greek democracy.[20] Political agonistics did become more pronounced in the polis when there was not a clear social consensus. This leads to the next item of discussion.

Perspectivism

If we presume Nietzsche's critique of truth and his perspectival alternative, and then concentrate on politics as *praxis*, as the practical requirement to make *decisions*, we notice an opening for democracy. Indeed, the denial of a fixed, absolute, or uniform truth can clarify and reinforce the aptness and dynamics of a democratic contest of speeches. If the very possibility of truth is *in question* and a number of different perspectives are in play, then the only political alternative to one perspective ruling absolutely (which would seem purely arbitrary), or to the disarray of no perspective ruling (assuming anarchy is not a viable option), would be an arranged contest of *all* perspectives, decided by a majority (or plurality) of votes, where votes designate the preferential judgments of all participants in, or witnesses of, the verbal contest. To balance the need for continuity of governance with the denial of any fixed and lasting warrant for governance, the political contest of speeches must be repeated periodically. Political "authority" in a democracy, therefore, is not something theoretically preestablished or fixed, but something continually earned, challenged, and altered in civic debate. Consequently, democratic politics is a perpetual *questioning*

of governance that operates by an open-ended orchestration of conflict.[21]

Here we have an agonistic, nonfoundational configuration for democracy that can express a postmodern alternative to various traditional models and assumptions that have been problematic even for proponents of democracy. Elections and other voting formats need not be designated as anything more than *decision procedures* in matters that are globally *undecidable*. We can consequently forgo the belief expressed by some political theorists that collective decisions are more likely to reflect the "truth" (since more input increases the opportunity for correction of error).[22] If truth is not presumed, then neither defenses nor criticisms of the status of majority decisions are to the point.[23] In the same way, we can forgo the belief that the majority viewpoint is in any substantial way "better" than minority viewpoints. Finally, we can sidestep the problems associated with the common rhetoric that democratic elections reflect the "will of the people" (a sizable portion of "the people" might be *denied* their will). Democracy in an agonistic sense can be understood not precisely as "rule by the people," but as "agonarchy," or rule which is decided by a contest among the different perspectives in the political field. Majority (or plurality) rule would simply stand as a decision procedure, serving the same function as point totals in games. Indeed, majority or plurality totals would seem to be the only plausible procedure for making political decisions in an ungrounded competition with no presumption of truth. What kind of politics would we have if, for example, we held out for unanimity or some kind of super majority? In effect, we would be giving the "victory" of veto power to contestants with lower totals.[24]

The unhinging of democracy from traditional supports and assumptions would not therefore undermine democratic procedures in any way, and it would also uncover some difficulties for Nietzsche's interpretation of democracy. For instance, Nietzsche identifies democracy with herd values, and one mark of the herd mentality is its need for security and its fear of risk and loss. Such fear, however, is also connected with intellectual dogmatism and

the presumption of knowledge structures that can ward off every-thing strange and questionable (*GS* 355). The demand for certainty is no different from other fears of finitude, and it therefore stems from weakness (*GS* 347). It seems to me, however, that democratic procedures described above (and indeed much of the spirit of traditional democratic theory) presuppose a nondogmatic outlook, an openness to engage other viewpoints, and a respect for differ-ences. Such attitudes mutually inform each other and require, I think, what the poet John Keats called "negative capability," the capacity to dwell with uncertainty.[25] As I see it, the kind of closure that Nietzsche diagnoses as weakness in the face of finitude is precisely the kind of attitude that does *not* lend itself well to democratic procedures or to the motivation to affirm such proce-dures.

An emphasis on existential finitude and agonistics can give us a number of avenues for rethinking the political meaning of *respect*, which has usually figured prominently in democratic theory. In the end, my respect for other persons and other viewpoints in demo-cratic exchanges would seem to mean, ideally, that my beliefs are not absolute, that I do not have a lock on the truth, that other views might have some merit and might even improve upon my view in some way. Otherwise, the democratic affirmation of free, open, and fair competition of all views would amount to an irresponsible courting of error, or an insincere, condescending duplicity, or perhaps a failure of nerve. Respect, therefore, follows from a kind of existential "fallibilism": it is more likely to flourish when truth is *in question*, and less likely to do so when truth is presumed. In this regard, we should take note of some passages in which Nietzsche talks of a "species of genius" associated with justice, which is described as an "opponent of convictions" (*HAH* I,636). A conviction (*Überzeugung*) is "the belief that on some particular point of knowledge one is in the possession of the unqualified truth" (630), but it is really nothing more than an opinion (*Meinung*) that has become stiffened because of laziness (*Trägheit*) of the spirit (637). What can connect with our suggestions about respect is that counterconvictional justice "wants to give to each his own." To do

this one must cultivate a knowledge that "sets everything in the best light and observes it carefully from all sides" (636). Respect, therefore, can be understood as an openness that acknowledges limits.

This last point gives us another angle on the familiar contrast between democracy and tyranny. Authoritarian regimes have never described themselves as unwarranted or arbitrary, but rather as serving some truth or virtue that is securely established with confidence.[26] Indeed, we might even speculate that authoritarianism is the only consistent and straightforward political option when truth and error are presumed to be decisively delineated, since "openness to error" would seem to be a strange political prospect. We notice then that tyrannies of all kinds, especially so-called "benevolent despotisms," arise not simply from sheer power, but from a sense of *certainty*. From this angle we can understand more clearly something that is quite evident in human history: *any* conviction can become tyrannical; indeed the greater the confidence in goodness and truth, the greater the danger of oppression. As Nietzsche puts it, what has made history so violent is not the conflict of ideas, but rather the conflict of hardened convictions; if there had been more self-examination and self-criticism, history would have been more peaceful and we would have been "spared all the cruel scenes attending the persecution of heretics of all kinds" (*HAH* I,630). The conviction of truth is what prompts the elimination of opponents (633).

Democratic respect, therefore, depends not so much on regarding others positively as upon recognizing the finitude and contingency of one's own beliefs and interests. Again, a myopic disrespect or disregard can be evident in any viewpoint (including even "liberal" outlooks), so any remedy would have to begin with loosening the fixation of conviction. Even groups that affirm their own dignity in response to past disregard and exclusion are susceptible to a kind of cultural closure. In any case, democracy demands that both individuals and groups be open to the fair engagement of other individuals and groups. This together with the *binding* results of democratic contests enables us to summarize a basic attitude that would seem to be essential to democracy: From

a political standpoint *we must value democratic procedures more than our own beliefs*. Consequently a democratic praxis and ethos would have to involve a recognition of existential finitude, a kind of intellectual modesty, and an experimental disposition.

We have already established the importance of existential finitude in Nietzsche's thought, and there are some interesting indications in the texts that address the kinds of comportment described above, and indeed specifically in relation to democracy. Nietzsche generally favors an experimental attitude over intellectual closure and security (*GS* 51,319,324).[27] In the so-called middle period, Nietzsche often speaks of intellectual modesty.

> [T]here are no absolute truths. Consequently what is needed from now on is *historical philosophizing*, and with it the virtue of modesty. (*HAH* I,2)[28]

He even indicates a connection between democratic movements and a liberated, experimental artistry of self-improvisation, as opposed to eras in which human nature and possibilities were fixed by traditional patterns (*GS* 356). There are also passages in *The Wanderer and His Shadow* that contain positive remarks about democracy: A tyranny of fixed ideas can be countered by a "democracy of concepts" (230); democracy is inevitable in modern Europe, it distinguishes us from the Middle Ages and can protect culture from tyranny and all forms of enslavement, both physical and spiritual (275); democracy aims to maximize freedom of thought and lifestyle (293).[29]

Nietzsche's agonistic orientation can also refine our understanding of respect in the context of political practice. As we have seen, the will to power expresses an agonistic force-field, wherein any achievement or production of meaning is constituted by an overcoming of some opposing force. Consequently, my Other is always implicated in my nature; the annulment of my Other would be the annulment of myself. The self forms itself in and through agonistic relations; it is not formed first in a self-contained space and only then related to an Other. This is why Nietzsche often speaks of the need to affirm our opponents *as* opponents, since they figure in our self-development.

How much reverence has a noble man for his enemies!—and such reverence is a bridge to love.—For he desires his enemy for himself, as his mark of distinction (*Auszeichnung*); he can endure no other enemy than one in whom there is nothing to despise and *very much* to honor! (*GM* I,10)

Another triumph is our spiritualization of *hostility* (*Feindschaft*). It consists in a profound appreciation of the value of having enemies: in short it means acting and thinking in the opposite way from that which has been the rule. The church always wanted the destruction of its enemies; we, we immoralists and Antichristians, find our advantage in this, that the church exists. In the political realm too, hostility has now become more spiritual—much more sensible, much more thoughtful, much more *considerate*. Almost every party understands how it is in the interest of its own self-preservation that the opposition should not lose all strength. (*TI* 5,3)[30]

Consider the analogy of athletic opponents. They engage in vigorous competition, but they need each other for the opportunity to succeed and to bring out their respective talents. A victory would mean nothing without a worthy opponent (a weak opponent depreciates the value of a win). The elimination or degradation of the Other would be self-defeating. In addition, the loser should honor and yield to the winner of a fair contest.[31] The cogency of this example may explain why respect for opponents is more evident in athletics than in other competitive domains, but Nietzsche's configuration of will to power implies that the analogy can and should apply to all circumstances of contention. What is useful in applying agonistic respect to politics is that we do not have to equate respect with "positive regard," or with problematic notions such as equal consideration or equal worth.[32] Democratic respect forbids exclusion, it demands inclusion; but respect for the Other *as* other can avoid a vapid sense of "tolerance," a sloppy "relativism," or a misplaced spirit of "neutrality." Agonistic respect allows us to simultaneously affirm our beliefs and affirm our opponents as worthy competitors in public discourse. Here we can speak of respect without ignoring the fact that politics involves perpetual disagreement, and we have an adequate answer to the question "Why should I respect a view that I do not agree with?"[33] In this way

beliefs about what is best (*aristos*) can be coordinated with an openness to other beliefs and a willingness to accept the outcome of an open competition among the full citizenry (*demos*). Democratic respect, therefore, is a dialogical mixture of affirmation and negation, a political bearing that entails giving all beliefs a hearing, refusing any belief an ultimate warrant, and perceiving one's own viewpoint as agonistically implicated with opposing viewpoints. In sum, we can combine 1) the historical tendency of democratic movements to promote free expression, pluralism, and liberation from traditional constraints, and 2) a Nietzschean perspectivism and agonistic respect, to arrive at a postmodern model of democracy that provides both a nonfoundational openness and an atmosphere of civil political discourse.

Suspicion

> A philosopher . . . has a *duty* to suspicion today, to squint maliciously out of every abyss of suspicion. (*BGE* 34)

The preceding discussion allows us to locate and clarify an essential ingredient in democratic inclinations: cognitive and moral suspicion. Aristocracies and authoritarian regimes have historically defended their right to dominance and unchecked power by way of confident knowledge claims about the nature and order of things. Political power should never be put in the hands of those who lack the intellectual or ethical aptitude to apprehend the truth or the good—so goes the argument for aristocracy. The most famous example of this argument unfolds in Plato's *Republic*, and the force of its rhetoric is gathered in the cave allegory in book 7. The exterior of the cave symbolizes the realm of eternal Forms, and the interior symbolizes the realm of change, time, and physical nature, where our minds are distorted by sensation, passion, and material interests. If we want to know what "justice" is or how to properly order society, we should turn to those who have made the difficult journey to free themselves of physical constraints and self-interest, and who have discovered the universal insights hidden from the rest of us. The key to this aristocratic argument is indicated when the

freed individual returns to help the other prisoners in the cave. They
do not understand his unfamiliar ways and in fact they turn on him
in anger and would kill him if they could (517a). The source of this
anger is the pain that accompanies the journey to the "light" (516a).
The message here is clear: Most people cannot (or will not) endure
the difficulties and sacrifices that are required to rise above the
contentious arena of ordinary pursuits, to achieve a vision of the
universal truth that will reflect the good of all. Something like
democracy amounts to the pooling of ignorance that will permit the
overruling of wiser minds.[34] Political authority should operate
according to a hierarchy of classes: the legislative intelligentsia, the
executive and military guardians, and the common citizens. Those
who can demonstrate a capacity for wisdom and leadership have a
right to political power, and they should not be challenged or
contested by the incompetent masses.

The appeal of Plato's position should not be underestimated. The
competence of citizens is an issue recognized by democrats, and
indeed outside of politics we readily affirm and accept all sorts of
hierarchies when we have confidence in a certain kind of knowledge
and its unequal distribution—consider the deference given to
officers by privates, doctors by patients, teachers by students.[35]
Plato's challenging question is simply this: Why should politics be
any different? If someone possessed superior knowledge or virtue,
would it not make sense to yield political authority?[36]

Part of my argument for democracy turns on the disruption of
hierarchical confidence that should follow from dismantling
cognitive, moral, and metaphysical warrants. As Lefort says:

> democracy is instituted and sustained by the *dissolution of the markers
> of certainty*. It inaugurates a history in which people experience a
> fundamental indeterminacy as to the basis of power, law and knowl-
> edge.[37]

We can argue against political hierarchy *not* by countering that
knowledge and virtue are or can be equally distributed, but by
radically putting traditional models of knowledge and virtue *in
question*. In other words, it is confidence in truth that lends itself so
easily to hierarchy and exclusion of the Other, and so suspicion of

truth lends itself to a preference for polyarchy. To see the subtleties in this relationship between truth and hierarchy, consider the case of Mill, one of the strongest defenders of democracy. Mill also believed in truth and considered democracy to be the unfettered vehicle for discovering truth. Accordingly, appropriate knowledge must be considered superior to deficiencies of same. For this reason, Mill proposed that two or more votes might be given to certain certified groups, e.g., the liberal professions or university graduates.[38] Defending "one person, one vote" against this proposal would not require defending the equal competence of every voter, but simply a *disruption* of the confidence that would allow a liberal like Mill to propose such a thing in the first place.[39]

My mention of Plato points to the confusion I have experienced regarding Nietzsche's political thought. Nietzsche engaged in a masterful critique of Platonic metaphysics and all its descendants, but he seemed to miss or sidestep the political implications of this critique that I am trying to spotlight. In fact, at one point Nietzsche sketches the outlines of a political hierarchy that is remarkably similar to Plato's triad of intelligentsia, guardians, and masses (*A* 57). The problem is that for Nietzsche, Plato is the typical dogmatic philosopher, who "*knows* what is true, what God is, what the goal is, what the way is" (*WP* 446). Plato's aristocratic politics, however, depends upon this cognitive certainty. If that certainty is suspended, as it is for Nietzsche, so too should the political structure. To be sure, Nietzsche would not suggest Plato's particular version of political order or the metaphysical warrants supporting it, but my question is this: Where does a thinker like Nietzsche get his *confidence* in a clear political hierarchy when other delineations are subjected to so much suspicion?[40] Perhaps Nietzsche might have meant that the new aristocracy does not need any warrant or justification, that it can simply assert itself by sheer power alone.[41] I am not convinced that politics could be this arbitrary for Nietzsche, since an interest in certain cultural excellences figures in his aristocraticism (excellences, though, that still might be separable from political hierarchies). Even if aristocratic power were simply "willed" or established by some kind of aesthetic fiat, that would

open the door for *any* orientation taking power—including democracy—without having to justify itself.

In the middle period Nietzsche seemed to recognize the connection between authority and truth, and the political consequences when truth is challenged.

> Subordination . . . is bound to disappear because its foundation is disappearing: belief in unconditional authority, in definitive truth. . . . In *freer* circumstances people subordinate themselves only under conditions, as a result of a mutual compact, thus preserving their own interests. (*HAH* I,441)

The kind of cognitive and ethical deconstruction that operates in Nietzsche's thought should not lead to some new version of aristocracy but to the radical openness and pluralism of democracy.[42] Traditional democratic theory, however, must be deconstructed as well, so that democracy can be redescribed in nonessentialist terms. Aristocratic and democratic theories alike have shared a belief in truth. That is why democratic rhetoric was so attached to the notion of equality, because it simply permitted the rerouting of philosophical warrants to a wider territory. Where aristocrats claimed that only a select few possess virtue and knowledge, democrats could argue that virtue and knowledge are potentially common to all or can unfold in the pooling of all capacities. In this respect we can see that egalitarianism may have been *historically* necessary for the emergence of democracy, since the philosophical ground rules were governed by foundationalist criteria, so that a *challenge* to aristocratic stratification required the promotion of a *destratified foundation*. Things are different in the postmodern condition; the ground rules have changed. Where traditional democratic theory subjected only particular kinds of truth (e.g., religious revelation) to critical suspicion, postmodern democracy can follow through by subjecting all truth claims to suspicion. Such a critique of truth can sidestep proposing either the unequal or the equal distribution of knowledge and virtue, by insisting that such matters are perpetually in question, and that the only appropriate political arrangement is a wide-open contest for making decisions—an agonarchy.

The idea of suspicion is certainly not foreign to traditional democratic theory, since cognitive and moral skepticism were often implicated in its rationale. The American system of separation of powers and the Bill of Rights were based on a distrust of government power and on the belief that both the government and the masses tend to oppress individual interests. Writers like Madison justified such suspicion by citing the power of passion to rule human nature.[43] Consider also Dewey's classic remark that "no man or limited set of men is wise enough or good enough to rule others without their consent."[44] Accordingly, any belief in "enlightened despotism" is ruled out *in principle* as a dangerous fiction. Such a deconstructive distrust of human wisdom and moral perfection has much in common with a Nietzschean perspectivism and naturalism.[45]

Postmodernism represents a radicalization of traditional democratic skepticism by undermining *all* confidences and preempting even the *possibility* of traditional epistemological and ethical groundings.[46] Not only passion can cause trouble; cognitive fixations of all sorts support and fuel the exercise of power and its interests. As we have indicated, most modern political theories had confidence in science and technological progress. Usually there was also a presumption about rational decision making and its status, where the free and open exercise of reason could lead to individual and collective betterment, since the human mind will, in the end, conform to what is objectively right. Postmodernism demurs, and interjects that such "rational" confidence can serve any orientation and is susceptible to its own capacity to oppress when the Other simply cannot "see the light."[47]

Suspicion is important in politics because politics is so decisive, consequential, and potentially coercive in its effects on people's lives. Democracy shows itself to be a politics of suspicion, but it can be maximized in a postmodern atmosphere to unmask unwarranted fixtures wherever they may reign—even, and especially, within democracy itself.[48]

To recapitulate, it seems to me that democracy as heretofore described is consonant with, and appropriate for, the following

basic features of Nietzsche's thought: 1) *Suspicion*. To be clear, Nietzsche was not suspicious of power as such, since he considered all human activities to be expressions of power; he was critical of the presumed justifications for power and the highminded pretense of its executors. A central Nietzschean insight is that *no* viewpoint is without a biased slant toward a particular interest at the expense of some other viewpoint; *all* positions, therefore, contain the danger of exclusionary effects. Here we notice the aptness of democratic suspicion in the political sphere. 2) *Will to power*, conceived as an agonistic field, wherein power is pluralized and continually checked by challenges in an interplay of power sites. Here we notice the aptness of democratic electoral contests and ballot formats. 3) *Antiperfectionism*, where human existence is an incorrigible mixture of positive and negative forces, where disinterest and pure benevolence are a fantasy, indeed a decoy for control. Here we notice the democratic dismissal of aristocratic vouchers promising enlightened sovereignty.[49] 4) *Perspectivism*, an antifoundationalist depiction of human knowledge, where no claim can pretend to apprehend ultimate truth. Here we notice the democratic affirmation of open and continuing exchanges of differing viewpoints, with no expectation of closure. 5) *Narrative pluralism*. Nietzsche's texts display a variety of different narratives and styles, which reflects his insistence that human discourse is in continual tension, which prevents any one narrative from claiming sole authority. Again, Nietzsche does not argue against a particular position asserting itself or gaining power, only against positions that aim for or presume to establish a unified closure. Nietzsche's agonistic pluralism is a constant check against any "total victory." In this context we can gain insight into one of Nietzsche's last pronouncements that has great significance for interpreting his polemics:

> I only attack causes (*Sache*) that are victorious (*siegreich*); I possibly wait until they become victorious. (*EH* I,7)

In other words, it seems that *every* position must be challenged if it gains ascendancy. Here we notice the continual challenge of periodic elections in democratic politics. This is the problem that I

see in Nietzsche's political aristocraticism: Victories in nondemocratic arrangements are far less open to challenge and change.

Postmodern Democracy

We can summarize the case for a postmodern, postmetaphysical democracy as follows: In politics, since we have no certainty, no absolutes, no transcendent or a priori guidance, since we cannot trust human beings to be fully knowledgeable or good, we need an ongoing contest of perspectives, a vote to provide temporary, contingent decisions, and an agreement that such decisions be binding. Nothing in this description involves or requires some positive condition, property, or capacity that makes us "equal," that indicates some universal "human nature" or "common good." Indeed it is driven by negativity, opposition, and limits. We can therefore replace "all persons are equal" with "no person should be excluded from participation," or, if one likes it in positive terms, "all persons should be allowed to participate." Why should everyone be included? Because we do not know *the* truth or *the* good, and we cannot know in advance with any a priori confidence what course we should follow or who is privileged to identify or execute that course.

In such an ungrounded, perspectival atmosphere, with its uncertainty and disagreements about social ends or means to those ends, democracy must permit more conflict than other forms of government—which is a main reason why democracy is often resisted. Although democratic theory has had commerce with notions like a common good and civic harmony, it seems to me that the postmodern condition draws out an essential feature of democracy that belief in such "communal" notions has concealed: Democracy *presumes* and even *encourages* political conflict; its procedures simply channel conflict into a perpetual ritual of organized competition. A profile such as this has significant relevance for today's world, since pluralistic and multi-ethnic societies—a growing feature of contemporary life—make the notion of a common good not only less likely, but less desirable.[50] If there

is a defensible version of the common good, it would be the affirmation of democratic arrangements, procedures, and attitudes, which does not presume any particular social or cultural content.[51]

Aristocratic theories such as Plato's have been driven by an interest in harmony and order. The same can be said for thinkers like Hobbes and Rousseau, and in the end even Hegel and Marx.[52] As was indicated in an earlier chapter, a mark of modern political theory is that difference is experienced as *alienation*, that otherness is to be overcome when the true purpose of the state is actualized; this helps explain how modern politics has often been unwittingly repressive when difference has persisted. In affirming difference by way of agonistic pluralism, democracy has built-in protections against repression. At the same time it also permits more desires to be satisfied and more goods to be discovered than in more regulated societies. So its contentious environment makes democracy not only more open, but also more dynamic, productive, and creative. Nietzsche himself says that democracy "thirsts for innovations and is greedy for experiments" (*WS* 292). This kind of angle on democracy is what prompts my questions about Nietzsche's political preferences. No form of government seems less prone to closure and abridgment of productive power than democracy.[53]

4

Agonistic Democracy

In the next two chapters I want to elaborate on the Nietzschean path I have taken, by detailing some agonistic features of democratic practice and then addressing the problem of mediocrity and excellence in a democratic society.[1] In preparation, I want to rehearse the differences of my overall approach to political philosophy compared with other treatments. First of all, I am trying to work Nietzsche into discourse about democracy while remaining as faithful as possible to the texts and atmosphere of Nietzsche's thought. At the same time, I am suggesting a political outline that can improve our understanding of democracy and avoid some of the pitfalls of traditional political theories.

Hermeneutical Differences

As I have said, I am advancing a kind of pragmatic phenomenology in my defense of democracy, a quasi-Aristotelian tactic that amounts to a *via negativa*. Given the radical finitude of existence that is presumed in the postmodern critique of tradition, and given the need for some form of government and political procedures, democracy wins by default, in that no other political option can

match democracy's "fit" with finitude. In this way I am not making any claims about the inherent "truth" of democratic notions, at least not in the sense that traditional political theory has expected. Here I am in agreement with Rorty when he says that there is no bedrock justification for democracy, that we should simply affirm democracy as preferable to all alternatives.[2] As I have said, however, I think that we can do more than appeal to a notion of historical happenstance. A *via negativa* does amount to an argument, not a justification but a route to establishing some fashion of intellectual preference—something essential, I think, to a pedagogical milieu, if nothing else.

In many ways my account fits in with so-called procedural, as opposed to substantive, theories of democracy, in that I am not beginning with any presumptions about cultural content or political outcomes.[3] I take democracy to be a continual political "experiment," an open-ended procedure for generating and testing outcomes; in this sense democracy is both the *creation* and the *interrogation* of social goods, rather than a politics derived from fixed assumptions about the social good.[4] A procedural account of democracy, however, cannot be purely formal in the sense of a strict normative neutrality, with no commitment to anything other than the outcomes of a political process. Democratic procedures imply and require familiar freedoms, rights, and elements of justice that have been argued for in (substantive) democratic theory. A radical proceduralism simply proposes a reversal in the derivational relation between such democratic norms and procedures, wherein the norms are now derived from the procedures, rather than the procedures from the norms. So rather than beginning with a "theory" of the state or social order or human nature, and with foundational notions like equality and rights, and then viewing democratic practices as inferred from, and instrumental for, such groundworks, the procedural approach I am adopting begins with basic political and intellectual *questions* in an ungrounded social environment, selects democratic arrangements by default, and then locates certain freedoms and rights as "epiphenomena," as operational requirements for political practice.[5] So the starting-point of my analysis is a fluid "field" of social forces, and not theoretical

foundations in certain bedrock conceptions about human nature, freedom, justice, and so on. Such conceptions are not to be abandoned, however, or exchanged for postmetaphysical neologisms; rather, they can be reviewed, contextualized, and redescribed in a way that sustains them but alters their contours and conceptual reach. The hope is that important postmodern insights can improve our understanding of politics and sidestep various difficulties that have bedeviled traditional theories.

A central problem in modernist political theories is that certain constructions have been presumed and fixed as guiding criteria for philosophical analysis: for example, freedom of the will from constraint and necessity, egalitarian justice, social unity, individualism, and rationalistic decision theory. For one thing, such constructions create intrinsic mutual tensions (the resolution of which was a preoccupation of modernist projects). Beyond that, the habit of conceptual fixation means that elements of finitude, difference, and strife in the political life-world would continually tear at the conceptual edges. This situation incites a tendency to ignore, marginalize, or annul those elements, or it generates conceptual bifurcations that pit various theoretical "isms" against each other as a result of mutually conditioned responses to exclusionary fixtures (e.g., rationalism and romanticism, individualism and collectivism, egalitarianism and elitism, materialism and spiritism). The point is not to dismiss the political concerns of modernism, but to suspend certain theoretical constructions and habits that have hampered political philosophy and distorted politics. Relief is made possible by drawing the lines of philosophical reflection *in medias res*, from within conditions of finitude and social practice. To take an example, instead of beginning with a theory of human nature that presumes rational individual selfhood, then moves to political questions in the light of this presumption (as in the case of liberalism and contractarianism), and tends to view social relations and conflict as subsidiary considerations, a postmodern/agonistic/contextual approach to politics can sidestep theoretical questions about the human "self" and point out that we are *already* socially involved with each other in an interacting field of differing perspec-

tives. So a practical social milieu, conflict, and finitude are *givens*, and this can prompt a thinking that does not depend upon fixed constructions of human nature or the human good, yet nonetheless can be adequate for political philosophy. Concentrating on concrete political circumstances, procedures, and practices can open up avenues of analysis that standard theoretical models have missed or cut off.[6]

A postmodern redescription of democracy can also help resolve certain controversies that have nagged democratic theory owing to a number of definitional presumptions. Let me begin this discussion with a recapitulation. My political analysis focuses on the *participatory* and *procedural* elements of democracy. The participatory element insists upon complete inclusiveness; it thereby rejects aristocraticism and echoes certain aims of egalitarianism. The procedural element insists upon an agonistic, ungrounded dynamic; it thereby sidesteps traditional ingredients of democratic theory that have led to doubts about the viability or authenticity of democracy. I can elaborate by citing three examples. First, if we assume that only direct democracy is "pure" democracy, then representative democracy appears tainted, indeed it appears to border on aristocraticism. A postmodern approach need assume nothing of the kind, and so representation can unfold as simply a practical procedural requirement for a large-scale democratic society. What is more, there is nothing forbidding the proposition that representationalism is a political improvement over direct democracy, independent of scale considerations and despite the fact that democracy took its first form historically in a nonrepresentational manner (more on this later). Second, if we assume that the purpose of democracy is to discover and express the "will of the people" or the "will of the majority," then election outcomes can appear less democratic when sizable portions of the people are denied their will. A postmodern democracy can view elections as procedures for deciding ongoing *contests* of will, and so the problem dissolves. In fact, majoritarianism should be suspect to a democrat for a number of reasons, not the least of which is the familiar counterconcept of individual rights in democratic theory. The right of free expression is surely essential

to democracy, and so the will of the majority would *not* be demo-
cratic if it wanted to silence a citizen. Defending free expression,
however, would not require some notion of natural rights that
inhere in the individual person; rather, free expression is a require-
ment for an open-ended, ungrounded contest of ideas. Third, if we
assume that democracy requires equality, then human differences
and elitist elements can appear to be undemocratic.[7] As my
approach is suggesting, however, a postmodern democracy need not
buy into traditional egalitarian sentiments and constructions, as
long as there is open and fair participation in political procedures.
In sum, then, many puzzles in democratic theory can be unraveled
and resolved by stepping back from certain conceptual commit-
ments that in fact can be shown to have created these puzzles in the
first place.

Another contribution that a postmodern approach can make to
political philosophy concerns a problem that was first identified in
the Greek debate about *physis* and *nomos*, about whether ethical
and political norms are part of human nature or artificially imposed
by convention. Aristotle's response to the conventionalism of the
Sophists was that norms are neither strictly natural nor unnatural,
since the human person has certain natural potentials that require
a cultural environment to foster their actualization.[8] This issue was
rehearsed in many modern political theories, especially in familiar
"state of nature" conceptions (such as those of Hobbes and Rous-
seau) that tended to view social structures as supervenient upon a
primal nonsocial condition, and in developmental conceptions
(such as those of Hegel and Marx) that saw socialization as the
actualization of human nature.[9] In a certain sense a postmodern
analysis can sidestep the *physis-nomos* problem or resolve it in a
different way—without, however, neglecting the insights that
thinkers mentioned above have provided in this matter. We can
begin by agreeing that humans are intrinsically social beings and
that some form of government is necessary in human existence. We
can avoid, however, the problem of whether political forms are an
expression of "human nature," or are superimposed upon some
presocial human nature. The advantage here is that we can reject

two problematic convictions: 1) the notion that the state is something "artificial," which can undermine the legitimacy of, and confidence in, politics; and 2) the counternotion that the state is something "natural" in the sense of being the vehicle for the emergence of a discernible human nature, which can become suppressive of differences or oppressive in the face of resistance to what is presumed to be "human." The idea that politics is artificial or arbitrary is certainly suspect, since history would seem to display so much counterevidence, and since the sociality of the self has more and more superseded assumptions about atomic individualism. In my account, however, such a social condition is also *agonistic*, and so it should not be reduced to any particular form or coalescing of forms, or to a project of harmony and consensus.[10] It is important to establish that the "social" is by no means synonymous with something like the "common good." The opposite of the social, therefore, is not disharmony or conflict, but rather isolation. The finitude of the human condition and the agonistic pluralism of the social milieu lead to a political preference for democracy as a procedural arrangement that is *not* reducible to any bounded concept of human nature or to any particular story of the human condition. In this way democracy avoids both the extreme openness of anarchy and the seeds of closure in preprocedural modeling.

Democracy as Agonistic Praxis

Polls often show that Americans have a low regard for Congress but a relatively high regard for their own representatives in Congress.[11] Such seemingly disparate results can be easily explained if we focus on the agonistics of democracy. People tend to complain about the wranglings, the partisanship, and the gridlock that supposedly interfere with "the good of the nation." It would seem, however, that the poll data indicate a public confusion about politics, in that we regret the contentiousness of governance but appreciate our own contestants in the enterprise. The same would hold for the frequent complaints about the influence of "special interests" in the legislative process. One person's special interest is another person's

champion. The approach I am suggesting would forgo any talk of the "national interest" and simply focus on democratic procedures as the management of political conflict and the production of contingent decisions. Again, given an affirmation of existential differences, democracy can be conceived as requiring a certain positive regard for conflict, in that the absence of conflict would amount to the erasure of differences. I hasten to add that we must nonetheless insist that political conflict can operate in appropriate and inappropriate ways, that there are intrinsic questions of justice and injustice in democratic agonistics; this subject will be addressed in due course.

Political debate is one of the basic rituals of democratic conflict, but debate is surely not a device that is unique to democracy, since monarchy, for example, has operated with debate formats among royal advisors or within aristocratic councils. The question at hand involves the extent of participation, the status of decisions, and the reasons for the different possible formats. As we have seen, democratic inclusiveness has historically depended upon egalitarian gestures against aristocratic exclusions. Differential conflict, however, seems to bring a disruptive dissonance into egalitarian expectations and habits, so that persistent differences can appear problematical. A postmodern democracy, however, can argue for inclusiveness without equality by simply refusing to sanction any decisive criteria for *exclusion*, since postmodernism is suspicious of privileging any discourse. Such inclusion-by-nonexclusion would not then have any baseline conceptions that would problematize difference and conflict.

Why should democracy settle for such a *via negativa* and limit itself to agonistic openness? Because politics reflects, and cannot help being caught up in, matters of meaning, purpose, and philosophical interpretation that are not decidable in a global sense. In addition to categorial tensions that confront political society by definition (tensions between the individual and the group, freedom and authority, rights and obligations, and so on), policy questions in everything from education to economics to social programs to criminal justice to environmental concerns force us to confront

normative and philosophical questions that do not sustain answers
without remainder—questions about human nature, freedom and
determinism, nature and nurture, identity and difference, science
and values, and cultural priorities. The openness of philosophical
questions is what compels us to say that in politics truth is always
in question (as it is not, say, in bridge-building). Consequently we
should restrict reflections on democracy to procedural matters, in
such a way that any "baseline" conviction about philosophical
questions would be a contestant *in*, rather than a presupposition *of*,
political discourse.

Here we mirror somewhat the traditional liberal notion that
baseline convictions, especially in religion, should be left to
individual deliberation and conscience. For liberals, what Rorty
calls a "final vocabulary"[12] and Rawls calls a "comprehensive
doctrine"[13] cannot be a criterion or telos of political life. In this way
liberalism distinguishes between the "right" and the "good,"
between political principles and how people want to lead their
lives.[14] A postmodern variant of liberal pluralism, however, can
radicalize the "separation" of politics and final vocabularies in such
a way that even certain problematic baseline assumptions in
traditional liberal theory can be subject to critical review—for
example, an overconfidence in individualistic, rationalistic, and
emancipatory paradigms that can distort political life and lead to
various binary oppositions that create their own problems in the
wake of their resistance to monistic or coercive political programs.
The tendency in liberalism to separate the "individual" and the
"social," the "private" and the "public," should be no less suspect
than holistic models that endanger individuality and co-opt the
inner life. An example of the ambiguity of liberalism is the tendency
toward the secularization of public life, which on the plus side
prevents the public square from being restricted to any particular
sacred dress, but which on the minus side can denude the public
square to the point where religious beliefs become marginalized,
suspect, or even taboo in political discourse.[15] As long as religious
belief is not a requirement for citizenship or the presumed measure
for public decisions, the postmodern approach I am suggesting

would have no qualms about fundamentalist Christians, for example, pursuing a political agenda or engaging in civil disobedience at the site of abortion clinics. A postmodern openness would allow no criteria for excluding *any* beliefs from political discourse, even if some citizens have very closed convictions. If, for example, through the political process abortion were to be outlawed, that would not mean that abortion *is* wrong in an objective sense, or that Christian doctrine had become law, any more than is the case with laws against theft (and keep in mind that some atheists, Nat Hentoff, for example, think that abortion is wrong); it would simply mean that political procedures had produced a *decision* that abortion will not be permitted. Moreover, such an outcome would not prevent pro-choice advocates from attempting to reverse that decision through political means or civil disobedience.[16] An agonistic democracy should presume *nothing* other than the civic attitude and the procedural requirements that foster the fair *competition* of baseline beliefs for the prize of contingent decisions.[17]

Order and Conflict

Democratic agonistics must be distinguished from notions of sheer conflict and struggles for total domination or annihilation. Democracy is an oscillation of order and disorder, a dialogical contest that generates order out of conflict through rituals of assertion, challenge, response, and decision—a contest, however, that is not to be resolved into any consummation of sheer order, harmony, synthesis, or consensus.[18] Although democratic dialogue can and does produce agreements in the course of debate, and although democracy requires the agreement that political decisions will be binding, nevertheless disagreement and differences are in a global sense the sine qua non of democratic politics. Those who are uncomfortable with an agonistic model of politics and prefer a notion of civic harmony or consensus should remember the Nietzschean lesson that innovation implies a certain conflict with the established order, and so a world without conflict would be a world without innova-

tion. The "negativity" of the agon, therefore, is nothing like a void, absence, or disintegration, but a dynamic that can be and is productive of positive consequences. A teleological model of conflict such as Hegel's can agree here, but I would insist on a nonteleological openness (in the global sense) that amounts to insisting on the perpetuation of politics, since a teleological resolution of political conflict would in fact mean the *end* of politics-as-praxis.[19]

Here, as an aside, I want to rehearse a point developed in chapter 1 concerning the supposed "negativity" of postmodern discourse, a point that can be reinforced by the political applications presently under discussion. I suggested that the negativity of postmodernism should be understood in the fourfold sense of the *limits* of conceptual constructions, the *potential for innovation* that an agonistic dynamic continually presumes and protects, the *openness to* "difference," and the irreducible *openness of* "identity." The application of postmodern openness to democratic praxis gives us a concrete instantiation of the *positive* consequences of the disruptive challenge to traditional structures. Such an application has benefits for both postmodern thought and political philosophy: On the one hand it provides a setting wherein postmodern discourse can be cashed out in specific ways, which can improve upon some of the more arcane and unhinged academic treatments; on the other hand it provides a means of addressing the limitations and persistent problems of traditional political theory, which can improve our understanding of democracy. So what might seem to be "negative" and a loss by the standards of customary theories can be a significant gain for political philosophy.

The Range of Political Agonistics

The agonistics of democracy shows itself at every level of political practice, from local formats (which can operate in a direct manner, as in town meetings) to state and national formats (which tend to require direct election of representative bodies). In all cases the contestation of different perspectives seems to be a necessary (if not sufficient) condition for democratic procedures. Even though a

society can exhibit areas of consensus, and even though political exchanges can create degrees of agreement by means of persuasive discourse, nevertheless sheer unanimity is not only extremely unlikely, in fact it would imply the end or irrelevance of democratic practices. As we have seen, the open invitation to all perspectives and the employment of vote tabulations to provide contingent settlement of contested issues seem to presuppose an ineradicable economy of differences and a retreat from the presumption of a globally decisive truth. Accordingly, all the seemingly fractious features of democratic practice—from local debates to election campaigns to legislative disputations to judicial arguments—are in fact simply the orchestrated rituals of political life, without which democracy would evaporate. As we will see, the affirmation of conflict does not entail permitting a kind of political donnybrook; there are better and worse, fair and unfair ways of conducting a political contest. The point is simply that democracy should not recoil from the disorder and friction of political dispute; something like sheer harmony or unanimity would spell the end of politics or perhaps amount to nothing more than the silhouette of coercion, suppression, or erasure.

Political agonistics are more evident in electoral procedures, since voters are asked to make a choice between competing candidates or propositions, and vote tabulations delineate clear lines of victory and defeat. In the legislative process, agonistic differences are often ameliorated by negotiation, coalition, or compromise prior to a disposition by ballot. Such transactions, however, do not mean that conflict has been supplanted; in fact, they presuppose the permission of conflicting perspectives and the procedure of balloting that provides the measure for the force of those perspectives.[20] Predispositional bargaining can also be understood as a practical requirement for achieving legislative results in an atmosphere of highly diversified conflicts of interest. The forging of alliances and compromises, therefore, is still animated by the agonistic praxis at the heart of democratic politics. One question, though, that still remains to be addressed, especially in the light of Nietzsche's critique of democracy, is whether or not,

or to what extent, political compromise is a diminishment or dilution of civic practice or the quality of governance—a question that will be engaged in the next chapter.

Legal Agonistics

There are many parallels between the political agonistics of democracy and a democratic legal system, at least in the Anglo-American common law tradition. That tradition is often called an adversarial system, to distinguish it from the so-called inquisitorial system that operates in France and Germany, for example. An adversarial model pits two procedurally equal parties against each other in open court, where each competes to persuade a jury of the guilt or innocence of a defendant. Most of the procedural rules and the presumptions about the posture of lawyers are built around the notion that each party in a trial is entitled to have its best possible case presented in court and to vigorously challenge the other side's case; the judge in most respects serves as an impartial, procedural referee; the contest is then decided by the deliberations of a jury. An inquisitorial system is different to the extent that a judge is given much more deliberative and evidentiary power. Proceedings are not restricted to aggressive advocacy of competing parties; the court is responsible for presenting the arguments and is not confined to the parties' presentations; a judge does most of the questioning of witnesses and can guide the course of a case in ways that are impermissible in an adversarial system.[21] One attraction of the inquisitorial system is that it is simpler, less restricted by procedural rules, and much relieved of the various lawyerly tactics, probings, and challenges that often frustrate observers of the adversarial system, and that often acquit a seemingly guilty defendant on a technicality or because of evidentiary exclusions.

Despite its difficulties, the agonistics of an adversary system can at least be better understood in the context of our discussion of democracy. An inquisitorial system puts much more trust in the performance, integrity, and impartiality of judges and the judicial system. An adversarial system in many ways is animated by suspicions about the competence and possible motives of the

government and judicial officials. Adversarial procedures, then, are intended to give competing parties every appropriate means of challenging or subverting possibly unfair, deceptive, fallacious, or discriminatory practices. Once again, cognitive and ethical suspicion are operating here, and this is often forgotten in complaints about legal machinations that clog proceedings or block the government's case against an apparently guilty party. We should at least remember that procedural rules and the so-called presumption of innocence are meant to *contest* the government, to protect citizens from abuses of power—and not, as is often supposed, to express "sympathy" for the interests of criminals. Accordingly, we should be *willing* to trade the acquittal of guilty persons for protections against the presumably more heinous outcome of convicting innocent persons. In this way, an adversarial legal system mirrors the separation of powers that marks the American form of government; legal and political structures are organized around the contestation of power sites, rather than the termination of conflict. It is interesting to note that Nietzsche suggests a similar formulation when he declares that a legal order should be understood as "a means in the struggle between power-complexes," rather than a means of preventing struggle (*GM* II,11).[22]

Legal agonistics can be associated with a certain egalitarian concept that we have already admitted is essential to democracy: equality before the law (what the Greeks called *isonomia*). Equal application of the law, however, can still be distinguished from substantive egalitarianism. As long as a law does not single out particular individuals or groups (as do racial laws, for example), equal application seems to follow from the very generality and anonymity of law as an abstract regulation applying to any and all citizens and to formal categories of actions rather than particular performances. The agonistics of an adversarial legal system, then, is meant to protect against and repair possible "unequal" treatment, an inequity that can be redescribed simply as follows: being singled out, excluded from legal incorporation, or falsely included in a category of illegal action. Equality before the law, therefore, need not make any purchase on substantive egalitarian assumptions, and

in a functional sense it shows itself to be inseparable from agonistics.

A final word about the connection between the law and truth. Our legal system is often described not simply as a contest, but a contest meant to ferret out the truth. There is no dissonance here, however, with the Nietzschean, postmodern critique of truth that informs much of my analysis. There are many dimensions of belief and judgment in a court proceeding, a mixture of elements that are explicit and implicit, exact and inexact, factual and normative, empirical and a priori. When it comes to the historical and constitutional founding of a legal system and the degree to which rhetoric and interpretation are inevitable aspects of judicial deliberation, a postmodern "openness" is appropriate and instructive. The bottom line in a trial, however, will usually be an empirical question that even a postmodern orientation will grant is in principle decidable and measurable by reliable truth criteria of a particular sort. In an individual case, a law was either violated or it was not; the facts in question either occurred or did not; the defendant either committed the act in question or did not. Even though the conditions of a case and the capacity for human deception or distortion make it difficult to decipher what is empirically true or false, and even though interpretation and judgment are often inseparable from factual considerations, nevertheless a certain confidence in empirical truth conditions is always presumed in a courtroom.[23] So in one sense a legal proceeding is not veridically open; it is a contest for a decidable, though possibly elusive, truth. Things are different when a law itself is being established, or is in question, or is open to interpretation; the legislative process and judicial review are more indicative of postmodern undecidability and therefore depend more on an open-ended contest that is decided not by "the truth" but by the results of contestation, by a tabulation of votes.

Nonprocedural Agonistics

Despite the fact that a well-working democracy should in principle minimize the disaffection of citizens in the wake of political outcomes, there are still defensible agonistic opportunities at the

margins of political procedures for defeated interests, at points either between, or after repeated failures in, electoral and legislative contests. Such nonprocedural agonistics, however, would have to be peaceful, since violence and rebellion cross the edge of defensible political practice—at least in a properly functioning democracy, I would argue.[24] Examples of such peaceful attempts to affect or provoke political outcomes include public protest, economic boycott, and civil disobedience, the latter as long as citizens submit to the penalties of violating a law that they think is unjust.[25] Democracy does not guarantee any particular outcome, and sometimes entrenched opinions or social forces diminish conditions of a fair hearing or desensitize much of the community to certain concerns. Political confrontations of the sort mentioned here show that the democratic agon need not be restricted to formal procedural results. It is safe to say, for example, that civil disobedience was an essential ingredient in the generation of American civil rights laws because political procedures were insufficient; indeed, they may have remained obstructive without the pressure of public awareness that grew from the streets.

As such an example suggests, a democratic, agonistic openness can operate in numerous areas of life, which is why many would extend the category of "the political" widely across the social landscape, beyond government, formal procedures, institutions, and practices directed at effecting legislative or judicial outcomes. This is particularly relevant for the nonforced associations of interest groups and local communities that are often classified as "civil society." The present study can certainly accord with such an extension, but there is a deliberate attempt here to narrow the focus to typical political practice and governance, because a wider application of "politics" often misses or underdevelops the ways in which a working democracy actually operates.[26]

Subgroup Tensions

Before closing this chapter, one last problem deserves mention. It is possible for a democratic society to be divided in such a way that certain subgroups find the binding results of democratic procedures

unacceptable, in the sense that majority rule might amount to continual exclusion and disenfranchisement of a group's interests. This is especially possible when subgroups are defined along ethnic, religious, or linguistic lines. The problem of subgroup divisions is growing in significance today, since a spirit of multiculturalism and sensitivity to ethnic differences are being affirmed in many quarters. In a later chapter we will take up this problem in relation to democratic politics in a little more detail. Presently, however, I can mention a number of possible responses to the problem of subgroup tensions in a democratic society. First is the option of so-called consociational arrangements for resolving franchise conflicts, where majority rule and winner-take-all formats are exchanged for various coalition structures (as in the Netherlands, Belgium, Switzerland, and Austria, for example), or proportional representation in decision-making bodies.[27] Second is the option, if feasible, of breaking up a society into separately operating democratic units, involving either a complete separation or some kind of confederation. Third is the option of subgroups finding strategies to inculcate their interests in nonproportional formats by virtue of being a sizable voting block in the electoral population. Finally, there is the cultural option of working against the overdetermination of, and fixation on, subgroup identities on the part of citizens. A reductive confinement to particularity (what is sometimes called "tribalism") may be no less problematical than a universalistic erasure of differences. This last point will occupy our attention in a later discussion.

5

Democracy, Excellence, and Merit

In this chapter and chapters to come I want to sort out and develop various issues confronting a postmodern politics that takes its intellectual bearings from Nietzsche's thought. In the introduction, we noticed the unresolved dilemma in postmodern appropriations of Nietzsche that ignore or reconstitute his political passages. In addition to embracing Nietzsche's nonfoundationalist/antimetaphysical orientation, postmodern writers also have been eager to take up his critique of egalitarian mediocrity and resentment—without, however, taking up his call for a nondemocratic political order. One explanation for such a hermeneutical disjunction is that postmodern writers have tended to *separate* the question of cultural mediocrity from politics, so that Nietzsche's antidemocratic remarks can be read as diagnostic appraisals of cultural, social, and psychological phenomena. The problem, as we have seen, is that Nietzsche did not separate these latter issues from politics; he seemed to insist that traditional belief systems, herd values, and democracy are all inextricably intertwined, and that a new political order is required if the philosophical tradition is dismantled. This political blind spot in postmodern discourse is what I am trying to address in this study, by simultaneously challenging Nietzsche's

politics and rethinking democracy along Nietzschean lines. The present chapter will focus on the particular question of the herd mentality by engaging the problem of mediocrity, excellence, and politics in their *connectedness*, so as not to ignore or shy away from Nietzsche's potent challenge to political philosophy.

To accomplish such an engagement with Nietzsche, I want to distinguish (rather than separate) democratic politics from egalitarian mediocrity and resentment in two ways: 1) The Nietzschean problematic of cultural creativity can be marked off to a certain extent from the practical arena of politics, from the project of delineating procedures for generating political decisions and the rationale for such procedures. To whatever extent this is done, we can make some sense out of Nietzsche's creator-herd dichotomy, without having to adopt a political hierarchy of domination and control. Accordingly, we can still attend to Nietzsche's insights about creativity and the kinds of excellence that elevate creative individuals and that might entitle such individuals to a certain amount of cultural deference, honor, and status. Nietzsche's creator types, however, can give meaning and direction to culture without having to run things politically. In this respect we can lean toward the "coexistence" thesis that was suggested earlier, wherein democracy and cultural creativity can run parallel to each other without having to encroach on each other's domain. One question we will address in this regard is the following: How would things in fact play out if Nietzsche's creator types were actual legislators or members of a politically privileged class? 2) In order not to ignore or conceal Nietzsche's political gestures, however, we can take up his critique of egalitarianism and consider the degree to which his elitism can be reflected in democratic politics. We may agree that mediocrity and resentment tend to be fostered in democratic societies and seem to be implicated in traditional political theories, but we can also question whether such herd values are intrinsic to, or inevitable in, democratic practice. Although a defense of democracy must take issue with Nietzsche's political stratification of "higher" and "lower" types by arguing for an inclusive, non-hierarchical political system, nevertheless we can consider the

political ramifications of mediocrity and resentment that prompted Nietzsche to question democracy, and we can even locate certain aspects of a Nietzschean elitism that operate in, and are necessary for, democratic politics. To sum up the two analytical tacks I have identified here, there is plenty of room for Nietzsche's sense of *cultural* elitism in a democratic society, and at the same time there are certain elitist and nonegalitarian elements that are indigenous to *political* practice and governance in a democracy. To prepare for a discussion of these issues, let us rehearse the manner in which the question of equality has governed the concerns of political theory.

Equality and Freedom

In early modern political thought, the concepts of equality and freedom tended to have a happy marriage, in that political equality required a range of civic liberties that challenged aristocratic rule and that presumably allowed all citizens a chance to further their interests. In late modern and most of contemporary political thought, however, equality and freedom have gone through a rocky relationship—primarily, though not exclusively, because of social and economic problems that have seemed indigenous to capitalism, since unregulated economic freedom generates inevitable, systemic inequities of wealth that support and sustain all sorts of social and political disparities. This tension between equality and freedom along with their possible permutations mark the different profiles of three influential political theories in contemporary thought: free-market conservatism, which emphasizes freedom and inequality in the economic sphere; socialism, which emphasizes equality and restraints in economics; and liberal welfare capitalism, which occupies a middle ground, trying to balance an interest in freedom with a concern for the harmful effects of economic inequities.[1]

As I have indicated, I am withholding a specific discussion of economic questions for a later chapter, so that we can take a fresh look at political principles by shelving for a time the contemporary preoccupation with economic justice (which is not to say that economic inequities are unproblematical or tangential to politics).

In any case, I want to suggest that equality and freedom need not be incompatible in any basic sense and need not be counterposed as they often are in political theory. A Nietzschean, postmodern approach can reconcile political equality and freedom by advancing two strategies: 1) A deconstruction of traditional paradigms, whereby a) substantive egalitarianism and equal regard are exchanged for an inclusive agonistics, and b) modernist freedom is exchanged for an existential openness that is not confined to individualistic, rationalistic, or laissez-faire presuppositions. Accordingly, we may find that many conflicts between equality and freedom can be dissolved or resolved in a new way. 2) A contextual approach to freedom and equality, wherein overly generalized theoretical constructions are renounced in favor of specific, situational analyses that allow us to sort out those occasions where freedom and equality are rightly at odds with each other or wrongly assumed to be so.

A contextual analysis of freedom can apply an operational formula—"x is free from y to do z," where x is an agent, y is an obstacle, and z is an action or goal—and ask *specifically* who is the agent, what is the obstacle, and what is the action or goal.[2] In each instance we can address a particular context for a particular kind of freedom and consider whether or not it is defensible and address any complications that adhere to the situation. We can notice different types of freedom (economic, moral, personal, political, and so on) attending to z, different types of agents (adults, children, soldiers, workers, students, innovators, and so on), and different types of obstacles (nature, material need, violence, institutional coercion, social conformity, and so on). Analyses of these contexts can issue different and divergent answers to questions of freedom. For example, democratic freedom can entail a wide range of personal and political liberties, but perhaps not the freedom to refuse one's children an education. Moreover, certain interpretations of freedom can be unmasked as concealing elements of coercion and harm. For example, capitalist freedom from regulation tends to exploit workers and harm consumers; so in this instance "x is free from y" can be reconfigured as "x is free *at the expense* of y."

The same contextual approach can be directed to the question of equality and can serve to sort out many of the topics that occupy this study. We can apply the formula "x is equal (or unequal) to y in z," where x and y are persons and z is a certain feature, ability, or situation, and ask specifically who is x, who is y, and what feature, ability, or situation is at issue. Shortly, with the help of Nietzsche and Aristotle, we will expand upon this contextual formula as a check against egalitarian hyperbole. First, however, let us revisit some of the critical questions aimed at egalitarian political theory.

Contemporary Egalitarianism

As was indicated in an earlier chapter, most current egalitarian theories do not tend to presume any kind of substantive human equality in the manner expressed by traditional religious and metaphysical models. Socialist egalitarianism leans toward equality of condition, equality of treatment, or equality of result in the socio-economic sphere. Liberal egalitarianism stops short of such regulated outcomes by promoting equal opportunity, a sense of equal worth, or equal consideration of interests, while allowing for certain socio-economic disparities. We have seen, however, that such notions are still subject to a Nietzschean critique, in that they may be trying to cash in on the appeal of human equality while forgetting its dependence on traditional substantive constructs that are now suspect or off the table; or, more pointedly, nonsubstantive egalitarianism may still be a vivid expression of the discomfort with rank and the resentment that Nietzsche suggests spawned tradi-tional egalitarian paradigms in the first place.

Accordingly, my response to contemporary egalitarianism is threefold: 1) Following Nietzsche, if equality means any kind of sameness or even equilibrium in the human condition, then it is an unwarranted and undesirable political concept. 2) We should be wary of disguised purchases on such a concept in supposedly nonsubstantive egalitarianism. 3) If equality is not meant to connote or make purchase on sameness or equilibrium, then we should ask: What would be lost if we gave up the word entirely and rethought

politics without equality? As I see it, a Nietzschean approach to democracy helps us nourish a certain political realism. Democratic inclusiveness not only need not pursue a socialist equality of treatment, condition, or result, it also need not adopt the looser liberal notion that all citizens should be given equal consideration, that everyone should matter equally, that all interests should count the same.[3] The liberal ideal of "equal regard," as I have summarized it, never *has* been fully actual in human society or human relations; we simply do not count everyone's interests equally. More, I think that a Nietzschean analysis can help us understand why equal regard *can*not and *should* not be a baseline political ideal. I am suggesting a postmodern route to certain political notions that liberals espouse, a route that can sidestep equal regard, avoid some of the philosophical traps of liberalism, and unmask some of the problematic motives and effects of liberal theories. If equal regard means something like fair treatment or fair play, I see no problem. I suspect, however, that liberals take equal regard to mean more than fair play, that a request to drop egalitarian tropes and simply talk of fair play would meet with some resistance. Fair play need not make any purchase on equal regard, and any resistance to such a move might bear out a Nietzschean suspicion that equal regard continues to express a problematic resentment and discomfort with difference.

Much of liberal egalitarianism is concerned with the problem of unequal talents or circumstances that are a consequence of natural or accidental inheritance, and that are detrimental to the disadvantaged in the distribution of goods. It certainly seems right that no one should be unduly penalized for deficiencies of endowment, and later we will make a case for government involvement and certain social policies that can follow from the political line we are taking in this study (although the degree of government involvement will be a subject for dispute). What rattles my Nietzschean instincts, however, is the moralistic rhetoric of many liberal writers in describing those whose endowments are more fortunate. Talents and other inherited advantages are often described as "undeserved" or "unfair," and as acceptable only to the extent that they contribute

to the betterment of the less fortunate.[4] Liberals also take issue with
an uncritical notion of equal opportunity, since it is often a fraud in
the face of unequal endowments with which people start their
enterprises.[5] It seems clear that equal opportunity is problematical
and even fraudulent when social and environmental obstacles lessen
opportunity or its chances of success; in this regard, laissez-faire
conservatives too often are banking on an abstract or purely formal
sense of opportunity without attention to contextual factors. At the
same time, the amount of intrusion into the social order that would
be required to actually give everyone the *same conditions* of
opportunity should give us pause. There is, however, a defensible
middle ground between liberal and conservative viewpoints, where
equal opportunity can signify an open chance to make the best out
of one's initial (unequal) allotment, assisted by public education and
programs that can help compensate for endowment deficiencies and
social hindrances—without, however, assuming that opportunity
conditions should be identical, or that outcomes need to be
comparable, or that endowment advantages are somehow unfair or
undeserved. Equal opportunity need not entail the promotion of
equal resources, whatever that would mean short of a socialist
redistribution.[6] There is a need to balance extreme disparities in
order to make opportunity viable, but as I see it there is nothing
wrong with tolerating a social order in which some people may have
to work harder to develop their potential, especially considering
Nietzsche's insight that obstacles often figure into a person's
incentive and development, that discontent and performance often
go together. Of course such an insight cannot turn into a "policy"—
that people should not be helped because they need their obsta-
cles—since this would ignore the influence and effect of severe
deficiency and would tend to reflect the vested interests of those
who have already succeeded and their progeny. Nonetheless,
unequal endowments and results need not incur moral reproach or
political rectification.

Describing endowed talents or inherited advantages as unfair or
undeserved betrays a concealed substantive egalitarianism and
resentment that Nietzsche has rightly challenged; such description

uncritically and naively begs the question of traditional assumptions that supposedly are no longer in play. In this regard, Nietzsche's postmodern gesture in the Madman passage once again needs to be addressed in order to unpack problematic implications in contemporary political rhetoric. To be sure, getting something you do not deserve by unfair means is a classic and defensible formula for designating injustice, but assigning such a formula to inherited endowments seems to be nonsensical if we accept to any degree Nietzsche's naturalistic direction in the wake of the death of God— and most political theorists *do* want to separate their reflections from traditional transcendent constructs that no longer command intellectual assent. Let us take natural talent as an example. Calling the endowment of talent undeserved or unfair seems rather strange. If something I have is undeserved, this usually means that I did not do anything to get it and that I could have or should have done something to properly attain it. To "do anything" before birth, however, is impossible, so the issue of desert in the matter of talent seems moot. If an outcome is unfair, this usually means that a certain a priori procedural measure has not been met, but being born with talent is presumably an accident and not a matter of "distribution," despite what the (bad) metaphor of "endowment" might seem to suggest. Consequently, the issue of fairness also seems moot here. We can and do describe the endowment of talent as a matter of luck, which is incommensurate with notions of fairness or desert. Lottery winners are lucky, but calling their winnings unfair or undeserved seems odd, since no one would even suggest that they did deserve their winnings, or that they could have done something different to deserve them, or that it is unfair that the rest of us did not win. So if desert or fairness would not even apply, it seems that talk of an undeserved or unfair outcome would be a conceptual slip. In the case of talent, the *fruits* of talent may be a matter for reflections about justice: One may be entitled to the fruits of one's talent or such fruits may be subject to certain limits. We can pursue such topics, however, without ever entertaining the idea that one deserves or does not deserve one's *talent*.[7] A Nietzschean perspective would call on us to accept, even affirm, the

natural inequities of fortune and to be very wary of our aversion to such things and our capacity for overt or covert resentment in the face of advantages that are simply a matter of luck. A probing Nietzschean question that can be posed in this regard is, why should I not relish the good fortune of someone whose ability surpasses mine and outstrips my achievements?

A number of traditional influences might be implicated in the almost effortless way in which some political theorists can talk of undeserved endowments. A modernist agent-subjectism can perhaps account for associations with desert when analyzing human selfhood and performance (a postmodern contextualism and openness to chance would represent an alternative analysis). It would not seem likely, however, that such an agent-subjectism could sustain itself in prenatal matters, as we have seen—unless, of course, Nietzsche is right in suspecting that modern, secular developments carry the shadows of traditional assumptions that informed Christian Europe. One *can* comfortably talk of undeserved talent when the concept of human equality is an a priori imperative that animates reflections on justice; or when providential and teleological habits of thought long nourished by the Judeo-Christian tradition—a sense of larger purposes and preconceived purposes in God's plan—can tacitly render "before birth" a relevant notion that subliminally underwrites a discussion of desert or fairness in the matter of endowments. Nietzsche's radical naturalism, however, insists on surrendering *any* notion that would suggest a site of responsibility that could either insinuate a global teleology or prompt a project of rectification.

> What alone can be *our* doctrine? That no one *gives* man his qualities— neither God, nor society, nor his parents and ancestors, nor he himself. (The nonsense of the last idea was taught as "intelligible freedom" by Kant—perhaps by Plato already.) No one is responsible for man's being there at all, for his being such-and-such, or for his being in these circumstances or in this environment. . . . Man is not the effect of some special purpose, of a will, and end; nor is he the object of an attempt to attain an "ideal of humanity" or an "ideal of happiness" or an "ideal of morality." It is absurd to wish to devolve one's essence on some end or other. We have invented the concept of "end": in reality there is no end. (*TI* 6,8)

Impartiality is another classic and defensible formula for justice, where partiality is a source of injustice and unfairness. Still, it is the *extent* of impartiality that would be open to question. Following Nietzsche's naturalistic turn, which admits no a priori or transcendent purpose in the overall course of existence—and again, most current theorists are at least separating such teleological considerations from political discussions—talk of the "partiality" of inherited talent would seem to be nonsense, unless again one has been subliminally influenced by the mythology of a Creator "intending" the results of creation. In general terms, we should be careful not to overdetermine impartiality or demean partiality, depending on context and attending to Nietzsche's warnings about resentment. Partiality toward oneself or toward certain persons is natural and can never be excised from human relations and need not pose automatic problems for reflections on justice.[8] The question would involve delineations where partiality and impartiality are to be counterbalanced, all the while avoiding the theoretical presupposition that partiality and impartiality are binary opposites, which presupposition has the effect of loading political reflection in such a way that its philosophical substructure becomes suspect and its applicability to political practice is impaired.[9]

To cite some cases, academics can easily agree that impartial grading is just and grading on the basis of personal affection or disaffection rather than performance is unjust. At the same time, although we might find it hard to admit, I daresay that we are often partial toward certain colleagues in our institutions and disciplines on grounds other than simply their performance—we like or dislike them—and at times we make professional decisions, render assessments of work, and grant favors that are not entirely impartial. In such a context, however, partiality may not be unjust, since certain personal and collegial elements are important and beneficial in professional settings. Personal intimacy often gives us access to subtle and ambiguous levels of discernment that more formulaic approaches would miss. I am not arguing that partiality is unproblematic, only that questions of justice are often complex, ambiguous, and contextual, so that partiality is not always detri-

mental to justice. How could selecting a charity or cause to support be anything but partial? A criterion of impartiality would seem bound to recognize an element of injustice here, which would seem to be resolvable only by giving equally to all causes (or to none). Moreover, the procedural analysis of democracy that we have outlined indicates that democratic politics is in effect an orchestration of partiality, an open invitation to people to advance their interests and oppose others; rights, however, provide a necessary counterweight in political life by dictating elements of impartiality.

The point here is that an uncritical, a priori commitment to impartiality is inimical to certain features of political practice, incongruent with certain elements of human existence, and susceptible to the Nietzschean charge that such commitment is an echo of traditional aversions to the differential finitude of lived experience. With Nietzsche's agonistic naturalism as a backdrop, we can understand why he thought that modern, secular constructions had not really delivered themselves from transcendent belief systems in their supposed effort to situate themselves in the "real world." For Nietzsche, modern conceptions of justice and injustice are secular reverberations of ancient aversions to the inequities of the natural order, with the difference being that modern diagnoses and rectifications have turned away from a divine script toward human social and political projects. In the end, though, Nietzsche would say that conceiving the "partiality" of unequal endowments or differential treatment as "unjust" is in fact a perpetuation of the psychology of resentment that spawned religious and metaphysical flights from the natural world.

> One speaks of the "profound injustice" of the social pact; as if the fact that this man is born in favorable circumstances, that in unfavorable ones, were in itself an injustice; or even that it is unjust that this man should be born with these qualities, that man with those . . .
>
> This pose, an invention of the last few decades, is also called pessimism, as I hear; the pessimism of indignation. Here the claim is made to judge history, to divest it of its fatality, to discover responsibility behind it, guilty men in it. . . . To this end, they need an appearance of justice, i.e., a theory through which they can shift the responsibility

for their existence, for their being thus and thus, on to some sort of scapegoat. This scapegoat can be God—in Russia there is no lack of such atheists from *ressentiment*—or the social order, or education and training, or the Jews, or the nobility, or those who have turned out well in any way . . .

That such a theory is no longer rightly understood, that is to say despised, is a consequence of the bit of *Christianity* that we all still have in our blood; so we are tolerant toward things merely because they smell somewhat Christian from a distance—The socialists appeal to the Christian instincts, that is their most subtle piece of shrewdness.

Christianity has accustomed us to the superstitious concept of the "soul," the "immortal soul," soul-monads that really are at home somewhere else and have only by chance fallen, as it were, into this or that condition, into the "earthly" and become "flesh"; but their essence is not held to be affected, to say nothing of being conditioned, by all this. Social, family, historical circumstances are for the soul only incidental, perhaps embarrassments; in any event, it is not produced by them. With this idea, the individual is made transcendent; as a result, he can attribute a senseless importance to himself.

In fact, it was Christianity that first invited the individual to play the judge of everything and everyone; megalomania almost became a duty: one has to enforce *eternal* rights against everything temporal and conditioned! What of the state! What of society! What of historical laws! What of physiology! What speaks here is something beyond becoming, something unchanging throughout history, something immortal, something divine: a *soul*!

Another Christian concept, no less crazy, has passed even more deeply into the tissue of modernity: the concept of the "equality of souls before God." This concept furnishes the prototype of all theories of equal rights: mankind was first taught to stammer the proposition of equality in a religious context, and only later was it made into morality: no wonder that man ended by taking it seriously, taking it practically!—that is to say, politically, democratically, socialistically, in the spirit of the pessimism of indignation. (*WP* 765)

From a Nietzschean standpoint, if our politics is to be truly "worldly," we must accept and affirm the natural inequities of fortune, be ever on guard against a tendency to resent such disparities, and simply proceed to think about political possibilities informed by this naturalized departure from traditional presumptions and habits.[10]

Redescribing Equality

As I have suggested, substantive equality may have been historically necessary in the establishment of democracy, as a powerful rhetorical counterstroke to entrenched hierarchies and their traditional warrants. In other words, egalitarianism may have been *agonistically* necessary. That would not mean, however, that egalitarianism is a "necessary condition" for democracy, any more than certain theological notions that played an essential role in the development of science would be necessary for scientific thought. Given the theoretical and practical problems that befall egalitarian assumptions, we can explore a redescription of democratic politics without equality, to see if such problems can be resolved and if our understanding of democracy can be improved by this redescription.

I suppose it is possible to retain the word "equality" if purged of its substantive connotations and separated from some of its more vacuous uses. Species classification, for example, is certainly not enough to underwrite political equality; simply being "human" would not deliver any more parity than being a "lion" would in the natural pecking order of the pride. We might do better by focusing on certain human capacities and stressing what we have in "common," which is not synonymous with "equal." We have in common a capacity to think for ourselves (what modernism wanted to call "autonomy"), to deliberate about and pursue our individual interests.[11] Such commonality could warrant democratic inclusiveness, but it would not as such indicate anything "equal." A common capacity in one sense crosses all the different members, but it in no way suggests any parity in performance or results that would be politically relevant. A common capacity for language use, for example, still includes wide disparities of ability and effectiveness. Moreover, a common capacity to think for ourselves does not guarantee that we always *do* think for ourselves (a classic Nietzschean charge); nor does it entail that our interests as we conceive them should all have equal worth; nor does it allow—given a postmodern perspective—any presumption of "truth" or "objectivity" that could nourish projective hopes for some kind of consensual

gathering around a common good after we have negotiated our different interests.[12]

Although retention of egalitarian rhetoric in politics might be possible, it seems to me that the word "equality" can still harbor echoes of problematic assumptions and attitudes, and that the procedural approach adopted in this study seems to render the word superfluous anyway. An agonistic openness can redescribe what *is* important in egalitarian rhetoric without any of its theoretical or psychological drawbacks. Equality can be redescribed as an open, fair opportunity for all citizens to participate in political contention. The inclusiveness of democracy can be defended as follows: 1) All who are affected by political decisions should be able to participate—we should not want to say "all who are *equally* affected," however, because even the familiar idea that we all can equally suffer from bad political decisions is suspect, if not patently false. 2) The postmodern "uncertainty principle" gives us no decisive grounds for *excluding* any perspective from political participation; we can rest only with agonistic procedures for generating contingent decisions, without presuming that any view or any person can be put out of play.[13]

This sense of democratic inclusiveness need have no commerce with any notion of sameness, commonality, or equal worth. As we have seen, it is possible to refigure civic respect on the basis of a postmodern openness, uncertainty, and intellectual modesty, without having to advance the dubious idea of equal regard. Some might take equal regard to mean not an equal estimation of all interests, but simply equal attention, in the sense of giving all citizens a chance to air their views and have their concerns heard in the political process. No problem here, except that this appears to be a rather vacuous sense of equality. Indeed, a monarch could give all subjects an equal hearing and then dictate a decision. It seems to me that in the end we would lose nothing important politically if we gave up the word "equality." Democracy can still mean "rule by the people" if it is redescribed as rule arising out of a process of political contention that is open to all citizens; here the *demos* would retain its force against an aristocratic few, but would

designate nothing more than an agonistic field that can be shorn of questionable egalitarian associations.

If there is one egalitarian usage that should be retained, it would be "equal rights," since its rhetorical tone and implications seem indispensable. As I argued earlier, however, rights can be defended by reference to democratic practice, rather than to the nature of persons; and as I will argue later, rights need not depend on humans *being* equal or even on being *regarded* or *treated* "identically." Equal rights can mean that all citizens have the *same* rights without *being* the same in any way, without being entitled to identical outcomes or even identical treatment in the sense of the concrete details of political activities.[14] With such a nonegalitarian orientation, a postmodern, agonistic approach to politics opens up new lines of thinking that can respond to many social, political, and cultural challenges that democracy has had to face, both externally and internally.

Merit and Mediocrity

Democracy represents the disbelief in great human beings and an elite society. "Everyone is equal to everyone else." "At bottom we are one and all self-seeking cattle and mob." (*WP* 752)

This passage can help highlight the ways in which my analytical path diverges from both Nietzsche and traditional democratic theory. The first sentence represents a familiar democratic notion that I can accept in some fashion, while the second sentence is one I want to challenge. The last sentence reflects a typical Nietzschean invective that I intend to dispute.[15] Our postmodern approach to democracy so far need not fall back on any egalitarian sentiments advanced by democratic theory and lambasted by Nietzsche. Human beings do not have to be deemed equal in any way. Not only can democracy accept a certain kind of cultural elitism, but its political procedures can be called an agonistic meritocracy, because temporary rule and authority are earned in a discourse contest that all citizens and groups have the opportunity to engage in.

Nietzsche is surely right in spotlighting the various ways in which conformism born out of resentment inhibits and hinders

human achievement. There is no culture without excellence, but in all milieus, people who stand out, succeed, or innovate often meet resistance and obstacles cast at them by others who feel threatened or diminished by excellence. This is especially pernicious in the education arena, where young students who excel or who challenge the received wisdom can experience covert and overt castigation from their peers and teachers. Thus, many creative and capable people are sabotaged and debilitated early in their development, and then our culture suffers as a result of this loss—such is the paradox of a conformist culture that is so vulnerable to a Nietzschean critique.

Nietzsche is also empirically correct in claiming that excellence is rare, that most people do not exhibit high achievement or are quite content with sensibilities that one might call ordinary or shallow. Moreover, it would be far from preposterous to argue that an egalitarian mediocrity is more likely or even very likely in a democratic society, and that its leveling effects on culture and politics are quite detrimental. In this respect, Nietzsche's creator-herd distinction might well apply to cultural, social, and political matters whenever resentment, conformism, and mediocrity predominate. As a personal aside, which I intend only as a gesture toward the ambiguities and difficulties of this question, I admit that I am often tempted by Nietzsche's aristocraticism, that I often experience an elitist seizure when I glance at the tabloids in the supermarket, or watch some of the raucous television talk shows, or gaze at the spectacle of professional wrestling. I think of the millions who enjoy such things and I have a little fit: Good grief, these are my fellow citizens! Plato and Nietzsche were right! If I want to remain a democrat, however, there are a number of possible responses to this experience: I can ignore it (which would be insincere); I can assume it is only a subjective, personal attitude that need not have any bearing on political reflections (which would be mistaken); I can become a kind of pessimistic democrat (which I would like to avoid); I can become an optimistic reformist (which I cannot abide); or—and this is the option I prefer—I can face up to all these issues, rethink democracy in the light of elitist challenges,

and conclude that democracy is not as debased as my Nietzschean seizure would suggest, and even where there is debasement, things can be improved.

It is not at all evident that democracy necessarily implies the hegemony of mediocrity and the leveling tendencies duly criticized by Nietzsche. The degree to which such phenomena seem more pronounced in democratic societies might be due in part to the egalitarian rhetoric of our traditions, the valorization of that rhetoric in our political documents and rituals, and the influence of that valorization on all sorts of social practices. All of this can create a kind of cultural catalyst for instigating or nourishing the human potential for resentment of excellence—a resentment which, though based on fear and weakness, can nonetheless conspire for power by way of a punitive conformism. Following Nietzsche, I want to challenge that egalitarian rhetoric, undermine resentment and mediocrity, and encourage a rhetoric of excellence—all the while, however, affirming and sustaining a democratic politics. I think that nothing in democracy forbids the recognition of excellence in culture or in politics; a shallow conformism is neither intrinsic to, nor inevitable in, democratic practice. In fact an egalitarian psychology seems to run counter to the ideals of liberal openness, self-expression, and individuality that have usually inspired proponents of democracy and that have led some of these advocates to warn against conformism and the tyranny of mass thinking. Consider these near-Nietzschean passages from Mill:

> Society . . . practices a social tyranny more formidable than many kinds of political oppression, since, though not usually upheld by such extreme penalties, it leaves fewer means of escape, penetrating much more deeply into the details of life, and enslaving the soul itself. Protection, therefore, against the tyranny of the magistrate is not enough; there needs protection also against the tyranny of the prevailing opinion and feeling, against the tendency of society to impose, by other means than civil penalties, its own ideas and practices as rules of conduct on those who dissent from them; to fetter the development and, if possible, prevent the formation of any individuality not in harmony with its ways, and compels all characters to fashion themselves upon the model of its own. There is a limit to the legitimate interference of

collective opinion with individual independence; and to find that limit, and maintain it against encroachment, is as indispensable to a good condition of human affairs as protection against political despotism.[16]

To be sure, there may be significant differences between Nietzsche's interest in contesting conformity and many contemporary appropriations of a Nietzschean line. Nietzsche wants to undermine uniformity on behalf of excellence and cultural creativity. Some writers have sidestepped a concern for "higher types" by emphasizing instead the ways in which human *differences* of various stripes can be suppressed through conformity to a standardized norm; this can open up defenses of different sexual preferences, of resistances to traditional gender roles, of eccentric behavior, and so on.[17] Such defenses surely can couch themselves in a Nietzschean rhetoric of "self-creation," but we should take care and attend to the differences between "difference" and "excellence." Nietzsche seems to focus on a liberation of cultural excellence and not a generalized liberation of different life styles. Many contemporary writers have embraced Nietzsche on behalf of an openness to difference, but from an exegetical standpoint we should ask if Nietzsche's rhetoric is being expropriated for a purpose he would resist—or, to put this question more critically, if his contemporary admirers betray a concealed egalitarianism in their avoidance or suppression of Nietzsche's clear comfort with stratifications of higher and lower, better and worse performances.[18] At least I am trying not to shy away from these delineations in my appropriation of Nietzsche. This may be significant because the aristocratic line in Nietzsche may provide important challenges that force postmodern thinking to ask how much stock should be put in a generalized liberation of differences.

Apportional Justice

Justice in a political and cultural sense need not depend on a strict, uniform conception of equality or on the ideas of equal worth and equal regard. It can be right and proper to "discriminate" in political matters and to acknowledge superiority and excellence in cultural

matters when warranted. Here we can take up a previous reference to Nietzsche and Aristotle in order to amplify this discussion. Nietzsche calls for a conception of justice that portions equal treatment to equals, unequal treatment to unequals, wherein it would not be just to make equal what is unequal (*TI* 9,48; *BGE* 228). This is an echo of Aristotle's conception of justice delineated primarily in the *Politics*. With some attention to Aristotle's texts we can develop a working principle that I will call *apportional justice*. In the *Politics*, Aristotle tells us that justice requires attention to both equality and inequality, that neither category can ever hold absolutely in matters of justice (III.9.1280a10–15). If justice refers to the distribution of material, social, and political goods, then the component of Aristotle's configuration that would interest us most is the view that to treat people unequally, to portion out more or less of a good to different people or to deny some people a good altogether, is sometimes just. We can work with Aristotle's idea by devising a formula for what I will call *contextual apportionment*: "*a* and *b* can be treated equally (or unequally) when they are equal (or unequal) in *c* relevant to *d*," where *a* and *b* are persons, *c* is a particular condition or ability, and *d* is a particular context for which *c* is appropriate.

This formula can, as Aristotle says, be applicable to any good in question (III.12.1283a2); we must simply ask specifically: equality or inequality *of what* or *in what*? (1282b23). For example, to portion out political rights according to complexion or height would be unjust, since these conditions are not relevant to politics (1282b25–30). If a low-born flutist excels in ability over well-born, wealthy players, not to give the best flute to the low-born player would be unjust, since wealth and status are not relevant to musical performance (1282b30–1283a1). Clearly, such a formula will give us variable results in various contexts, so that equality will not always indicate justice, nor will inequality always indicate injustice.[19] To extend either equality or inequality to all contexts would be wrong.

> Those who are equal in one thing ought not to have an equal share in all, nor those who are unequal in one thing to have an unequal share in all. (III.13.1283a22–30)

Any social or political arrangement that violates this maxim, that overdetermines equality or inequality in a given context, will be unjust. Treating equals unequally or unequals equally is the source of social quarrels and complaints (*Nicomachean Ethics* V.3.1131a20–25) and the catalyst for political revolutions.[20]

As an example of contextual apportionment, consider a university setting. All admitted students should be treated equally, in the sense that their admission gives them the right to fair treatment. Since a standard of performance is the relevant factor, all students in a course should be given the same assignments and conditions, and their assessment should be limited to their performance. Anything else would be unjust. The results of performance, however, permit the unequal distribution of goods (e.g., grades); for example, to award equal assessment to a clear, articulate, persuasive essay and a poorly written, unfocused, unconvincing essay would be unjust. Students can readily accept apportional justice here, once the different contexts are delineated. They see it as just that only some people are admitted to the university (all persons who want to go to college are not treated equally if there are admissions standards); they easily see it as just that all students in a course be given the same conditions and criteria for performance; and, with a little reflection, they see it as just that with respect to performance students are not treated equally, but rather some students are given a greater amount of distributed goods—in other words, in a certain context, some students are designated as *better* than others.

Apportional justice in this sense can apply to many different milieus, and it can be easily sustained or encouraged, so we can sort out and affirm social and cultural areas of excellence and stratification (I leave politics aside for the moment). Accordingly, we can dispute Nietzsche's charge that democratic societies need be sources of rampant mediocrity; and even where Nietzsche is right, we can agree and speak against such egalitarian excesses without renouncing democracy. We can and should be vigilant about egalitarian resentment and revenge as diagnosed by Nietzsche. Any form of excellence necessarily implies a certain elevation of some persons

and, by contrast at least, a diminishment of others. Those who do not or cannot excel can naturally experience psychological distress in the face of such differentiation, some remedies for which include tearing down or sabotaging those who succeed, discouraging the qualities or attitudes that generate excellence, or valorizing average conditions.[21] Nietzsche's critique of such things implies in a general sense a certain ethos of apportional merit, wherein we should accept and affirm comparative estimations of performance, of better and worse outcomes, of praise and detraction—both in ourselves and in others. Such an ethos follows Aristotle's affirmation of pride (*Nicomachean Ethics* IV.3), which implies individual and societal comfort with the recognition of excellence, and, it seems to me, the appropriate identification of diminished or undistinguished achievement as well. Honoring a certain excellence in others would seem to imply an acknowledgment of one's own lesser capacity in that respect—and why not? As long as the estimation is contextual, such self-depreciation would have no bearing on one's overall worth as a person. As we will see shortly, a postmodern, decentered approach to selfhood would have no trouble acknowledging performance gradations, without in any way slipping into talk of better and worse persons; indeed it may be substantive models of the self that are more likely to generate essential depreciations of people.

Nietzsche's assault on egalitarianism indicates that he seems to think that most people are not capable of honoring excellence and success, that tendencies toward resentment and revenge are inevitable in the vast majority of human beings, so that any gestures toward democracy would only institutionalize and strengthen a debasement of culture. Well, I simply do not think this is true to the extent suggested by Nietzsche's diatribe. First of all, it is possible to cultivate and encourage an ethos of apportional merit. Secondly, there are elements of such an ethos in place already; democratic societies have never collapsed into egalitarian mush—consider how readily we affirm many unequal power relations in milieus such as the military, the professions, and education, and how prone we are to idolize talent in various arenas. So it is not at all evident that

egalitarian rhetoric has had an actual comprehensive effect on human relations. In the words of Nietzsche himself, we "are accustomed to the *doctrine* of equality, though not to equality itself" (*GS* 18).

Another problem with Nietzsche's aristocraticism is that he seems to apportion excellence and mediocrity in such clean and categorical terms: higher and lower "types," the creators and the herd, and so on, suggesting clear delineations between a few great individuals and a mass of lowly, inept sheep. The formula for apportional justice that we drew from Aristotle, however, gives us much more contextual flexibility, so we can discern areas of excellence or potential for excellence in all walks of life. People can cultivate their own talents and interests, aspire to their level of excellence, deserve praise for their achievements, and owe praise to others for their achievements. Nietzsche indeed may have been emphasizing only a certain kind of excellence, namely culture-creation and life affirmation. Nevertheless, the texts seem to ignore or conceal a much wider range of excellence and apportionment, thereby denying us the impact this range can have on social reflections.[22] Consider this: Most people are no match for me when it comes to philosophy, I am far and away their superior; but in the context of automobile machinery and technology, where I am a complete idiot, I yield to the mastery of my mechanic, who is like a god to me. My point is that we can all experience elements of superiority and inferiority, a contextual fluctuation of pride and humility, where no one need be presumed to be wholly lacking excellence of some kind. In fact, Nietzsche himself in two passages from the middle period offers an uncharacteristic gesture toward a universal capacity for elevation and excellence:

> *Everyone* [my italics] has his good days when he discovers his higher self; and true humanity demands that everyone be evaluated only in the light of this condition and not in that of his working-day unfreedom and servitude. (*HAH* I,624)[23]

> Under civilized conditions everyone feels himself to be superior to everyone else in at least *one* thing: it is upon this that the general mutual goodwill that exists depends, inasmuch as everyone is

someone who under certain circumstances is able to be helpful and who thus feels free to accept help without a sense of shame. (*HAH* I,509)

Consider also this passage from *The Gay Science*:

> Only artists, and especially those of the theater, have given men eyes and ears to see and hear with some pleasure what each man (*Jeder*) is himself, experiences himself, desires himself; only they have taught us to esteem the hero that is concealed in everyday characters; only they have taught us the art of viewing ourselves as heroes—from a distance and, as it were, simplified and transfigured—the art of staging and watching ourselves. Only in this way can we deal with some base details in ourselves. Without this art we would be nothing but foreground and live entirely in the spell of that perspective which makes what is closest at hand and most vulgar appear as if it were vast, and reality itself. (*GS* 78)

The formula for apportional justice can also be applied to democratic politics, since equality and inequality are both relevant in certain distributional contexts. Not every citizen is granted political equality; since age is a relevant factor, nonadults in the community are denied a certain political good—the right to vote, for example—which, according to the formula, can be called just. To deny adult citizens the right to vote, however, would be unjust, since they are all equal in this respect; and previous exclusions in democracies, such as those based on race, gender, and property, can be called unjust because such variant conditions can be seen as irrelevant to political practice (at least we have come to understand this application of the formula in recent history). Shortly we will take up some other possible applications of apportional justice in political practice, some of which will show us how ambiguous the question of equality can be in democracy.[24]

Meritocracy Without Essential Superiority

Apportional merit in the sense of comparative estimations of better and worse performance can easily be incorporated into a democratic framework, in both cultural and political matters. Democracy can be seen to require a meritocratic stratification, although

opportunities to gain placement in any social and political hierarchy must be open to all citizens, and all hierarchies must be open to challenges in ongoing contests for recognition and authority. At any rate, nothing would be lost if we renounced or challenged an egalitarian psychology and affirmed cultural and political excellence by recognizing our "betters" in various domains. Such meritocratic recognition, however, should be thoroughly contextual and never reductive to the point of designating better and worse "persons" who are essentially superior to other persons and who might therefore be seen to deserve vested or entrenched privileges in culture or in politics.

In this respect we can draw on Nietzsche's repudiation of a metaphysical self, of a unified essence behind contingent and performative differences. As we have seen, for Nietzsche there is no "self" behind performance, there is no "doer," only deeds. Since performance is temporal, situational, and variable, we should then limit the recognition of excellence to praising contingent performances rather than "persons." If we take Nietzsche's lead and adopt a postmodern alternative to essentialist conceptions of selfhood, wherein we emphasize performances and take the human self to be decentered, contextual, and pluralized, we can go a long way toward resolving the egalitarian-aristocratic debate in which democracy has had to engage. People can be ranked in all sorts of contexts in terms of better and worse performance, without any *essential* ranking of persons. We can sustain stratifications of superiority and inferiority in democratic societies because we renounce *any* sense of essential superiority (a democratic gesture), while apportional justice and contextual merit allow us to make comparative judgments in appropriate settings (an aristocratic gesture). Artists, thinkers, leaders, athletes, laborers, and so on across the social spectrum, all can have their excellences, both within and between domains, and the recognition of excellence will continually fluctuate within and between domains—on a given day in a given context, for example, a good locksmith is far superior to a President of the United States (or even a Zarathustra, for that matter).

Egalitarian rhetoric is most impressive when pitted against aristocratic estimations of human worth in terms of class, lineage,

or other designations that fix people into stratified categories held firm from the ground up and throughout the temporal span. Postmodern selfhood can address this same issue without swinging to an egalitarian extreme. From a postmodern perspective, achievements, even great achievements, would not translate into any notion of a superior "person" or someone who is closer to the "truth" or the "good." With a decentered self, we can talk of performances rather than "natures." There is no unified essence in the light of which we might be tempted or prompted to sum people up, close the books on them, or presume to measure them in any fundamental way. Consequently the "person" in postmodern discourse can be a functional, but nevertheless nominal, signification; it makes no reference to strict "identity," substantive or otherwise. For this reason (as we have seen) no *exclusions* of persons from political participation can find any support in postmodern thinking either, since exclusions typically have been based on certain closed and fixed categorizations and identities.

Ironically, traditional essentialist models of the self may be implicated in the hierarchical and exclusionary practices that democracy has always tried to oppose. Perhaps the habit of seeing the self in fixed, definite terms of identity has nourished the temptation to interpret different patterns of achievement as fixed, essential differences, and thus led to presumptions of superior and inferior "selves." The democratic impulse to overcome hierarchical exclusion and alienation in the social order should not arm itself with presumptions of equality or a rhetoric of equal regard; rather, it should embrace a decentered, differentiated, ungrounded self. Accordingly, democracy could acknowledge excellence and merit without any fixed or substantive hierarchy.[25] Perhaps our traditional essentialist habits have caused us to recoil or shy away from recognizing superiority and inferiority, since such distinctions would seem to suggest some fundamental differentiation. A postmodern contextual apportionment, however, can affirm comparative judgments without drawing any fundamental conclusions from such estimations. So persons can be better or worse in this or that performance, but no person can be essentially devalued

to the point of being excluded from the political order because of a presumption of some kind of fundamental, unalterable inferiority.

Political Equality as Fair Competition

An agonistic, meritocratic approach to democracy can redescribe political equality as fair competition. Such redescription first of all accords with democratic gambits against aristocratic and certain conservative objections to egalitarianism, which objections can now be unmasked as resistance to fair competition on behalf of vested interests and advantages. Secondly, with a notion of fair competition we can sidestep many of the theoretical and practical problems that seem indigenous to egalitarian doctrines.

The word "fair" need not entail any sense of sameness that adheres to the word "equal." The closest egalitarian concept that might apply to fair competition is equal opportunity, but even here equality may be a misplaced or dispensable term. Rehearsing the analogy of athletic competition might help identify a nonegalitarian sense of fairness in political practice. Fairness in athletics is built around granting all contestants an equal opportunity to compete for victory; it specifically eschews, however, the idea of equal results and even equal capacity in the strict sense. The constitutive rules of athletic contests stem from an internal logic of competition that even the most ardent player or partisan fan must accept as just. Rules pertaining to both the structure of the contest and the conduct of contestants reflect the central idea that performance should be neither too easy nor too difficult, in terms of both the skills involved and the interaction between players. Excessive ease or difficulty and imbalances of ease or difficulty between contestants would undermine or subvert the whole point of the competition. Either side of the contest must be capable of winning and must not be unfairly impeded from exercising its attempt to win. So competing against an unqualified opponent or incapacitating an opponent is not only unfair, but in fact senseless, since a "victory" over an incapable opponent is really no victory at all; indeed, an "incapable opponent" amounts to an oxymoron.[26]

Whatever "egalitarian" elements there are in athletics are reflected in 1) the rules that promote fair play, and 2) a rough range of comparable ability. None of this, however, entails equal results or even equal ability. No contestants should encounter inappropriate barriers to their performance, but a loss in a fair contest is just and proper. Moreover, a contestant with more talent or greater ability is not as such automatically considered to have an unfair advantage in a contest. Athletics is such that many factors contribute to winning, and so talent and natural advantages do not always prevail. There is a limit, however, outside of which an imbalance of talent would no longer constitute a fair contest. Who would praise the New York Knicks for beating a high school basketball team? What professional athlete would ever want to play such a game?[27] To sum up: 1) an athletic competition aims for unequal results (otherwise it would not be a contest); 2) there must be fair playing conditions so that all contestants at least have the potential to win and the opportunity to give their best effort (otherwise it would not be a true contest); 3) there need not be exact parity in ability or resources, but simply a roughly drawn range of permissible inequities that excludes excessive imbalances (otherwise the second point applies).

Although the analogy of athletics does not completely match political practice—considering the range of participants and the different stakes involved—nevertheless some parallels can be drawn that can help shape an agonistic sense of fairness and a non-egalitarian sense of equal opportunity in political practice. Fair competition in politics can signify an open opportunity for all citizens to compete for political victory. The competition must have fair procedural conditions for all, but it need not mandate equal resources or influence for all participants. At the same time it must correct for excessive imbalances of assets. True, the elements of justice and injustice in an athletic competition are easier to discern. If someone wins a fair contest, we do not view the unequal results as unjust; at the same time, if someone is not equipped to compete, we readily sympathize and even recognize the pointlessness of the supposed contest; we see that the contest should not even be held

under such unequal conditions. Nonetheless, we tend to be comfortable with a certain range of unequal capacities (we even find the prospects of an unexpected win—the "upset"—more exciting). Drawing on this agonistic sense of justice in athletics, we can identify comparable issues of fairness and opportunity that can clarify conditions of political practice and that can even underwrite social programs meant to address resource and access inequities.[28]

As we have seen, equal opportunity in politics may be nothing more than an empty charade if certain obstacles or deficiencies make opportunity futile measured against an excessively endowed opponent. This, of course, is especially true when money is a crucial factor in politics. The same point obtains, however, in matters of educational, environmental, and other indirect factors that bear on political participation (such issues will be discussed shortly and in a later chapter). Certain segments of society that continually win political power owing to excessive advantages should in a sense be as embarrassed by such outcomes as a professional basketball team that beats a high school squad—the different stakes in the political contest, of course, can blind us to this comparison, but the conceptual analogy holds, I think. Unless there is a rough range of comparable access and resources for developing human potential, political outcomes can be called unfair to varying degrees. At the same time, political fairness need not entail anything like equal results, guaranteed results, or identical resources and abilities.[29] A certain range of inequities can still exist without crossing over the edge of democratic fairness. First of all, political results are unequal in the sense of victory and defeat. Secondly, politics in the age of technology and mass communications means that opportunity, access, and resources need not be identical in the brute sense in order to promote fair competition (more on this later). Thirdly, even if opportunity, access, and resources were identical, that would not guarantee comparable performance or success in the political arena. For example, two candidates may have equal exposure and resources, but one might trounce the other in the campaign; this is certainly not a condition of equality, but it is fair. In sum, then, equal opportunity in politics is better rendered as fair competition

so we can 1) avoid any substantive egalitarian measures with respect to resources, ability, influence, or outcome, measures that would require massive intrusions into the political process that are either unjustifiable or unworkable; and 2) compensate for imbalances that are so excessive that the political contest becomes unfair, even fraudulent.[30]

Aristocratic Elements in Representative Democracy

A central contention of this study is that democracy can be understood as a blend of egalitarian and aristocratic features; in this way we can disarm some of Nietzsche's criticisms of democracy and at the same time spotlight discrepancies and drawbacks in Nietzsche's hierarchical politics. Recognizing and affirming excellence is a Nietzschean ideal that we have suggested can be sustained in democracy. Affirming one's opponent is another Nietzschean ideal that we have suggested is indigenous to democratic practice. This latter ideal is what seems to undermine Nietzsche's political authoritarianism, as I see it. Not only would eliminating one's Other violate this ideal, but so too would seeking or effecting complete *control* over one's Other.

As indicated earlier, resentment and the ascetic ideal can be understood as wanting to annul an opposing force in order to preserve a state of "being" from the flux of finitude. A nihilistic resentment can be corrected by an agonistic, pluralistic openness to opposition, which was also nominated as a revised civic respect that is, or should be, endemic to democracy. This sense of openness may provide clues for diagnosing a concealed or unwitting resentment in Nietzsche's aristocraticism. Promoting control over others in a political sense may be no less a consequence of weakness than the indirect control regimes of a conformist culture that concerned Nietzsche so much.[31] Political domination can be unmasked as a flight from competition, a will to eliminate challenges, a fear of possible loss, and therefore as a weakness in a Nietzschean sense.[32] Democracy, as I am trying to depict it, permits only power that is

earned in a civic contest, that is continually open to challenges, and that consequently is always willing to risk itself. In sum, I am trying to distinguish democracy from *both* authoritarian/totalitarian political domination *and* an egalitarian conformist mediocrity—both of which stem from a weakness that lies behind their respective techniques of control. Democratic openness to opposition and difference in both politics and culture, therefore, requires an existential (Nietzschean) strength.

The *quality* of political governance is surely a question that forces us to face important Nietzschean criticisms, but if we recall our procedural approach to democracy, we notice that in a formal sense the quality of political outcomes is so far a separate issue; nothing in democratic procedures guarantees either high-level or low-level results. As indicated earlier, political mediocrity is not intrinsic to democracy, and a discussion of representative government may help develop this point.

In political practice, representative democracy can be interpreted as a kind of temporary aristocracy, and in fact traditional discussions of democracy have often said as much, some approvingly, some disapprovingly, depending on how democracy has been theoretically conceived. In these discussions, aristocracy has meant either oligarchic rule by the (wealthy) few or rule by an elite, both of which have been counterposed to democratic mass politics. Some have considered representative government to be undemocratic on two grounds: 1) it is not direct rule by the people, and 2) it is not truly representative of the people's interests, since elected officials do not always, or cannot always "represent" or "stand in for" the concerns of constituents. It seems, though, that such objections stem from an overly rigid and formal definition of democracy that is unnecessarily restricted by egalitarian and populist principles. Since our approach has deliberately moved away from such principles, we can draw from other more favorable discussions of representation without having to defend our democratic credentials, since we might now be able to incorporate apparently undemocratic elements into a revised and more open conception of democracy.

One sense in which representation can be seen as democratic is the familiar notion that direct democracy is impossible in large-

scale societies (although modern technology could change this, as we will see), so that representative government is a practical necessity in maintaining democracy on a large scale. Some have argued, however, that representation is also defensible on more substantive grounds, since (it is held) most people have neither the competence for, nor an interest in, governance. Representation, at least in theory, puts government in the hands of motivated and capable people. Moreover, elected officials, especially on the national level, often have to strike a balance between being a "delegate" and a "trustee," that is to say, between serving the interests of constituents (at best a majority of them, to be exact) and being free to exercise individual judgment or to consider larger interests.[33] Citizens do not necessarily see their representative's role as nothing more than a conduit for their interests; people often vote for candidates that they think will be capable, responsible, intelligent, and so on, with only a rough sense of ideological criteria or self-interest behind their vote. Nothing in representative democracy need rule out the quasi-aristocratic notion of voting for the leadership of a political "elite."

Some democratic theorists have recognized and affirmed the need for leadership by a select few.[34] Democratic elitism, of course, is distinguished from aristocracy in that leadership is always subject to review or replacement in the electoral process. Nonetheless, such elitist sentiments have tended to mirror traditional aristocraticism: political rank often has been justified on cognitive or moral grounds as a result of the conviction that the masses lack a certain capacity for wisdom or virtue. We have already indicated that democracy can and should be suspicious about such estimations, but a Nietzschean perspective at least helps show how a certain element of elitism can and should animate democratic thought. Representative democracy can be conceived as a deliberate mix of egalitarian and aristocratic forces, both meant to balance each other in a structural counterplay.

Such a political order was certainly implicated in reflections on, and the construction of, the American Constitution and system of government. The Federalists, in their defense of representative

government, generally argued on behalf of a natural aristocracy, whereas the Antifederalists tended to be suspicious of this and more egalitarian in outlook. Jefferson distinguished a natural aristocracy of virtue and talent from an artificial aristocracy of wealth and birth, calling the former "the most precious gift of nature" for government.[35] The structural separation of powers included a deliberate admission of elite components that could counterbalance mass components of democratic government: the Presidency; the Senate, whose specific powers (confirmation, for example), smaller size, and longer terms were intended to balance the more majoritarian, more populist House of Representatives with a more deliberative, reflective body; and the Supreme Court, a nonelected legislative institution that could be called thoroughly elitist in conception, except that its functional restriction to the Constitution, its own agonistic features, and the possibility of impeachment sustain democratic elements.

There is no reason why elitist and quasi-aristocratic notions cannot be incorporated into democratic theory and practice, especially if egalitarian rhetoric can be tempered, redescribed, or even suspended altogether. Nietzsche declares that "the best should rule, the best also *want* to rule" (Z III,12,21). Although not in keeping with Nietzsche's version of aristocraticism, representative democracy can be called a political aristocracy that is *chosen* by citizens, *temporary* in duration, and *deposable* in the electoral process. Even though many tendencies and outcomes might not always indicate it, democracy contains no formal or intrinsic opposition to the idea of citizens choosing a political elite.

Political leadership in democracy can be, and often is, acknowledged as requiring exceptional qualities and special vision, even though leaders are beholden to citizen election.[36] Political campaigns and deliberations do not *require* that candidates and officeholders try to please everyone or pander to citizens' immediate impulses, nor do citizens necessarily see excellence as a threat or catalyst for conformist retaliation.[37] Moreover, it is possible to elevate democratic discourse, to break egalitarian habits in political exchanges. I am not arguing that such elevation is easy or likely; it

is difficult work to engage political issues well. I sometimes think that our "soap opera" campaigns—the emphasis on sensationalism, personal dirt, private behavior, and so on—appeal to people (including journalists) because such things allow for simplistic analysis and easy, decisive judgments. Nevertheless, political deliberations in Congress, for example, are far from an unrelieved parade of pandering and debased discourse. The cable network C-SPAN—an important contribution to democracy, I think—can give citizens a look at day-to-day political sessions that often show some hardworking, intelligent people trying to do the work of governance in a responsible way.

In general terms, if a politician does pander, or is afraid to commit to a principle or policy, or retreats in the face of a controversy, these tendencies can be called nothing more than self-serving cowardice. Candidates and officials can challenge citizens, try to persuade them, and simply take on and accept the political risk of losing office or election to office.[38] One way to summarize our nod toward elitism here is that it helps identify a balance that is needed between the beneficial and deleterious effects of representative government: On the plus side, representation cultivates a political professionalism, where talented and motivated people can pursue a career in governance, a career that many other citizens would neither want nor do well in; on the minus side, career politicians can then easily regard *keeping* office as their top priority, which can cultivate pandering, backsliding, or worse, in order to hold on to the job. A nonegalitarian appeal to excellence can both foster professionalism and mitigate its defects in a representative democracy.

Those who might object to defending elitist elements in representative democracy would have to confront certain telling problems that adhere to egalitarian ideals. We can spotlight such problems by addressing three issues: 1) a lottery as an egalitarian alternative to elections; 2) the viability of collective decisions in direct democracy; and 3) a certain *de facto* stratification in democratic practice.

1) In Athenian democracy, most political decisions were born out of the Assembly, as a direct reflection of citizen opinion. So the

need for public officials and decisions stemming from their deliberations was minimal in Greek democracy. Where government officials were needed they were generally selected by lot, rather than by election. Aristotle tells us that the election of magistrates was thought to be undemocratic; their appointment by lot was thought to be more democratic (*Politics* IV.9.1294b7–9). One reason is that a lottery avoids certain selective and elitist features in other forms of government—monarchy being rule by a single person, oligarchy having a property qualification, and aristocracy having an educational qualification (*Rhetoric* I.8). A random assignment by lot implies an egalitarian assumption that all citizens are qualified (if not equally qualified) for government service; or put another way, a lottery would be the only procedure that is truly consistent with egalitarian presumptions. This provides another angle on the implicit elitism of representation. Election by way of a public contest that tests ability and that results in winners and losers suggests comparative judgments that raise some citizens above others. Egalitarianism, therefore, indeed ought to prefer political service by lot to the election of representatives. Any reservations about a lottery, however, would imply favor toward a certain elitist alternative to strict egalitarianism; and as I see it, there are few circumstances where service by lot would be appealing, in politics or any other context.[39]

2) In matters of collective decision making, direct democracy is certainly more egalitarian than representative democracy. Nonetheless, as we have seen, some have argued that scale considerations are not all that recommend representation. Political decisions by direct tally of citizens' opinions may be more egalitarian, but it may also be less desirable than deliberations by an elected body. We can ponder this point by recognizing that modern technology can overcome the spatial and temporal limits that have made direct democracy unworkable in a large-scale society.[40] We can easily imagine citizens hooked up to a communications network wherein political issues can be presented, debated, and resolved by a tally of votes across the network—giving us decisions directly expressive of citizen opinion on any given question. Such a prospect should at

least give us pause, however, given the notorious volatility of poll numbers over short stretches of time, and considering the question of citizen competence or capacity to engage complex issues in all their details. We might regard anew the import of arguments in favor of a deliberative body as opposed to direct collective decisions.[41] In any case, the preceding two sections can be summarized by way of the following distinctions: a) office by lot vs. election by contest, and b) direct democracy vs. representative democracy. The former in each distinction is more egalitarian, the latter more aristocratic. Any drawbacks in the former or advantages in the latter show us a route toward nonegalitarian dimensions in democracy that need not diminish or adulterate its basic political profile.

3) Even if direct democracy were possible, or even if all citizens were given equal access and resources in electoral politics, the phenomenon of so-called "stratified pluralism" casts some suspicion on egalitarian expectations and hopes. Stratified pluralism has been suggested to account for uneven participation in American politics.[42] A single model of the ideal voter may be unwarranted, so too the notion that low voter turnout or citizen apathy are signs of an ill-working democracy. There are a number of possible explanations for citizen nonparticipation in politics: less access, fewer resources, contentment with the status quo, disaffection, cynicism, noninterest, laziness—all of which are probably relevant to the question in varying degrees. The mix is such, however, that even if resources and access were distributed equally, it is not at all clear that citizen participation would increase dramatically. There may always be a mass of citizens who are reluctant to vote, or unconcerned, or uninterested in politics. Stratified pluralism suggests that there is a smaller number of concerned and attentive citizens, within which an even smaller number of activists and opinion leaders tend to influence elections disproportionately. To whatever extent this is true, political results tend to stem from the activities of a certain elite and a narrow sector of the citizenry. Such an elite, however, is not like an aristocracy of birth, inheritance, wealth, appointment, or certification. A democratic elite is open and it

crosses all areas of interest, occupation, economic class, race, and so on; it is more a function of motivation, talent, and effort that can be located anywhere on the social and political spectrum. American politics, therefore, may be called "elitist" in the sense that there is no compulsory participation and that a natural, variable stratification unfolds in which interested and capable persons have a disproportionate influence on results. There need be nothing undemocratic about such tendencies, however; here we may simply see mirrored in the electorate the same kind of meritocratic features that have figured in arguments for representative government. Once again, it may be that in practice democracy has very little to do with egalitarian propensities.[43]

Education and Excellence

Nietzsche's reason for opposing democratic decision-making in its employment of majority rule is not hard to figure, since his estimation of the majority of humans is usually quite harsh. In *GM* III,1, for example, he calls them "physiologically defective and ill-tempered" (*physiologisch Verunglückten und Verstimmten*). I am trying to unsettle Nietzsche's apparent aristocratic confidence by pointing his own critique of truth back at that confidence and by taking a pragmatic approach that might neutralize both aristocratic and democratic tendencies to associate politics with truth. As we have seen, a procedural approach to politics might be able to sidestep altogether the classic problem of the "quality" of majority decisions that has occupied political philosophy—where democrats argue that majority rule produces "good" decisions and aristocrats argue that it produces "bad" decisions. From a postmodern perspective, both sides can be seen as trafficking in suspicious or precarious assumptions about quality and truth that political philosophy might be better off without. This is not to say that the quality of political practice is an unimportant issue, but simply that a procedural approach relieves us of certain global assumptions on both sides of the egalitarian-elitist debate; and such relief, in its deliberate avoidance of suspicious global claims, suggests and

opens up a more localized, contextual treatment of the crucial questions of citizen competence in a democracy.

The quality of political participation is a recognized problem in democracy. It should be added, however, that nondemocracies are no less subject to this problem; in fact it is significantly worse in nondemocracies since people are stuck with the results and effects of vicious or incompetent leadership. In any case, democracy requires an educated citizenry, otherwise whatever defects democracy might possess surely become magnified or assured. Here is one area in which "the political" cannot be limited to procedural matters and formal principles; the formation and maintenance of institutions that foster and sustain cultural and human development are essential to any political system. Educational institutions are especially important in democracy (but even here, when public education is involved, the procedural elements of politics remain operative in decisions concerning legislation, funding, curriculum, pedagogy, and so on). The educational ideals of open inquiry, critical thinking, and reasoned dispute that have been a hallmark of Western culture are essential to, and in fact productive of, a democratic praxis and ethos. This is the sense in which the Greek and European "enlightenment" periods were so germane to the development of democracy. The liberation of thought from dependence on religious revelation and other traditional/conventional patterns eventually undermined the political warrants attached to those structures. Democratic procedures were a natural fit for the political conjunction of civil discourse, critical examination, and an open intellectual atmosphere. In a democracy, as we have seen, the good is not preordained, so citizens are expected to think for themselves, to question authority, to engage fellow citizens in dialogue, to defend their positions and submit them to scrutiny in the public contest of ideas, and lastly to accept defeat (if it comes to that) in a spirit of global openness and respect for democratic procedures. Incidentally, this may be one reason why Western-style democracy often fails or does not work well in cultures that have not gone through the same historical movements, that have not moved beyond traditionalistic or conventionalistic patterns, or that have not been habituated to the same educational ideals.[44]

The maximum extension of this intellectual ethos has been accomplished in the American experiment with universal public education. The idea that all citizens should have access to a comparable range of educational opportunities to develop civic skills and acquire a knowledge base that can enhance political participation is a significant improvement in democratic provisions over other more selective, more class-oriented approaches to education. A program of universal education, however, need not have any egalitarian expectations or assumptions at its core. We do not have to believe in or hope for equal intellectual ability or results, nor do resources or endowments have to be identically distributed across the community. We can simply affirm and support programs that guarantee all citizens a viable opportunity to develop their abilities. As Nietzsche puts it, "the individual, each according to his kind, should be so placed that he can achieve the highest that lies in his power" (*WP* 763). We can still recognize, honor, and reward excellence in results, and pay attention to the special needs of gifted students so as not to diminish their interests and capabilities in the name of academic equality.[45]

Universal education can be defended against elitist restrictions on the grounds that intelligence and talent are randomly distributed in the population and are not the province of any identifiable group or class—this is our improvement over the Greeks and many past and present tendencies in European societies. Perhaps excellence is rare, but a universal education program can acknowledge this and indeed maximize the net amount of talent that a society can generate. Nietzsche was a nineteenth-century German who had limited exposure to democracy—his depiction of it is almost entirely a caricature—and who probably was subject to biases about educability, since class consciousness was (and is) such a strong force in European life. Perhaps this is why he feared democracy as an inevitable leveling of culture, rather than see it as a potential force for generating *more* excellence by throwing out a wider net. Nietzsche cannot escape the charge that aristocratic elitism in practice winds up being a self-fulfilling prophecy; when the social order is structured around the assumption that certain groups or

types are inferior, then the uneven distribution of opportunities and resources produces the expected results (if one believes to any degree that environmental influences play a significant role in people's development). Where do aristocrats get their confidence that some groups or types cannot perform well, or raise the quality of their performance even if there is not much evidence yet? Where do they get their typological delineations in the first place? The answers to such questions are many: vested interests, sheer bias, fixation on irrelevant factors such as race, gender, and class, and especially the inertia of cultural conservatism. Much in democracy is radical, particularly certain background assumptions about human nature and development. One of the marks of American democracy is its experimentalism (a thoroughly Nietzschean idea), something made affordable by the relative lack of entrenched patterns and institutions in the "New World." And American experiments with universal education have *demonstrated* that talent and excellence can be found in all groups and walks of life. Categorical stratification in education and cultural achievement is now a dead idea.

One of the most effective examples to illustrate the random distribution of excellence in the context of our discussion is the phenomenon of jazz, an art form that grew out of significantly disadvantaged segments of American society, and that represents an intersection of European and African musical roots. Jazz is not only a distinguished and demanding art form, it is significantly Nietzschean in its way: the mixture of theme and improvisation echoes Nietzsche's conjunction of form and freedom, and the rhythmic innovations stemming from the more complex and corporeal African motifs introduced a "bodily" texture to music that echoes Nietzsche's movement away from formalized, symmetrical, and spiritualized structures of thought. That something so great could emerge from such relatively low socio-economic origins is testimony supporting a non-elitist program for harvesting excellence. What can remain of Nietzsche's elitism, however, is a meritocratic attention to distinguished results. We should simply entertain no assumptions about where excellence might be found

prior to performance, and we should also not expect that excellence will be or should be widespread, since the skills, efforts, and demands that attach to high achievement are either not within the reach of all or not pursued by all. In one passage Nietzsche himself seems to balance the idea of a select few with a recognition of a wider field of potential:

> In as highly developed a humanity as ours is now, everyone acquires from nature access to many talents. Everyone *possesses inborn talent*, but few possess the degree of inborn and acquired toughness, endurance, and energy actually to become a talent, that is to say to *become what he is*: which means to discharge it in works and actions. (*HAH* I,263)

Democratic institutions can attend to such a distinction and simply make available whatever resources, incentives, and forms of encouragement are needed to nurture finer performance. To this extent, democracy can attach itself to the Nietzschean insistence that politics be concerned with cultural excellence. Nietzsche repudiated liberalism for supposedly limiting its concerns to forging space for individual interests and pursuits. For Nietzsche, the very purpose of political society should be the production of higher things that have cultural import. We can agree in a way, and also suggest democratic arrangements as the appropriate vehicle for *more* cultural productivity than is possible in closed, regulated, or stratified societies.

How Far Should Democracy Extend?

Early on I suggested distinguishing the creator-herd dynamic from politics, so that Nietzsche's hierarchism might be preserved in milieus of culture-creation but blocked at the point of a political order. At the same time, we have been exploring ways in which democratic politics can operate without egalitarian assumptions, so that defending democracy against Nietzsche's criticisms can be given even more weight by incorporating some of his own predilections. The distinction between culture-creation and politics needs some attention, since the tack we are taking in analyzing democracy

suggests some problems that need to be addressed concerning the relation between culture and politics.

A main line in my argument is that a postmodern nonfoundationalism makes democracy an appropriate political arrangement; if truth is problematical or in question, then hierarchical fixtures are undermined in favor of an open, continual contest for contingent political rule. Given that postmodern suspicion is directed at all levels of thought, however, the question arises: Why limit the democratic agon to politics? Why not see it as appropriate in nonpolitical arenas like the arts, the professions, intellectual disciplines, and other cultural domains in which elitist hierarchies of some sort have seemed appropriate, but in which truth might be no less problematical than in politics? To address this issue, we can revisit an aristocratic challenge to democracy and open up some further concerns by rehearsing the question posed by aristocrats: If we are comfortable with hierarchies in certain professional or cultural areas, why not in politics? We have attempted to disarm this question by arguing that an open agonistic politics is suited to a nonfoundationalist intellectual atmosphere. Well, should we reverse the question? If we are comfortable with a democratic agon in politics, why not in all other pursuits? Why accept any elements of cultural expertise or rank, why not leave everything up to an open, inclusive contest of opinions decided by vote tallies?

Questions such as these open up other angles of thought in considering matters of truth, culture, and politics. How can we defend areas of cultural rank that presumably should not be subjected to universal suffrage? First of all, in professions such as medicine, we already tend to assume a subordinate position: We believe in a certain tangible expertise in an area we need help in; we willingly accept a kind of hierarchy because we do not give equal estimate to our own abilities. There is a quasi-democratic, meritocratic agon *within* a profession, in the means and procedures for selecting and certifying its practitioners. To the extent that we accept this local agon as authoritative for our own needs, however, we would not think that a democratic agon should extend beyond

this professional population. In addition, seeking professional help and our acceptance of professional findings are usually not coerced; we are free to challenge experts or reject their advice, especially if we think they are not measuring up to the standards of their profession. Politics, however, involves coercive effects on our lives, which makes our inclusion more appropriate. This same analysis could apply to knowledge disciplines. We tend to accept local agonistic results of disciplinary deliberations, especially in areas where more exacting truth conditions are at issue. What should be added, however, is that professional and disciplinary concerns often involve grey areas and contextual overlaps where social and political interests make subjection to broader democratic procedures and decision-making more apt (for instance, where technological developments have direct and significant effects on people's lives).

As we have seen, truth and expertise are much more problematical in politics than in certain professions and disciplines, and the coercive effects of political rule extend to all citizens; so an open, inclusive contest for temporary rule is more appropriate in politics. Issues of coercion and extent can also help us segregate a democratic agon from cultural areas where truth is even more problematical than in politics—in the arts, for example. If I am defending democratic procedures in the light of veridical openness, what is more open than art? Why not a democratic aesthetics? Even though I have attempted to challenge Nietzsche by excising egalitarian sentiments from democracy, I would want to sustain Nietzsche's creator-herd dynamic to a certain extent in culture, so that even a nonegalitarian inclusive agon would be out of bounds in cultural creativity. Although the marketplace tends to produce democratic judgments in the arts, it would seem that citizens would not have too much trouble accepting a certain Nietzschean ranking of cultural importance and status that emerges in aesthetic milieus, and Nietzsche's analysis of the agon between conformity and creativity is not something utterly foreign or disturbing to most people. Once again, matters of coercion and direct effect can distinguish a democratic political agon from more local agons in

other domains. Most people, I daresay, are not clamoring to be included in the assessment of cultural achievements, whereas they want to be included in politics, and this division might be enough to delineate spaces for both elitist and political agons in a democratic society.

Once again a contextual approach is desirable and effective in matters such as these. Politics is a particular context. Other contexts like art and creativity might be well served by a Nietzschean rhetoric of rank and difference, but politics is concerned with deciding how the general social order is to be defined and administered, which relates to, and has a direct effect upon, every citizen's interests and needs—all in the midst of globally undecidable questions, as we have suggested. My argument has been that in *this* context, a democratic agon is appropriate, and to varying degrees it might be appropriate in other contexts as well that exhibit a comparable profile.[46] Scientific research, however, is a context in which inclusive democratic decision-making would be inappropriate (although the agonistic meritocracy indicated in the process of disciplinary refereeing and deliberations allows *our* analysis to label such a process democratic in a way). So context can help us sort out appropriate avenues for democratic, quasi-democratic, and non-democratic arrangements across the cultural field.

One way to navigate a departure from Nietzsche's political elitism is to question his close association of politics and culture. Since politics, for Nietzsche, should be intimately joined with cultural projects, any indications of cultural mediocrity were automatically of political concern to him. He believed democratic inclusiveness inevitably manifests as a drag on cultural development. In this chapter I have tried to show ways in which democratic politics need not be such a drag. Moreover, to a certain extent, I am challenging Nietzsche's association of politics and culture by proposing a "separation of culture and state," if you will. Culture-creation and politics certainly overlap in many ways, but a formal separation suggested by both a procedural politics and the often removed, eccentric, and internal conditions of creativity might serve both sides well. As I have said, I have no problem with a certain

cultural rank granted to creators, but political rule is another story. Although politics can exhibit its own elements of creativity, excellence, and leadership that can borrow from Nietzsche's insights, nevertheless the particular kind of creativity and uniqueness that marks Nietzsche's higher types need have no political warrant. Nor should, I would argue, *any* particular cultural project. Creative vision about the meaning and purpose of human existence will always affect politics, but it should not *be* political in the sense of having unchecked coercive power. The openness of meaning makes fixed political power inappropriate, if not dangerous.[47]

Our challenge to Nietzsche's authoritarian politics can be located in the following two points: 1) His own nonfoundationalism makes fixed political warrants suspect. 2) "Great politics" is dangerous and also suspect on Nietzschean grounds. Culture-creation can be a social project and even connect with and influence politics—without, however, being a formal or institutional political project, something that would be inimical and injurious to cultural development as such. This is the paradox of Nietzsche's political vision, as I see it. No one is more suspicious of grandiose, global ideals than Nietzsche, but somehow he succumbed to a political version of the kind of closure and grandeur he so often disdained. Culture-creation in Nietzschean terms is ungrounded and open; but politics involves coercion, which is a sort of closure—and authoritarian politics involves more closure still.[48] That is why democracy seems so appropriate as a resolution of this paradox, since it permits culture-creation free from coercive closure, while sustaining open-ended procedures for the *contingent* closure of temporary rulings that political reality requires.

Nietzsche's Creators and Politics

Let us assume for the moment the following: that Nietzsche does recommend some sort of hierarchical political system; that the top level of this system would be occupied by Nietzsche's higher types—the creators of values, cultural artists, and so on; and that the typical operations and concerns of modern nation-state politics (for

example, the economy and everyday societal needs and services) are not of primary interest to Nietzsche, or presumably to his higher types. If we regard these assumptions as a package, what is not at all clear is how Nietzsche's political vision would cash out in practice, since it is very short on direction and details. There is a vague but persistent call for authoritarian rule. The question is: rule of *what*? The economy and daily affairs seem too mundane for cultural creators. Perhaps a rule of the herd? Herd values, however, are already in place ruling people's lives, according to Nietzsche. Perhaps a rule of higher pursuits, something like a cultural academy? There would be no connection, then, between these rulers and lower affairs that occupy most people. Would the elite simply issue reports while the rest of us look up in awe, adulation, and gratitude? If the "rule" of creators amounts to measuring cultural excellence and life affirmation, this can be allowed but separated from concrete politics. There can be a cultural meritocracy without a politically managed or entrenched hierarchy. In short: *it is not clear what Nietzsche's political aristocracy would accomplish.*

There is also the problem of how Nietzsche's political order would be established. It seems that most traditional aristocratic machinations would not work in the modern world, and their presumptions about truth and virtue would not fit a Nietzschean outlook. Perhaps the herd can simply be persuaded that the new arrangement is desirable. This is unlikely, given Nietzsche's insistence on the herd's own power interests. Force appears to be the remaining option, something that Nietzsche occasionally hints at.

> It is not enough to introduce a doctrine: one must also forcibly change people, so that they will accept it!—Zarathustra finally understood that. (*KSA* 10, p. 519)

Assuming that Nietzschean creators could summon up enough muscle to actually pull off a revolution, what would prevent history from repeating itself? Resentment would build in the wake of the new master-slave relation and lead to cultural and political transformations similar to those that overturned aristocracies of the past. We would be back at square one.[49]

Questions such as these have not been the main tack in our analysis (although they easily show the shortcomings of Nietzsche's political vision, I think). We have acknowledged that what Nietzsche calls slavish weakness is a significant problem in psychological, cultural, and political matters. We have also suggested, however, that such a problem can be recognized in a democratic society, indeed that democracy can be redescribed along the lines of such a recognition. Moreover, we have suggested that opting for the political closure of unchallenged authority should be incorporated into the catalogue of slavish infirmities diagnosed by Nietzsche. Democracy seems to emerge as the best balance of forces in matters of political and cultural life: It is predicated on avoiding closure, it can reflect a full range of human interests without systemic exclusions, and it can nonetheless affirm excellence and difference by retreating from egalitarianism and its tendency to foster mediocrity.

Even if I were wrong about the prospects for excellence in a democratic society, in which case a Nietzschean elite would seem to be necessary, and even if those elite were not actually political rulers, but simply privileged cultural leaders backed up by an authoritarian political structure, I would still question Nietzsche's opposition to democracy on behalf of creator types, and I would do so by way of Nietzsche's own reflections on creativity and self-development. Given a Nietzschean agonistics, creative types would seem to need social conditions of normalcy and constraint as an oppositional stimulant for creativity. Creative will to power would need a worthy counterforce against which it could struggle and through which it could open up its innovative alternatives. Creativity in *context* is both productive and destructive, it both affirms the new and displaces the old. The psychology of creativity is in part a reaction *against* established conditions.[50] The elements of resistance in the creative situation (both resistance *to* the establishment on the part of creators and resistance *from* the establishment) would seem to have intrinsic value for Nietzsche, and not simply instrumental value. We have already seen that Nietzsche affirms conditions of the rule and argues against the exception becoming the rule (*GS* 55,76).

Moreover, he tells us that "hatred for mediocrity is unworthy of a philosopher" (*WP* 893). The exception needs the rule as part of its own constitution.

> What *I* fight against: that the exceptional type should make war on the rule—instead of grasping that the continued existence of the rule is the precondition of the value of the exception. (*WP* 894)

Still, Nietzsche does speak of the "cruelty" of creative types in contention with the established order (*BGE* 229–230). At the same time, as we have noticed, Nietzsche insists that one's opponent should not lose strength, otherwise one's own agonistic posture would be diminished or lost (*TI* 5,3). In this sense, affirming mediocrity or the rule as the creator's Other would have to mean more than toleration, coexistence, or gratitude; conditions of normalcy would have to possess a formidable *power*. Perhaps this is why Nietzsche suggests that the exception may emerge in greater and stronger forms out of democratic frameworks (*BGE* 242).[51]

This very agonistic correlation, however, is what seems to speak against Nietzsche's aristocratic politics. If it were established politically and institutionally that now creator types are desired, expected, encouraged, and supported, would this not ruin an agonistic tension that is essential to creativity? Might it not produce ersatz creators, those who would normally be weeded out and impeded by the risks of rocking the boat? If the exception needs the resistance of an established rule not only to define itself but to catalyze itself, would the creator flourish or be motivated if honored and sustained by institutional support? How would a sanctioned cultural elite be able to follow Nietzsche's maxim to "live danger-ously" (*GS* 283)? If Nietzsche's political aristocracy is meant to foster creativity that would be lost or impeded by the predominance of herd values, we must ask, does Nietzsche's creator, the life-affirming, strong individual, need protection, as it were? Or encouragement? Or sustenance? Must not the creator be able to withstand the challenge and resistance of conformity, even to *want* it? Was this not the final test of Zarathustra's capacity to affirm existence?[52] Finally, the "victor principle" that we noted in a previous discussion, where Nietzsche declares that he only attacks

what is victorious (*EH* I,7), together with various textual references to self-overcoming that imply vigilance against complacency, self-satisfaction, and closure in one's own thinking—such Nietzschean elements would seem to argue against an aristocratic "victory" over the herd, and against the comfort of civic support.

Creativity and Normalcy

In closing this chapter, I want to turn a Nietzschean eye toward contemporary discussions of freedom and normalization. We can begin by rehearsing Nietzsche's influence on postmodern challenges to liberal conceptions of selfhood. Liberal "freedom" has been underwritten by the exercise of reason, but rational frameworks repel what is unique, and so liberalism underwrites the rule of normalization, which suppresses the *disruptive* freedom of eccentricity and creativity. We should recall, however, that Nietzsche not only opposes the liberal notion of rational freedom, he also rejects any call for a universalized or indiscriminate freedom. As we have seen, most people, according to Nietzsche, cannot handle the demands of decentered self-creation. Although we have been trying to undermine the political ramifications of Nietzsche's aristocratic delineation of creative and ordinary types, nevertheless we should consider his thinking in this regard carefully, to make sure that Nietzsche's position is not misinterpreted and subsequently to question some applications of Nietzschean rhetoric in the matter of creativity and normalization. In my view, Nietzsche's texts would call for caution in the face of certain hyper-creative conceptions of selfhood that have currency today.

We recall that Nietzsche does not recommend freedom for everyone. The value of self-interest, for example, is to be measured according to the person who has it (*TI* 9,33). Without "spiritual greatness, independence ought not to be allowed, it causes mischief" (*WP* 984). Normalization for the masses, then, would not be regretted by Nietzsche. Nietzschean freedom is a freedom *for* creative work and not simply an unbridled satisfaction of desires (*Z* I,17). Furthermore, the freedom of the creator type cannot be

considered a complete departure from structure and constraint. Creativity, for Nietzsche, breaks the bounds of existing structures, but only to fashion new ones, so innovation can never be separated from constraints; it is a kind of "dancing in chains" (*WS* 140). Creativity is a complex relationship of freedom and form; certain "fetters" (*Fesseln*) are needed both to prepare cultural departures from purely natural states (*HAH* I,221) and to give a comprehensible shape to new cultural forms (*WS* 140).[53] Creative freedom, then, is not a sheer denial of normalization or an abandonment of constraint; it is a disruption of structure that nevertheless needs structure to both prepare and consummate departures from the norm.

Nietzsche could not seem to resist a politico-cultural stratification based upon a typology of creators and ordinary human beings. In challenging this stratification, we can nonetheless draw on Nietzsche's thinking to sort out complex questions of social psychology. We can detypify creativity and normalcy and ask how Nietzsche's insights can apply to any and all human experience. As this chapter has suggested, Nietzsche's problem was an underdetermination of excellence and freedom; all sorts of people can take up a Nietzschean script when it comes to the pursuit of an excellence or self-expression in the midst of resistance. Although the range of creativity is thereby widened significantly, we can still follow Nietzsche by entertaining a ranking of performances and a certain stratification of different types of performance (without a stratification of persons). At the same time, we can avoid the overdetermination of creativity and freedom by heeding Nietzsche's affirmation of both the exception and the rule. Every human being can be understood as a combination of socialization and individuation. Creativity would involve the degree to which individuation modifies, disrupts, or alters socialization patterns. Although the danger of socialization is its normalizing power that can suppress creativity, nevertheless some sense of order and convention is necessary for social life, as well as for channeling (and catalyzing) creative departures from the norm. In the spirit of detypification, we can translate Nietzsche's dictum that freedom is not for everyone

into the notion that freedom is not appropriate for every human performance or stage of development. The rule of normalization should not be seen as a constant enemy of self-determination, but rather as a problematical participant in self-determination.

Although writers such as Foucault have done much to survey the links between normalization and domination in modern life, nevertheless we should be careful not to valorize heterogeneity to the point where any attempt to judge, restrict, or regulate human performance is deemed an unwarranted regime of control.[54] The normalization of sexuality, for example, is surely a problem when nonheterosexual sex is considered deviant or when erotic expression and experimentation are suppressed. At the same time, an aestheticization of sex that celebrates sexual liberation as a form of self-creation or that is suspicious of entertaining any ethical questions in matters of sexuality should be no less problematic. Perhaps erotic excess and experimentation exemplify a Nietzschean adventure of self-discovery that shatters and creates selves by breaking social boundaries and exploring new vistas. I see very little in Nietzsche's texts, however, that would lend credence to such an association; how much stock Nietzsche would put in such "creativity" is not clear. Sexual "liberation" may be nothing more than the overestimation of sensual gratification.[55] Moreover, I do not think that pedophilia, for example, is a defensible sexual practice; nor do I think that recommending "abstinence" to thirteen-year-olds is a constriction of their personal development.

The issue of madness is another important topic in current research. Surely the "politics" of diagnosis and therapy is a crucial question that demands all the attention it is getting. Normalization has the effect of marginalizing or "reforming" eccentric and creative departures from ordinary behavior that have every right to flourish and be left alone; and certain psychological "dysfunctions" that supposedly need treatment are in fact produced by social resistances to unusual behavior styles. There are times, however, when a paternalistic intervention is justified or when restorative therapies are appropriate in the face of severe disintegration. Not all psychological troubles can be traced to cultural regimes of control. It

would be wrong to see in every form of "madness" a site of freedom from, or resistance to, homogeneity.[56]

The most important area where questions of normalization and freedom are in play is pedagogy. American education methods since the 1960s have been significantly influenced by theories that have departed from regimentation and standardization. Old techniques of rote memorization, rule-governed instruction, and formulaic models have been replaced by attention to self-expression, affective comfort, looser standards, and multiple learning styles—not always to the benefit of education, in my opinion. Although the reasons for the well-known decline in academic achievement are complex, there is room to blame the blind adherence to an emancipatory rhetoric in a context that requires some degree of normalization and discipline, at least in early stages of development (reading, writing, and speaking skills are especially at issue here). If we could learn from Nietzsche's insistence that freedom and constraint are inseparable in creativity, such a charge would not sound so reactionary. We should remember that, for Nietzsche, a normalized environment in fact *stimulates* creative transgression. In the end, then, we should resist the apotheosis of creativity just as much as the sanctification of control. Social life is a complex and ambiguous concurrence of freedom and order that cannot come to rest on either side.

6

Perspectivism, Truth, and Politics

In chapter 3 we advanced the idea that democracy is well suited to a Nietzschean perspectivism. In this chapter we will take up Nietzsche's perspectival pluralism in more detail and address questions pertaining to truth in the face of his nonfoundationalist philosophy. Then we will develop further the application of perspectivism to democratic politics.

Perspectivism and Truth in Nietzsche

As we have seen, Nietzsche challenges the notion of an absolute, uniform, stable truth and substitutes a dynamic perspectivism. There is no free-standing truth or purely objective, disinterested knowledge, only the perspectives of different and differing instances of will to power.

> Henceforth, my dear philosophers, let us be on guard against the dangerous old conceptual fiction that posited a "pure, will-less, painless, timeless knowing subject"; let us guard against the snares of such contradictory concepts as "pure reason," "absolute spirituality," "knowledge in itself": these always demand that we should think of an eye that is completely unthinkable, an eye turned in no particular

direction, in which the active and interpretive forces, through which alone seeing becomes seeing *something*, are supposed to be lacking; these always demand of an eye an absurdity and a nonsense. There is *only* a perspective seeing, *only* a perspective "knowing" (*Erkennen*). (*GM* III,12)[1]

Accordingly, motifs of knowledge and truth are better rendered in terms of an open field of interpretations.

> *Our new "infinite."*—How far the perspective character of existence extends or indeed whether existence has any other character than this; whether existence without interpretation, without "sense," does not become "nonsense"; whether, on the other hand, all existence is not essentially actively engaged in *interpretation*—that cannot be decided even by the most industrious and most scrupulously conscientious analysis and self-examination of the intellect; for in the course of this analysis the human intellect cannot avoid seeing itself in its own perspectives, and *only* in these. We cannot look around our own corner. . . . But I should think that today we are at least far from the ridiculous immodesty that would be involved in decreeing from our corner that perspectives are permitted only from this corner. Rather has the world become "infinite" for us all over again, inasmuch as we cannot reject the possibility that *it may contain infinite interpretations*. (*GS* 374)

Nietzsche has often been taken as denying any sense of truth or as advancing a kind of relativistic phenomenalism. There is much ambiguity on the question of truth in Nietzsche's texts (and some shifting in the different periods), but I think it is plausible to say that he accepts and employs motifs of truth, as long as truth has been purged of metaphysical foundationalism and limited to a more modest, pluralized, and contingent perspectivism. Even if knowledge, for Nietzsche, is variable, historical, and born out of human interests, this does not make it false, arbitrary, or uncritical.[2] For one thing, Nietzsche's frequent judgments of so-called life-denying perspectives in favor of life-affirming perspectives would seem to rule out a crude relativism and suggest something like a "life realism." Moreover, there are tantalizing passages where Nietzsche hints at a kind of pluralized "objectivity," wherein the more perspectives one can take up, the more adequate one's view of the world will be.

[T]he *more* affects we allow to speak about one thing, the *more* eyes, different eyes, we can use to observe one thing, the more complete will our "concept" of this thing, our "objectivity," be. (*GM* III,12)

It may be necessary for the education of a genuine philosopher that he himself has also once stood on all these steps on which his servants, the scientific laborers of philosophy, remain standing—*have to* remain standing. Perhaps he himself must have been critic and skeptic and dogmatist and historian and also poet and collector and traveler and solver of riddles and moralist and seer and "free spirit" and almost everything in order to pass through the whole range of human values and value feelings and to be *able* to see with many different eyes and consciences, from a height and into every distance, from the depths into every height, from a nook into every expanse. (*BGE* 211)

I will try to sort out the various and seemingly conflicting references to truth in Nietzsche's texts by way of the following distinctions: 1) a global, negative truth that Nietzsche affirms; 2) a positive, foundational model of truth that Nietzsche denies; and 3) a modified sense of perspectival truths that strikes a balance between the first two conditions.

1) Throughout the different periods, Nietzsche affirms a dark, tragic truth of becoming, in the sense that conditions of becoming must be accepted as a baseline notion that renders all forms and structures contingent and groundless.[3] In this way we can understand various references in the texts to a difficult truth that must be appropriated to counter our myopic fixation on life-promoting structures of thought.

A thinker is now that being in whom the impulse for truth and those life-preserving errors clash for their first fight, after the impulse for truth has proved to be also a life-preserving power. Compared to the significance of this fight, everything else is a matter of indifference: the ultimate question about the conditions of life has been posed here, and we confront the first attempt to answer this question by experiment. To what extent can truth endure incorporation? That is the question; that is the experiment. (*GS* 110)

Something might be true while being harmful and dangerous in the highest degree. Indeed, it might be a basic characteristic of existence that those who would know it completely would perish, in which case the strength of a spirit should be measured according to how much of

> the "truth" one could still barely endure—or to put it more clearly, to what degree one would *require* it to be thinned down, shrouded, sweetened, blunted, falsified. (*BGE* 39)[4]

Nietzsche is pursuing a negative truth that so far has been forbidden (*EH* P,3); indeed, faith in traditional belief systems has meant "not *wanting* to know what is true" (*A* 52).

2) Because of Nietzsche's commitment to the truth of becoming, positive doctrines of truth that presuppose foundational conditions of "being" are denied, indeed they are often designated as "appearances" or "errors."

> What then is truth? A movable host of metaphors, metonymies, and anthropomorphisms: in short, a sum of human relations which have been poetically and rhetorically intensified, transferred, and embellished, and which, after long usage, seem to a people to be fixed, canonical, and obligatory. Truths are illusions we have forgotten are illusions. (*OTL* p. 84)

> The world with which we are concerned is false, i.e., is not a fact but a fable and approximation on the basis of a meager sum of observations; it is "in flux," as something in a state of becoming, as a falsehood always changing but never getting near the truth: for—there is no "truth." (*WP* 616)

> Becoming is not a merely *apparent state*; perhaps the world of beings is mere appearance. (*WP* 708)

Our knowledge structures are based upon a filtering process that screens out strange and unusual elements that disturb our sense of stability (*GS* 355). Although such structures are life-enhancing, they must still own up to their dependence on falsification and error (*BGE* 24).

3) Even though the truth of becoming gives Nietzsche some ammunition for designating traditional truth conditions as appearances and errors, he notices a trap that befalls us in trafficking with the binary oppositions of reality and appearance, truth and error. Falsification is simply the flip-side of verification. If traditional truth conditions are renounced, then "errors" lose their measure and hence their deficiency.

The true world—we have abolished. What world has remained? The apparent (*scheinbare*) one perhaps? But no! *With the true world we have also abolished the apparent one.* (*TI* 4,6)

There are a number of ways to supplant the negative connotations of "appearance" that have been set up by traditional measures of "reality." We can notice, for example, a positive connotation of appearance—as in "the actor appears on stage"—which indicates a temporal condition of "appearing" that is anything but deficient, and that could easily fit Nietzsche's scheme of things.[5] In any case, we do not have to restrict ourselves to a choice between the sheer flux of becoming and the sheer stability of being when it comes to truth. In various ways, Nietzsche provides avenues for discerning a modified, contingent, and pluralized array of *truths* that are neither completely unhinged nor fixed in uniformity and closure.

There are many kinds of eyes. Even the sphinx has eyes—and consequently there are many kinds of "truths," and consequently there is no truth. (*WP* 540)

There are several motifs in Nietzsche's texts that can indicate a nonfoundational, pluralistic sense of truth that is disclosive of the world and yet open and nonreductive: a) *Art.* As we have seen, art becomes a primal metaphor for Nietzsche, since it is a presentation of meaning without the pretense of a fixed truth. In this respect, art is more "truthful" than traditional belief systems (*OTL* pp. 96–97). Moreover, the meanings disclosed by art are what give human existence its bearings in the midst of the tragic truth of becoming: "We possess *art* lest we *perish of the truth*" (*WP* 822).[6] Art provides an effective setting wherein we can overcome a naive realism in philosophy and come to understand the *creative* dimension in thought (*GS* 58). In fact, truth can then be redescribed as an openended *process* of creative formings that can never itself become fixed or closed (*WP* 552). b) *Perspectival interpretation.* As we know, Nietzsche insists that the world cannot be reduced to a stable or uniform measure; there are only interpretations from different perspectives. We need not banish the terms knowledge and truth, however, as long as they do not connote the reductive mistakes of the tradition.

In so far as the word "knowledge" has any meaning, the world is knowable; but it is *interpretable* otherwise, it has no meaning behind it, but countless meanings.—"Perspectivism." (*WP* 481)

Are these coming philosophers new friends of "truth"? That is probable enough, for all philosophers have so far loved their truths. But they will certainly not be dogmatists. It must offend their pride, also their taste, if their truth is supposed to be a truth for everyman. (*BGE* 43)

Nietzsche's opposition to hardened "convictions" is also associated with an interest in truth; indeed, "convictions are more dangerous enemies of truth than lies" (*HAH* I,483). c) *Experimentalism.* Nietzsche connects an experimental attitude with truthfulness (*GS* 51) and he calls his new philosophers *Versucher*, "attempters" (*BGE* 42). Nietzsche is not in favor of unbridled thought or an abandonment of intellectual discipline, but rather continual self-assessment.

[W]e others who thirst after reason are determined to scrutinize our experiences as severely as a scientific experiment—hour after hour, day after day. We ourselves wish to be our experiments and guinea pigs (*Versuchs-Thiere*). (*GS* 319)

d) *Criticism.* Along the lines of experimentalism, Nietzsche does not disdain critical reason, only a reductive rationalism. Even with the inevitable ambiguities and uncertainties of a finite existence, Nietzsche has no favor for those who lead an uncritical life, who do not continually question and give reasons for their beliefs (*GS* 2). Good arguments and good reasons are not ignored or devalued (*GS* 191,209).[7]

In sum, then, Nietzsche's so-called repudiation of truth is best restricted to traditional models of truth and knowledge, since there are several senses in which the word "truth" can function "in between" sheer becoming and sheer being—as long as contingency, contextuality, and agonistics continually check the tendency to elevate our disclosures to an unimpeachable status.[8]

Even with this proposal of a modified, perspectival, nonfoundationalist sense of truth in Nietzsche, we should confront the nagging problem of self-reference that attaches to such gestures and that would affect everything from Nietzsche's judgments of life-denying perspectives to the very assertion of perspectivism itself. If Nietz-

sche is right about an ungrounded, perspectival field of thought, why should we put any stock in his many critical judgments? Why should we accept his perspectivism? His judgments and his perspectivism would themselves only amount to a certain perspective. Has not Nietzsche committed a performative contradiction (as Habermas would put it) in advancing his ideas while at the same time denying a foundation for ideas? Is not some decisive sense of truth and validity needed to make any philosophical advance, even a nonfoundationalist one?[9]

I want to engage this problem by arguing that Nietzsche's various judgments and his perspectivism can be sustained without succumbing to the charge of self-referential inconsistency. I will begin by citing a passage in which Nietzsche seems to *affirm* the fact that a perspectival approach could be thrown back at itself and be subject to self-referential limitation. After challenging the scientific picture of a law-governed world with the counter-interpretation of an unregulated field of will to power, Nietzsche closes with this remark:

> Supposing that this also is only interpretation—and you will be eager enough to make this objection?—well, all the better. (*BGE* 22)

Notice that Nietzsche is saying something quite dramatic here. Far from saying "Oops, you caught me in a contradiction," or "You are right, I will have to work that out," or "That cannot be helped," or even "So what?"—Nietzsche says "all the better" (*um so besser*). In other words, it is *better* that his stance only be an interpretation, that it be self-referentially limited; it would be *worse* otherwise. The philosophical problem of self-reference that has been directed at Nietzsche's texts seems to be completely dissolved by such a remark, which refuses to see self-reference *as* a problem by expressing a preference for its conditions. Let me attempt to work from this remark and sort out the various dimensions of Nietzsche's thought that would have to be addressed in accordance with this unusual response to self-reference. I build my discussion around the following questions: How and why does Nietzsche regard both his own judgments of "weak" perspectives and his general proposal of

perspectivism as themselves only perspectives? And why would he prefer that this be the case?

Nietzsche is willing to offer judgments against weak, life-denying perspectives and in favor of strong, life-affirming perspectives. Nevertheless, Nietzsche also indicates that overall evaluations of life cannot be given any veridical status, since they stem from perspectival interests.

> Judgments, judgments of value, concerning life, for it or against it, can, in the end, never be true: they have value only as symptoms, they are worthy of consideration only as symptoms; in themselves such judgments are stupidities. One must by all means stretch out one's fingers and make the attempt to grasp this amazing finesse, *that the value of life cannot be estimated.* (*TI* 2,2)[10]

Evaluations of life, then, are local estimations that serve the interests of a certain perspective but that cannot stand as a global measure to cancel out other estimations. This would not be inconsistent with Nietzsche's texts; although he vigorously opposes what he calls the perspectives of the weak, nevertheless these perspectives have their authenticity, according to Nietzsche.[11] Life-denying perspectives serve the interests of certain types of life, who have been able to cultivate their own forms of power that have had an enormous effect upon the world.

In order to make headway here, we have to distinguish between life-*affirmation* and life-*enhancement*. According to Nietzsche, even life-denying perspectives are life-enhancing, since they further the interests of weak forms of life. Different forms of life are continually affirming their own perspective *on* life; their cultural productions, even if animated by otherworldly projections, express their local affirmative posture. Even philosophical pessimism is affirmative in this sense. Schopenhauer's elaborate philosophical output on behalf of pessimism was in effect an affirmation of a pessimistic life, in part as a vigorous—and stimulating—condemnation of optimism.[12] Short of the practical nihilism of suicide, all forms of human life seek to will their meaning, even if that meaning is a conviction about the meaninglessness of life. As Nietzsche says, "man would rather will *nothingness* than *not* will" (*GM* III,28).

Nietzsche *does* have a "global" philosophical position, namely *perspectivism*, in the sense that the life-world is a field of perspectives, each willing their own life interests; as perspectives in a field of becoming, however, none can pose as the "truth." Nothing here would forbid Nietzsche from making judgments about perspectives that *he* thinks are deficient estimations of life.

> Morality is merely an interpretation of certain phenomena—more precisely, a *mis*interpretation (*Missdeutung*). Moral judgments, like religious ones, belong to a stage of ignorance at which the very concept of the real and the distinction between what is real and imaginary, are still lacking. (*TI* 7,1)

Since, as we have seen, overall estimations of life can have no veridical status, Nietzsche's critique cannot amount to a project of refutation or erasure, but rather a "plea by an interested party."[13] The promotion of life-affirmation over life-denial should be taken as *Nietzsche's* perspective, as a battle that he is willing to wage, as a commitment that involves an existential decision rather than a search for justification. In this way other perspectives can have their place, in their service to the interests of different types of life.

> "This is *my* way; where is yours?"—thus I answered those who asked me "the way." For *the* way—that does not exist. (Z III,11)

To repeat, Nietzsche's global philosophical offering—not to be confused with a metaphysical framework—is a vitalistic, agonistic perspectivism. The world is a field of becoming in which different perspectives assert themselves and contend with each other—all as a function of life-enhancement, the furtherance of different perspectives on life. This is a philosophical position for which Nietzsche is ready and willing to contend. We could call it a kind of inductive proposal as opposed to an a priori assumption. Given the evident conditions of becoming and historical change, given the evident differences in forms of life, given the absence of an accomplished consensus about truth and meaning (at least so far), and given Nietzsche's diagnosis of the psychological deficiencies that might be behind an interest in uniformity, stability, and universality—given all this, his perspectivism comes across as a plausible,

even compelling philosophical offering, to which we are simply called upon to *respond.*

Nietzsche's *own* perspective in this global field is the *affirmation* of the perspectival *whole,* of all the finite conditions of life without exception—the "necessity" of all life conditions that is dramatically portrayed in the notion of eternal recurrence. Here Nietzsche opposes himself to other perspectives that cannot affirm the agonistic whole, that seek conditions of being, order, and stability as a resolution of existential finitude. These perspectives cannot affirm the necessity of their Other, which is the "weakness" counterposed to a Nietzschean "strength." Nietzsche's global perspectivism, however, acknowledges that these perspectives are at least affirming their own life interests. What they cannot affirm is the agonistic whole—and this becomes Nietzsche's particular battle to wage in the perspectival field. What is unusual in all of this is that Nietzsche will grant that both his global perspectivism and his affirmation of the agonistic whole are themselves perspectives, that neither view can claim any warrant beyond their presentation as a philosophical offering by Friedrich Nietzsche.[14]

The "consistency" of Nietzsche's position with respect to the self-reference problem can be uncovered by some further attention to Nietzsche's insistence that philosophy can be nothing more than agonistic praxis. The pragmatic angle helps us see how Nietzsche's perspectivism can be advanced consistently. Nietzsche will take a stand for his global perspectivism and his affirmation perspective without, however, seeking to invalidate or erase contrasting views. Even perspectivism needs its opponent, even perspectivism must be willed and committed to in the context of opposition. As we have seen, Nietzsche maintains that any viewpoint is constituted by its Other, so the erasure of its Other would be the erasure of itself. That is why it is "better" that perspectivism be a perspective in the midst of other perspectives (in this case, anti-perspectival perspectives). The self-reference criticisms, therefore, assume something that Nietzsche does not accept, namely that a global position presents itself as a "panoptical" scan of the knowledge field, measuring the entire territory and correcting all the different regions by way of its

overarching vision—and if its own content can be placed in its scan and be subject to a similar correction, we have the dilemma of self-reference. Nietzsche, however, denies the very possibility of a panoptical scan (whether it be called something nonperspectival or metaperspectival), and so the problem of self-reference dissolves. Nietzsche proposes a model of thought that can never surpass the *immanent* engagement of perspectival agonistics, wherein we simply must take up our positions in context and in contest with others, never to attain panoptical heights. It seems that self-reference critiques of Nietzsche assume that philosophy cannot be perspectival, that global statements are meant to be panoptical. Nietzsche simply disagrees and offers his philosophical gambit for response.[15]

In sum, then, Nietzsche's inclusive, global perspectivism together with the inter-perspectival correlation suggested by agonistic praxis allows him the following: 1) an end-run around the self-reference problem, 2) an inclusion of all perspectives, and 3) a commitment to his own perspective in opposition to others. In this way Nietzsche can offer judgments of better and worse beliefs without a project of refutation or erasure. Again, Nietzsche's global position declares that all perspectives serve particular life interests in contest with other perspectives, a kind of "agonistic vitalism." Nietzsche's own perspective is an affirmation of this agonistic whole. Life-affirmation is a Nietzschean commitment that measures beliefs according to their capacity to affirm or not flee from the finite conditions of earthly existence. Life-enhancement, on the other hand, as indicated in Nietzsche's global position, is the alternative to sheer nihilism; *any* perspective achieves life-enhancement by way of its particular creation of meaning. Christianity, for example, violates life-affirmation but not life-enhancement, since it enhances the lives of those types who need it.[16] This would help explain why Nietzsche is so vigorously opposed to perspectives he considers life-denying while not seeking to deny these perspectives. Nietzsche can *challenge* beliefs on the grounds of life-affirmation but *include* them on the grounds of life-enhancement. To conclude, Nietzsche cannot seek the intellectual exclusion of life-denying perspectives for three

reasons: 1) his global perspectivism does not permit such a dismissal; 2) these perspectives are needed to enhance certain forms of life and to avoid practical nihilism; 3) these perspectives are agonistically correlated with Nietzsche's own perspective of life-affirmation, so he himself cannot do without them. Nietzsche's orientation here is evidently much more complex and ambiguous than typical strategies of intellectual adjudication.

As we have seen, Nietzsche *affirms* opposition to his thinking (*TI* 5,3). One's position must be *willed* in the context of opposition. In this sense perspectivism itself must be a perspective in the midst of anti-perspectival views. A "defense" of perspectivism is still possible, however, in the locality of agonistic praxis. Say that I am a perspectivist and you are not: Let's talk to each other and open our views to scrutiny. We will both get a hearing, and some might embrace my view and some might not. We may both find each other's position ultimately unacceptable. I can live with this unresolved condition (as a perspectivist must), perhaps you cannot. Fine, we will part, hopefully as friends, perhaps even laughing, as did Zarathustra and the saint (*Z* P,2). Leaving things in an agonistic condition *without* resolution is in fact a phenomenology of intellectual *practice*, as opposed to the myth of "completion" that has heretofore governed the analysis of such practice. Christianity, for example, in historical *context* emerged as a contest with other existing forces, a contest that defined its contours. This struggle also forced it to adopt certain versions of the aggressive "vices" it was supposedly aiming to oppose—here is a classic Nietzschean motif, that the promotion of neighbor-love, for example, was unable to avoid new forms of "cruelty." Such an analysis gives Nietzsche some muscle in judging the "inconsistency" of life-denying or flux-transcending models of "being." Since they *arose* in an oppositional context, promoting a transcendence of agonistic becoming amounts to promoting their own disintegration.

Philosophers tend to want warrants for their thinking; even philosophers who deny warrants can turn their refusal into a warrant (calling metaphysics, for example, a dispensable "error"). The alternative to warranting gestures of all sorts is to simply

contend for one's view in the midst of one's Other, which is both phenomenologically accurate and expressive of the existential meaningfulness that one's perspective will have in not being "commanded" by external measures of "truth." Our intellectual commitments as such are incommensurable with cognitive commands.[17] Perspectival pluralism means that everything is perpetually in question, even perspectivism. This does not imply that we should surrender to quietism or radical skepticism, but simply that we should be willing to *contend* for our commitments in the midst of differing perspectives. In this respect we need to cultivate the "negative capability" that can dwell with uncertainty and contention, without surrendering to the negative *in*capability that characterizes dogmatism. The issue here is not simply a renunciation of metaphysical foundationalism, but also attention to the psychology of negative incapability that generates metaphysical thinking, indeed that generates dogmatic attitudes even in anti-metaphysical thinking—when a measure of sheer openness banishes metaphysics or any approximation of closure. Any tendencies in postmodern discourse that seek an exclusion of traditional struc-tures, or that view such structures as deviant, or that display a hyper-confidence in "negative" gestures are in fact *perpetuating* the psychology of binary thinking that generated metaphysical closure in the first place.[18]

Nietzsche's perspectival pluralism demands more than simply acknowledging or tolerating the Other, or even affirming the necessity of the Other for those who espouse it or need it. The agonistics of perspectivism shows that my Other has legitimacy not only for others but for *me* as well. Even a perspectivist *needs* antiperspectivism, otherwise the dynamics of will to power will disintegrate. I must *want* to be "only" a perspective, I must *want* my Other, I must *will* it. This is the deepest meaning of eternal recur-rence, for Nietzsche. To will the repetition of events is the fullest expression of my capacity to affirm the finite conditions of existence—but not in the abstract, since the true test only comes when I am confronted with willing the repetition of my Other. As we have seen, however, willing eternal recurrence does not imply

resignation, or an "approval" of everything, or an enjoyment of all life conditions. My Other will be eternally *opposed*, I affirm it *as* an opponent in a global agonistic environment.[19] Nietzsche's life-affirmation is different from the life-enhancement that each perspective affords its proponents; Nietzschean affirmation asks me to affirm the entire finite field of play, the agonistic interplay of *all* perspectives—while still committing to my own perspective.

Truth as Contextual, Agonistic Pluralism

If we deny the existence of an absolute, purely objective, uniform truth, this need not call up any baseline skepticism or crude relativism—both of which can be seen as unwittingly banking on absolute truth as an absent measure. We renounce any version of truth that seeks to erase or suppress otherness, but we can still advance judgments about better and worse claims, as long as we embrace a contextual, rather than a panoptical, orientation. We can readily privilege certain discourses in certain contexts—technicity over poetics in bridgebuilding, for example; no poets at the construction site, please! And within discourses, we can find local and contingent measures for discussing better and worse perfor-mances—sturdier bridges and finer poems—without, however, any pretense of closure or global measures. Contextuality can also help us negotiate the legitimate reach of "objectivity." In certain contexts, an insistence that "subjective" elements like emotions or personal interests be screened out in favor of "the facts" is quite appropri-ate—in scientific findings and judicial proceedings, for example. This does not mean, however, that there is a panoptical "objectivity" that can adjudicate all claims or purge any discourse of "nonobjec-tive" elements. An understanding of science, as contemporary writers have shown, must include historical, sociological, norma-tive, and even aesthetic elements.[20] So objectivity itself is a perspec-tive that can have its place, as long as it does not presume to replace or displace other perspectives.[21]

Perspectivism in this sense can help address perennial philo-sophical problems much more effectively. The mind-body question,

for example, might be resolvable by way of a contextual, pragmatic pluralism. Just as the science of acoustics and the aesthetics of music easily coexist in the context of musical technology and performance conditions, without by any means calling on us to find a common language or to wonder whether "music" is a separate reality from "sound waves," so too context can help us decide that there is an *irreducible* coexistence of mentalistic and physicalistic perspectives in the human condition. Introspection and empirical investigation are different "takes" on experience that call for incommensurable, but contextually appropriate, discourses. If I need a brain operation, I want my physician to be thoroughly immersed in the physiological perspective when it comes to diagnosis and surgery; no pausing to probe into the "soul," please! On the other hand, discussing the import of this operation for me— my fears and expectations—will elicit a completely different discourse of experiential meanings, in which any talk of "brain events" would not arise; it would be strange if my physician were to refer to my fears as particular neural firings. These different perspectives are not, however, *isolated* from each other in the context of medicine. One would hope that concern for a patient's existential fate is essential to a physician's life, and we know that physical health and recovery are not unrelated to a patient's "state of mind." Different perspectives are variously correlated in a fluctuating field of shifting and interpenetrating elements that we all recognize, affirm, and enact in *practical* contexts.[22] This ongoing process with which we *live* is what should guide philosophical reflections, and it renders something like Nietzsche's perspectivism more telling and cogent, as an accurate model for the "orchestral" balancing of the different instruments, tones, lines, and styles that make up the movements of a life.[23]

Throughout his texts, Nietzsche gives attention to the positive contributions that various perspectives have given to human culture—including, as we have seen, perspectives that Nietzsche vigorously challenges (e.g., slave values and bad conscience). One finds support for perspectives such as a hardnosed physics (*BGE* 14), a contemplative reflection (*GS* 301), and even a religion of sin

and eternal punishment (*GS* 78). To a certain extent, life-denying outlooks contribute to Nietzsche's philosophical ideals, since habits of denial and departure from accustomed perspectives constitute the discipline needed to prepare the intellect for its future "objectivity," which, as was indicated earlier, Nietzsche takes to mean a gathering of as many perspectives as possible, that is to say, as

> the ability *to control* one's Pro and Con and to alternately display and retract them (*sein Für und Wider in der Gewalt zu habèn und aus- und einzuhängen*), so that one knows how to employ a *variety* of perspectives and affective interpretations in the service of knowledge. (*GM* III,12)

Nietzsche's new philosophers will exhibit both creativity and an adequate knowledge of the world, according to the extent to which they can be polyperspectival, that is to say, take up the various vantage points that human culture affords and has afforded in the past—from skeptic to dogmatist to historian to poet to moralist to free spirit, indeed "almost everything" (*BGE* 211). Even asceticism and puritanism will be useful in the development of mastery over common human attachments (*BGE* 61). Accordingly, familiar assumptions about the "constancy" of a philosophical outlook must be challenged.

> We usually endeavor to acquire a *single* department of feeling, a *single* attitude of mind towards all events and situations in life—that above all is what is called being philosophically minded. But for the enrichment of knowledge it may be of more value not to reduce oneself to uniformity in this way, but to listen instead to the gentle voice of each of life's different situations; these will suggest the attitude of mind appropriate to them. Through thus ceasing to treat oneself as a *single* rigid and unchanging individuum one takes an intelligent interest in the life and being of many others. (*HAH* I,618)

What makes Nietzsche's perspectival pluralism different from other proposals that affirm a variety of "truths" is that Nietzsche insists on an *agonistic* pluralism—neither an atomistic aggregate of unrelated perspectives, nor a potential harmony of interrelated perspectives, but rather a plurality that is constituted by conflict, both between and within perspectives. Perspectivism in this sense must embrace paralogy over univocity, heterogeneity over homoge-

neity, and dissensus over consensus, conditions that continually subvert the hope that thought can be governed by some unifying metanarrative.[24] This does not mean that truth is lost, only that truth will have to be converted from traditional criteria so as to include conditions of conflict and their various movements, conditions that are no less real or disclosive if we attend to the agonistic field of pragmatic engagement. Agonistic pluralism not only supplies analytical guidance for addressing competing differences within particular perspectives such as art, ethics, religion, and even science; it also opens up the paralogical differences *between* perspectives, especially in the matter of those existential ruptures that befall us when we have to traverse incommensurable orientations, whose discourses tend to repel each other in certain ways.[25] Significant examples are found in situations that move between the scientific perspective and the ethical perspective. Although "facts" and "values" are inseparable in various circumstances we confront—we have to incorporate both in any reflections about how to engage each other and circumstances in the world— nevertheless the *movements* between empirical and normative considerations encounter certain "breaks," both conceptual and existential, wherein we lack an overarching measure that can coordinate the "is" and the "ought," since what is operative in one is absent in the other. Still, we have to make decisions in the midst of these disparities.[26] The same dynamic of disparity can be found in movements between the empirical and the religious, the instrumental and the aesthetic, the customary and the novel—the list can go on.[27] We do not simply inhabit various perspectives; engaging different perspectives in life situations involves elements of dissensus and dissonance, since what is evident in one perspective can be absent, even deliberately suppressed, in another perspective. And yet we must continually dwell with this oscillating dynamic in circumstances that interlace different perspectives. This makes human thought and action not only multifarious, divergent, and finite, but also unsuited to any overarching sense of harmony and coalescence. As Nietzsche suggests, however, nothing here would taint our sense of truth if we could see how "accurately" this agonistic model fits the actual course of cultural practice.[28]

Perspectival truth, then, is perpetually limited and limiting in the following ways: 1) It is *plural*, in that no one perspective can stand as the measure for thought. 2) It is *finite*, in that perspectives cannot speak for each other or exhaust their own domains. 3) It is *agonistic*, in that conflicting tensions animate the conditions of thought, both within and between perspectives. 4) It is *contextual*, in that different perspectives are variously appropriate in different situations and settings. 5) It is *dynamic*, in that context is continually shifting, so that no one perspective can serve as a perpetual lens or panoptical vantage point. 6) It is *complex*, in that most settings call for a multiplicity of perspectives and a certain overlapping and inter-penetration of perspectives. To whatever extent these conditions are an appropriate reflection of how the world is engaged, we can talk of truth that is plural, finite, agonistic, contextual, dynamic, and complex—but truth that is accordingly always in question and not hospitable to closure.

Perspectivism and Democracy

As we have indicated, democracy is intrinsically perspectival, or it should be seen this way. The kind of perspectivism championed by Nietzsche would seem to be, from a political standpoint, best exemplified and least ignored in a democratic society. Perspectivism implies the illegitimacy of any one perspective holding sway and erasing or suppressing other perspectives. Even Nietzsche's ardent advocacy of his own perspective regarding higher types and such—which he admits is itself only a perspective among others and not "the truth"—would not lend support to his apparent confidence in an aristocratic order and authoritarian rule. Nietzschean "height" is itself only a perspective that would find no warrant for establish-ing itself as an uncontestable measure of political life. Democracy would seem to be the political equivalent of what Nietzsche calls the conditions of "grand cultural architecture," wherein a concord between competing powers is accomplished by way of a "massive assemblage" (*übermächtigen Ansammelung*) of the contending parties, without suppressing (*unterdrücken*) any of them (*HAH*

I,276). Democracy understood as an agonistic pluralism seems to be the only political safeguard against a particular site becoming totalized. The affirmation of differing perspectives in the political field amounts to a continual assertion of multiple power sites that consequently limit each other's power by way of this ongoing confrontation.

In this regard, we should notice an interesting element of agonistics operating in the construction of the American Constitution. Madison argued that the division and separation of powers in government (an idea developed by Montesquieu) provides an internal structure that will prevent tyranny by simply *multiplying* the number of tyrannical units and permitting them to check each other by mutual self-assertion and distrust.

> But the great security against a gradual concentration of the several powers in the same department, consists in giving to those who administer each department, the necessary constitutional means, and personal motives, to resist encroachments of the others. The provision for defence must in this, as in all other cases, be made commensurate to the danger of attack. Ambition must be made to counteract ambition. The interest of the man must be connected with the constitutional rights of the place. It may be a reflection on human nature, that such devices should be necessary to controul the abuses of government. But what is government itself but the greatest of all reflections on human nature? If men were angels, no government would be necessary. If angels were to govern men, neither external nor internal controuls on government would be necessary. . . . A dependence on the people is no doubt the primary controul on the government; but experience has taught mankind the necessity of auxiliary precautions.[29]

In this way, tyranny is avoided not by a principle of "harmony" but by counterposing elements of strife. As White puts it, "tyranny's vice became a republican virtue."[30]

We might also want to employ Nietzsche's suggestion of a perspectival "objectivity"—where the adequacy of one's view is proportionate to the number of different perspectives one can take up—to rehearse an understanding of negotiation and compromise, which operate so frequently in democratic exchanges. Although there is always the danger that compromises can dilute a political

outcome to a detrimental degree, nonetheless if we are not bound
by a belief in a baseline truth, if we affirm a perspectival pluralism
as an alternative path, then we need not be "compromising"
ourselves in a negotiated outcome. A compromise would seem to be
a degradation only if one assumed that a particular perspective had
a special warrant, but we have been arguing against such a thing in
politics. A compromise—which, as we have seen, is still driven by an
agonistic setting—may even produce a more globally adequate
result by incorporating many different perspectives into the political
mix.

Perspectivism, Reason, and Political Practice

Nothing in a perspectival approach to truth implies an abandon-
ment of reason, either in politics or in any other human pursuit.
Reason can be affirmed in a number of senses: more loosely as a
term designating the human capacity to act on the basis of reasons,
which renders the question "Why are you doing that?" pervasively
applicable in human discourse; more strictly as a set of guidelines
for discerning better and worse reason-giving, in other words,
guidelines of consistency and patterns of inference that can
distinguish coherent and incoherent, successful and unsuccessful,
strong and weak arguments—this in the *context* of defending
positions in a dialogical engagement of differing beliefs. If we pay
attention, however, to the standard distinction between logical
validity and soundness, and to the complex processes that make up
inductive inferences, we can better understand the *limitations* of
reason in ethical and political discourse (at least). Take the issue of
abortion: Valid arguments can be constructed both for and against
permitting abortion on the basis of the status of a fetus, concerning
whether or not a fetus is a "person." The soundness of each
argument, however, would depend on the *truth* of the person-
premise. *How* one comes to regard the fetus as a person or non-
person, in other words, how one comes to take the person-premise
as "true," sends us beyond the bounds of formal reason, evidence,

and the like. Reason can help us understand how different view-points are structured, it can help clarify the issues at hand in a debate, it can even produce alterations, revisions, and moments of persuasion in the course of critical exchanges. The persistence of sincere disagreements in political discourse, however, indicates that rationalistic or objectivistic hopes for consensus or convergence around decidable truth conditions or ideal speech conditions are unfounded—not because political discourse is fundamentally irrational, but because the question of *how* one comes to affirm the "truth" of baseline beliefs leads us to confront processes and forces that are perspectival, noncognitive, and nondiscursive, and that cannot therefore converge around a stable and uniform reference. Such an irreducible perspectivism helps explain the undecidable plurality that marks the political field. Perspectivism also lends credence to our suggestion that the decision mechanism required by politics should be restricted to an ongoing contest for contingent decisions. And finally, since "cognition" is itself a certain perspective, a perspectival approach opens up the importance of various "noncognitive" elements that operate in political practice, a subject to which we now turn.

We have seen that Nietzsche's genealogical analysis of morality was not meant to erase it, but to derail the pretense of its "purity" by highlighting the naturalistic conditions, messy contingencies, and subliminal drives that constituted the genetic milieu of cherished moral beliefs. In general terms, Nietzsche's message is that any value one affirms cannot help being caught up in its Other, cannot help implicating apparently contrary perspectives in its own constitution—such is the agonistic alterity of cultural life. A comparable analysis of democracy likewise need not erase or threaten it, but rather redescribe it in naturalistic, perspectival, and complicitist terms. Furthermore, such redescription can give us some revealing Nietzschean angles on democratic performance. It seems that many of the criticisms of democracy, even among its proponents, stem from modernist and cognitivist criteria, in that democratic practice does not often measure up to standards of "objective rationality." On this score there may be an interesting

homology between democratic propensities and Nietzsche's analysis of the human condition. Some of the nonobjective and noncognitive elements that Nietzsche insists we acknowledge may be more evident and more operative in democratic societies than in others.

To begin with, it is important to retrieve our finding that Nietzsche did not reject the importance of critical reason.

> The school has no more important task than to teach rigorous thinking (*strenges Denken*), careful judgment and consistent reasoning. (*HAH* I,265)

> The most perfidious way of harming a cause consists of defending it deliberately with faulty arguments. (*GS* 191)

> There is a way of asking us for our reasons that leads us not only to forget our best reasons but also to conceive a stubborn aversion to reasons in general. This way of asking makes people very stupid and is a trick used by tyrannical people. (*GS* 209)

Nor did Nietzsche recommend an unbridled passion, but rather the channeling and cultivation of passion.

> All passions have a phase when they are merely disastrous, when they drag down their victim with the weight of stupidity—and a later, very much later phase when they wed the spirit, when they "spiritualize" themselves. . . . *Destroying* the passions and cravings, merely as a preventive measure against their stupidity and the unpleasant consequences of this stupidity—today this itself strikes us as merely another acute form of stupidity. We no longer admire dentists who "pluck out" teeth so that they will not hurt anymore.
> . . . an attack on the roots of passion means an attack on the roots of life. (*TI* 5,1)

> Blind indulgence of an affect, totally regardless of whether it be a generous and compassionate or a hostile affect, is the cause of the greatest evils.
> Greatness of character does not consist in not possessing these affects—on the contrary, one possesses them to the highest degree—but in having them under control. (*WP* 928)[31]

What Nietzsche opposes is the *reduction* of human experience and discourse to reason or passion or any particular perspective in isolation from other perspectives.

Accordingly, as long as critical reason is affirmed as a necessary part of democratic political campaigns and decision-making, then the role of passion, partisanship, self-interest, rhetoric, and various other "deficient" forces frequently regretted by critics can receive a back-door Nietzschean defense.[32] Such forces cannot and should not be suppressed or purged from human engagement, for they have their place in promoting life interests. The untidy, contentious, and visceral aspects of democratic practice might be understood as having a certain "Dionysian" role in political dynamics. For Nietzsche, passion and instinct are not "thoughtless," are not opposites of cognition. Just as Nietzsche shows cognition to be blended with instinct, we can go the other way and suggest that instinctive intimations and passionate responses have disclosive power. How can we be sure that the infamous propensity for "image over substance" in democratic campaigns generates only defective or degraded results? Might there be something important in the noncognitive dimensions of our political exchanges? I can cite one example that opens up this question with surprising ambiguity: The Kennedy-Nixon television debate in 1960. Nixon's visual image was seen to be less attractive than Kennedy's presentation in several ways. A poll of viewers had Kennedy the winner; but a poll of radio *listeners* had Nixon the winner.[33] By cognitivist standards we seem forced to conclude that the real winner was Nixon, since the radio listeners would have more direct access to the debaters' *ideas* without the distraction of visual and perceptual interpolations. Given Nixon's later difficulties and failings, however, might it be that his looks gave something away? Not so much the infamous stubble and pallor, but the darting, discomforting eye movements? Perhaps the television audience was right after all. Sometimes image might properly outweigh substance.

This brings us to the question of rhetoric. For Nietzsche, philosophy cannot be separated from rhetoric, since he traces all thought structures to operations in language that coax us to interpret experience by way of indirect devices such as metaphor and metonymy, which shows that thought is anything but strictly representational or referential. So philosophy can never function without rhetorical elements of persuasion and seduction.[34] Much of

postmodern thought has been concerned with subverting the traditional division between truth and rhetorical persuasion.[35] Sophisticated treatments of such issues do not suggest an abandonment of logic or a complete reduction of human discourse to rhetoric, but rather an ineradicable confluence of logical and rhetorical tropes that simply *complicates* what we mean by "reason" and "logic."[36]

If such a mixture of logic and rhetoric holds for philosophy in general, it is short work to argue for the inevitable—and, in Nietzschean terms, necessary—role of rhetoric in political discourse. Here we can again turn to Aristotle. In his *Rhetoric*, in apparent disagreement with Plato's dismissal of the Sophists, Aristotle recognized the positive role that rhetoric plays in politics. When it comes to political speech in the context of persuading an audience, noncognitive and passional elements must be recognized and utilized, and the character of a political figure can be an essential ingredient in winning the assent of citizens.[37] What is sometimes called "charisma" in politics is operative here.[38] As I have suggested, we make noncognitive judgments about people all the time, and such judgments are not necessarily faulty. If politics were limited to rhetoric and charisma, this would be dangerous, but politics without rhetoric and charisma would be lifeless and devoid of certain nonrational powers that figure in our sense of the world.[39] Style and character may in fact run deep and tap less mediated intuitions and intimations. Such forces can be dark, of course, but also noble; for every Hitler, there is a Martin Luther King. The point here is that the "content" of King's message, for example, cannot be separated from his existential bearing and oratorical gifts. The same content in a different voice would not be the same—*at least* from the standpoint of effect and historical consequence, which may be all that counts in the end. Political discourse operates according to an interpenetration of reason and emotion, substance and style. If either side of the mix is significantly diminished, so too is politics diminished.[40] Hoping for political speech solely on "the issues," without the effects of style, personality, and emotion, would be naive or suspicious from a Nietzschean standpoint.

To further our application of Nietzsche's genealogical principle of agonistic alterity to democracy, we can take a look at the issues of political leadership in relation to character, virtue, and vice. As indicated earlier, many democratic theorists have recognized the need for leadership by a select few in politics, but such recommendations traditionally have been predicated on a kind of intellectual and ethical elitism, the supposition that the masses do not possess adequate measures of wisdom or virtue.[41] We have already subjected such cognitive and moral confidences to a Nietzschean suspicion, but we can go further in addressing the general question of politics and virtue.

Nietzsche considered the Sophists to be political "realists," and he thought that "it was their honor not to indulge in any swindle with big words and virtues" (*WP* 429). Platonic "idealism" was partly characterized by a battle against the Sophists; it opposed their relativism, skepticism, pragmatism, and their willingness to engage in expedient political machinations. The model of Socrates searching for a perfect virtue and justice untarnished by self-interest and power became a classic measure for assigning a good deal of political practice to the category of "vice." One mark of political reflection ever since has been a hope for the confluence of political leadership and "moral character."[42] We tend to bemoan qualities of aggressiveness, ambition, pride, truculence, dissimilation, and expediency in our politicians, and we especially regret various intrigues and power plays that always seem to characterize political administration and governance. The idea that certain ethical traits should be as operative in politics as in other walks of life, however, is a notion ripe for a Nietzschean critique, a critique prefigured, of course, in Machiavelli's political writings. Machiavelli also preferred a more realistic outlook that recognizes the need for switching concepts of virtue and vice when it comes to political leadership.

> [I]t appears to me more appropriate to follow up the real truth of a matter than the imagination of it; for many have pictured republics and principalities which in fact have never been known or seen, because how one lives is so far distant from how one ought to live, that he who neglects what is done for what ought to be done, sooner effects his ruin

than his preservation; for a man who wishes to act entirely up to his professions of virtue soon meets with what destroys him among so much that is evil.

Hence it is necessary for a prince wishing to hold his own to know how to do wrong, and to make use of it or not according to necessity.[43]

Here I am not suggesting some crude reversalist position or defense of vicious political behavior, but rather the more subtle implications of a Machiavellian analysis that are also indicated in Nietzsche's agonistic alterity: namely, that "virtue" is contextual, complicated, ambiguous, and often complicitous with apparently contrary attributes. There can be virtues of political leadership, therefore, that will often be incongruent with virtues operating in other contexts, or that will blend performances and attributes that might be vices in other contexts. I want to challenge the regret we often express about political practice with what I will call the *executive principle*, which stipulates that we cannot adequately assess political performance without attention to the actual circumstances of 1) crafting decisions and policies that encounter real resistances in the making, and 2) being responsible for enacting decisions and policies that have real consequences in people's lives. Such a contextual analysis will often show that our regrets and complaints are either naive or luxurious. To take an example from the academic setting, complaints and suspicions about administrators are almost compulsory dispositions in the culture of faculty attitudes. The fact that most administrators are former faculty calls for the executive principle to unravel some discrepancies in such a culture. It is easy for me to denigrate an administrator when I do not inhabit the twofold context of crafting and enacting policies described above. The glitch that I am denigrating someone who used to inhabit my own context as a faculty member could be explained in one of three ways: 1) Administration attracts faculty who possess the deficient traits that elicit my complaints. 2) Faculty who might not possess such traits somehow become corrupted or mysteriously transformed as soon as they become administrators. 3) The context of administration demands certain performances that are indigenous to the situation, that are dissonant with other

contexts, and that therefore are "deficient" only from another perspective. The contextual explanation seems more plausible, and it suggests that *anyone* who becomes an administrator will likely have to cultivate traits and performances that are appropriate to this situation and that are *inevitably* in tension with other settings to a certain degree.

The executive principle should likewise temper our regrets and complaints about political leaders in the context of democratic practice. As an example, let us apply the two provisions of the principle to the American presidency. First, the crafting of policy in the midst of resistance: The agonistic pluralism indigenous to democratic procedures means that legislation will always involve opposition and obstacles to implementing an agenda. If *enacting* a certain agenda defines the presidential context, then it seems that our complaints about all the wrangling, intimidation, muscling, horsetrading, and machinations of power that goes on between the President and the Congress are naive. What alternative does a President have in such a context? How can such tactics be avoided without losing the political contest? What President would refuse to utilize all available levers of power, bestowal, and prestige that adhere to the office in the service of a legislative agenda?[44] Second, the responsibility for the consequences of executive decisions: To take a significant example that can illuminate a host of others, consider the President's role as Commander in Chief. Once a President is confronted with actual circumstances requiring a decision about the use of force, it is quite likely that previous hawkish or dovish propensities might be modified somewhat or even reversed in the face of concrete consequences and the burden of responsibility. In this respect, external criticisms of Presidential actions from confident hawks or doves might be called naive or luxurious.

The general point to be drawn from this section of the chapter is that democratic politics—in its electoral, legislative, executive, and judicial components—is not "pure" in practice; indeed a contextual pragmatics ought to convince us, along Nietzschean lines, that strict standards of cognitive or moral purity are inappro-

priate for, even injurious to, political life.[45] Democratic practice as
a whole can be seen as a complicated and complicitous mixture of
rational and nonrational forces, of varying contexts and demands,
of different and dissonant virtues—a kind of political dance that
cannot be choreographed by any overt or overarching design,
benevolent or otherwise. We should be able to affirm the messy,
contentious, and all-too-human aspects of democracy. Human
beings will always be self-interested, partial, and fractious to various
degrees and in different ways in political life, so we should surren-
der the fantasy that citizens and politicians can or ought to be
"objective," or "pure of heart," or sacrifice their interests for the
"common good" or the "whole." What democracy provides us,
rather, is a system of procedures and principles that can produce
contingent decisions that arise out of the free play and agonistic
permutations of all the differing forces in the political field.[46]

Our analysis can help undermine a certain cynicism and
disillusionment about politics that can afflict both citizens and
theorists alike, and that can subvert our confidence in democracy
when politics is viewed as inevitably degrading, corrupt, or corrup-
tive. The contextual realism and agonistic perspectivism we have
outlined indicate that in the actual practice of human politics there
will always be elements of passion, power, ambition, strife, and so
on. These elements are not unproblematical and they are subject to
criticism and correction; nevertheless, their presence in politics is
not an automatic degradation, but rather an indication of political
life. What disillusions us about politics is the persistence of an
idealistic perfectionism, not political practice itself. In this respect,
those individuals who join the fray, who commit themselves to the
daunting world of politics despite its frustrations, those activists and
career politicians ought to be honored, because it takes courage,
fortitude, perseverance, and finesse to do the necessary work of
governance. The complaint that one must "sell out" when getting
into politics is a loaded and ultimately antipolitical gesture. A single
activist who compromises or even fails inside the political arena is
still worth more than a thousand cynics or purists or theorists
moralizing on the sidelines. Here in the political sphere we have

something analogous to Nietzsche's general problematic of life-denial, wherein certain moralistic assumptions are translated from an apparent affirmation of "the good" into their tacit nihilism and denial of life conditions; aiming this problematic at civic affairs, we can say that excessively "pure" or unambiguous conceptions of politics cannot help but spell the *denial* of politics. A Nietzschean perspective on democracy may help cultivate an *affirmation* of politics.

7

Ethics and Politics Without Foundations

In this chapter I will explore the possibilities for an ethics in a Nietzschean, postmodern orientation, something that will overlap significantly with our reflections on democratic politics. At the same time, our analysis will enable us to draw certain lines of distinction and even separation between the ethical and the political. Such delineation is needed in order to complete a postmodern critique of political philosophies that have not only been wedded to problematical theoretical assumptions, but also enmeshed in an excessive overlap with ethics that is no less problematical. I will then argue for an exclusion of any "metanarrative" from the general conception of a democratic political order, while at the same time avoiding a sloppy and subtly exclusionary "neutralism" that aims to screen out baseline value commitments from political discourse. A postmodern political philosophy can affirm baseline commitments as *contestants* in the democratic process, but an agonistic conception of democracy must avoid folding in any such commitments into its overall political scheme.

Ethics and Nietzsche's Thought

Although Nietzsche occasionally calls himself an "immoralist" and suggests an overcoming of "morality," what he challenges in these maneuvers is a *particular* moral system. If morality refers to values that assess human actions and attitudes in terms of better and worse ways of living, then Nietzsche is certainly recommending a kind of morality, and so thinking about ethics in general in the light of Nietzsche's thought is quite appropriate. A nihilistic denial of values would be the farthest possibility in a thinker who champions the affirmation of life and who proclaims the human condition to be that of *der Schätzende*, the esteemer, the creator of values (Z I,15). Nietzsche's recommendation to surpass the distinction between good and evil does not indicate a refusal to distinguish between good and bad.

> [I]t has long since been abundantly clear what my *aim* is (*was ich will*), what the aim of that dangerous slogan is that is inscribed at the head of my last book, *Beyond Good and Evil*.—At least this does *not* mean "Beyond Good and Bad." (*GM* I,17)

A note appended to this section reiterates Nietzsche's intention to advocate a *reordering* of values, an "order of rank among values" (*Rankordnung der Werte*), rather than an abandonment of values. Herd morality is only one type of morality among others. It is the *reduction* of "the good" to herd morality that Nietzsche opposes.

> *Morality in Europe today is herd animal morality*—in other words, as we understand it, merely *one* type of human morality beside which, before which, and after which many other types, above all *higher* moralities, are, or ought to be, possible. But this morality resists such a "possibility," such an "ought" with all its power: it says stubbornly and inexorably, "I am morality itself, and nothing besides is morality." (*BGE* 202)[1]

Drawing on life-affirming features implicated in "master morality," Nietzsche wants to displace a transcendent, antinatural morality with a naturalized morality that serves, and is measured by, life instincts (*TI* 5,4).

We should not oversimplify or polarize Nietzsche's approach to "herd morality," however. The kinds of moral values that are so

problematical for Nietzsche still find a place in his world view, and they might even be revamped and rehabilitated in the light of his criticisms. First of all, part of Nietzsche's point is that herd values such as harmony and peacefulness are not entirely misguided, but rather harmful when extended to all contexts and all human types— creativity, for example, is a context in which such values can be detrimental.[2] In certain contexts and for certain types, then, herd values can be appropriate. Consequently Nietzsche's attack upon certain moral systems is not meant to erase them or to promote a mere reversal of their values by promoting opposite actions and forms of life. As Nietzsche puts it in the context of religion, refuting God does not mean we are left with the devil (*BGE* 37). To simply recommend the Other of a moral system is to still be caught up in the measure of that system. To put this in concrete terms, it would be a mistake to interpret Nietzsche's texts as a call for suspending traditional moral prescriptions against killing, stealing, lying, abuse, violence, and so on; nowhere can we find blanket recommendations for such behaviors. Rather, Nietzsche wants to contextualize and problematize traditional moral values so as to undermine their transcendent isolation from earthly conditions of finitude, their pretense of purity, universality, and stability.

Nietzsche's destabilization of traditional moral *belief systems* may not imply a renunciation of certain moral *values* that are existentially operative in those systems. Indeed there may be hidden resources in Nietzsche's critique that can open up these values in a more existentially meaningful way. There are passages in Nietzsche's texts that suggest as much—that one might uncover concealed insights and a deeper sense of morality by denying morality and unsettling its unambiguous presumptions and comfortable acceptance.

> I do not wish to promote any morality, but to those who do I give this advice: If you wish to deprive the best things and states of all honor and worth, then go on talking about them as you have been doing. Place them at the head of your morality and talk from morning to night about the happiness of virtue, the composure of the soul, of justice and immanent retribution. The way you are going about it, all these good things will eventually have popularity and the clamor of the streets on

their side; but at the same time all the gold that was on them will have been worn off by so much handling, and all the gold *inside* will have turned to lead. Truly, you are masters of alchemy in reverse: the devaluation of what is most valuable. Why don't you make the experiment of trying another prescription to keep from attaining the opposite of your goal as you have done hitherto? *Deny* these good things, withdraw the mob's acclaim from them as well as their easy currency; make them once again concealed secrets of solitary souls; say *that morality is something forbidden.* That way you might win over for these things the kind of people who alone matter: I mean those who are *heroic.* (*GS* 292)

Thus nobody up to now has examined the *value* (*Wert*) of that most famous of all medicines which is called morality; and the first step would be—for once to *put it in question.* Well then, precisely this is our task. (*GS* 345)[3]

Nietzsche's moral criticisms might therefore be called internal in a sense, and this would fit in with the complex meaning of "overcoming" that animates his thought. Just as one must overcome the sedimented fixations of one's culture, one must also overcome the polar *opposition* to one's culture that marks the initial gesture of independence.

If one would like to see our European morality for once as it looks from a distance, and if one would like to measure it against other moralities, past and future, then one has to proceed like a wanderer who wants to know how high the towers in a town are: he *leaves* the town. "Thoughts about moral prejudices," if they are not meant to be prejudices about prejudices, presuppose a position *outside* morality, some point beyond good and evil to which one has to rise, climb, or fly—and in the present case at least a point beyond *our* good and evil, a freedom from everything "European," by which I mean the sum of imperious value judgments that have become part of our flesh and blood.

. . . One has to be *very light* to drive one's will to knowledge into such a distance and, as it were, beyond one's time, to create for oneself eyes to survey millennia and, moreover, clear skies in these eyes. One must have liberated oneself from many things that oppress, inhibit, hold down, and make heavy precisely us Europeans today. The human being of such a beyond who wants to behold the supreme measures of value of his time must first of all "overcome" this time in himself—this is the test of his strength—and consequently not only his time but also

his prior aversion and contradiction *against* this time (*seiner bisherigen Widerwillen und Widerspruch gegen diese Zeit*), his suffering from this time, . . . (*GS* 380)

Consequently we need not segregate certain moral notions that Nietzsche identifies with the "herd" from the rest of his reflections on value and meaning. We need not rest with clear delineations between "Nietzschean" values on the one hand and "traditional" values on the other. We might be able to give a Nietzschean interpretation of familiar moral themes that can *revise* our understanding of ethics, rather than overcome, supersede, or marginalize perennial normative concerns.

Nietzsche's deconstruction of "good" and "evil" is not concerned with denying normative judgments, but rather supplanting the polar opposition and isolation of the good and the nongood. Such categorical segregation generates a number of mistakes and distortions in moral understanding. First of all, it encourages a hyperconfidence in the rectitude of one's sense of the good and in the malignancy of the Other—which can instigate exclusion, oppression, or erasure. Secondly, it ignores or conceals the essential *ambiguity* in values, that no value is "pure" or separable from its Other or immune from complicity with harmful effects. Human existence is enormously complex, and no moral category can be clean enough to adequately cover the normative field or to avoid discrepancies, ironies, and unintended detriment in its own operation. In many contexts it is no mystery to recognize the harm in something like murder and violence, or the benefit in something like nurturance and kindness. Nietzsche's contribution lies in alerting us to the margins—to contexts in which familiar moral juxtapositions become unsettled. What is called "kind" and "cruel" is not always "good" and "evil." Sometimes what is meant to be kind can be overprotective and inhibiting, and what is perceived as cruel can be a proper challenge to break a debilitating fixation. The "dangerous" is often productive of good results, and the "safe" is often productive of bad results. Any apparently "positive" value contains an intrinsic capacity for "negative" effects, and vice versa. Nietzsche concentrates on the values that have a good reputation so

as to warn us about their inherent dangers, their unhealthy dimensions, and their propensity to be a mask for what they profess to oppose. Compassion, for example, can be good, but it can also stem from a hatred of suffering and a desire to shield people from suffering, which Nietzsche calls life-denying and life-inhibiting. Or compassion can be an indulgence stemming from relief (or perhaps satisfaction) that someone else is suffering rather than oneself.

Finally, with whatever is called "good," *becoming* good will involve a continual contest with its Other, otherwise the existential sense of developing and living out the value would evaporate. Without a capacity to be cruel, "being kind" would not have any moral meaning; recommending kindness would be like recommending aging. And a pose of kindness only to avoid certain reprobations or to gain certain benefits is really a bogus kindness. So becoming kind in an authentic sense would have to involve an existential confrontation with the pull of cruelty—and every human being has the capacity for cruelty and has been cruel at one time or another—with an eye toward cultivating its Other. Consequently the existential *field* of "kindness" includes cruelty, and without such a field-concept, the nature of kindness is distorted or even lost. The moral polarization of kindness and cruelty would attempt to insulate us from our cruelty and view it with disdain, but a moral developmentalism would require that we acknowledge, examine, and orchestrate the tensions between kindness and cruelty. Without attention to the "negative" side, the "positive" side loses its existential authenticity, and any presence of "the good" may be nothing more than an abstraction, a compliance with external commands, an instrumental calculation, or a masquerade. What is more, polarization can encourage a *repression* of propensities toward cruelty, and we know well that repression can produce pathological effects and even terrible outbursts of cruelty when the force of subliminal drives becomes too great. In these ways, then, the polarization of values into "good" and "evil" 1) subverts an existential appropriation of cherished values and 2) ironically nourishes conditions for the fermentation of the most vicious forces that such values are presumably meant to prevent. Becoming good, therefore, must include an engagement of contrary forces.

> Of all evil I deem you capable: therefore I want the good from you.
> Verily, I have often laughed at the weaklings who thought themselves
> good because they had no claws. (*Z* II,13)

One other effect of polarization that Nietzsche stresses again and
again is the tendency toward a nihilistic psychology of self-con-
sumption. An ideal of "love" divorced from "hate" conjures up a
notion of *perfect* love that eventually leads to self-hatred, since finite
existence can never measure up to such an ideal. Self-loathing
(embodied in bad conscience and the ascetic ideal) is for Nietzsche
an endemic danger in, and a frequent consequence of, traditional
moral systems that trade on perfection and unambiguous virtues.

If we take a lead from Nietzsche's preference for the good-bad
distinction over the good-evil distinction, as indicated in the master-
slave relation, we can conclude that moral distinctions and
judgments regarding good and bad are possible in the light of
Nietzsche's thinking, and are preferable to the traps and distortions
that follow from isolating the good from its Other in the manner of
good and evil. One and the same action can be called either "evil"
or "bad." In both cases there is a moral judgment, but the second
term is favored from a Nietzschean perspective, since it allows for
the ambiguities and inclusive correlations that adhere to normative
judgments. The good must always be incorporated with its Other,
there can be no overarching principle of unambiguous moral purity,
or judgments without remainder or regret, or hopes for the
complete rectification of the tensions within the moral field. Here
we notice the contours of an agonistic ethics that can correlate with
an agonistic politics.

Agonistic Ethics

We can and should distinguish Nietzsche's critique of the slave/
herd mentality from certain traditional moral values and not
assume that his critique exhausts what can be said of those values.
How is it that feeding the hungry is a sign of slavish weakness and
life-denial? Or preventing violence and abuse? Or aiming for
honesty in human relations? Or treating people with kindness and

respect? I have no trouble saying that all these actions are worthy of moral praise and are worth recommending, and I see nothing of weakness or denial in them as such. Nietzsche is surely right when he targets a revulsion against suffering and finite life conditions that spawns resentment, exclusions, unhealthy dispositions, and perfectionist hopes. He is mistaken, however, if he means to suggest that moral prescriptions against violence, let's say, arose only and exclusively by way of a slave mentality. The issue concerns a certain *attitude toward life* that can be implicated in such values, not necessarily the values themselves. I prefer to say that such values can be healthy and life-affirming, but that they are complex and always in danger of inciting or valorizing life-denying attitudes and practices.

We can make some headway here by distinguishing the following: 1) existential moral commitments, decisions, and judgments that indicate particular estimations of better and worse ways of living, that reflect particular decisions about a normative affirmation or denial—choosing one's Yes or No in a certain ethical context; 2) moral theories, formulas, and metaphysical foundations that have served to ground and guarantee moral judgments, which in effect decides the issue *for* us—we only have to conform our decisions to such measures in order to be in the right; 3) moral universalism and perfectionism, which suggest some transformed condition wherein normative differences and conflicts can be resolved or overcome in the light of a secure concept of the good; and 4) moral judgments that involve a condemnation or vilification of the Other, of that which stands on the other side of the good—which tends toward practices of exclusion, denial, or erasure. Items 2, 3, and 4—which can easily interconnect—are proper targets of a Nietzschean critique; but the first item can be sustained, indeed it can be called an ethical version of the agonistic perspectivism championed by Nietzsche, by allowing for existential moral decisions without guarantees, without suppression of conflict, and without casting the Other into oblivion, invisibility, or silence.

Any moral value or virtue, in its emergent conditions and existential environment, is constituted by a contest with counter-

forces. When we make a moral decision or act out a moral commit-
ment, when we take a moral stand and are willing to judge better
and worse ways of living, we are engaged in specific instances of
overcoming, the creation of meaning in the midst of opposition—
which is what Nietzsche means by will to power. Indeed moral
practice in this sense seems to embody central Nietzschean motifs
such as challenge, strife, power, differentiation, rank, and risk.
Moreover, to identify the herd with morality seems wrong, since it
is often conformist and group forces that work against and inhibit
certain moral behaviors—honesty, for example, is often the last
thing most people want to hear. In the midst of convention and
established power interests, moral action will often require a
"pathos of distance." In this sense, egalitarian aversions to harm,
offense, difference, and rank that have marked traditional moral
rhetoric deconstruct themselves when we consider contexts of
moral enactment. *Being* moral often entails disruption, conflict, and
gradation.[4]

Applying Nietzsche's agonistic perspectivism to ethics would
certainly disallow any objective foundation for morality, but we can
also intercept a crude intellectual pessimism or facile relativism by
recalling that perspectivism, for Nietzsche, is not equivalent to
radical skepticism or to the notion that differing viewpoints are
equally valid (notice the egalitarian element in relativism). Although
Nietzsche considers all knowledge and value to be perspectival, he
advocates *commitment* to one's own perspective over others; a
detached condition or an absence of resolve or a skeptical reserve
are diagnosed by Nietzsche as forms of weakness. The "objective"
person who strives for "disinterested" knowledge is deficient in
having no specific stand to take or judgments to make.

> His mirror soul, eternally smoothing itself out, no longer knows how to
> affirm or negate; he does not command, neither does he destroy. *"Je ne
> méprise presque rien"* ["I despise almost nothing"], he says with Leibniz:
> one should not overlook and underestimate that *presque* [almost].
>
> Neither is he a model man; he does not go before anyone, nor
> behind; altogether he places himself too far apart to have any reason to
> take sides for good or evil. (*BGE* 207)

Our mistake has been "confusing him for so long with the *philosopher*." Likewise we tend to assume a connection between philosophy and skepticism.

> When a philosopher suggests these days that he is not a skeptic—I hope this is clear from the description just given of the objective spirit—everybody is annoyed. One begins to look at him apprehensively, one would like to ask, to ask so much—Indeed, among timid listeners, of whom there are legions now, he is henceforth considered dangerous. It is as if at his rejection of skepticism they heard some evil, menacing rumbling in the distance, as if a new explosive were being tried somewhere, a dynamite of the spirit, perhaps a newly discovered Russian *nihiline*, a pessimism *bonae voluntatis* [of good will] that does not merely say No, want No, but—horrible thought!—*does* No. . . .
>
> For the skeptic, being a delicate creature, is frightened all too easily; his conscience is trained to quiver at every No, indeed even at a Yes that is decisive and hard, and to feel as if it had been bitten. Yes and No—that goes against his morality; conversely, he likes to treat his virtue to a feast of noble abstinence, say, by repeating Montaigne's "What do I know?" or Socrates' "I know that I know nothing." (*BGE* 208)

Skepticism, in fact, is here identified with a certain "nervous exhaustion and sickliness." Finally, Nietzsche is anything but a laissez-faire moral relativist or moral nihilist. Although perspectivism forbids the notion that one's own morality is binding on all, nevertheless to infer from the existence of different moralities that no morality is binding or worthy of commitment (*Unverbindlichkeit aller Moral*) would be childish (*GS* 345).

A phenomenology of commitment and decision would help distinguish a nonfoundationalist ethics from a crude moral relativism, which tends to mean that different moral beliefs simply hold true for those who hold them, that the different beliefs are no better or worse in comparison with each other, simply different. Although some normative areas might properly be called relativistic in this sense, certain moral decisions and commitments would not make existential sense in the light of such thinking. If I believe that political imprisonment and torture are wrong, for example, and I join Amnesty International to make appeals to governments that practice such things, it would seem strange if I were to claim that

these governments' "perspectives" on the matter are right "for them"
or simply "different" from my perspective. I can be a moral
perspectivist who denies the possibility of objective foundations and
still commit to my position—which in this instance would have to
mean that I think these governments are *wrong* and that my
position is *better* than theirs. Such decision and commitment fit in
well, I think, with what Nietzsche means by willing in the midst of
opposition.

In the midst of different moral possibilities, what ultimately
matters is "a brave and rigorous attempt' (*Versuche*) to *live* in this or
that morality" (*D* 195). From an existential, lived standpoint,
however, one cannot equally affirm one's own values and opposing
values; that would make morality so arbitrary as to be blind and
meaningless. One must *contend* with other perspectives, both
practically and intellectually, and this entails that one argue and
work *against* other perspectives and *for* one's own, that one think
one's own perspective to be the *better* option—all of which would
make an attitude of equanimity inappropriate. An agonistic
perspectivism simply stipulates that one's commitments cannot be
backed up by some decisive "truth," and that a complete resolution
or panoptical adjudication of differential strife will not be forthcom-
ing.[5]

Such an approach to ethics can amount to a phenomenology of
"willing" in a differentiated, contested field that shows no signs of
coalescing around a common good or issuing a heretofore con-
cealed ground that can provide a definitive formula for the good.
The absence of unity or foundations, however, need not mean a loss
of bearings or an invitation to chaos, but simply an acknowledg-
ment of, and attention to, the ways in which ethical issues present
themselves and the ways in which people engage each other in such
matters. We must simply see the ethical field *as* agonistic and *decide*
how to live—without allowing *global* undecidability to demoralize
us or debilitate our capacity to make local commitments (which
Nietzsche would call weakness of will).

The search for a ground or a formula in ethics can be under-
stood as an attempt to escape the existential demands of contention

and commitment. Moral "decisions" and the sense of "responsibility" for decisions may in fact be constituted by the global *undecidability* of ethical questions.[6] In cognitively decidable areas we do not talk of human choice or responsibility: I do not "decide," for example, that 2 + 2 = 4, or that Socrates is mortal in the classic syllogism. Traditional moral "theories" can be diagnosed as an attempt to ward off the unstable and groundless elements of existential decision by modeling ethical deliberation along the lines of demonstrative and calculative techniques that in effect would decide things for us—we would "know" what is right; our "decision" would be simply whether or not to comply.[7] Demonstrable moral certainty, however, would wind up clashing with our *sense* of moral action—we can only *choose* and *commit* to things that are *not* demonstrable (I do not make a "commitment" to 2 + 2 = 4).[8] In the field of human discourse, though, one can defend one's commitments and even aim to teach and persuade; global undecidability does not make ethics arbitrary or vacuous. An emphasis on decision also undermines a counterfoundational extreme of sheer openness and freedom that is suspicious of any moral position for fear of closure. Even if there is no ultimate answer to moral questions, we cannot avoid situations in which we have to come up with answers by choosing some options and excluding others. In this regard, we should consider whether certain postmodern proposals for "nomadic" alternatives to closure are not themselves escapist in Nietzschean terms, in that they can underwrite an avoidance of the demands and consequences that accompany moral decisions. Excessive freedom is no less a flight from difficulty than is an overarching order.[9]

Distinguishing the Ethical and the Political

At this point I will admit to a problem that haunts my analysis. An agonistic pluralism is significantly "negative" in its depiction of human nature and human relations—arguing against universality, sameness, harmony, and so on, stressing differences and conflict.

Ethical and political theorists might well ask whether something like love, compassion, or concern for others would find a place, indeed whether such things are possible, or might be discouraged, in an agonistic social dynamic. Would not ethical and political life need some sense of *positive* regard in human relations, where people care for and about each other? I want to engage this question and answer Yes with respect to ethics and a qualified No with respect to politics.

We will sustain our focus on Nietzsche in discussing this question. Nietzsche's deconstruction of atomistic individualism and subjectivity opens up an intrinsically social and interactive sense of selfhood. The emphasis, however, is on an agonistic interaction, ruling out any baseline sense of social unity, harmony, or collectivity.[10] Nietzsche's texts do indeed emphasize strife, challenge, and distance, with less attention to "positive" experiences of love and beneficence. In fact love and compassion are in some instances reduced to egotistical and possessive instincts (*GS* 14; *WP* 777). Neighbor love is counterposed to a sense of solitude (*Z* I,16) and to a kind of friendship that thrives on challenge rather than support and nurturance:

> In a friend one should have one's best enemy. You should be closest to him in your heart when you resist him. (*Z* I,14)

We do find positive remarks about love—for instance, it is connected with going beyond good and evil (*BGE* 153)—and sympathy (*Mitgefühl*) is listed in one passage as a virtue (*BGE* 284). Nonetheless there is much more "distance" in a Nietzschean relation, and this would seem problematical in ethical and political relations. Do we not need a stronger sense of *recognition* of others and *concern* for them, at least as a countermovement to our capacity for hatred, violence, and abuse?

Although I have suggested a kind of agonistic recognition that can generate a sense of civic respect, such a notion indeed does not require any positive feeling about or toward others, and one might wonder whether stressing a Nietzschean agonistics would only encourage or instigate elements of hatred and abuse that are all too

ready to assert themselves. A positive regard for others does not often show itself in Nietzsche's texts, but we should give him his due in his diagnosis of hatred and violence. An openness to becoming and strife is ambiguous; for Nietzsche, it is something that is connected with creativity and human development; it can, however, serve the instincts of those who simply hate and want to destroy.

> The desire for destruction, change, becoming *can* be the expression of an overfull power pregnant with the future (my term for this, as is known, is the word "Dionysian"); but it can also be the hatred of the ill-constituted, disinherited, underprivileged, which destroys, *has* to destroy, because what exists, indeed existence itself, all being itself, enrages and provokes it. (*WP* 846)

In fact Nietzsche suggests that human abuse does not stem from a wanton exercise of power; rather, hurting people "is a sign that we are still lacking power, or it shows a sense of frustration in the face of this poverty" (*GS* 13). The blockage of self-development is what may lie behind abusive behavior, since "whoever is dissatisfied (*unzufrieden*) with himself is continually ready for revenge, and we others will be his victims" (*GS* 290).[11] Consequently, one route to diminishing maltreatment is not to call for more love toward others, but to encourage and foster a sense of empowerment that stems from striving to overcome obstacles and enact one's projects.[12] Self-development is an avenue toward human joy, and "if we learn better to experience joy (*uns freuen*), we learn best not to hurt others or to devise hurts for them" (Z II,3).

It is important to recognize the correlation of positive and negative forces in Nietzsche's thought that pays particular dividends here. For Nietzsche, finite conditions of loss and conflict are implicated in our sense of value—the possibility of failure is built into the meaning of success; the less the possibility of failure, the less the sense of success (remember the Knicks and the high school squad). So negative forces allow for the possibility of *heightened* senses of value and self-creation that can mitigate elements of resentment and rancor toward life and other people.

Nevertheless, it is right to worry that ethics would at least be greatly diminished without some sense of positive regard *toward*

others, especially some affective regard—if not love, then at least compassion for human suffering. Some philosophers (Hume and Schopenhauer, for example) have made compassion the centerpiece of their ethics; for them, the existential fuel that animates the moral life is compassion rather than mere rules, formulas, or commands. Further, the atmosphere of existential finitude that we have emphasized in this study can easily connect with a discussion of compassion. The word literally means "suffer-with," and it indicates an openness to peoples' pain and misfortune. It seems clear that an unflinching attention to the limit conditions of life—the losses, hardships, wounds, and anxieties that are endemic to a finite world of becoming—can be an effective ethical stimulant, by cultivating a sensitivity for human vulnerability and a visceral concern for diminishing or preventing unnecessary human suffering. Although people certainly differ in their forms of life, there is a common understanding of finitude, in the sense of what it means to *lose* one's life interests. Compassion in the face of pain, loss, and death may be an effective starting-point for an ethics that can cross human differences and distances.[13] What is interesting here is that such an ethical openness to others is generated not by some positive condition but by an openness to the *negativity* of finitude.[14] Accordingly, we might diagnose moral indifference as a flight from finitude, as a psychological strategy to *minimize* one's exposure to the pains of life. Despite all this, we would have to heed Nietzsche's warnings about the dangers in our moral sentiments. The danger in compassion, as we have seen, is that it can prompt a life-denying attitude, or tend toward an insidious benevolence that controls people, debilitates them, or covers up the life lessons that arise from confronting pains and losses. Ethical compassion should involve a delicate oscillation between responding *to* suffering and letting people learn *from* suffering.[15]

The question that concerns our study is the limits of ethical motifs when it comes to politics, and the degree to which political philosophy should segregate certain ethical concerns from its reflections on a democratic polity. Although ethics and politics will always overlap—at the very least where normative principles are

implicated in citizens' rights and procedural rules—nevertheless certain ethical intimations about positive regard and our attitudes toward each other can only go so far in politics and might even be misplaced. This suspicion can even be directed at writers who follow a postmodern line of affirming differences by recommending an "ethics of letting-be,"[16] and a "delight in difference,"[17] in order to promote a relation to otherness that can undercut forces of domination and control. Political philosophy must address the inevitable limitations in our capacities to "affirm" each other. A Nietzschean agonistic perspectivism serves us well when we recognize that politics involves a perpetual *conflict* of perspectives, which renders an interest in positive dispositional bearings limited at best, and potentially oppressive at worst. At the limits of our affections for each other, an agonistic respect is still possible and necessary, wherein we affirm our opponents and their participation in political procedures. Affirming them as *opponents*, however, means that a certain positive regard toward them is unlikely, perhaps even an odd prospect. Affirming differences sounds warm and fuzzy in the abstract, but in concrete political engagement, difference is usually opposition, and that is why a competitive respect for what I do *not* regard with favor is a more realistic political ideal than advancing some transformative attitude of positive regard that is better left to *ethical* discourse.[18]

The problem addressed here can be traced to proposals or hopes for a political "community." To a certain extent I am siding with liberalism in its debate with communitarianism.[19] A community suggests a group of people held together by certain common values, interests, projects, or identities. Defining a *political* community in a pluralistic society, however, runs into the problem of suppressing or washing out differences, particularly in the light of coercive institutional power that marks the political sphere. If community is meant to designate a unified "whole" in any sense, or reflect some kind of universal category, then the status of different particulars is automatically diminished. If it refers to particular groups or some sort of integrated harmony of different sub-groups, we run into several problems. What groupings will we select to emphasize?

People can be grouped into multifarious associations: religion, race, ethnicity, gender, sex, economic class, age, language, geographical region, social role, occupation, and so on. Moreover, differences both between and within these groupings are more than differences; they manifest an array of *tensions* that render the idea of an organized harmony suspect.[20] We have already indicated that nostalgia for a lost sense of community that has become ruined in our fractious times is really bogus, since any "harmony" in the past was due more to *exclusions* of certain groups from political participation, or to mutual *seclusions* of different cultural groups within their own enclaves. If we could go back in time and institute complete political inclusiveness, and introduce modern forces of mobility and interpenetration that disrupt group identities, I daresay that "harmony" would directly give way to the kind of turmoil we know today.

The point is that past experiences of a cohesive community were *selective* and therefore defined by identities that were *not* really holistic. Once we have genuine political inclusiveness, all *differing* identities are permitted to assert themselves, and we are faced with the dissensus familiar to contemporary politics. There seem to be two options here: 1) We can attempt to formulate a new sense of communal wholeness that will not repeat the exclusions and seclusions of the past; or 2) We can recognize that political inclusion of all perspectives will produce inevitable conflicts that will not be resolvable around some sense of the common good. The second option is the better one, I think. For one thing, it is more descriptive of the way in which democratic politics has in fact unfolded in the wake of greater inclusiveness; it also avoids trafficking in suspect constructions of unity that in one way or another tend to problematize differences.[21] The only truly "inclusive community" would seem to be one that did not define itself according to any particular *content*.

All of this lends support to our agonistic, procedural model of democracy over more substantive models. This is not to say that agonistics rules out any sense of community or is sufficient for reflections on justice and the good. A democratic society can and

should have a certain ethical concern that basic human needs be met, that no citizen be abandoned to destitution; and its political principles should give all citizens a certain set of shared values. Reflections on a democratic political order, however, should avoid incorporating larger meditations on human relations that connote or imply conditions of meaning, purpose, or attitude, since such things do not lend themselves to communal convergence. Democracy *is* communal in the sense of a political "gathering," but only to orchestrate a conflicted field of meanings toward contingent decisions.[22]

If our restriction of political justice to competitive fairness and our confinement of a civic attitude to agonistic respect seem inadequate, too narrow, or disheartening, let me suggest how such criticisms might be intercepted. First of all, competitive fairness generates a significant number of rights, norms, and social programs. Secondly, agonistic respect gives us a *minimalist* approach to civic attitudes that can summon support for competitive fairness when more ethical attitudes of love, concern, and positive regard are absent or weak—without having to appeal to such attitudes. Thirdly, ethical concerns and larger narratives about meaning, purpose, dispositions, and human relations are not banished from politics in our agonistic model; they are encouraged to be *contestants* in the political agon. Such narratives, however, should not be folded into an overall political design as necessary conditions for civic justice.

One advantage here is that any perspective has the opportunity to win political support and temporary power, but it cannot claim to have "democracy" on its side, or "the people," or the "common good," or "justice," and so on; it can only claim a temporary victory in an ungrounded field of political conflict over what the public good ought to be. A socialist redistribution of wealth, for example, can result from democratic procedures, but neither it nor competing perspectives can claim any normative or political warrants that would render opponents less democratic or less just. Of course a perspective might be called undemocratic and unjust if it calls for or enacts the abrogation of basic civic rights that democratic

procedures require (more on this later). In fact, precisely the kind of ideological "modesty" that is implied in our procedural definition of democracy can work against the tendency of political factions to wittingly or unwittingly deny rights and freedoms to people on the other side of "the good." Again, the political elements of coercion and institutional power make possible the dangers that can befall us at the hands of ideologically *immodest* narratives. This is especially important when it comes to things like attitude and concern, which get us into the labyrinthine intricacies and ambiguities of human psychology. A political dedication to certain ethical ideals, dispositions, and standards for human relations, coupled with institutional power, can produce psychological oppression in various forms: for example, corrective or punitive treatment of "abnormal" or "deviant" behaviors and life styles; and insidious, transformative therapies, whether they be reeducation camps or sensitivity workshops.[23]

There are obvious connections and overlaps between the ethical and the political, but distinguishing the two spheres and in some instances separating them is important because human relations in families, friendships, and other daily associations are in many respects quite different from political relations in modern, pluralistic, large-scale societies. The former can involve notions of ethical regard, but the latter should be governed by a baseline notion of political (agonistic) respect, which not only forbids political exclusion of the Other, but also omits an obligation to view the Other with positive regard.[24] An agonistic model of politics will certainly not deliver everything one might want regarding human relations, but it may suffice for *political* relations. Political justice is better suited to protecting rights, guaranteeing fair procedures, and preventing human abuse than it is to prompting and enforcing ethical regard or beneficent attitudes and behaviors. The political sphere does fill in some gaps in ethical regard with institutions that enact and enforce certain norms, but without the requirement of psychological compliance on the part of citizens. The very existence of political institutions indicates that people are *not* always treating each other with ethical regard, that there *are* differential distances

between people. This of course connects with Marx's diagnosis that government institutions are a sign of social "alienation," wherein the human species is divided from itself since people have not yet tapped their capacity for cooperative, mutually supportive social relations.[25] An agonistic democracy can acknowledge such a diagnosis and yet renounce Marxian prospects for organic socialism in modern, developed societies. In this way, democracy affirms an inevitable need for institutions, and therefore an inevitable "alienation," that is to say, an inevitable *differentiation* in social life. In the bargain we avoid the terrible irony of communist experiments with Marx's supra-institutional vision that aimed for a holistic social order by means of centralized institutional controls that only magnified the forces of human abuse and terror.

The Nietzschean lesson here is that the most well-meaning conception of the good will become tyrannical if it attains control in the midst of finite conditions of existence that will inevitably include *resistances* to the perceived good.

> Mistrust all who talk much of their justice! Verily, their souls lack more than honey. And when they call themselves the good and the just, do not forget that they would be pharisees, if only they had—power. (Z II,7)

Agonistic democracy is the preferable arrangement for devising political rule, since as such it has no overarching conception of the good, and the sites of power that do unfold in democracy will always be unstable and susceptible to challenges from other power sites. In this respect a general conception of democracy should steer clear of visions that propose some *transformation* of the life world, and limit itself to less grandiose concerns of orchestrating the tensions and conflicts that mark the continual *formation* of political life.

Metanarratives and Democratic Politics

One consequence of our discussion is a connection with postmodern suspicions about metanarratives, or baseline comprehensive vocabularies about meaning, purpose, and goodness. We

should avoid conceptions of the political that depend upon, or are informed by, metanarratives. Why? First of all, postmodern nonfoundationalism subverts any justification for the "truth" of one metanarrative over others. Secondly, the subsequent perspectival pluralism is more than simply a coexistence of different narratives; different beliefs are constituted by an agonistic relation with each other, with each opposing and checking something in the other. This makes particular narrative meanings *ambiguous*, in that there is always something excluded or marginalized that nevertheless persists in registering its effects. Whatever meaning is asserted, it will not escape contention from, and even complicity with, its Other. So one reason for being suspicious of "big" words in politics—emancipation, community, individuality, unity, diversity, and the like—is not simply because of a nonfoundationalist critique, but also a recognition that the *meaning* of such words is far from clear, since political life shows continual countergestures that disrupt their focus. Thirdly, the power of institutional coercion in politics makes the issue of metanarratives more than just an intellectual exercise; there are real dangers of oppressive effects on people's lives.

Divorcing democracy from metanarratives, however, is itself ambiguous. From the standpoint of political *philosophy*, wherein we reflect on the overall structure of the political order, metanarratives should be suspended in favor of a procedural model that is "neutral" with respect to baseline meanings, except for those norms and principles that are presupposed by democratic procedures. Political *practice*, however, is a different story. Here we cannot slip into an anti-narrative posture that is suspicious of narratives in political discourse and campaigns. Any and all narratives should be invited to compete in the political contest for contingent rule, and they should be free to frame their discourse in any way that suits them. Democracy demands narrative neutrality, but democratic practice cannot be neutral.[26] A proposal for "value-free" political discourse is not itself value-free; it depends upon a particular narrative about politics, a preference for "objective rationality" in the order of human capacities, and the insistence on a common vocabulary for

the public discussion of political issues.[27] Equally suspect would be a postmodern proposal for "nomadic" citizens who are not tied to any particular narrative, or for keeping narrative commitments "private," secluded from the public sphere. Postmodern democratic discourse ought to be wide open, so that any narrative can compete in the public square on its own terms. Any political victory that a certain viewpoint might attain, however, can never be described as anything more than that, a temporary win in an ungrounded contest for political authority. No victorious narrative is entitled to *define* its authority in terms of its own vocabulary, nor is it entitled to elevate its vocabulary to a universal status and claim victory for "democracy," "the people," "the nation," "humanity," "freedom," and so on. As Lefort says, democracy creates an indeterminate public space that "has the virtue of belonging to no one."[28]

Affirming the participation of different narratives in democracy forbids them status as *meta*narratives but grants their importance *as* narratives in the life of politics. There are two main reasons why political practice cannot and should not be "narrative-free." First, all citizens' lives are informed by certain scripts that depict different perspectives on life. Political participation divorced from such narratives would be vacuous and inauthentic.[29] Secondly, different narratives, although not exhaustive, contribute important and relevant perspectives on political matters. In fact, the conflicts and tensions between different scripts not only show the folly of metanarrative reductions, they also display in their countermovements the ineradicable ambiguities and complexities of political questions that will not be resolved in any stable consensus or single line of thinking. Let me explore this point by first listing a number of broad narrative categories that have marked various political theories and that have figured in political orientations in different ways and to different degrees. They all tell different stories that depict meanings, diagnose problems, identify agents or conditions that cause the problems, and propose solutions that eliminate, transform, or mitigate the causes. The script of each story has protagonist and antagonist elements, since each narrative is contending with an Other—and notice how each Other can be located somewhere on the list.

Significant political narratives include such identifications as the following: religious, aristocratic, authoritarian, egalitarian, socialist, communist, fascist, conservative, capitalist, liberal, libertarian, communitarian, multicultural, feminist. Within many of these, there are also teleological scripts that promote progressive developments in moral, social, scientific, technological, or economic spheres. With a brief discussion of this complex of narratives (some elements of which will be developed further in the next chapter) we will add to our understanding of postmodern democracy as a metanarrative refusal. Each script is unacceptable as a metanarrative, but important as a *competing* narrative in the political field of play. A reduction to any one script would omit or suppress something important; indeed, each script is challenging exclusions or over-sights in other scripts. Each script is therefore politically relevant but limited, marked by trade-off, and hence susceptible to counter-movements from other scripts. Democracy itself acknowledges the global openness of politics by committing itself to no narrative other than a "letting-compete" of different narratives for contingent decisions and authority. Democratic openness in my sense, however, is not "empty," since it encourages and thrives on the *interaction* of different perspectives, their mutual challenges and responses, which displays their constant oscillation in various social concerns;[30] such a dynamic fosters the *enrichment* of political discourse by enacting the ambiguities, complexities, and tensions that mark the social world. The existence of competing narratives is therefore *constitutive* of political discourse; the problem in politics is not conflict, but the reductive promotion of any one script into a metanarrative.

Consider the following set of interplays and counterplays that portray the complex oscillation of political narratives we have identified above. Each movement expresses something important about political life that nevertheless becomes problematical when reduced to a baseline reference that marginalizes other narratives, which then stimulates countermovements from these narratives that nevertheless contain their own reductive dangers, and so on. Religious narratives disclose a sense of ultimate meaning and

purpose that still inform most people's lives—despite the "death of God." Such scripts are bound to influence political thinking, but the obvious danger is a theocratic reduction that has rightly been challenged by liberal and multicultural narratives. The notion of a separation of church and state is a great gift to politics, since religious commitments—*because* of their profound importance to people and the element of undecidability—have been a significant source of oppression when joined with political power. This is one sense in which modernist writers have prefigured a postmodern suspicion of metanarratives. The separation of civic interests from religious interests was in part a recognition of the dangers in "grounding" human belief when it comes to nondemonstrable areas of thought.[31] Civic "neutrality" concerning religion, however, has often spilled over into civic indifference or hostility toward religion, where citizens are expected to filter or suppress their religious beliefs in "public" affairs. Communitarian narratives have rightly argued that citizens cannot be expected to keep their deepest sense of self "private," since that would amount to a kind of political schizophrenia or a bogus conception of public discourse.

The communitarian idea that the human self is social by nature and informed by its traditions is an important counterweight to liberal individualism and suppositions about context-free rationality.[32] The danger of collective envelopment of the individual, however, rekindles liberal and libertarian narratives, along with multicultural narratives that seek to protect particular cultural orientations from being cancelled out in favor of a universal conception of community. The dangers in both communitarianism and multiculturalism can be located in their proximity to fascism, which was partly characterized by a reaction against Enlightenment universalism, individualism, and rationalism, in favor of fostering a particular cultural tradition and protecting its identity from consumption by modernist forces.[33] The significant dangers of fascism are well known, and they can be understood as a movement from a diversity narrative into a reductive tribalism and supremacism, from a communitarian narrative into a collective tyranny, from an authoritarian narrative—banking on the importance of

leadership in politics—into autocratic dictatorship, and from a postmodern suspicion of rationality into a virulent primitivism and biologism. In this light we can understand why communitarian, multicultural, and fascist narratives alike have excited challenges in different ways from liberal, egalitarian, socialist, and communist narratives.

The connections between liberal, conservative, and capitalist scripts open up further political oscillations. Capitalism is in part wedded to individual freedom from government control and from entrenched traditional social forces; the free market is meant to replace landed aristocratic arrangements with an open invitation for economic initiative and talent to test itself in the marketplace. Marx himself acknowledged the liberating effects and productive advances of capitalism,[34] but socialist and communist criticisms are built on the recognition of systemic inequities, exclusions, and manipulations that follow from unregulated economic freedom. The concentration of wealth and the cleavages between capital, labor, and consumption call for centralized management to redress economic deprivation and the debasement of human work. The laboratory of history, however, has born out the dangers and deficiencies in socialist and communist narratives, in their excesses of bureaucratic controls and suppression of individual achievement, creativity, and freedom—which has thus rekindled capitalist and libertarian narratives.[35] The experience of communism is an effective illustration of the Nietzschean paradox that an attempt to overcome suffering produces new cruelties that perpetuate suffering. We cannot forget, however, that communism and socialism are important responses to real conditions of suffering; a crude reversal in the direction of discrete capitalist or libertarian scripts is not the answer to the reductive dangers of a controlled economy. Again, from a Nietzschean standpoint *all* narratives are dangerous.

Political conservatism has an ambiguous placement in all of this. It shares traditional liberalism's commitment to individual freedom from government interference, but it also has lent itself to certain religious and communitarian narratives by touting the importance of tradition and sacred meanings over a kind of secular humanism

and individualism (which is why fascism had conservative elements). Attention to economic matters can help unravel some of the ambiguity, though. Conservatives are often comfortable with government enforcement in certain normative areas, but vigorously opposed in economic areas. The convenience of conservative connections with religious otherworldliness is obvious here: One can stand for the cultural importance of Christian values, for example, but at the same time affirm decidedly unchristian elements in capitalism by dismissing the notion that "this world" can ever measure up to the perfection of the world to come. Another paradoxical convenience that Marx stressed occurs when the Christian ethic of loving your enemies is combined with the expectation of rectification in the afterlife. This combination gave capitalists a whole lifetime of breathing room from rebellion by the dispossessed. The religious connection helps explain why conservatism has been challenged by liberal, socialist, and communist narratives that otherwise have significantly diverged from each other.

We need not address the oscillations between aristocratic and egalitarian narratives, of course, since this entire study has focused on that dynamic. Final mention should be given to significant contributions to political philosophy from feminist thought, which shares many elements of other narratives but distinguishes itself by identifying patriarchal reductions and exclusions in *all* previous political stories. Feminism, however, faces the danger of instigating new exclusions, polarities, and oversimplifications in political discourse; and feminist thought has been marked by its own oscillation between a concern for gender equality and an affirmation of gender differences.[36]

In the end we should define democracy as an invitation to any and all narratives to compete in the public square, and we should prefer such an agonistic politics over one that designates any one story or group of stories as a measure of the public good. Some of the narratives we have mentioned, of course, are democratic in nature, but they suffer from certain reductions, omissions, or exclusions that prompt questions of adequacy. Of all the narratives,

liberalism is the most democratic, I think, and it lies closer to the kind of open political dynamic promoted in this study. Significant questions arise, however, concerning liberal assumptions about selfhood, rationality, freedom, equality, and issues pertaining to the public and private spheres, all of which opens up challenges to liberalism from just about every other narrative on the list. On the other hand, some of the scripts that have called themselves democratic are surely not, or at least are inimical to democratic practice. One reason for such confusion (or obfuscation), is the essential ambiguity of key political terms like freedom and equality. In one sense, debates between liberalism, conservatism, socialism, and communism are contests about the *meaning* of freedom and equality—for instance, freedom to succeed vs. freedom from want, equal opportunity vs. equal condition, and so on.

So it is not merely the danger of coercive closure and domination that recommends democratic openness, but also the ambiguity of political discourse. A system of agonistic exchange allows politics to benefit from exposure to all important meanings without privileging any of them in essential terms. Accordingly, politics is the continual interaction of competing forces, ambiguous meanings, and unstable signifiers: individual freedom, order, authority, law, equality, inequality, fairness, excellence, inclusions, exclusions, the sacred, the secular, tradition, innovation, economic freedom, responsibility to human needs, individuality, and various group identities pertaining to race, class, gender, ethnicity, age, occupation, and so on.[37] Consequently, democracy should be characterized as the *absence* of a baseline political story, unless we say in negative terms that the story of democracy is that we do not have a primal political story—not even the supposedly "negative" story of liberalism and conservatism: the emancipatory keep-the-hand-of-government-out-of-our-lives story, which is not without its own reductions and ambiguities that elicit responses from other narratives. The script of democracy should be limited to our commitment to procedures and principles that give all stories a hearing in the episodic production of contingent themes and orders in political life.

Politics and Teleology

Various political narratives have been teleological in the sense of proposing some overall purpose in political life, some progressive development of the human condition in moral, social, scientific, technological, or economic terms that politics can help advance. Nietzsche's philosophy, of course, is decidedly anti-teleological; the idea of purpose in the world is repudiated[38] and the accompanying belief in progress is also dismissed.

> Mankind does *not* represent a development toward something better or stronger or higher in the sense accepted today. "Progress" (*Fortschritt*) is merely a modern idea, that is, a false idea. (*A* 4)

To say that Nietzsche opposes any sense of purpose, however, would be a mistake, since he declares that humanity cannot live without some sense of meaning and purpose in life (*GS* 1). I think we can say that Nietzsche affirmed the creation of *local* senses of purpose, but that he refused to acknowledge any *global* purpose in existence; the overall course of life is an unstructured chaos (*GS* 109) and is governed by chance (*Z* III,4).[39] The main reason for Nietzsche's opposition to teleology is that a purpose implies an end point of some sort, a resolution of becoming into a state of being (*WP* 708). For all its interest in movement and development, the promotion of a *telos* amounts to a self-consuming movement, since an *achieved* purpose is no longer an "end" in the sense of an aim, but the *end* of movement, the cessation or restriction of development. That is why Nietzsche considers his anti-teleological outlook to be a baseline affirmation of freedom and creativity.

> The absolute necessity of a total liberation from ends (*Zwecken*): otherwise we should not be permitted to try to sacrifice ourselves and let ourselves go. Only the innocence of becoming (*die Unschuld des Werdens*) gives us the *greatest courage* and the *greatest freedom*! (*WP* 787)

The innocence of becoming challenges the very beginnings of Western philosophy and religion—represented primarily by Platonism and Christianity—wherein finite worldly existence is portrayed as a primordially flawed or fallen condition that can only

be repaired by a radical transformation afforded by an ascent into a transcendent, eternal domain. According to Nietzsche, such transformative/reformative beginnings nourished comparable habits of thought that show up in secular, social, and political movements even when Platonic and Christian belief systems are no longer overtly professed (*WP* 339); now worldly progress, rather than aspirations for transcendence, is the site of existential reform. We can sense such progressivism in all sorts of narratives promoting a historical movement that resolves some primal deficiency: from domination to emancipation, from strife to harmony, from exploitation to cooperation, from ignorance to knowledge, from passional self-interest to objective rationality, from subjection to nature to control of nature, from technicity to poetic dwelling, from alienation to integration, from difference to identity, from disparity to a common good, from deviance to normalcy, from homogeneity to heterogeneity, from religion to humanism, from humanism to religion, from want to prosperity, from bourgeois consumerism to aestheticism, and so on. The teleological structure of such movements is what Nietzsche would oppose and what presents political dangers. Once we clearly identify a "flaw" and construct a line of thinking toward its erasure or reform, once this trajectory is the definitive outline of the good, then any persistence of the flaw or resistance to reform can be demonized and justifiably suppressed. Nietzsche's anti-teleological orientation provides a global guarantee for freedom and innovation, which can protect politics from the trap of closure in the name of rectification.

8

Selfhood, Rights, and Justice

Human Existence and the Political Sphere

Political theories have usually incorporated reflections on human nature in their considerations of a just social order; and rightly so, since a political structure that clashes significantly with elements of the human condition will not fare well. Usually such reflections have been concerned with the nature of the "self" or the "person," and the key problem has been the relationship between individuality and sociality, particularly with respect to tensions between freedom and order, emancipation and control, self-interest and responsibility, singularity and group identity. Various attempts to bridge or coordinate such forces have been attempted, and we will concentrate on the following influential paradigms that bear on the question of human nature: universalism, multiculturalism, individualism, and communitarianism. The relationships between these paradigms are complex and often ambiguous. By universalism is meant the Enlightenment affirmation of something common in the human condition that surpasses natural and cultural differences, especially the rational mind's capacity to apprehend comprehensive and necessary truths. Multiculturalism is the particularistic

countermovement that affirms different group identities rather than a common human nature. Individualism names the liberal model of the human self as a free, rational, atomic individual that is only secondarily associated with group affiliations. The connection here with Enlightenment universalism is shown in reason's capacity to liberate the individual from dogmatic traditions and their entrenched social controls. Communitarianism is the countermovement that sees the human self as essentially social in nature and inevitably informed by traditions in certain ways. The ambiguity of communitarianism is that it can attach itself to either universalism or multiculturalism, depending on how far the collective transcendence of difference is taken to extend.

Such outlines have been operative in political narratives that privilege certain social arrangements in accordance with their respective models of human selfhood. However, the reductive dangers attaching to these narratives that were analyzed in the previous chapter are no less evident in their conceptions of selfhood and human nature; and again, a Nietzschean perspective allows us to intercept these dangers with a postmodern self that is decentered, ungrounded, and contextualized. Accordingly, the "negativity" of an agonistic pluralism will once again pay dividends in avoiding the distortions, omissions, and cancellations entailed in more "positive" constructions of selfhood. For example, the emancipatory universalism championed by the Enlightenment project wound up being suppressive of freedoms in various ways, as we have seen. While the liberation of the rational individual did have an emancipatory effect, nevertheless scientific rationality generated a host of disciplinary regimes, normalization techniques, and bureaucratic controls that tended to overpower human individuality and heterogeneity. Moreover, the Enlightenment promotion of a universal humanity was in many ways a sham, since it was a *disguised* ethnocentrism that cashed out in practice as colonialistic paternalism and cultural genocide. One can therefore decode grand rhetorical phrases like "We are all the same" and sincere pronouncements like "We are here to free you for your humanity" into the following offer: "Be like we Europeans—or else!" Undercutting

universalism thus opens up space for affirming and protecting individual and cultural differences.

The celebration of differences, however, is not without its own reductive dangers. Multiculturalism can slip into a myopic tribalism, which gravitates from proclamations like "We are not all the same" to the more insular "We have nothing in common" or, more subtly, "You cannot understand our world." With such movements an indifference toward, or dehumanization of, other cultural groups can become almost effortless.[1] Individualism, of course, is always a challenge to the social order, in that it either promotes or permits an atomistic concentration on self-interest, and it creates structural and psychological obstacles for legitimizing social projects.[2] Communitarian challenges to liberal individualism are therefore important, but the danger here is the emergent category of "deviance" in the wake of individual resistances and departures from a given group identity or set of common values.

The problem is not individuation, group associations, or social networks, but rather the reductive grounding of "human nature" in any definite condition or identity, whether it be universal, social, or individual. Identities of all sorts—wherein we *identify* who or what we *are* by means of signifiers that are *identical* with our *nature*—are reductive and exclusive of *difference*, of that which is *other* than identity.[3] In the end, the nature of the human person should not be reduced to *any* category, even to "individuality" or "difference." What is needed is a sense of human existence that can celebrate a dynamic openness, which is neither suppressive of differences on behalf of cohesion nor limited to differences on behalf of diversity. The human self is a complicated interplay and tension between individuation, socialization, identification, and differentiation that is not resolvable into any discrete or stable reference. In affirming these tensions we can include their oscillations in political reflections without installing the reductions that render politics either too controlled or too unhinged.[4]

An agonistic conception of democracy has the advantage of sidestepping all problematic identities, since it is neither a universalistic erasure of differences nor a tribalistic reduction to group

differences nor an atomistic reduction to individual differences. Democracy can be none of these things because it is a *social* arrangement that orchestrates an ongoing *interplay* of differences instigated by a sustained *suspicion* of truth claims and identities. The postmodern modification of traditional democratic theory can be understood as the sifting out of elements that wind up undermining a democratic dynamic—a hyperbolic liberal individualism, rationalism, and neutralism; a conservative or communitarian nostalgia for harmony; a majoritarian overconfidence in group decisions; a multicultural insularity—leaving us with an oscillating agonistics in remainder as the heretofore overshadowed element that defines and perpetuates a *working* democracy.[5]

To close this section, a few words about the American experience in relation to postmodern openness. Although American democracy in its formation was built from modernist ideals born in the Enlightenment, if we take into consideration historical context and happenstance—in relation to European traditions—we might be able to see the emergence of American culture as a workshop for the kind of identity oscillations we are addressing here. The American motto *E Pluribus Unum*, which originally referred to the idea of one republic out of thirteen states, eventually was broadened in the wake of massive immigration to include the sense of one nation drawn from different cultural backgrounds. Both historically and geographically, America was able to define itself as new and set apart from previous traditions—having no long history of cultural fixtures, no single set of myths, legends, or exemplars, no single church, no single set of habits, memories, or common roots.[6] Although American pluralism can be connected with Enlightenment universalism, which theoretically opened space for an inclusive ideal, nevertheless universalism, as we have seen, was informed by certain intellectual and cultural biases that were not in fact truly "open." An Anglo-liberal-rationalism was in place to create the force of "assimilation," which, as implied in the famous "melting pot" metaphor, suggested that the cultural identities of immigrants be melted down (to be poured into an Anglo mold). Although American culture never became fully homogenized, nevertheless assimilation

represented a bogus, vacuous pluralism that has been challenged by
multicultural movements, which in turn have created worries about
a hyperdiversified politics.

If we attend to the concrete, existential phenomenon of immigra-
tion, however, we can notice the contours of a postmodern open-
ness that is neither too homogeneous nor too heterogeneous. The
"uprooting" and "embarking" that characterizes immigration and
that has marked the experience of all peoples coming to America—
leaving aside African slaves and Native Americans, which is another
sorry story altogether—gives us a sense of frayed identities reaching
an "empty" space that can receive them all since it is defined by
none. Each identity consequently would have to engage a balance
between the following conditions: 1) the loss of fixed attachments
to one's home culture, 2) the uprooted remembrance and retention
of one's cultural heritage, and 3) a coexistence with other deraci-
nated identities. Such a balance represents an intermingling of
identity and difference that is not reducible to any one identity, a
mere aggregate of identities, or a merging of identities—an inter-
mingling captured, I think, in the alternative metaphor of a "stew."

The Unstable Self

We can take a lead from Nietzsche's analysis of language in
exploring the meaning of selfhood in a postmodern orientation.
According to Nietzsche, in all the periods of his writing, linguistic
structures falsify or distort the uniqueness, complexity, and fluidity
of lived experience.

> Our usual imprecise mode of observation takes a group of phenomena
> as one and calls it a fact: between this fact and another fact it imagines
> in addition an empty space, it *isolates* every fact. In reality, however, all
> our doing and knowing is not a succession of facts and empty spaces
> but a continuous flux. . . . The word and the concept are the most
> manifest ground for our belief in this isolation of groups of actions: we
> do not only *designate* things with them, we think originally that through
> them we grasp the *true* in things. Through words and concepts we are
> still continually misled into imagining things as being simpler than they
> are, separate from one another, indivisible, each existing in and for

itself. A philosophical mythology lies concealed in *language* which breaks out again every moment, however careful one may be otherwise. (*WS* 11)

We no longer esteem ourselves sufficiently when we communicate ourselves. Our true experiences are not at all talkative (*geschwätzig*). They could not communicate themselves even if they tried. That is because they lack the word. Whatever we have words for, that we have already got beyond. In all talk there is a grain of contempt. Language, it seems, was invented only for what is average, medium, communicable. (*TI* 9,26)[7]

Nietzsche faces a certain difficulty here in supposedly counterposing linguistic formations against a nonlinguistic experiential flux. We have to wonder about the status of *his* language in this regard, of words like "experience," "flux," and so on, and whether the word "falsify" falsifies what language supposedly does.[8] Rather than completely segregate language from some primal flux or indeterminacy, Nietzsche's critique can be better directed at certain types of linguistic usage—particularly substantives—and how they tempt us into dividing thought into discrete categories that cover up the unstable movements of language that help disclose our experiences. The *oscillations* of linguistic meanings can then be the focus of a Nietzschean preference for "becoming" over "being." Moreover, the Nietzschean idea of a primal "chaos" need not indicate some utterly formless disorder, but rather the recognition that the frequent and continual disruptions and breaks occurring in the oscillations undermine the idea of a *global* order that can organize or harmonize the whole.

The specific issue of human selfhood can be addressed in the same way. We can draw from existential finitude a nonfoundational approach to the self, in that human existence dwells in conditions of becoming and limits, which from a global standpoint suggests a kind of formlessness and abyss.[9] We find no "ground" for personal, social, and cultural identities. At the same time, we can avoid *anti*foundational hyperbole by attending to the oscillation of meanings that makes the self neither fixed nor chaotic, but simply "unstable" in the continual transpositions that constitute human engagement.

Modernism inherited a longstanding philosophical habit that insisted on fixed and clear definitions that allow the "location" of things in their "being" as distinct from something "other."[10] In its historical context, modernism was promoting free inquiry, liberation from dogmatism and traditional controls, and was also concerned with the normative problem of responsibility and legitimation in the social order. What arose from this, to satisfy definitional fixation, was the modernist conception of selfhood: the "subject" defined as a free, rational, responsible, individual agent—distinguished from its Other: that which is controlled, irrational, determined, and collective. The postmodern critique of modernist subjectivity targets the omissions, contradictions, and ironies detected in such a conception of selfhood. When we emphasize *free agency* as a site of responsibility, we overlook the complex ambiguities of human action in the midst of contextual forces; we thereby can target "agents" as the origin of problematic or deviant behaviors, and we can appeal to these agents to adopt techniques of *self-control* for their own good (and ours). At the same time, modernist *rationality* opens up avenues of scientific analysis that can erase human freedom in the light of deterministic explanations and assumptions about environmental and social conditioning, which opens up extrasubjective sites of origin and techniques for systemic control of individuals in the name of reforming problematic or deviant behaviors (again). Finally, emphasizing the *individual* self overlooks sociality and instigates the problem of legitimizing social and political structures. Certain modernist responses to individualism, however, simply widened the location of the subject in the manner of a collective self, the communal force of which could override resistance in the name of the individual's "true" being.[11]

The postmodern self should be understood as an agonistic complex of forces and meanings that are in continual oscillation, that cannot be "located" in any stable site or organization of sites.[12] Human persons are a dynamic mixture of transversing and adversing elements: voluntary actions, natural constraints, reasonings, instinctual drives, passions, agent responsibilities, social conditionings, innovations, traditional influences, conformities,

abnormalities, individuations, social relations, group associations, private and public concerns. Attempts to locate selfhood in any of these elements apart from others can be traced to intellectual laziness—to attend to complex relations is hard and laborious work—or to a negative incapability that cannot abide finite limits and the threats to one's site posed by the force of an Other. An ungrounded dynamic does not, however, make the self vacuous or chaotic. The ongoing flux of the elements is episodically ordered and contoured by way of different movements and countermovements, which permit moments of judgment about appropriate and inappropriate interpretations or outcomes. Such judgments will be complex and difficult, and will not be immune to doubt, disagreement, and ambiguity; but as long as we sustain a contextual analysis, we can avoid both an anarchistic denial of judgments and the reductive, exclusive, and intrusive judgments that stem from metaphysical (metacontextual) criteria.

Surely, for instance, there are countless situations in which attributions of individual agency and responsibility make sense and can be implicated in judgments about human behavior; but there are also situations in which ignorance, compulsion, or constraint render responsible agency inappropriate; and then there are grey areas where we cannot be clear about sites of responsibility. On the one hand, there cannot be a legal system without some sense of accountability for actions, and we have to be able to attribute successes and failures to people's efforts and abilities in some way. On the other hand, natural, social, and environmental conditions often impede or ruin people's lives, so that "responsibility" for failure can often be shifted from individual agents to these conditions. We cannot fall prey, however, to simplistic accounts of human selfhood and action that would claim to explain behavior in terms of definite characteristics or causes without remainder.[13] In most cases, successes and failures cannot be traced to *discrete* locations of individual agency or supra-individual forces. No one can claim full authorship for an action, since the network of influences is vast and elements of luck and happenstance are always in the mix; at the same time, our actions are rarely fully beyond our

control. So "responsibility," in the sense of how and why people's lives turn out the way they do, is a limited, complex, and ambiguous conception that is enormously easy to misuse, especially when conservatives prattle on about choice, initiative, and the culpability of the poor, or when liberals try to detect victimization at every turn.[14]

On another issue, the debate between liberal individualism and communitarianism should be seen as an agonistic correlation that can be negotiated contextually, rather than as a contest for the proper model of human selfhood. Atomic individualism, as we have seen, is unsustainable because of the sociality of human experience; at the same time, some social relations are agonistic, so there is space here for individuation rhetoric, especially in the context of creativity. Politically speaking, the value of liberalism lies in its battle with social and governmental forces that move to control or consume individual lives. Even Nietzsche noticed the value of liberal appeals for freedom in the context of such a struggle (*TI* 9,38). When liberalism goes beyond this context to construct a "self" appropriate to its setting, however, philosophical problems arise and openings are created for communitarian rhetoric. The debate is really over the *extent* to which freedom, privacy, and self-interest are appropriate in the social order. Liberalism has never actually implied sheer individualism: social constraints and obligations have always been recognized; democratic dialogue and the binding results of elections suggest something extra-individual; social responsibility has become a significant ingredient in modern liberalism. The strength of communitarianism is that it asks us to fold some of this sociality into reflections on selfhood. Social configurations and structures need not be an "appendage" to the self; social controls are not always a violation of freedom or a necessary evil.[15]

The liberal division between the public and the private is fraught with difficulties. For one thing, it gives appeals for social responsibility a decidedly contingent ring. In addition, it overlooks the extent to which the private sphere itself is constituted by, and intermingled with, social and political elements. Whatever private

projects we pursue are made possible by forces of socialization (at the very least by the learning of a language). Moreover, any confidence we have in affirming the importance of privacy over the public sphere shows that certain political forces have succeeded in *protecting* privacy to the point where such forces have become "invisible," but surely not on that account absent. We cannot forget how "personal lives" have become informed and protected by certain political norms—consider the quality of personal lives in societies that lack such norms or that have suffered complete political breakdown.[16] In addition, behaviors in the private sphere often need to be challenged and scrutinized by civic incursions, as in the case of domestic violence and abuse. Finally, there are "communities" of all sorts that sustain and characterize individual lives: familial, ethnic, professional, and other associations in civil society. However, one problem with communitarianism, as we have seen, is that we do not know which community should count or have priority, especially since some community associations conflict with each other in an individual's life, which is one reason why we should be suspicious of the idea of a community as a stable measure. Communitarianism also overdetermines organic and group elements at the expense of individual freedom and resistance.[17] So *no* community, wherever located, should ever be immunized from the disruptive effects of individuation. Accordingly, community, individuality, the public, and the private are ultimately unstable signifiers that continually respond to intertextual movements and countermovements. And this is not so much a "new theory" as a phenomenological description of social life.

Of all the elements of selfhood, the one that might carry the greatest weight in a postmodern analysis is what can be called *singularity*, which gets us close to the sense of personal selfhood that existentialist writers have emphasized (something different from liberalism's "rational individual"), but which is also intended to name the excess and remainder at the edges of all unstable signifiers—in other words, singularity names each person's own unique, irreducible, nonlocatable, elusive existence in the midst of finite becoming. Singularity, therefore, is the ultimate "difference"

or "otherness" of the self that cannot be fully captured by *any* human category, because each self exists as the oscillating interpenetration of all these categories; and this not only makes human selves unstable, it makes it impossible to talk of selves as the "same," since the movements are so complex and variable as to never issue equal permutations.[18] When describing a human person, then, there is always "more" to the matter than we can say—more in the sense that to any reference (e.g., "criminal") must be added the potential for change and the relevance of other, often contrary references; also in the sense that any reference in its *abstract* form will pass over particular variations in the individual. In this way singularity ultimately eludes our grasp, but at the same time it is each of us in the concrete.[19] Here I want to rehearse for a third time the point that postmodern "negativity" is different from notions of absence or indeterminacy. Our postmodern analysis of selfhood is negative only in the sense of insisting on the *limits* of all constructs, the *potential* for innovation and change, the *openness to* "difference," and the *openness of* "identity." Our analysis therefore refuses to bank on traditional political notions such as equality, the general will, the community, the common good, and consensus, because they cannot help being exclusionary in the midst of differential otherness. Such refusal, however, does not leave us lost in an empty nothing; since the postmodern self incorporates contextual and performative content, we can redescribe its negativity as a dynamic and rich intricacy.

Rights

At this point we can take up the crucial question of rights in the light of previous discussions. The hope is that a procedural model of democracy and the analysis of unstable selfhood can provide an adequate postmodern perspective on rights that can satisfy the needs of a democracy, while avoiding certain modernist assumptions that have become questionable. A postmodern deconstruction of "natures" and "essences" would seem to dismantle traditional vocabularies for human rights, where rights are inviolable individ-

ual "possessions" based in some universal conception of "human nature" or human "equality." Rights can be redescribed, however, as functional and practical relationships that are *conferred* upon human beings in the social order, and not as something "natural," as individual possessions that stem from certain truths about human beings.[20] Rights are *social* phenomena that are nothing without recognition and the obligations they entail; and they are *political* phenomena that must be conferred upon people and guaranteed by the power of the state. The philosophical question, of course, is: *Why* grant rights to people? The Nietzschean negativity motif that runs through this analysis can continue to work here, in my view. Rights can be defended by way of the *absence* of decisive truth in politics and the *absence* of essences in human nature.[21] In the discussion to follow, we will concentrate on what can be called *civic* rights and *existential* rights.

Civic rights are those that follow from democratic operations, and that therefore need to be guaranteed *for* politics. Civic rights need not adhere in the strict sense to "persons," rather they can be seen as emergent upon an affirmation of democratic arrangements. To traditional person theory, such an approach might seem merely instrumental, but we can say alternatively that civic rights are intrinsic to *democracy*. This gets us around the thorny problem of "natural rights" because we can say that democracy does not stem from accepting a prior conception of rights, but that rights stem from accepting democracy in an ungrounded atmosphere without "natures."[22] Civic rights would simply name the guarantees that are necessary for political *participation*, which would include freedom of expression, freedom of association and assembly, and access to all political procedures and institutions. Such guarantees against exclusion or control fit what are sometimes called "negative" rights, but participatory requirements would also include so-called "positive" rights that demand some provision by the state or community, such as the right to an education, to a certain level of economic sustenance, and to public dissemination of political information and discourse. Negative rights can be defended on the grounds that we have no grounds for excluding people from

participation and that politics would not *be* democratic without such rights. Positive rights can be defended on the grounds that political agonistics demands an atmosphere of fair competition that such provisions are meant to foster. If democracy is affirmed as an open discourse contest for political decisions, then certain freedoms and provisions cannot be denied without retracting a commitment to democracy.

Existential rights in many respects overlap with, and are implicated in, civic rights, but they are extended to include pursuits and settings that are distinct or separate from political practice, and that therefore are to be protected *from* politics, in the sense of restricting government power and interference in citizens' lives. Existential rights approach what are sometimes called "human rights," except that the former construction can sidestep certain loaded assumptions about "human nature," and it can also extend more easily to nonhumans, as in the case of certain rights that might be conferred upon animals. Existential rights include the right to life, to own property, to pursue one's interests, to freedom of movement, to safety (protection from harm, abuse, or cruelty), and to justice (fair treatment and access to resources in the legal system).

Both civic and existential rights must be honored and guaranteed by the state, and therefore also limited by the state when citizens in the exercise of their freedoms restrict or erase the rights of other citizens. It should be added in this regard that rights have certain agonistic features. First of all, rights are different from mere liberties in that a right entails the obligation of others to respect that right, and so a rightholder has a certain claim *against* certain treatments or *for* something that might be *denied* by others.[23] In this way, rights can be associated with conflictual power movements, which, as a matter of fact, is how Nietzsche characterizes rights.

> That is how rights originate: recognized and guaranteed degrees of power. . . . The rights of others constitute a concession on the part of our sense of power to the sense of power of those others. (*D* 112)

Secondly, in certain settings rights themselves are conflicted, when one person's right might restrict or diminish that same right or a

different right for another person, for instance when property rights interfere with safety rights or positive civic rights. Political and judicial responses to such conflicts show the limits of absolute or substantive characterizations of rights. A more pragmatic and contextual approach permits us to adopt a nondogmatic method of "ad hoc interest balancing"[24] when it comes to the enactment of rights.

Rights therefore display categorical oscillations comparable to the political dynamics we have been analyzing, so that rights should not be fixed or grounded in any discrete references, but open to intertextual and countertextual social movements. In this way we can listen to communitarian and Marxist critiques of the liberal doctrine of rights—that it is grounded in individualistic biases—but we should not go so far as to ignore the wide range of circumstances in which individual citizens need protection against controls and abuses that are often grounded in communal biases.[25] The social and political dimension that is indigenous to any talk of rights, however, undermines the idea that they can be based somehow in a discrete individual subject.[26]

The notion of an unstable self subverts the grounding of rights in any identifiable "human nature." Indeed we can affirm civic and existential rights more readily and less selectively by working the negativity of the self *against* various groundings that are implicated in treatments presumably challenged by a conferral of rights. In social and political arenas, abuses or exclusions of people usually stem from confident classifications and reductions—"You are a . . . *woman*," a "*Jew*," a "*homosexual*," and "Women are ———," and so on. If, however, we take the human person to be ultimately *elusive*, to be a unique singularity who is unfinished, introspectively or subliminally concealed, and dwelling in the flux of finitude—all of these, by the way, are Nietzschean formulations—then we can disrupt the stable linguistic reductions that usually figure in exclusionary practices, i.e., categories of race, gender, class, function, and the like.[27] We can also disrupt our own identity fixations, from the vantage point of which other identities pose a differential threat and prompt the passions of fear and hatred that

spawn so much trouble in human affairs. Not that such categories and identities should play no role in self-understanding or understanding others; such designations and meanings are unavoidable and disclosive.[28] Identities can be challenged and limited if they are meant as substantive reductions or "essences" that aim to stabilize, segregate, or close the books on human persons. So objections to abuses and exclusions can stem from a *suspicion* of all positive attributions, rather than from the assertion of some discernible property or nature that all human beings share. Where the traditional approach to rights tried to base *in*clusiveness on some comprehensive construction (which was often unwittingly selective, as we have seen), a postmodern approach to rights simply works against *ex*clusions by undermining all constructions that presume to identify human persons for the purpose of omission or retribution.

We might call this approach a postmodern modification of the Kantian notion that rights follow from human freedom, that human beings have rights not in order *to* be free but because they *are* free. Postmodern freedom, however, can expand beyond a "grounding" in rational faculties or powers that liberate us from the constraints of physical nature (such was Kant's framework). We can declare a more radical notion of existential freedom: a release from all categorical reductions, so that no one can be "fixed" for displacement. Can we say, then, that rights follow not from what we *are*, but from what we are *not*? In this way rights can be affirmed in accordance with a postmodern nonfoundationalism and we can forgo problematic assumptions that attach to modernist conceptions of rights.[29]

Respect and Freedom

A postmodern approach to rights can also bear some resemblance to the Kantian notion of respect for persons, where persons are free ends in themselves and cannot be reduced to a means to my ends, as in the case of "things." The distinction between persons and things does provide a distinction between openness and closure, but

Kant's version of respect is itself tied to certain assumptions about human nature and the normative sphere that raise questions about the locus of respect. Whether Kantian respect is directed at persons in the full existential sense is not clear; more likely it is an abstract conception of freedom, reason, or the moral law that stands as the object of respect.[30] Moreover, there is a formalism in Kant's categorical imperative that bypasses concrete existential forces that operate in human relations. An existential perspective that draws on Nietzsche's analysis of finitude gives us a richer account of how and why human beings disrespect each other and what it would take to alter such attitudes. To be told formally that all persons deserve respect is not enough. We have to acknowledge conditions of conflict and the psychological resistances to a differential flux that prompt compressions within "truth" structures meant to repel, control, or eradicate an Other. An agonistic respect that affirms finitude, that affirms the Other *as* other, and that is predicated on an existential and intellectual modesty in the face of a veridical *openness*, can better address those human experiences in the midst of which respect and disrespect unfold. As was said in an earlier chapter, an inclusive respect for different viewpoints is more likely when truth is *in question* and when one can dwell affirmatively in this ungrounded atmosphere, less likely when there is conviction about a decisive truth of some kind.[31]

In any case, respect in a general sense is connected with freedom in that we release people to their own pursuits and participation in politics, without a requirement that we view them with positive regard. The question is, why should people be granted this freedom and how much of it should be allowed? Our postmodern *via negativa* has provided some answers, and we can continue the discussion by engaging Mill, whose liberty principle dovetails with our treatment in some ways. As we have seen, however, certain cultural and veridical biases attach to Mill's thought, and his principle might be overly stable on the side of freedom, disallowing any paternalistic intervention that might be warranted in some cases.[32] Moreover, the principle is ambiguous regarding its limits: People should be given freedom as long as they do not cause harm

to others;[33] or as long as they do not interfere with the freedom others.[34] The harm provision is the more problematical one, since the nature of "harm" might include indirect injuries or psychological effects.[35] Nevertheless, Mill's defense of liberty is important since it provides a modernist precedent that offers some ammunition for the postmodern argument undertaken in this study. We will concentrate on his defense of free expression, since it can apply directly to politics and also lead us to raise important questions about respect.

We begin with Mill's strong claim that any and all forms of speech should be permitted (barring speech that can cause direct harm, such as libel and incitement to riot).[36] The only way to truly confront the question of free speech is to consider your Other, indeed to engage the beliefs that rattle you the most. Free speech is never an issue when you love what you hear, and the range of the issue is missed until you hate what you hear. The question is, why should one want to permit presumably hateful or false speech? We want to borrow from Mill's answers[37] and find elements that accord with our discussion, while shifting from some of Mill's modernist confidence in truth to the more open, perspectival approach to truth that we have taken from Nietzsche. First of all, we are told, a banned belief might turn out to be true or partly true; plenty of historical evidence here, and though we might want to draw back from Mill's expectations about truth unfolding in an open exchange, we can certainly agree with his assessment that "all silencing of discussion is an assumption of infallibility."[38] Then Mill gives an agonistic analysis that fits our orientation well. All viewpoints emerge in a contest with other viewpoints, and so even if one's belief were decidedly true, the silencing of contrary views would eventually turn one's belief into an empty prejudice or a formalistic dogma devoid of its animated emergence as a response to opposing beliefs. Again, even if we hold off on the question of truth, and demur from Mill's attribution of differences in belief to human "imperfection,"[39] nonetheless we find in Mill the notion that beliefs are constituted in part by a contest with an Other. Indeed, the following passage is quite Nietzschean in its way.

It is illustrated in the experience of almost all ethical doctrines and religious creeds. They are all full of meaning and vitality to those who originate them, and to the direct disciples of the originators. Their meaning continues to be felt in undiminished strength, and is perhaps brought out into even fuller consciousness, so long as the struggle lasts to give the doctrine or creed an ascendancy over other creeds.[40]

The point is that we should affirm the participation of opposing beliefs in part as a recipe for the construction and sustenance of our own beliefs. If we add a postmodern suspicion about truth to such an agonistics of belief, we conclude that free speech can be defined as a willingness to contend with all beliefs in an open atmosphere of uncertainty. This means that free speech demands that we *risk* our beliefs by inviting opposition, rather than silencing it. Respect, therefore, can be couched in terms of this risky invitation.

This brings up an important question about the limits of respect. We have indicated that a democratic agonistic respect can be coordinated with a postmodern suspicion about truth, one's own beliefs included, so that a certain intellectual modesty will cultivate an openness to allowing all views a hearing in public debate. At the same time we noticed that agonistic respect can include vigorous opposition, and so it need not mean a relativistic tolerance. To be precise, then, we need to distinguish two kinds of agonistic respect for differing viewpoints: 1) *dialogical respect*, where I am open to other beliefs and to the potential alteration of my own beliefs; and 2) *antagonistic respect*, where some beliefs are not or no longer an open prospect for me, but I affirm their opportunity to contend for support in political discourse. Both forms of respect reflect, and are necessary for, a democratic ethos. Now, however, the question arises, should I grant agonistic respect if it is not reciprocated? Should I respect viewpoints that deliberately speak against pluralistic openness and democratic values? If I am committed to democracy, I would not likely have dialogical respect for such views, but I suppose I could muster up antagonistic respect. This, however, brings us to worries associated with the indigenous risk in agonistic respect. Why might we not forgo respect and even *forbid* decidedly antidemocratic convictions from participating in the political process? Democratic societies have not usually tended toward such

a restriction, in part because of a certain optimism that citizens would not rally to such convictions in great numbers. Nevertheless, this issue is still an important one because some democratic societies have voted themselves out of business (Germany in the thirties, Algeria recently). The question has many levels but we can focus on exclusionary views that speak against certain rights and authoritarian views that call for an end to democracy itself.

Let us take a racist platform as an example. Why should we respect or permit such a platform in democratic politics? First, if we have any confidence, we might have faith that an airing of such a viewpoint and vigorous opposition to it would weaken it in the public arena. Indeed, censoring a troublesome belief may only strengthen it in the minds of its proponents whereas full exposure may be the surest route to its demise or decline (how would those who deny the Holocaust, for example, handle all the voluminous records of human shipments and body counts kept by the Nazis themselves!). Such an airing would also approach Mill's point that commitments against racism might atrophy in the wake of a silenced opposition. Secondly, we might want to say, in accordance with perspectivism, that there is some truth in every viewpoint, even a racist one. This is a much more delicate idea, but I think it can be sustained. Racists at least display strong attachments to their own racial identity, something that by itself is not automatically heinous. We can also learn about the fears of otherness that give rise to racist agendas, with the hope that we might learn how to forestall or diminish them. Demonizing or silencing racists, then, may be of little help in a democratic project.

Of course what is at issue here are racist *beliefs* and not abusive actions that might follow from such beliefs. This, however, opens up the deepest problem. Why should we respect or permit political expressions that might seek to undermine certain democratic freedoms, rights, and, in effect, democracy itself? What if such expressions were to succeed in the political process? Why should democracy be open to its own demise? There are two answers to this question that I want to suggest, and both can be understood as responses to the kind of political philosophy undertaken in this

study. With a postmodern approach to democracy that is non-foundational and procedural, we might legitimately worry that theoretically *any* political result is possible in a democracy, even a dismissal of democratic principles. Without some sense of pre-procedural truth, we seem forced to accept the paradox that a democratic refusal of democracy would be democratic. Resistance to such a paradox would mark the *substantive* response to the question we have posed. In this case democratic rights and principles would be so intrinsic to democracy that we cannot accept (and might not permit) political views whose victory would undermine democracy. There would be a limit, then, to democratic respect and to permissible results in a democracy. We can accept any results of the democratic process except those that subvert the process. I admit to having some favor for this response, at least from a rhetorical standpoint. However, my philosophical preference for a postmodern, Nietzschean orientation leads me to the second response to the question, the *tragic* response. From a historical and performative standpoint, any results *are* truly possible in a democracy, even antidemocratic results. The American Constitution, for example, emerged out of a convention that wrestled with many options, including opposition to the Bill of Rights. There is nothing preventing subsequent constitutional conventions, and with the right amount of support, anything can happen, even a vote to limit or eliminate voting.[41] The idea of tragedy is appropriate here, in that democracy could die at its own hands, which is a "paradox" that need not be considered a contradiction.[42] Any reinstatement of democracy would simply take us to the realm of action and resistance, which, of course, accords with the script of historical happenstance anyway. In sum, then, the substantive approach would insist that rights, for example, cannot be opposed in a democracy, while the tragic approach would insist that they can be opposed and we might conceivably lose them by way of the right to free expression. The latter view at least can forgo any silencing of discourse, even in the name of democracy—a banner that can always serve as a decoy for garden-variety tyranny. A tragic bearing can keep democratic openness truly open, with some faith, I would think, that self-consuming results would not be likely.[43]

Justice and the Political Process

An obvious problem in a democracy is the degree to which economic inequities skew the political process; divisions of wealth and poverty render the idea of equal opportunity to effect political decisions suspect, if not bogus. Given the way a capitalist economic system works, and especially its legal protections of private property, the wealthy will naturally have political advantages over most citizens—more clout, more access to officials, and more influence on elections through campaign spending and use of media. The charge that the interests of most citizens are not served by such a system are well known and important. Egalitarian conceptions of justice have responded to such conditions with general models of equal resource distribution, or approximations thereto. The degree of government intervention and control required by such proposals, however, raises significant concerns. The agonistic, procedural model of democracy advanced in this study, which suggests an apportional conception of justice that can accommodate inequities in certain respects, can still respond to economic and political disparities in the name of competitive fairness, as we have seen. When the political process is demonstrably tilted in favor of certain segments of society that have more control of the political agenda, more access to political power and resources, and more political success owing to educational advantages—all of this at the expense of other citizens through no fault of their own—then competitive fairness would demand certain public services that can give other citizens a fighting chance, that "ostracize" excessive imbalances of advantage so that the political agon can be a genuine contest.

The most significant service in this regard, as we have already indicated, is a system of guaranteed public education, together with methods of funding that avoid excessive disparities in the quality of schools. Since politics demands certain intellectual skills and cognitive development, a comprehensive effort to cultivate the minds of all citizens from the earliest age on is an important ingredient in promoting political fairness. Education in a democ-

racy should go even further and focus as much as possible on *civic* education, not only concerning the nature, history, and structure of democratic government, not only the habits, values, and attitudes necessary for a democratic society, but also attention to political *practice*, to how citizens can make a difference politically and make their voices heard—by forming associations, lobbying, using the media, organizing grassroots operations, and so on. The more citizens understand how the political system works, the more potential there is to compensate for certain imbalances in political access and results that may prevail.[44] Without available avenues for political activism, however, all of this will be for naught in the face of economic costs in a capitalist society. That is why competitive fairness would require certain public expenditures for the dissemination of political discourse.

The main avenue today for the dissemination of discourse, for better or worse, is mass communication technology. Here is one inheritance from modernism—often called technicity, the systemic control and organization of entities and information by way of completely rationalized frameworks—that is turning out to be surprisingly ambiguous, especially in the political sphere. A significant criticism of modern technology has been concerned with its capacity for totalization, normalization, and control. Television has been cited for its compression of time and space into instant availability and homogeneity (this was Heidegger's complaint), and for its threat to politics and culture through centralized management and manipulation of information that can perpetuate or produce a uniform, mass consciousness. Things are not so simple anymore, however. First of all, the early days of communication technology were more susceptible to criticisms concerning control and normalization. Microchips, fiber optics, cable systems, miniaturization, and other technologies have changed everything. The mass availability of personal computers and interactive systems has made it possible for more people to have access to more information in ways that work *against* manipulation and deceit in the public sphere. The availability of hundreds of channels in cable systems will break the hold of centralized delivery by "network

broadcasting" and allow "narrowcasting" to smaller audiences with particular tastes and interests, allowing for more variety, quality, access, and proliferation of voices than has ever been possible before.[45]

The point is that modern technology can have a liberating and pluralizing effect on politics by multiplying and spreading avenues of access and participation that can overcome certain concentrations of power and influence that have prevailed in the past. A significant example of the ambiguity of technology for politics is the world-wide reach of video recording and transmission technology. In some respects, an instantaneous, global network of cameras does pose a threat of homogeneity, dissemblance, and constant visibility. One of the prevailing fears of camera technology, especially with the prospects of hidden cameras, concerns its possible use by the government for the surveillance of citizens. Technical advances, however, have made video devices easily portable and available to anyone, deployable for any location and circumstance. Now the government can be put under surveillance, too, by private citizens or reporters on the scene of breaking events. Visibility works both ways. In the past, governments have always depended on invisibility and extended stretches of time and space to conceal nefarious actions. Such things do not come easily now. For instance, when there was an attempted coup in Moscow as Russia was moving toward democracy, officials on the scene declared that the presence of network cameras was a decisive factor in the collapse of the coup.

These examples pertain to the private sector, independent of government control—which shows at least one sense in which capitalism and democracy accord well with each other, since a government-run media is anathema to democratic arrangements. However, government funding of public outlets or the establishment of nonprofit outlets or occasional public service operations in the private media can play an important role in compensating for disparities or shortcomings in the political process—when certain voices tend to go unheard or under-represented, or when the economic interests of the media debase or distort political discourse

without any direct manipulation by the government (the quality of American political journalism is often shameful).[46] One way to foster an open, agonistic democracy would be to give free air time to all political platforms in electoral campaigns, from the major to the minor parties, including the "radical fringe." Let them all have at it. Then we will have gotten closer to a fair contest. We must, however, live with the results, and groups that lose an election should not be entitled to attribute their loss to the "false consciousness" of citizens (more on this shortly).

If we are able to promote a more open and competitive process, we should nevertheless recall a previous discussion of stratified pluralism to limit our expectations about political outcomes. The best that can be done is to provide the means and opportunity for political participation. Likely, though, many people will still not get involved in politics or will not succeed in the political contest. An agonistic alternative to egalitarianism, however, can rest easy with such circumstances and not be faced with threats to any of its baseline assumptions.

Economic Justice

Modern political theory, beginning primarily with Rousseau, has stressed economic considerations as essential to justice. Poverty impedes human development and creates social stresses that instigate civic disorder. The question concerns how much a society should contribute to alleviate the plight of poor and disadvantaged citizens. In a strict sense, our agonistic, procedural model of democracy has no intrinsic provisions for economic redistribution of wealth or resources, except that any such proposal can openly contend for political favor. As we have seen, however, public services such as education seem intrinsic to fostering fair competition in politics, and the same can be said of certain social services that assist and administer to the dispossessed in matters pertaining to both politics and economics. An agonistic orientation at least lends some rhetorical advantage to the idea that we owe some help to people in certain circumstances. We probably owe little to people

who will not compete economically, but it would seem wrong to let people who *cannot* compete (e.g., the disabled) go to grief, or to ignore the fact that some people's failures are attributable to unfair competition. At the same time, proposals for complete equity in resources or outcomes run afoul of agonistic conditions too, by stalling the economy with overmanagement or disincentives. I think, therefore, that an agonistic democracy should conceive itself as an oscillation between capitalist and socialist narratives when it comes to economics.

The Nietzschean gambit taken in this study would seem to favor capitalism, since the deconstruction of equality softens the supposed conflict between democracy (as egalitarian) and capitalism (as nonegalitarian). A market economy *is* more Nietzschean in its way, given over to risk, competition, freedom, differentiation, and ascendancy—this despite the fact that Nietzsche himself seemed little concerned with economic questions and put little stock in commercial achievements.[47] Moreover, the conception of apportional justice that we culled from Nietzsche and Aristotle can justify economic disparities, as long as manifest differences in effort, skill, demand, and value are considered relevant to economic production and exchange. So people who work harder or more effectively, whose activities or products are in greater demand or of greater importance to society, *deserve* more economic reward than others. If self-interest and self-regard are added in as ubiquitous human motivations that attach to these economic conditions, it follows that intrusive projects of redistribution can come to be unjust and oppressive.

The modern liberal and socialist interest in ameliorating degraded social and economic conditions is certainly an important ethical force, and to a certain extent it is defensibly implicated in a democratic political order.[48] Once we go beyond providing and guaranteeing competitive opportunity, however, we run up against Nietzsche's warnings about pity and resentment, which stem from a hatred of suffering and which ironically promote a degeneration of life by trying to alleviate its negative conditions. Too often we assume that life can be improved by removing obstacles and painful

circumstances, but we forget how often the drive to *overcome* obstacles and discontent figures in human achievements. Sometimes people turn out better that others *because* of certain deprivations and difficulties. Since suffering is therefore necessary for human development (*BGE* 225), pity at the presence of suffering and an impulse to erase suffering indicate, for Nietzsche, a "hostility against life" and amount to "the *practice* of nihilism" (*A* 7). That is why Nietzsche rates socialist programs on a par with Christian denials of life (*BGE* 202). Socialism as a political *reality* would have to battle and negate so many life forces that it would go beyond mere attitudes of denial and precipitate destructive effects. Here is one of Nietzsche's projections:

> In the doctrine of socialism there is hidden, rather badly, a "will to negate life"; the human beings or races that think up such a doctrine must be bungled. Indeed, I should wish that a few great experiments might prove that in a socialist society life negates itself, cuts off its own roots. The earth is large enough and man still sufficiently unexhausted; hence such a practical instruction and *demonstratio ad absurdum* would not strike me as undesirable, even if it were gained and paid for with a tremendous expenditure of human lives. (*WP* 125)

Despite the foresight in Nietzsche's remark as it applies to certain communist experiments, we cannot forget the important contributions of Marxist thought to social and political philosophy. Marx's analysis of capitalism goes far beyond questions of wealth and poverty to show how a capitalist economic system alters the way we live, work, and relate to each other. From Marxism we learn how systemic causes of poverty require systemic changes (making appeals to personal initiative pointless), how profit-driven production methods make human work debased, uncreative, and unfulfilling, how the abstraction of money changes the way we regard things and human achievements, how the complexities of production in the modern world render "private property" an ambiguous, if not unjustified, conception, how traditional democratic ideals of freedom, equality, and rights look very different from a material perspective, how institutional and environmental changes *can* change human consciousness, making appeals for change in the "minds" of individuals inefficient at best.

The problem with Marxism, in admittedly simplistic terms, is that it is not democratic, at least in the ungrounded, agonistic sense sketched in this study. A Nietzschean orientation provides many clues for diagnosing the difficulties in Marxist thought and why its political applications have so often produced oppressive results.[49] Nevertheless, the influence of Marxism and socialism on capitalism must be noted. One reason why capitalism did not self-destruct as Marx expected is because it incorporated (often by way of a democratic agon) many reforms and modifications that address the abuses and disparities identified by its critics. Everything from welfare programs to labor laws to consumer protection regulations shows that there is no such thing as a pure "free market" economy, if there ever was one. The expansion of social mandates into many areas of life has met with some success, but the extension to property concerns will probably continue to meet deep resistance, since the importance of one's "own" domain seems too much a part of human interests to be surrendered for the "collective good" without significant coercion.[50]

There are many problems indigenous to capitalism that can be ameliorated by applying democratic principles and procedures to economic relationships, especially those between workers and employers. So-called "workplace democracy" may be a solution to many of the abuses, frustrations, exclusions, and manipulations that beset employees in their heretofore relatively powerless position.[51] Such economic democracy, however, need not bank on egalitarian notions any more than political democracy. Since the "right" to "ownership" and "authority" is at least ambiguous in a complex, developed economy, and since economic matters are no more amenable to decisive truth criteria than are other cultural pursuits, then an open atmosphere of differing interests orchestrated by a democratic agon seems as appropriate in the workplace as in politics, at least in certain respects. The "aristocracy" of the employer-employee hierarchy, then, may be susceptible to a democratic challenge that can mirror our political analysis. Economic democracy would not have to be egalitarian in a strict sense, but simply more multivocal than it has been, by extending the competition of the marketplace to include the workplace.

A Last Word: Democracy and Political Radicalism

In closing I want to address an issue that has become more pointed since the decline of communism and the rethinking of Marxism. The procedural and nonteleological model of democracy advocated in this study implies a deep suspicion of revolutionary and radical political narratives. Challenges to the existing order and the potential for change are certainly essential to democracy, but its agonistic openness and procedures for *immanent* transitions through electoral and deliberative exchanges are preferable to violent change and "radical" theories that diagnose the "roots" of social problems and promote a complete transformation of the civic and cultural order, what Yack calls "total revolution."[52] The reason why radical ideologies and revolutions are so often catastrophic can be answered by a Nietzschean analysis. Such doctrines have not escaped the implicit nihilism haunting teleological and transformative paradigms in the Western tradition. On behalf of a presumed good, revolutionary programs cannot avoid unleashing terrible forces of destruction in the face of finite world conditions.

> There are political and social fantasists who with fiery eloquence invite a revolutionary overturning of all social orders in the belief that the proudest temple of fair humanity will then at once rise up as though of its own accord. In these perilous dreams there is still an echo of Rousseau's superstition, which believes in a miraculous primeval but as it were *buried* goodness of human nature and ascribes all the blame for this burying to the institutions of culture in the form of society, state and education. The experiences of history have taught us, unfortunately, that every such revolution brings about the resurrection of the most savage energies in the shape of the long-buried frightfulness and excesses of the most remote ages. (*HAH* I,463)[53]

The confident detection of a fundamental "flaw" in the social order, the reductive exclusion and suppression of an Other, the dismissal of existing contexts and traditions—such fixation and myopia instigate the violence and disintegration that usually follow revolutionary overhauls. The social world is too complicated, diverse, and ambiguous to accommodate clear and pointed prescriptions for global reform.

In this regard, some postmodern writers (e.g., Derrida and Rorty) have been labeled by the left as conservative or reactionary, or at least as quietistic.[54] These judgments, however, would not hold up apart from typical confidences in radical thought. Attention to complexity, oscillation, and ambiguity is anything but a defense of the existing order. Postmodern thought implies continual criticism and challenges to the status quo, but not, as I see it, a design for revolutionary transformation. What the left really means, then, is that such writers are not radical enough, are not clear enough about the underlying causes of social problems. Fair enough, but too often clarity and diagnostic certainty are what cause havoc in the execution of reform. Perhaps the complexity and complicity of postmodern thought are the best protection against "root" projects that can destroy a plant.

I repeat, however, that radical theories have much to contribute to political discourse; there is a great deal to challenge in the capitalist order, for example. Radical narratives can and should be welcomed as *contestants* in democratic procedures—without, however, being permitted to lay any special claim to the signifier "democracy."[55] In conjunction with the problem of exclusivity and neofoundationalism associated with political radicalism, there is a red flag in "democratic radicalism" when something like "false consciousness" is introduced to explain the failure of revolutionary programs to gain sufficient acceptance in the body politic.[56] If a radical doctrine does not fully succeed in the democratic process, a postmodern orientation would not seem to sustain the notion that citizens have been "conditioned" by existing regimes to reject what is really in their best interest. False consciousness, though not an entirely useless notion, on a global scale would seem to be a thoroughly modernist conception that begs the question of the "truth" of a radical project—mix a little Marx, a little Freud, a good dose of veridical confidence and, presto, out comes false consciousness. Besides being suspect from a postmodern standpoint, such a conception seems inimical to the minimalist sense of democratic "equality" that we were willing to entertain earlier: a common capacity among citizens to think for themselves and choose their own interests. This explains, I think, why political radicalism has

always seemed to have an uneasy, if not hostile, relationship with democratic politics, and also why the execution of radical projects has often been comfortable with paternalistic coercion on behalf of citizens' "true being."[57]

Our analysis will also help illuminate the attractions and the dangers in "aesthetic" conceptions of politics that have been favored by some radical thinkers (including Nietzsche, in a way). Conceiving the state or the social order as an "art work" fits well the notion of a fundamental refashioning of society from the ground up, *de novo*—a kind of Platonic *poiēsis* stemming from the insight of the visionary, rather than a more Aristotelian *praxis* that involves an interactive collaborative fashioning of the social order in the midst of existing conditions.[58] A praxical democracy is much more open and provisional, less prone to the danger of abrupt impositions that clean the canvas of existing contexts and competing visions of social life. Such a conception of democracy is thereby more amenable to a postmodern orientation, because the reasons for social change are complex and unclear, and yet change happens in historical movements. Agonistic democracy allows for social change that is less likely to outstrip the capacity of a population to affirm and absorb that change. Perhaps this is latent conservatism, but I think not. A democracy should allow any radical doctrine a full hearing in the political arena, but outcomes in a democracy will likely frustrate most radicals, since democracy tends to generate more measured and mixed paths of change, the results of more deliberative exchanges between multiple narratives, rather than revolutionary overhauls. Given the ambiguities of historical processes, democracy is preferable to the clear, deliberate directives of radical programs, what Marx called "the control and conscious mastery" of the social world.[59] Such directives tend to polarize the social environment and thereby distort, even wreck, whatever possibilities for historical change obtain at the time. Again, the baseline "neutrality" (openness) of democracy may be the best vehicle for tapping whatever potential for political change a given society might possess.[60]

It should be noted that radical theories, especially socialism and Marxism, have had ambiguous and ambivalent connections with

Nietzsche's thought, which can give us another angle on a democratic deconstruction of Nietzsche's political vision. For one thing, many European socialists who were inspired by Nietzsche's critique of mediocrity thought that socialism could universalize, rather than cramp, a Nietzschean interest in creativity.[61] In addition, there is much in Marxism that can be called postmodern, especially its contextualism, historicism, and critique of modernist subjectivity. Marxists could also find favor with a Nietzschean emphasis on free thinking and aesthetics in their challenge to existing conditions and vision for the creation of a new social order.[62] The significant traces of modernism and egalitarianism in Marxism, however, make the linkages with Nietzsche tenuous at best.[63]

If there is one thing that best explains the attraction to Nietzsche among radical intellectuals in nineteenth- and twentieth-century thought, it is the ubiquitous problem of the bourgeoisie—the persistent complaints by various artists, writers, and social critics about bourgeois conformity, materialism, consumerism, and superficial sensibilities.[64] The intensity of such reproaches, however, would not fit the more kindly attitude toward mediocrity expressed by Nietzsche:

> When the exceptional human being treats the mediocre more tenderly than himself and his peers, this is not mere politeness of the heart—it is simply his *duty*. (A 57)

In addition, such reproaches ought to arouse a certain Nietzschean suspicion about motivation. The social critics perhaps doth protest too much. Would not a truly creative person, as we have seen, welcome conformity and "popular culture" as an agonistic correlate, and simply proceed to offer higher possibilities and productions? Might the critics be guilty of a kind of resentment? There is evident in anti-bourgeois judgments a kind of aesthetic puritanism, a moralistic tone about ordinary life that may be susceptible to a Nietzschean critique; an inability to affirm everyday conditions may be no less problematical than traditional refusals to affirm existential finitude.[65] Perhaps democratic inclusiveness is what helps explain the neglect of, or indifference toward, Nietzsche's antidemocratic posture among intellectuals who otherwise are not calling for

an aristocratic political order. Democracy seems to favor ordinary sensibilities, and complaints about such things would explain the selective appropriation of Nietzsche's discourse. It should be asked, however, if there is not a latent tyranny in anti-bourgeois mentalities. This is not to equate democracy with mediocrity; we have been trying to unsettle that supposition all along. It is only to say that there seems to be no alternative to an *open* conception of democracy that would not be problematized by any of its results as long as all perspectives have had a fair chance to influence results. Radical harangues against the tastes and proclivities of the mass of citizens are not out of line, but this should not be considered a baseline problem for *democracy*. After all is said and done, we should let people live the life they want to live.[66] This is why an agonistic, procedural conception of democracy is desirable; it precludes the latent tyranny in political stories that proclaim a certain salvific mission or transformation or elevation of the social order. In a global sense, a Nietzschean refusal of teleological prescriptions is what can protect a democracy from even the most subtle and camouflaged types of reformist closure.

It deserves mention that Nietzsche may have lost sight of his own warnings against teleological metanarratives with his dramatic story of slave values corrupting life and debasing culture, his call for higher types to assert themselves and affirm the earth, his hopes for philosophers of the future—even an *Übermensch*—to deliver us from our decrepit condition. Although eternal recurrence, in my view, represents the ultimate nonteleological conception and is anything but a metanarrative—since it affirms the repetition of all narratives—nonetheless Nietzsche's own vision for culture does suggest a grandiose, salvific sweep that borders on a reformist metanarrative. Those who interpret Nietzsche's vision apart from cultural and political concerns could find relief from this problem in "privatizing" Nietzsche for the sole purpose of self-creation. Indeed, this may be an effective way to resolve the incongruity of Nietzsche's apparent reformist posture. As we have seen, however, Nietzsche did promote a cultural/political vision that cannot be dismissed or closeted. Perhaps the point would be that, exegetical

questions aside, the only way to *salvage* Nietzsche philosophically is to privatize his transformational rhetoric. To a significant extent, such a strategy has merit; self-creation is certainly an appropriate setting for much of Nietzsche's philosophical dynamic. Nonetheless, a good deal of that dynamic is also appropriate for the public sphere—which has been the point of the political reflections in this study.

My tastes run toward denying all "big stories"—including Nietzsche's life-affirmation story—a special place in political philosophy. Nietzsche's thinking to be sure helps us formulate an appropriate political order: His reflections on resentment and affirmation, weakness and strength, closure and openness, and his agonistic pluralism allow us to effectively delineate the contours of democratic arrangements. Political *practice*, however, should be left free, and this includes citizens who are not "Nietzschean" enough, who might be "resentful," or "bourgeois," or "metaphysical." Otherwise we would seem forced to conclude that such citizens are not practicing politics in the "right" way. As long as democratic procedures are honored, one's attitude toward life should not matter—otherwise we are left with a choice between coercive reform and an insincere tolerance of the wrong kind of politics. Again, appeals to people's sense of life are not out of line, but appeals through public *discourse* should be the limit, because politics in the end includes force.

If there is one existential attitude that is worth promoting again and again in democratic discourse, it is suspicion of our narratives when it comes to political *power*—which is different from skepticism about narratives as such. Even if such an attitude is missing, though, democratic agonistics will provide continual checks and balances from other power sites in the social network. This pragmatic oscillation represents a postmodern alternative to various theories and stories that wittingly or unwittingly have measured politics according to prescriptive visions of social outcomes, purposes, and human relations. Such concentrations cannot avoid problematizing or marginalizing resistances, and political power permits an easy transition from mere criticism and judgment to

subjugations of all forms. Democratic openness and freedom, therefore, are best protected by a dialogical-paralogical politics unscripted by any primal story, a political experiment ungoverned by any theory.

Notes

Preface

1. Lawrence J. Hatab, *Myth and Philosophy: A Contest of Truths* (La Salle, IL: Open Court Publishing Co., 1990).

2. "A Nietzschean Defense of Democracy," in *Political Theory*, Selected Studies in Phenomenology and Existential Philosophy, vol. 20, ed. Lenore Langsdorf and Stephen Watson (Albany: SUNY Press, forthcoming).

3. In this context of pedagogy, I disagree with Richard Rorty when he exchanges "justification" for the rhetoric of luck and happenstance. See *Contingency, Irony, and Solidarity* (Cambridge: Cambridge University Press, 1989), pp. 184–85. Political education can and should pursue a defense of democracy without traditional theoretical techniques.

Introduction

1. The same is true for another central figure in postmodern thought, Heidegger. But this is another story that I am leaving aside. Incidentally, it was Heidegger's work on Nietzsche that served as a main conduit through which Nietzsche's writings grew to have the influence they enjoy today. See, e.g., Heidegger's four-volume *Nietzsche*, trans. David F. Krell and Frank Capuzzi (New York: Harper and Row, 1979ff.).

2. This is why writers (like Habermas) who call for a retrieval of certain modernist principles are on firmer ground so far in advocating democratic arrangements.

3. For some recent works in this regard, see Rorty's *Contingency,*

Irony, and Solidarity; Cornelius Castoriadis, *Philosophy, Politics, Autonomy: Essays in Political Philosophy*, ed. David Ames Curtis (New York: Oxford University Press, 1991); Claude Lefort, *Democracy and Political Theory*, trans. David Macey (Minneapolis: University of Minnesota Press, 1988); Aryeh Botwinick, *Postmodernism and Democratic Theory* (Philadelphia: Temple University Press, 1993); Chantal Mouffe, ed., *Dimensions of Radical Democracy* (London: Verso, 1992); William E. Connolly, *Identity/ Difference: Democratic Negotiations of Political Paradox* (Ithaca, NY: Cornell University Press, 1991); Bonnie Honig, *Political Theory and the Displacement of Politics* (Ithaca, NY: Cornell University Press, 1993); and Stephen K. White, *Political Theory and Postmodernism* (Cambridge: Cambridge University Press, 1991). A more traditional, but highly recommended analysis is Robert A. Dahl, *Democracy and Its Critics* (New Haven: Yale University Press, 1989). For the classic contemporary critique of postmodernism, see Jürgen Habermas, *The Philosophical Discourse of Modernity*, trans. Frederick G. Lawrence (Cambridge, MA: MIT Press, 1987). For works that try to strike a middle ground, see Fred Dallmayr, *Margins of Political Discourse* (Albany: SUNY Press, 1989) and Richard J. Bernstein, *The New Constellation: The Ethical-Political Horizons of Modernity/ Postmodernity* (Cambridge, MA: MIT Press, 1992).

4. I see my audience as twofold, those who accept the postmodern project but wonder about the prospects for democracy in such a setting, and those who are critical of postmodernism and think that traditional political principles should be retained in some way. I hope to convince the latter group that a postmodern approach can make a significant contribution to political philosophy.

5. See, for example, Walter Kaufmann, *Nietzsche: Philosopher, Psychologist, Antichrist* (Princeton: Princeton University Press, 1974), and Jacques Derrida, *Spurs: Nietzsche's Style*, trans. Barbara Harlow (Chicago: The University of Chicago Press, 1979). A recent influential study that has stressed individual self-creation in interpreting Nietzsche is Alexander Nehamas, *Nietzsche: Life as Literature* (Cambridge, MA: Harvard University Press, 1985).

6. See, for example, Tracy B. Strong, *Friedrich Nietzsche and the Politics of Transfiguration* (Berkeley: University of California Press, 1988); Ofelia Schutte, *Beyond Nihilism: Nietzsche Without Masks* (Chicago: University of Chicago Press, 1984); Ike Okanta, *Nietzsche: The Politics of Power* (New York: Lang, 1992); Kurt Rudolph Fischer, "Nazism as a Nietzschean 'Experiment,'" *Nietzsche Studien* 6 (1977): 116–122; Walter H. Sokol, "Political Uses and Abuses of Nietzsche in Walter Kaufmann's Image of Nietzsche," *Nietzsche Studien* 12 (1983): 429–35; and Douglas Kellner, "Nietzsche and Modernity: Critical Reflections on *Twilight of the Idols*," *International Studies in Philosophy* 23, no. 2 (1991): 3–17. A helpful survey of the literature on all sides can be found in Bruce Detwiler, *Nietzsche and the Politics of Aristocratic Radicalism* (Chicago: University of Chicago Press, 1990). Detwiler also takes Nietzsche's antidemocratic passages seriously. For a focused political analysis, see Keith Ansell-Pearson, *Nietzsche* Contra *Rousseau: A Study of Nietzsche's Moral and Political Thought* (Cambridge: Cambridge University Press, 1991). Ansell-Pearson also provides an effective general study of Nietzsche's political thought in *An Introduction to Nietzsche as Political Thinker* (Cambridge: Cambridge University Press, 1994).

7. I confess that in the past I had espoused a nonpolitical interpretation, but another tour of the texts with closer attention to political questions changed my mind.

8. Some other works that try to bridge the gap between Nietzsche and democracy are Mark Warren, *Nietzsche and Political Thought* (Cambridge, MA: MIT Press, 1988); William Connolly, *Political Theory and Modernity* (London: Basil Blackwell, 1988); Tracy B. Strong, "Texts and Pretexts: Reflections on Perspectivism in Nietzsche," *Political Theory* 13, no. 2 (May 1985); and Henry S. Kariel, "Nietzsche's Preface to Constitutionalism," *Journal of Politics* 25 (May 1963). Some of these works will be addressed in due course.

9. In using the terms "phenomenological" and "pragmatic," I do not want to be identified strictly with the movement of phenomenology growing out of Husserl's work or with American pragmatism. My approach might be labeled "neo-Aristotelian" in a way, the

meaning of which will hopefully become clear as we proceed. In any case, I want to emphasize political "appearances" (or "appearings") rather than essences or foundations, and I want "practice" to mean much more than instrumental reason, prediction and control, or experimental science. For me the pragmatic is better indicated in something like Hannah Arendt's category of "action" (drawn from the Greek sense of *praxis*) in *The Human Condition* (Chicago: University of Chicago Press, 1958). My sense of pragmatics is meant to cover every relevant milieu and manner of human activity and engagement, from science to art, from cooperation to conflict.

Chapter One: A Primer on Nietzsche and Postmodernism

1. This chapter is meant to be a brief and broad overview for the purpose of orientation. Details of key points will be developed in ensuing chapters as needed.

2. A Nietzschean naturalism is not to be confused with an essentialistic proposal of fixed "natures," or with a romantic "return to nature" (see *BGE* 230 and *WP* 100). On this last point, see Ansell-Pearson, *Nietzsche* Contra *Rousseau*, pp. 46–48.

3. See also *EH* IV,7–8.

4. See my *Myth and Philosophy*, chapters 5–8, for a detailed discussion of this transition.

5. See *GM* I, 10–11 and *BGE* 260. For an extensive collection, see Richard Schacht, ed., *Nietzsche, Genealogy, Morality: Essays on Nietzsche's* On the Genealogy of Morals (Berkeley: University of California Press, 1994).

6. See *GS* 276, 346–47; *BGE* 56; *EH* IV,1,4. For analysis, see my "Nietzsche, Nihilism, and Meaning," *The Personalist Forum* 3, no. 2 (Fall 1987): 91–111, and Richard Schacht, "Nietzsche and Nihilism," in *Nietzsche: A Collection of Critical Essays*, ed. Robert Solomon (Garden City, NY: Anchor, 1973), pp. 58–82.

7. Nietzsche's analysis of Schopenhauer's metaphysical uses of "will" (*HAH* II,5) is instructive, I think, in steering us away from

metaphysical interpretations of will to power.

8. See also *GS* 349; *GM* II,12,18; *A* 2. Nietzsche's reversal of traditional instrumental relations is expressly stated as follows: "Knowledge works as a tool of power" (*WP* 480).

9. See my *Nietzsche and Eternal Recurrence: The Redemption of Time and Becoming* (Lanham, MD: University Press of America, 1978), pp. 102–5.

10. See *GS* 341; *Z* III,2; *WP* 1053–1067.

11. Affirmation, therefore, should be distinguished from the attitude of "omnisatisfaction" (*Allgenügsamkeit*) ridiculed in *Z* III,11,2.

12. See Gary Shapiro, *Nietzschean Narratives* (Bloomington: Indiana University Press, 1989).

13. Nietzsche at one point borrows the metaphor of color "values" (*valeurs*) from the language of painting (*BGE* 34).

14. Nietzsche's writings are sometimes divided into "periods": an early metaphysical period (1872–1878), a middle positivist period (1878–1882), and a later antifoundationalist, transformationist period (1882–1889). There is some truth to this picture of a movement from an early idealism influenced by Schopenhauer to a more skeptical, naturalistic, even scientific outlook, to the powerfully disruptive and prophetic later works. But the picture is also misleading. There is a certain continuity in Nietzsche's thought; I think that most of the themes sketched in this chapter run more or less throughout the periods. Nietzsche's "autobiography," *Ecce Homo*, does not overtly tell of periods or "development" in reflections on his texts. There is mention of yes-saying and no-saying periods (*EH* III,BGE,1), but then yes-saying and negating are joined together (*EH* IV,4). The Preface to *On the Genealogy of Morals* indicates connections with earlier works: *Human, All Too Human* (*GM* P,2) and *The Wanderer and His Shadow* (*GM* P,4). And the early figure of the Dionysian later runs from *The Gay Science* all the way through to the last line of the last work (*EH* IV,9). So there is much overlap in the texts. I will occasionally draw from different periods to serve my analysis, though not without noting important differences when warranted. In my view, however, the textual

"periods" also lend themselves to a perspectival pluralism. Finally, a word about the infamous "nonbook," *The Will to Power*, a collection of unpublished notes from the *Nachlass*. There are purists who insist that only published materials are reliable (since Nietzsche often used his notebooks for thought experiments that were sometimes rejected). Then there is Heidegger's idiosyncratic view that Nietzsche's true thinking can be found more readily in the unpublished material. I take a middle course by being careful to use passages that are consonant with, or at least not clearly divergent from, views expressed in the published works. For a treatment of the issues surrounding the *Nachlass*, see the discussion between Peter Heller, R.J. Hollingdale, Bernd Magnus, and Richard Schacht in *International Studies in Philosophy* 22, no. 2 (1990): 35–66.

15. For a collection of various angles on postmodernism, see *A Postmodern Reader*, ed. Joseph Natoli and Linda Hutcheon (Albany: SUNY Press, 1993).

16. See Bernard Yack, *The Longing for Total Revolution: Philosophic Sources of Discontent from Rousseau to Marx and Nietzsche* (Princeton: Princeton University Press, 1986), chaps. 5–7.

17. Keith Ansell-Pearson focuses on the antinomical nature of modern political thought in *Nietzsche* Contra *Rousseau*; see especially p. 22.

18. William Connolly indicates that modernism has defined itself in contrast to earlier periods that were comparatively deficient, e.g., *less* free, rational, productive, comfortable, democratic, tolerant, and scientific. In the process, however, modernism winds up with its own deficiencies: it is less spiritual, less attuned to nature, less social, more rationalistic, more bureaucratic, and more commercialized (*Political Theory and Modernity*, p. 1).

19. There is some controversy over whether postmodernism is compatible with the notion of "critique." If critique presupposes certain epistemological or theoretical "criteria" that serve as a basis for judging existing conditions, then opponents of postmodernism (such as Habermas) can question its capacity for critique, and proponents (such as Lyotard) tend to distance themselves from critique as a term. Foucault tries to work with a notion of critique

that is simply disruptive and exploratory, driven by a "limit-attitude" that continually challenges entrenched structures and that experiments with exceeding them; see the essay "What is Enlightenment?" in *The Foucault Reader*, ed. Paul Rabinow (New York: Pantheon, 1984), pp. 32–50. Here Foucault identifies another connection between postmodernism and modernism, an emphasis on what is *new* in the present compared with the past—but now without any appeal to some totality or future consummation that will close off thought. For a discussion of these questions, see Bernstein, *The New Constellation*, chap. 5, and Calvin O. Schrag, *The Resources of Rationality: A Response to the Postmodern Challenge* (Bloomington: Indiana University Press, 1992), chap. 2. Lyotard goes so far as to affirm the apparent paradox of postmodernism (after-now) in the sense of its always being ahead of present results and directives (*The Postmodern Condition*, p. 81).

20. Foucault dedicated his researches to unmasking the oppression concealed in the Enlightenment's so-called "liberal" institutions, which instead operated by restraining divergent modes of experience in the name of knowledge and order. See *The Foucault Reader* for representative selections from works such as *Madness and Civilization, Discipline and Punish: The Birth of the Prison*, and *The History of Sexuality*. For a balanced analysis, see Bernstein, *The New Constellation*, chap. 5. For a study of the Foucault-Nietzsche connection, see Michael Mahon, *Foucault's Nietzschean Genealogy: Truth, Power, and the Subject* (Albany: SUNY Press, 1992).

21. Connolly, *Political Theory and Modernity*, p. 130.

22. Jean-François Lyotard, *The Postmodern Condition: A Report on Knowledge*, trans. Geoff Bennington and Brian Massumi (Minneapolis: University of Minnesota Press, 1984), p. xxiv. For some other works on the topic of postmodernism, see Max Horkheimer and Theodor W. Adorno, *Dialectic of Enlightenment*, trans. John Cumming (New York: Continuum, 1972); Hugh J. Silverman and Donn Welton, eds., *Postmodernism and Continental Philosophy* (Albany: SUNY Press, 1988); Linda Hutcheon, *A Poetics of Postmodernism: History, Theory, Fiction* (New York: Routledge, 1988); Charles Jencks, *What is Postmodernism?* 2d ed. (London: St.

Martin's Press, 1987); Gary Shapiro, ed., *After the Future: Post-modern Times and Places* (Albany: SUNY Press, 1990); and David Harvey, *The Condition of Postmodernism: An Enquiry into the Origins of Cultural Change* (Oxford: Basil Blackwell, 1989).

23. See Lyotard's analysis of science in the context of delineating denotative, performative, and prescriptive language games, in *The Postmodern Condition*, pp. 23–47. Despite the fact that pluralistic openness has been emphasized more in the Continental tradition, the Analytic tradition has overlapping interests with respect to the linguistic turn. Writers such as Heidegger and Wittgenstein, Derrida and Davidson, among others, have much in common when it comes to the status of language in shaping our understanding of the world; see Rorty, *Contingency, Irony, and Solidarity*, chap. 1.

24. Lyotard, *The Postmodern Condition*, p. 43. See also *The Differend: Phrases in Dispute*, trans. Georges Van Den Abbeele (Minneapolis: University of Minnesota Press, 1988), in which Lyotard unsettles modern theories of meaning and reference by stressing the heterogeneity of addressor-addressee relationships.

25. See, for example, Dallmayr, *Margins of Political Discourse*, p. 96. Indeed, Nietzsche suggests something along these lines on a few occasions, e.g., when he praises Kant for opening up the self-demotion of reason (*BT* 18), and describes atheism as the consequence of the Christian fixation on truth (*GM* III,27).

26. Derrida is an example of a postmodern thinker who is susceptible to the kind of distorted interpretation discussed here. For his cogent, straightforward response to typical criticisms and concerns, see the afterword to *Limited Inc.*, ed. Gerald Graff (Evanston: Northwestern University Press, 1988), pp. 111–54. There Derrida says that he is not suggesting a choice between pure presence and undecidability; what he calls free play is a "lexical network" that addresses the *limits* of decidability (pp. 115–16). *Différance* is called an aconceptual concept, a concept that marks both the possibility and the limits of conceptualization (p. 118), which makes language structures not illusory but problematical and complex (pp. 119–20). Rather than argue for anarchy or indeterminacy of interpretation, Derrida argues for a finite contextualism

in which meaning is simply unstable, an oscillation of deter-
mination and undecidability (p. 145). In another work, Derrida
claims that deconstruction is not destructive, but a method of
analysis that *opens up* important texts: *The Ear of the Other:
Otobiography, Transference, Translation*, ed. Christie McDonald,
trans. Peggy Kamuf (Lincoln: University of Nebraska Press, 1988),
pp. 85–87. See Bernstein's analysis in *The New Constellation*, chaps.
6–7. An excellent study that mines deconstruction for social and
political thought is Bill Martin, *Matrix and Line: Derrida and the
Possibilities of Postmodern Social Theory* (Albany: SUNY Press,
1992).

27. This is why Heidegger was preoccupied with etymology and
the history of elemental words in the tradition. I attempt to rethink
the word "truth" along these lines in "Rejoining *Aletheia* and Truth,"
International Philosophical Quarterly 30, no. 4 (December 1990):
431–47. Schrag, in *The Resources of Rationality*, provides an effec-
tive reexamination of critique as "discernment" (chap. 2) and of
reason as "transversal logos" (chap. 6).

28. Eugene Gendlin has produced important work on language
and concept formation that avoids the false choice between fixed
form and indeterminate formlessness; language is neither closed
nor arbitrary, but an open, flexible, dynamic process of meaning
formation. See "Experiential Phenomenology," in *Phenomenology
and the Social Sciences*, ed. M. Natanson (Evanston: Northwestern
University Press, 1973), and "Thinking Beyond Patterns: Body,
Language, and Situations," in *The Presence of Feeling in Thought*, ed.
B. denOuden and M. Moen (New York: Peter Lang, 1992). If we take
a looser, more pragmatic and contextual approach to thought
structures, we can get around a good deal of the enigmatic
exchanges about "subjectivity," "intention," and "authorship," about
whether "I" can be located as an intentional "source" of my text,
whether a text can be the "property" of a subject who claims a
certain author-ity. In a sense, this discussion is important, since all
texts are intertextual responses to other texts, and no author can be
located as a discrete "site" of origin. I do not fall into a metaphysical
trap, however, when I claim a certain minimalist sense of intention

and authorship: *I* wrote this book and I *meant* just about every sentence I wrote (I think).

29. See *The Philosophical Discourse of Modernity* (e.g., pp. 185–210).

30. Nietzsche specifically stated, for example, that *Beyond Good and Evil* is "in all essentials a *critique of modernity*" (*EH* III, *BGE*, 2).

31. See *Nietzsche as Postmodernist: Essays Pro and Contra*, ed. Clayton Koelb (Albany: SUNY Press, 1990); for a discussion of Nietzsche's visibility and invisibility in postmodern writings, see Babette Babich's essay in the same volume, "Nietzsche and the Condition of Postmodern Thought: Post-Nietzschean Postmodernism," pp. 249–66.

Chapter Two: Nietzsche Contra Democracy: Deconstructing Equality

1. For a discussion of Hobbes and Rousseau in this regard, see Connolly, *Political Theory and Modernity*, chaps. 2 and 3. For a full discussion, see Joshua Mitchell, *Not by Reason Alone: Religion, History and Identity in Early Modern Political Thought* (Chicago: University of Chicago Press, 1993). See also A. S. P. Woodhouse, *Puritanism and Liberty* (Chicago: University of Chicago Press, 1938).

2. John Locke, *The Second Treatise of Government* II,6. For a discussion of theological influences on the founders of the American Constitution, see Morton White, *Philosophy, The Federalist, and the Constitution* (New York: Oxford University Press, 1987), pp. 25–37, 203–7. For a general discussion, see Lefort, *Democracy and Political Theory*, chap. 11.

3. See Hegel's *Reason in History*, trans. Robert S. Hartman (New York: Bobbs Merrill, 1953), and *Phenomenology of Spirit*, trans. A. V. Miller (London: Oxford University Press, 1977), chaps. 7 and 8. Marx, of course, thought that Hegel's program was not realization enough. The only "realization" of a religious ideal is its *disappearance* into material conditions, the contradictions of which spawn spiritual notions in the first place. An interest in "spiritual"

brotherhood, for example, is an indication that *real* brotherhood is not yet at hand. In this way, Marx's relation to religious tradition is not without its own ambivalence. See the introduction to "Toward the Critique of Hegel's Philosophy of Law," in *Writings of the Young Marx on Philosophy and Society*, ed. and trans. Loyd D. Easton and Kurt H. Guddat (Garden City, NY: Anchor Books, 1967), pp. 249–64. For a general discussion, see Robert C. Tucker, *Philosophy and Myth in Karl Marx* (Cambridge: Cambridge University Press, 1961). Bernard Flynn attempts to show how metaphysical and theological notions haunt not only Marx, but also thinkers such as Habermas and Foucault, in *Political Philosophy at the Closure of Metaphysics* (Atlantic Highlands, NJ: Humanities Press, 1992).

4. We can see why it is wrong to say that Nietzsche's thought is amoral or antimoral; he is in fact preoccupied with how we "value" things. Nietzsche challenges a particular system of evaluation, and I suppose its historical *victory* is what prompts him to oppose "morality" and to adopt the rhetoric of "immoralism."

5. See Gilles Deleuze, *Nietzsche and Philosophy*, trans. Hugh Tomlinson (New York: Columbia University Press, 1983).

6. Nietzsche uses the French term *ressentiment*, probably because German lacks an effective equivalent. See Kaufmann's discussion in *Basic Writings of Nietzsche*, pp. 441–46.

7. See also *GS* 290.

8. Nietzsche suggests in *HAH* I,101 that slavery is no longer just.

9. Hobbes mentions that a "confederacy" of the weak can overpower the strong, but it is odd that he would use such a scenario in defense of the notion that humans are "by nature equal" (*Leviathan* I, chap. 13). The need for a confederacy is prompted by a natural *inequality* of strength.

10. Nietzsche's model of justice here is not unlike Aristotle's: See *Politics* III.9.1280a10–15, III.12–13, III.16.1287a13–15, and VI.1; see also *Nicomachean Ethics* V.3.1131a20–25. Later I will work with this notion of justice that aims for apportionment of equal and unequal status and treatment.

11. See Warren, *Nietzsche and Political Thought*, pp. 213ff. and Detwiler, *Nietzsche and the Politics of Aristocratic Radicalism*, pp.

92ff.

12. For a discussion in the light of modern voluntarism, see Keith Ansell-Pearson, "Nietzsche and the Problem of Will in Modernity," in *Nietzsche and Modern German Thought*, ed. Keith Ansell-Pearson (London: Routledge, 1991), pp. 165–91.

13. The legitimacy of politics is therefore based in a calculated self-interest, a mutual protection of individual possessions. See C. B. Macpherson, *The Political Theory of Possessive Individualism* (London: Oxford University Press, 1962).

14. See also *WP* 531. Against the idea of an immortal soul, Nietzsche suggests that the self be understood as "many mortal souls" (*HAH* II,17).

15. When Nietzsche talks of the "self" he often prefers to emphasize *embodiment*, to highlight his naturalistic alternative to nonphysical versions of selfhood (see *Z* I,4).

16. See Warren's analysis in *Nietzsche and Political Thought*, pp. 55–61.

17. This helps explain an otherwise perplexing pronouncement of Nietzsche's: "To become what one is, presupposes that one not have the faintest notion *what* one is" (*EH* II,9).

18. This element fits in with Nietzsche's remarks on solitude and how the community can corrupt the individual (*BGE* 284); but nothing in Nietzsche can be strictly asocial, since all experience involves a tension of relations.

19. Nietzsche also replaces the traditional scheme of the unity of the virtues with a conflicted field of differing virtues (*Z* I,5). For a discussion see Lester H. Hunt, *Nietzsche and the Origin of Virtue* (New York: Routledge, 1991), pp. 80–84.

20. We can see that Nietzsche is not uncomfortable using a traditional term like the "subject," as long as it is redescribed. Indeed, after denouncing the Christian concept of the soul, Nietzsche adds:

> Between ourselves, it is not at all necessary to get rid of "the soul" at the same time, and thus to renounce one of the most ancient and venerable hypotheses—as happens frequently to clumsy naturalists who can hardly touch on "the soul" without immediately losing it. But the way

is open for new versions and refinements of the soul-hypothesis; and such conceptions as "mortal soul," and "soul as subjective multiplicity," and "soul as social structure of the drives and affects," want henceforth to have citizens' rights in science. (*BGE* 12)

This passage can address concerns about agency in Nietzsche. See Christopher Janaway's analysis of Nietzsche's decentered self in "Nietzsche, the Self, and Schopenhauer" (*Nietzsche and Modern German Thought*, pp. 119–42), in which he argues that some notion of self-agency is needed if the Nietzschean dictum, "Become what you are," is to make any sense.

21. See *WP* 480 for a defense of "the calculable and constant" in the same vein.

22. See Warren, *Nietzsche and Political Thought*, pp. 152–58, which is especially good on the problem of agency in modernism.

23. Ibid., chap. 4.

24. Ibid., p. 176. For Warren's overview of problematic assumptions in Nietzsche's political thought, see pp. 226–48.

25. Ansell-Pearson has noticed this problem in "Nietzsche: A Radical Challenge to Political Theory?" *Radical Philosophy* 54 (Spring 1990): 11–14.

26. For Detwiler's critique of Warren along these lines, see *Nietzsche and the Politics of Aristocratic Radicalism*, pp. 95–97, 160–62; Detwiler gives a comparable critique of Kariel's efforts on pp. 90ff., 106ff.

27. Warren, *Nietzsche and Political Thought*, pp. 172–76.

28. Ansell-Pearson, "Nietzsche: A Radical Challenge to Political Theory?" p. 17. Honig makes the same assumption in *Political Theory and the Displacement of Politics*, pp. 47–49.

29. The term Nietzsche generally uses for "morality" is *Moral*, not *Sittlichkeit*.

30. See *HAH* I,618 for another use of *Individuum* that refers to a nonpluralized, rigid singularity.

31. Determinism is another modernist outcome; cf. Kant's affirmation of both freedom and determinism in his differentiation of theoretical and practical standpoints.

32. Schutte observes that wanting either freedom or unfreedom

is a flight from the burden posed by the other term (*Beyond Nihilism*, p. 56).

33. See *GS* 335, where Nietzsche connects "self-legislation" with the necessity of physics; contra Ansell-Pearson ("Nietzsche: A Radical Challenge to Political Theory?" p. 17), this text is not representative of the "sovereign individual," which term does not appear in the passage.

34. William Connolly is more sensitive to the incompatibility of Nietzsche's texts and traditional political theory; he tends to follow Foucault's line, and he sees in will to power a category of *resistance* that can help displace the fixtures of political theory and that also can provide a democratic setting with both justice and a refusal of slavish resentment. The *absence* of a political "theory" in Nietzsche's thought is what turns out to be a virtue in such an atmosphere, by providing openings rather than closure in probing the questions of politics (*Political Theory and Modernity*, pp. 168–69, 175). Connolly favors a turn toward a political aesthetics by emphasizing the Nietzschean idea of "giving style to one's character" (*GS* 290) as a guide for social dynamics. I agree with Ansell-Pearson ("Nietzsche: A Radical Challenge to Political Theory?" pp. 15–16), who sees the advantages of Connolly's approach but is concerned that aestheticization misses or underplays what appear to be Nietzsche's concrete political designs that go beyond mere self-creation. Connolly's call for a "radicalized liberalism" (p. 174) is provocative in that it avoids a theoretical starting-point in the individual subject and acknowledges inevitable tensions in human selfhood and social relations. I would question, however, his claim that egalitarian justice is necessary to help *quell* resentment (p. 172), because this seems to sidestep a confrontation with Nietzsche's insistence that resentment is the *cause* of egalitarian doctrines of justice.

35. See also *BGE* 257 and *TI* 9,38.

36. See also *BGE* 242; *WP* 890, 898.

37. See also *BGE* 262.

38. See also *WP* 734. These passages are quite disturbing and they bear some relation to the vilest rhetoric of Nazism, a topic we will address shortly.

39. See also *Z* I,10. For a discussion see Detwiler, *Nietzsche and the Politics of Aristocratic Radicalism*, pp. 54–58.

40. Ibid., pp. 58–64.

41. A note from 1884 sketches the features of a "New Enlightenment," which uncovers the errors of the past, the primacy of the creative drive, and the task of overcoming man. Freedom is restricted to new rulers who can replace the democratic herd that benefitted from the old Enlightenment (*KSA* 11, pp. 294–95).

42. Habermas, *The Philosophical Discourse of Modernity*, pp. 125–26.

43. See also *WP* 685.

44. See, e.g., Georg Lukács, *The Destruction of Reason*, trans. Peter Palmer (Atlantic Highlands, NJ: Humanities Press, 1981).

45. See Kaufmann, *Nietzsche: Philosopher, Psychologist, Antichrist*.

46. See Detwiler's critique in *Nietzsche and the Politics of Aristocratic Radicalism*, chap. 3.

47. See Steven E. Ascheim, *The Nietzsche Legacy in Germany, 1890–1990* (Berkeley: University of California Press, 1992) for a revealing study of the influence of Nietzsche on twentieth-century German cultural and political thought, how his ideas were received, interpreted, and disseminated. For a discussion of the role of Nietzschean ideas in Nazism and a survey of the literature debating Nietzsche's relation to National Socialism, see chaps. 8 and 9. For Derrida's remarks about the limits of Nietzsche's innocence with respect to his appropriation by the Nazis, see "Otobiographies: The Teaching of Nietzsche and the Politics of the Proper Name," in *The Ear of the Other*, pp. 3–38.

48. Ascheim, *The Nietzschean Legacy in Germany, 1890–1990*, chap. 2.

49. Ibid., pp. 153–55.

50. Ibid., p. 163.

51. Schutte (*Beyond Nihilism*, chap. 4) prefers to see will to power as a metaphor for affirming a world of flux, a more flexible interpretation that avoids the errors of limiting will to power to domination or ignoring the role of domination in the texts, errors

that mark interpretations given by Kaufmann, Stern, Heidegger, and Deleuze.

52. See also *GM* II,18–19 and *BGE* 51.

53. This helps explain Nietzsche's occasional praise of decadence; see *TI* 9,43 and *WP* 40.

54. To be precise, Nietzsche distinguishes slave *instincts* that are "instruments of culture" from *bearers* of these instincts who are not (*GM* I,11); so only certain individuals will carry slave instincts in a higher direction.

55. Such might be the meaning of the provocative construction "the Roman Caesar with Christ's soul" (*WP* 983).

56. Even Zarathustra had to confront the incorporation of his Other, indicated in the eternal recurrence of the "small man" (*Z* III,13). For this reason I think that Schutte is wrong when she proposes that Nietzsche's depreciation of lower orders of life repeats a slavish dualism (*Beyond Nihilism*, chap. 6). As we have seen, Nietzsche's analysis is much too complicated to be a new dualism.

57. See Charles E. Scott, "The Mask of Nietzsche's Self-Overcoming," in *Nietzsche as Postmodernist*, pp. 217–29.

58. See also *BGE* 289. Some possible decodings: "mastery" is connected with the philosophical spirit (*BGE* 5–6) and "breeding" (*Züchtung, züchten*) is often expressed in the more internal sense of "cultivating" (*BGE* 61; *TI* 9,28).

59. Warren, *Nietzsche and Political Thought*, pp. 157–58 and chap. 7.

60. Ansell-Pearson, in "Nietzsche and the Problem of the Will in Modernity," poses the following question for Nietzsche's politics: Does power over oneself (what I am calling power-for) require power over others (p. 185)? My point is that the issue here is more complex and ambiguous than such a question suggests.

61. I should say that I have put aside here another power category that could be called *power-with*, which indicates that certain interactive associations produce capacities that individuals could otherwise not achieve. This is the kind of power that a Habermasian analysis would want to stress. Power-with is certainly essential to any social project, and indeed it is central to, and

fostered by, democratic politics. I would only add that both power-for and power-with can still be connected with power-over in certain respects (one example being the pedagogical milieu). The only mistake would be to exclude agonistic and hierarchical meanings on behalf of a conception of power that overdetermines individuation (power-for) or cooperation (power-with).

62. Detwiler does a good job of challenging nonpolitical readings in *Nietzsche and the Politics of Aristocratic Radicalism*; see also Strong, *Friedrich Nietzsche and the Politics of Transfiguration*, chap. 7, and Schutte, *Beyond Nihilism*, chap. 7.

63. See also *WP* 957, 972. For a discussion of Nietzsche's approving references to political figures like Caesar, Borgia, and Napoleon, see Detwiler, *Nietzsche and the Politics of Aristocratic Radicalism*, pp. 48–54, 133–34.

64. These passages show that interpretations stressing self-creation are one-sided at best. Hunt's claim, for example, that "development of character is the only thing that Nietzsche is interested in" (*Nietzsche and the Origin of Virtue*, p. 57) is quite an overstatement.

65. Detwiler notices that such political aestheticism is uncomfortably close to Nazi ideology (*Nietzsche and the Politics of Aristocratic Radicalism*, pp. 111–14).

66. For Nietzsche's criticisms of anarchism and doctrines of *laisser aller*, see *BGE* 188 and 220; in fact, he sees anarchism in the same light as Christianity (*TI* 9,34).

67. See Strong, *Friedrich Nietzsche and the Politics of Transfiguration*, pp. 105–6. Consider the following passage regarding institutions:

> The whole of the West no longer possesses the instincts out of which institutions grow, out of which a *future* grows: perhaps nothing antagonizes its "modern spirit" so much. One lives for the day, one lives very fast, one lives very irresponsibly: precisely this is called "freedom." That which makes an institution an institution is despised, hated, repudiated: one fears the danger of a new slavery the moment the word "authority" is even spoken out loud. That is how far decadence has advanced in the value-instincts of our politicians, of our political

parties: *instinctively* they prefer what disintegrates, what hastens the end. (*TI* 9,39)

68. As Schutte remarks, Nietzsche's objections to the modern state turn on its subordination of creators, not its threats to individual liberty as such (*Beyond Nihilism*, pp. 172ff.).

69. Nietzsche suggests that the early Greeks experienced a social ambivalence wherein the Apollonian embraced politics and the Dionysian disdained it, but also that they were able to find a harmony in the cultural institution of tragedy (*BT* 21). Did Nietzsche experience a similar ambivalence in search of concordance? Ansell-Pearson argues that Nietzsche's position is neither an echo of traditional political meanings nor an embrace of meaninglessness and social chaos; his aristocratic politics is simply his own answer to the question of how society should be arranged given the death of God and the danger of nihilism (*Nietzsche* Contra *Rousseau*, p. 201).

70. Hunt, *Nietzsche and the Origin of Virtue*, p. 40.

71. Michael Haar argues that Nietzsche is not suggesting a politics of domination, but a kind of unforced aristocratic hierarchy: "Nietzsche and Metaphysical Language," in *The New Nietzsche*, ed. David B. Allison (Cambridge, MA: MIT Press, 1985). A *Nachlass* entry lends some support to a thesis of "coexistence." After Nietzsche distinguishes the egalitarian "last man" and the *Übermensch*, we read:

> The aim is *by no means* to conceive the latter as masters of the former. But: two types are to exist beside each other—separated as much as possible; *like the gods of Epicurus, the one not meddling with the other.* (*KSA* 10, p. 244)

This unpublished entry (1883) does not accord well with published material, and so its reliability is questionable. *HAH* I,438, however, might give the coexistence thesis some support.

72. Warren distinguishes Nietzsche's use of *Kultur* and *Zivilisation* to differentiate individuation and socialization (*Nietzsche and Political Thought*, chap. 2, notes 1 and 46).

73. Here I am trying to follow Connolly's suggestion that one

avoid the question of the "true" Nietzsche and pursue a political thematization of Nietzschean elements that one can endorse and enact (*Identity/Difference*, p. 197). I would like to think that my thematization can preserve more of Nietzsche's thought than has heretofore been the case.

Chapter Three: Nietzsche Contra Nietzsche: Democracy Without Equality

1. For a discussion, see Dahl, *Democracy and Its Critics*, chap. 3.

2. Frithjof Bergmann supplants state of nature myths, whether they conceive the prepolitical condition to be brutal or noble, with a conception of freedom that emphasizes facing obstacles, which avoids the polarization of freedom and the political that either overestimates or underestimates the importance of the state; see *On Being Free* (Notre Dame: University of Notre Dame Press, 1977).

3. Dahl, *Democracy and Its Critics*, p. 251.

4. Most of my layout here is borrowed from Dahl, ibid., chap. 8. For a comprehensive analysis of the theoretical questions in democratic thought, see J. Roland Pennock, *Democratic Political Theory* (Princeton: Princeton University Press, 1979).

5. I would not agree with Dahl that polyarchy is an "imperfect" conception of democracy (*Democracy and Its Critics*, p. 177). This will become clear as we proceed.

6. White, *Philosophy, The Federalist, and the Constitution*, p. 206. For a contemporary attempt to retrieve something of this tradition, see Thomas L. Pangle, *The Ennobling of Democracy: The Challenge of the Postmodern Era* (Baltimore: The Johns Hopkins University Press, 1992), a neoconservative analysis that challenges simplistic critiques of modernism, but that unfortunately banks on its own simplistic caricatures of postmodernism. Pangle concurs that American political ideals were drawn from Judeo-Christian and Enlightenment conceptions of human nature and rationality (pp. 73–74); he goes on to declare:

Only from this conception of human nature can we derive the fixed,

universal, and permanent moral principles . . . that lie at the heart of the U.S. Constitution. (p. 74)

Obviously I want to find an alternative to a nostalgic repetition such as this.

7. See Dahl, *Democracy and Its Critics*, pp. 22–23.

8. See Josiah Ober, *Mass and Elite in Democratic Athens* (Princeton: Princeton University Press, 1989).

9. In early American democracy, of course, women and blacks were excluded from participation, the justification for which was the belief that they were not truly capable of self-government. The ambivalence of Thomas Jefferson on the question of slavery is well known; in general terms he thought that slavery was immoral, but he continued to own slaves, and there are indications of racism in remarks about the intellectual abilities of blacks. See Peter S. Onuf, ed., *Jeffersonian Legacies* (Charlottesville: University Press of Virginia, 1993).

10. For a representative collection on this question, see J. R. Pennock and J. W. Chapman, eds., *Equality* (*Nomos* IX) (New York: Atherton Press, 1967). See also Amy Gutman, *Liberal Equality* (New York: Cambridge University Press, 1980); Kai Nielsen, *Equality and Liberty: A Defense of Radical Egalitarianism* (Totowa, NJ: Rowman and Allanheld, 1985); and Peter Weston, *Speaking of Equality: An Analysis of the Rhetorical Force of "Equality" in Moral and Legal Discourse* (Princeton: Princeton University Press, 1990).

11. See my *Myth and Philosophy*, chaps. 2–6.

12. *KSA* 1, pp. 783–92.

13. We notice here a prefiguration of Nietzsche's concept of will to power, in the sense of finding one's meaning in relation to an opposing force.

14. Consider Aristotle's remark:

Victory also is pleasant, and not merely to the competitors but to everyone; the winner sees himself in the light of a champion, and everyone has a more or less keen appetite for being that. The pleasantness of victory implies of course that combative sports and intellectual contests are pleasant. . . . That is why forensic pleading and debating contests are pleasant to those who are accustomed to them

and have the capacity for them. (*Rhetoric* I.11.1370b32–1371a8)

15. Focusing on character formation, Hunt has attempted to locate in *Homer's Contest* a deconstruction of Nietzsche's objections to a liberal social order (*Nietzsche and the Origin of Virtue*, pp. 59–68), by stressing an ideal of open competition, a "liberalism with teeth" (p. 65). Although I agree with Hunt that *Homer's Contest* contains a potential for social theory that Nietzsche did not develop (p. 66), I disagree that Nietzsche's thought later moved away from the implications of that early piece (pp. 67–68). *Homer's Contest* is quite consistent with will to power, as I have said; and Hunt is wrong in suggesting that Nietzsche moved away from a social construction of competition toward an agon stemming from "inner" drives and intentions (see *BGE* 32), and that he moved away from spontaneous emergence because he came to "abhor" chance, anything "not controlled by human intelligence and will" (see *Z* III,4). I hope to show that Nietzsche's distorted picture of *democracy* facilitates a deconstruction of his politics in the light of his own thinking. In this respect, Strong is right in claiming that Nietzsche saw democratization as a slavish decline in the cultural agon required by politics (*Friedrich Nietzsche and the Politics of Transfiguration*, p. 201), and Ansell-Pearson moves in a good direction by suggesting that Nietzsche's outlook can be modified by a "Dionysian politics that is both agonistic and democratic" (*Nietzsche* Contra *Rousseau*, p. 18). I want to challenge Nietzsche as well, but I aim to go further than Ansell-Pearson's mere conjunction by arguing that democracy *is* agonistic.

16. For a discussion of the connections between Greek democracy and contests, see Jean-Pierre Vernant, *Myth and Society in Ancient Greece*, trans. Janet Lloyd (Sussex: Harvester Press, 1980), pp. 19–44; on the open atmosphere of uncertainty and interrogation, see Castoriadis, "The Greek *Polis* and the Creation of Democracy," in *Philosophy, Politics, Autonomy*, chap. 5; see also Ober, *Mass and Elite in Democratic Athens*, pp. 291, 333. For an analysis of the relationship between Greek science and the sociopolitical atmosphere of argumentation, see G. E. R. Lloyd, *Magic, Reason, and*

258 Notes to Pages 63–65

Experience (Cambridge: Cambridge University Press, 1979), chap. 4. One other genealogical point that fits well with Nietzsche's predilections: Changes in military technology and the transition from a warrior class to a citizen army had a lot to do with the movement toward democracy. Both the need for, and the force represented by, an armed citizenry would certainly disrupt and threaten the select concentration of political power. For a discussion and references, see Dahl, *Democracy and Its Critics*, pp. 245–48. Aristotle mentions the connection between military power and democracy in *Politics* III.7 and 17.

17. Herein lies an improvement over Warren's attempt to incorporate will to power into liberal political theory by stressing the idea of self-constitution, which disregards the motifs of domination (power-over) in Nietzsche's texts.

18. See Ansell-Pearson, *Nietzsche* Contra *Rousseau*, pp. 214–15.

19. The more inclusive the political order, the less likely harmony will reign. See Dahl, *Democracy and Its Critics*, chap. 1. This speaks to the flaws in certain nostalgic yearnings for the supposed harmony and sense of community in past ages. Even if such conditions did obtain, they were bogus and unretrievable because they depended upon various forms of *exclusion*. See Kymlicka, *Contemporary Political Philosophy*, pp. 224–30.

20. Ober, *Mass and Elite in Democratic Athens*, pp. 73–85, 297–99.

21. As Lefort puts it:

> The exercise of power is subject to the procedures of periodical redistributions. It represents the outcome of a controlled contest with permanent rules. This phenomenon implies an institutionalization of conflict. The locus of power is an empty place, it cannot be occupied—it is such that no individual and no group can be consubstantial with it— and it cannot be represented. (*Democracy and Political Theory*, p. 17)

Castoriadis identifies politics with the questioning of all social and political norms; see "Power, Politics, Autonomy," in *Philosophy, Politics, Autonomy*, pp. 143–74.

22. Aristotle (*Politics* III.11) and Mill (*On Liberty*) professed something along these lines. For a treatment of this belief in the

Greek world, see Ober, *Mass and Elite in Democratic Athens*, pp. 163–69; aristocratic doubts about the "wisdom of the masses" are discussed on pp. 187ff.

23. For a discussion of the issues surrounding the assessment of majority decisions, see Dahl, *Democracy and Its Critics*, chap. 10.

24. See Brian Barry's analysis of majority rule in "Is Democracy Special?" in *Democracy: Theory and Practice*, ed. John Arthur (Belmont, CA: Wadsworth, 1992), pp. 59–66.

25. *Letter to George and Thomas Keats*, December 1817. Negative capability is something like what Rorty calls the condition of an "ironist" (*Contingency, Irony, and Solidarity*, p. 73).

26. Dahl, *Democracy and Its Critics*, p. 262.

27. See also *BGE* 42 and *GM* III,9.

28. See also *HAH* I,636–37.

29. As indicated earlier, Nietzsche's middle period reflects an interesting shift where rationality and science are given more emphasis and approval, which, I think, explains the higher regard for democracy. For a political analysis of the middle period in relation to early and later writings, see Detwiler, *Nietzsche and the Politics of Aristocratic Radicalism*, pp. 183–88. As I have said, however, I do not want to assume that these periods are sealed off from each other with no significant overlap. Nonetheless, the middle period does provide much more ammunition for a democratization of Nietzsche than do the more illiberal, immodest writings of the later period.

30. See also *D* 556 and *Z* I,10. This element in Nietzsche's thought should dampen Schutte's concern that will to power generates erasure and censorship (*Beyond Nihilism*, p. 30).

31. For an agonistic interpretation of athletics, see my essay, "The Greeks and the Meaning of Athletics," in *Rethinking College Athletics*, ed. Judith Andre and David James (Philadelphia: Temple University Press, 1991), pp. 31–42.

32. Warren notices the possibilities for a notion of respect implied in the relational structure of will to power (*Nietzsche and Political Thought*, pp. 234–35), but in simply stressing the "intersubjectivity" of will to power without enough attention to its

agonistic dynamic, he drifts past Nietzsche significantly and suggests the notion of "equal respect" (p. 247), which I think is an unnecessary construction that only rekindles a Nietzschean critique. For an articulation of agonistic respect that is more in line with a Nietzschean disequilibrium, see Connolly, *Identity/Difference*, chap. 6, especially pp. 166–67, 178–79.

33. In a later chapter I will take up the problem of giving political respect to views that promote *exclusionary* attitudes and practices.

34. The fate of Socrates at the hands of democratic Athens, of course, was a defining moment in the development of Plato's political views. The unregulated variability of democracy also bothered Plato; see the *Republic* 557–59, where democracy is described as free, multifarious, and tolerant, as an excessive array of possibilities that gets out of control.

35. My students not only "slavishly" follow my instructions and accept my judgments, they *pay* for this subordination.

36. Aristotle hints that something like Plato's scheme would be right if we were confronted with a person of preeminent excellence (*Politics* III.13.1284b25–35). Dahl labels political aristocracy "guardianship"; see his discussion in *Democracy and Its Critics*, chaps. 4–5. Some democratic theorists attempt to have it both ways on this question. See, for example, David Estlund, "Making Truth Safe for Democracy," and David Copp, "Could Political Truth Be a Hazard for Democracy?" in *The Idea of Democracy*, ed. David Copp, Jean Hampton, and John E. Roemer (Cambridge: Cambridge University Press, 1993), pp. 71–117. They explore avenues for affirming democracy while granting the existence of objective political truth that is unequally apprehended—which they admit could justify elitist rule of the type advocated by Plato. Estlund argues that many people might reasonably fail to recognize the wisdom of an elite, whose authority, therefore, would not be granted; Copp argues that there are other important things besides political truth that democracy serves and fosters. I remain unconvinced. It seems to me that they have already eaten their democratic cake when they stipulate a select, objective truth in

politics. Plato at least had the clearer and more consistent position.

37. Lefort, *Democracy and Political Theory*, p. 19.

38. See *Considerations on Representative Government*, in John Stuart Mill, *Three Essays* (New York: Oxford University Press, 1975), pp. 284–85.

39. The limits of Mill's openness are also indicated in his remarks about despotism being appropriate for governing "barbarians" (*On Liberty*, in *Three Essays*, p. 16).

40. Schutte notices the inconsistency in a philosopher of flux and pervasive critique being uncritical of his own rigid social categories (*Beyond Nihilism*, pp. 184–86). Strong, in "Texts and Pretexts," argues that Nietzsche's perspectivism subverts all hierarchies, and so his aristocraticism should deconstruct itself into a democracy.

41. In an 1885 note, Nietzsche discusses the loss of trust in eternal truths that had sustained traditional aristocrats like Plato. Accordingly the task of the legislator now has to confront a "new fearfulness" in the face of this loss. Nietzsche seems to suggest, however, that the new legislator should simply press on anyway (*KSA* 11, p. 612).

42. Warren highlights this discrepancy between Nietzsche's philosophical openness and political closure (*Nietzsche and Political Thought*, pp. 235–37).

43. See *The Federalist* #10 and #51. For an extended discussion, see White, *Philosophy, The Federalist, and the Constitution*, chaps. 6–8. One wonders, incidentally, to what extent Christian psychology contributed to this kind of democratic suspicion, since for Christianity all humans are sinners by nature, are always prone to fall from virtue, and cannot attain perfect virtue by their own efforts. Nietzsche, of course, takes this suspicion all the way and forbids *any* model of perfection that can tempt our confidence or dilute our suspicion with belief in the possibility of "divine sanction" (see *WS* 81).

44. John Dewey, "Democracy and Educational Administration," *School and Society* 45 (April 1937).

45. In addition to distrust, the context of decision-making in the

262 Notes to Pages 74–77

midst of empirical contingencies, complexities, and trade-offs is such that even the most competent people cannot claim enough certainty to render their decisions incontrovertible. See Dahl, *Democracy and Its Critics*, pp. 75–76. More generally, the scarcity of goods and resources is a persistent element of finitude that prompts inevitable conflicts over distribution; the resulting uncertainty and instability underwrites the perpetual need for politics, rather than simply administration in the light of firm principles of justice.

46. For a study of the connections between democratic politics and philosophical skepticism, see Aryeh Botwinick, *Skepticism and Political Participation* (Philadelphia: Temple University Press, 1990).

47. Another subtle example of the truth-authority correlation is illustrated in the case of Hamilton and Madison, who shared Locke's view that key "self-evident truths" such as natural rights could not be grasped by all people because of biases, passions, and prejudices (see *The Federalist*, #31). This fed a certain intellectual elitism, shared by many founders, wherein only a select few could come to know the true interests of the nation (see #17). The irony here is that a postmodern suspicion of truth can wind up being *less* elitist than certain traditional theories that ostensibly put so much stock in human equality!

48. For a postmodern analysis of political language that stresses context and power regimes in political speech as contrasted with "communicative" models, and that highlights Foucault's politics of subverting dominant discourses, see Michael J. Shapiro, "Weighing Anchor: Postmodern Journeys From the Life-World," in *Life-World and Politics: Between Modernity and Postmodernity*, ed. Stephen K. White (Notre Dame: University of Notre Dame Press, 1989), pp. 139–65.

49. Nietzsche himself warns against the danger of "great men" holding political power and of believing in their higher virtue (*TI* 9,44).

50. Nietzsche called the common good a contradiction in terms (*BGE* 43). For a discussion of the tension between pluralism and the common good, see Dahl, *Democracy and Its Critics*, chaps. 20 and 21.

51. There are also defensible versions of the common good in terms of operations on behalf of the general welfare that are proper functions of government: for example, defense, safety regulations, and infrastructure.

52. For Hobbes, the state of nature is the arena of conflict subdued by the political order. For Rousseau, social relations produce conflicts that corrupt an original harmony in the state of nature. For Hegel and Marx, conflict is a necessary dynamic for developing an articulated social order. In all cases, conflict is either erased, regretted, or sublated. As Connolly says, such displacements ignore the disruptive dimension of political practice and implicitly aim for the *disappearance* of politics into the harmony of a political order (*Political Theory and Modernity*, p. 130).

53. Hannah Arendt developed a comparable political vision that tapped many of the postmodern elements in Nietzsche's thought. For Arendt, political practice is nonfoundational, nonsubjectistic, performative, pluralistic, agonistic, and creative. See particularly *The Human Condition* and *On Revolution* (New York: Penguin Books, 1963). For an insightful analysis, see Honig, *Political Theory and the Displacement of Politics*, chap. 4. Honig includes a critique of Arendt's division between creative openness in the political sphere and normalized closure in the private sphere (which is a reversal of Rorty's public-private contraposition).

Chapter Four: Agonistic Democracy

1. Connolly, in *Identity/Difference*, has introduced the term "agonistic democracy" (p. x), and much in his work is a precedent for my efforts. I see my contribution as twofold: 1) providing more details of concrete political practices, and 2) confronting the problem of excellence and elitism that is indigenous to a Nietzschean agonistics.

2. See, for example, "The Priority of Democracy to Philosophy," in *Objectivity, Relativism, and Truth* (Cambridge: Cambridge University Press, 1991), pp. 175–96.

3. See, for example, Barry, "Is Democracy Special?" p. 60.

4. The pragmatic experimentalism of John Dewey is certainly relevant here, although I would question his overreliance on scientific methodologies and his emphasis on common ideals in a democratic society. An important study is Robert B. Westbrook, *John Dewey and American Democracy* (Ithaca, NY: Cornell University Press, 1991).

5. The procedural approach I am taking is radically pragmatic, then, to distinguish it from noninstrumental procedural theories that locate preconceived democratic ideals (e.g., equality) in procedures rather than in outcomes; see the collection of essays in section 4 of *Democracy: Theory and Practice*. I am trying to avoid the presupposition of such preprocedural ideals. I would also want to avoid being aligned with the so-called "best outcome" theories (see the collection of essays in ibid., section 3). Certain instrumental, consequentialist conceptions of democracy are no less susceptible to interrogation of their presuppositions about what outcomes are "best." For a discussion that tries to strike a balance between procedural and substantive theories, and that recognizes the pragmatic and oppositional nature of democratic politics, see Ian Shapiro, "Three Ways to Be a Democrat," *Political Theory* 22, no. 1 (February 1994).

6. This suggests another reason why Warren's attempt at a liberal appropriation of Nietzsche falls short. His emphasis on will to power as self-constitution and agency follows the habit of grounding political theory in a model of human selfhood. The agonistic approach I am suggesting avoids the "self" by stressing relational, procedural situations that bear more on actual circumstances than is often the case in theoretical treatments, and that can open up possibilities of appropriating Nietzsche in less restricted ways than is the case in many Nietzsche interpretations.

7. See, for example, Alan S. Kahan, *Aristocratic Liberalism* (New York: Oxford University Press, 1992), which identifies elitist elements in Burckhardt, Mill, and Tocqueville, and subsequently questions whether they can be called "democratic."

8. See *Nicomachean Ethics* II.1.

9. Much of modern political thought can be traced to the division between human freedom and natural constraint, a theme developed by Yack in *The Longing for Total Revolution*. Kant's bifurcation of freedom and natural necessity both focused this problematic and catalyzed much of the modern discontent with social ills (p. 106). The hyperbolic identification of "human nature" with freedom from constraint leads to many of the anomalies and ironies in modern politics. If physical nature is the constraint, then political culture can be seen as the ultimate liberator of human nature. If political institutions themselves are taken as the constraint, then the state can be seen as the inhibitor of human nature. Various emphases and mixtures of such thinking can be located in Hobbes, Rousseau, Hegel, Marx, and liberalism. In any case, humanization and the response to dehumanization are guiding themes in modernism. In chap. 8 Yack includes Nietzsche in this thematic, but his reading stresses early works and misses the disruptive challenge to modernist assumptions in later works. Nevertheless, Yack's analysis shows how modernist conceptions create incompatible tensions that spawn a host of incompatible political projects, and that stem from a flawed account of how humans are (or can be) situated in the world (see pp. 366ff.). In my view, a Nietzschean accommodation with finitude can steer clear of such paradigmatic problems.

10. Later we will take up the debate between liberalism and communitarianism in this regard.

11. See Roger H. Davidson and Glenn R. Parker, "Why Do Americans Love Their Congressmen So Much More Than Their Congress?" in *Legislative Studies Quarterly* (February 1979): 53–61.

12. Rorty, *Contingency, Irony, and Solidarity*, p. 73.

13. John Rawls, *Political Liberalism* (New York: Columbia University Press, 1993), p. xvi.

14. See ibid., Lecture V.

15. See Stephen L. Carter, *The Culture of Disbelief: How American Law and Politics Trivialize Religious Devotion* (New York: Basic Books, 1993). For a fair and pointed liberal response, see Rorty, "Religion as Conversation-Stopper," *Common Knowledge* 3,

no. 1 (Spring 1994): 1–6.

16. Honig points out that the pro-choice side wrongly assumed that the courts had settled the conflict without remainder, and they thereby gave an agonistic edge to their opponents who could tap into certain doubts about abortion in the minds of many citizens (*Political Theory and the Displacement of Politics*, pp. 14–15).

17. For this reason, I do not subscribe to Rawls' idea that comprehensive doctrines be "removed" from the political agenda for the purpose of "bypassing" certain deep controversies, in the hope of discovering an "overlapping consensus" that is "stable" (*Political Liberalism*, Lecture IV; quotations taken from pp. 151–52).

18. Bernhard Waldenfels has worked out an interactive model of human experience along the lines of a dialogical agonistics, which is ever productive of order out of conflict but never reducible to an uncontested order. In this way, intersubjectivity is preferred over traditional subject-centered models, but an agonistic openness is preferred over something like Habermas' sense of intersubjectivity, which affirms a telos of consensus and operates with constructions such as ideal speech conditions and universalizable norms. See Waldenfels, *Ordnung in Zwielicht* (Frankfurt-Main: Suhrkamp, 1987) and *Der Spielraum des Verhaltens* (Frankfurt-Main: Suhrkamp, 1980). For an analysis, see Dallmayr, *Margins of Political Discourse*, chap. 5. For a recent critique of consensus, see Nicholas Rescher, *Pluralism: Against the Demand for Consensus* (New York: Oxford University Press, 1993).

19. The latent annulment of political practice in various theoretical models is the general theme of Honig's insightful work, *Political Theory and the Displacement of Politics*.

20. Parliamentary democracies are distinguished from the American system of divided government by their relative diminishment of agonistics, in that a single party is given more legislative control. There remains, however, the baseline agonistics of elections and the capacity to remove a ruling government through a no-confidence vote.

21. For an overview of the differences between the two systems see David Luban, "Why Have an Adversary System?" chap. 5 in

Lawyers and Justice: An Ethical Study (Princeton: Princeton University Press, 1988).

22. As Honig puts it, the realm of the law and rights should be seen "as a part of political contest rather than as the instruments of its closure" (*Political Theory and the Displacement of Politics*, p. 15). For an analysis of the relationships between law and politics in the American common law tradition from a deconstructive standpoint, see Michel Rosenfeld, "Deconstruction and Legal Interpretation: Conflict, Indeterminacy and the Temptations of the New Legal Formalism," in *Deconstruction and the Possibility of Justice*, ed. Drucilla Cornell, Michel Rosenfeld, and David Gray Carlson (New York: Routledge, 1992), pp. 152–210.

23. The prior *establishment* of an empirical standard, however, is itself something more "open" from a postmodern standpoint.

24. Rebellion in the wake of a sham democracy and revolution to establish a democracy are different questions altogether.

25. See April Carter, *Direct Action and Liberal Democracy* (New York: Harper and Row, 1973).

26. For a discussion of the differences and interactions between civil society and the state, see Michael Walzer, "The Civil Society Argument," in *Dimensions of Radical Democracy*, pp. 89–107.

27. See Dahl, *Democracy and Its Critics*, pp. 254–60. For an advocate's analysis, see Douglas J. Amy, *Real Choices/New Voices: The Case for Proportional Representation Elections in the United States* (New York: Columbia University Press, 1993). Calls for proportional representation and redistricting along racial lines must be understood against the background of *de facto* domination of minority groups in the name of majority rule. Such solutions, however, are not immune from creating further problems that stem from overdetermining group identities, from simply rearranging majority domination (as long as new districts continue to have a mixed population), and from creating more hardened opposition from remaining districts once one's own group has been siphoned from those districts. There are alternative strategies that can interject minority interests into procedures governed by majority rule when there are many different sites of interest that by

themselves do not constitute a majority. It should be said, though, that proportional representation can be a way of augmenting and enriching political contestation in legislative bodies.

Chapter Five: Democracy, Excellence, and Merit

1. For a clear and cogent survey of current political theories that focuses on the questions of equality and economic justice, see Will Kymlicka, *Contemporary Political Philosophy* (Oxford: Oxford University Press, 1990). For a general discussion of the question of equality and freedom, see Pennock, *Democratic Political Theory*, chap. 2.

2. This formula is cited and discussed by Kymlicka in *Contemporary Political Philosophy*, pp. 146–51.

3. Influential treatments include John Rawls, *A Theory of Justice* (Cambridge, MA: Harvard University Press, 1971) and Ronald Dworkin, *Taking Rights Seriously* (Cambridge, MA: Harvard University Press, 1977). See also Peter Singer, *Practical Ethics* (Cambridge: Cambridge University Press, 1979), chap. 2.

4. See Rawls, *A Theory of Justice*, p. 102 and throughout; also Kymlicka, *Contemporary Political Philosophy*, pp. 70, 84–85, 122–25.

5. See Ronald Dworkin, *A Matter of Principle* (Cambridge, MA: Harvard University Press, 1985), chap. 9.

6. William Connolly has argued that liberals like Rawls and Dworkin who call for an economic balance of resources cannot, if it comes to instituting such a balance, avoid an intrusive programmatic incursion that would threaten the other liberal ideal of freedom from government constraint. See "The Dilemma of Legitimacy," in *Legitimacy and the State*, ed. William Connolly (Oxford: Blackwell, 1984).

7. I do not disagree when Rawls says that people do not deserve their talent (*A Theory of Justice*, p. 104); but again, who would ever say that they do? Talent is neither deserved nor undeserved. Rawls indicates that the natural distribution of talent is neither just nor

unjust, but simply a natural fact, and akin to a lottery (p. 102). I agree, but as I have said, a lottery outcome is neither fair nor unfair; and if justice is associated with fairness, it is not clear why something that is not a matter of justice in and of itself needs to be corrected by a principle of fairness. If it is not unjust, why is it unfair? The slide from differentiation to unfairness is effortless when equality is a "benchmark" conception for justice (pp. 62, 65). Later we will explore a notion of fairness associated with competition that can sidestep some problematic implications of egalitarianism.

8. In a discussion once about a dilemma situation—specifically, where one's own child and a stranger's child are drowning and only one can be saved—a colleague argued that justice would demand an impartial choice. To this day I find such thinking monstrous. For a critique of impartiality as an implicit suppression of difference, see Iris Young, "Impartiality and the Civic Public," in *Feminism as Critique*, ed. Seyla Benhabib and Drucilla Cornell (Minneapolis: University of Minnesota Press, 1987).

9. Difficulties attaching to Rawls' veil of ignorance in the original position (see *A Theory of Justice*, pp. 136–40) are well known in the literature. In order to screen out contingencies, differences, chance, and partialities—which are presumed to be problematical (p. 12)—persons in the veil do not know particular facts about their lives, interests, or capabilities. Without this restriction, "we would not be able to work out any definite theory of justice at all" (p. 140), we would not achieve the "desired solution" to the problem of arbitrary contingencies (p. 141). It is not clear, however, how we can be rational in this condition, since rationality involves deliberation about ends (p. 14), and yet in the veil we do not know what our ends are. This indicates to me that Rawls' analysis is completely dependent upon an essentialist paradigm that began with Platonism, wherein we can have general knowledge about human existence (pp. 137–38) without any particular experience; I can know about human desire, for example, without actually experiencing any desires. Only a conception of knowledge that privileges abstract and universal categories over concrete

circumstances and particular interests can entertain the veil of ignorance without feeling profound alienation. In this respect, the very proposal of the veil is not itself "impartial." To the extent that this scenario is existentially problematical, any conclusions drawn from it should be suspect, if not entirely rethought. One example is the rather dreary account of risk reduction that marks the quasi-wager in the veil (pp. 150–61). Only the bracketing of concrete experiences guarantees the success of this formula. In real life, some people tolerate more risk than others, some even enjoy it and seek it out. For a critical discussion of issues surrounding Rawls' project, see Honig, *Political Theory and the Displacement of Politics*, chap. 5.

10. Ronald Dworkin proposes an "envy test" for determining an egalitarian distribution of goods and resources; see the two-part essay, "What is Equality?" in *Philosophy and Public Affairs* 10, nos. 3–4 (1981). Not only would such a proposal be susceptible to Nietzsche's genealogical critique, it ignores the fact that egalitarian expectations themselves can *cause* envy in the face of any manifest differences; on this point see *WS* 29.

11. See Dahl, *Democracy and Its Critics*, chap. 7.

12. Some theorists seem to base equal consideration of interests on the supposition that all humans possess certain interests that are the same. Singer, for example, indicates that everyone has "the same interest in avoiding pain" (*Practical Ethics*, p. 33). I have no doubt that everyone has *an* interest in avoiding pain, but as Nietzsche insists, this interest is by no means the *same* in everyone. Some people are much less willing to tolerate or risk pain than others; and if this difference is ever relevant in estimating performances, as in the case of someone who is overly timid (the Rawlsian risk minimizer?), an equal consideration of the interest in avoiding pain would seem inappropriate.

13. We can also extract from this analysis whatever exclusions *are* necessary in democracy. We can exclude those who are not affected by political decisions (noncitizens) and those who cannot engage in political contention or adequately comprehend its meaning (young children and persons with severe mental

incapacity).

14. For example, we can all have the same right to a lawyer, but this need not and really could not mean a right to the same level of legal talent on our behalf (aside from provisions governing incompetence), or to identical treatment in all relevant features of actual proceedings.

15. It is odd that Nietzsche would put this sentence in quotes, as though democrats are eager to hail themselves as "self-seeking cattle and mob." That kind of appellation would only seem to come out of the mouths of aristocrats.

16. Mill, *On Liberty*, in *Three Essays*, p. 9. George Kateb argues that democracy provides greater avenues for the development and expression of individuality rather than a suppressive conformism; see "Democratic Individuality and the Claims of Politics," in *Political Theory* (August 1984).

17. See, for example, Connolly, *Identity/Difference*, pp. 184–90.

18. Rorty, to his credit, recognizes this problem and prefers Freud's more "democratic" concept of self-creation to Nietzsche's elitism (*Contingency, Irony, and Solidarity*, pp. 35–36).

19. This analysis can be compared with Michael Walzer's influential work, *Spheres of Justice: A Defense of Pluralism and Equality* (New York: Basic Books, 1983). Walzer's conception of "spheres" is meant to counter universalistic and uniform principles of justice with a pluralized and contextualized conception that defines injustice as an unwarranted transgression of one sphere into another sphere (e.g., wealth determining political power). Walzer's study is a rich and detailed account that explores different areas of life such as the family, work, education, and religion. My reservations are that the spheres are defined in overly consensual, stable, and fragmented terms. The different regions of justice seem too much secured and grounded in "shared understandings of the members" (p. 313), which can mask local forms of exclusion and domination; and not enough attention is paid to ambiguous and conflicting relations between different spheres. Moreover, there is not enough discussion of the justified inequalities that can follow from a contextual analysis. Walzer's notion of "complex equality" is

certainly an improvement over more substantive and formal conceptions, as is the idea that political equality is basically negative in meaning, namely the *opposition* to unwarranted domination (pp. xiv–xv). My questions involve whether the word "equality" is subsequently useful any longer and whether it will haunt political philosophy with echoes of "simple equality." For a comparative discussion of Walzer and postmodern thought (particularly Lyotard), see White, *Political Theory and Postmodernism*, chap. 7.

20. In the *Politics*, Aristotle attributes the disruptive tensions between democracy and oligarchy and their alternating insurrections to their faulty conceptions of justice, since democracy tends toward the extreme view that people equal in any respect are equal in all, and oligarchy assumes that people unequal in one respect (e.g., wealth) are unequal in all (V.1.1301a25–40).

21. Consider this interesting passage:

> *Two kinds of equality.* The thirst for equality can express itself either as a desire to draw everyone down to oneself (through diminishing them, spying on them, tripping them up) or to raise oneself and everyone else up (through recognizing their virtues, helping them, rejoicing in their success). (*HAH* I,300)

22. Hunt makes a comparable call for a wider application of a Nietzschean interest in excellence (*Nietzsche and the Origin of Virtue*, p. 178).

23. Keep in mind that this passage says nothing about a *common* higher self or excellence; and the passage continues by indicating that many people fear their higher selves.

24. It should be reiterated that the political equality indicated in the formula we are using still does not commit us to any substantive equality. The postmodern approach we are adopting provides a nonegalitarian route to political equality, which therefore is simply a procedural equity, but which can continue to operate putatively in the formula.

25. Mill did not think that something like equal worth was necessary in democracy; the idea that all views should count the

same, he thought, was foolish.

> [T]hough everyone ought to have a voice—that everyone should have an equal voice is a totally different proposition. . . .
> Everyone has a right to feel insulted by being made a nobody, and stamped as of no account at all. No one but a fool, and only a fool of a peculiar description, feels offended by the acknowledgment that there are others whose opinion, and even whose wish, is entitled to a greater amount of consideration than his. To have no voice in what are partly his own concerns, is a thing which nobody willingly submits to; but when what is partly his concern is also partly another's, and he feels the other to understand the subject better than himself, that the other's opinion should be counted for more than his own, accords with his expectations, and with the course of things which in all other affairs of life he is accustomed to acquiesce in. (*Considerations on Representative Government*, in *Three Essays*, p. 283)

Mill goes on, however (as we have seen), to suggest the possibility that votes from some segments of society could be given more numerical weight in electoral tabulations. A postmodern perspective could accept Mill's nonegalitarian gesture toward expertise and excellence but be quite suspicious of his institutional proposal to manage and delineate political procedures, since his apparent a priori confidence in "identifying" the respective voter groups can be challenged on both theoretical and practical grounds.

26. In the same way, cheating in an athletic contest or "fixing" the results would completely nullify the estimation of a victory, the proof of which would be that no team that won a game by cheating or such would want its fans to know. For a discussion of this and other relevant matters, see my essay, "The Greeks and the Meaning of Athletics."

27. In *Homer's Contest*, Nietzsche mentions the Greek practice of ostracism, which was meant to preserve a balance of talents by banishing someone of overly superior ability; if someone had an excessive advantage, then "the contest would come to an end" (*KSA* I, p. 788). So excluding someone who was "too good" was thought to be just. See also Aristotle's discussion of ostracism along these lines in *Politics* III.13.

28. Although affirmative action policies are far from

unproblematical, basing them in competitive fairness would not suffer from the same automatic discord as standard egalitarian principles such as equal consideration of interests, in which case affirmative action can be labeled "reverse discrimination." For an insightful analysis of the ambiguities of affirmative action, see Glenn C. Loury, "Why Should We Care About Group Inequality?" in *Social Philosophy and Policy* 5, no.1 (Autumn 1987).

29. For an analysis that shows the theoretical and practical shortcomings in assuming that democratic procedures are based on or lead to an equal consideration of citizens' interests and influence, see Charles Beitz, "Procedural Equality in Democratic Theory," in *Democracy: Theory and Practice*, pp. 223–35.

30. Such compensations can be associated with the previously noted phenomenon of ostracism, not in the sense of exiling persons, but of canceling certain excesses that undermine political competition.

31. Such a charge against Nietzsche is part of Schutte's agenda in *Beyond Nihilism*; see also Warren's criticisms of Nietzsche's sense of rank in *Nietzsche and Political Thought*, pp. 228ff.

32. Accordingly, both communist and fascist totalitarian regimes can be deciphered as weak and nihilistic in this respect. See Schutte, *Beyond Nihilism*, p. 53.

33. For a discussion of different issues pertaining to representation, see J. Roland Pennock, "Political Representation: An Overview," in *Democracy: Theory and Practice*, pp. 49–59.

34. See Dahl, *Democracy and Its Critics*, pp. 24–28, and chap. 19. For a good sample of the different sides of this question, see the collection of essays in parts 4 and 5 of *Key Concepts in Critical Theory: Democracy*, ed. Philip Green (Atlantic Highlands, NJ: Humanities Press, 1993). Particular mention should be given to Joseph A. Schumpeter, who argues that a populist "will of the people" model does not suit modern democracy, since citizen opinions are often formed or clarified *by* candidates or political parties. Democratic practice, therefore, is better rendered as the competition of potential leaders for the favor of the electorate. See *Capitalism, Socialism, and Democracy* (New York: Harper and Row,

1950), chaps. 21–23. Schumpeter's recognition of an agonistic element in democracy is important, but he underestimates the possibilities for grassroots movements and direct action by citizen groups.

35. See Thomas Jefferson, *Writings*, ed. Merrill D. Peterson (Library of America, 1984), pp. 1305–6.

36. Certain practical considerations and elements of social dynamics make political leadership compatible with democracy, especially when we realize that leadership is not synonymous with domination, that there is a symbiotic relationship between leaders and followers that informs both sides of the linkage. See Pennock, *Democratic Political Theory*, chap. 12.

37. Representative democracy has some advantages over direct democracy of the Athenian type in being less susceptible to demagoguery, mob rule, and rash decisions. Even Athenian democracy, however, could not be characterized as thoroughly egalitarian and populist, but rather as a blend of mass and elite elements. See Ober, *Mass and Elite in Democratic Athens*, pp. 123–25, 304–7, 316–24, 332–39. I should add that the problem of shallow political discourse in mass democracy can partly be attributed to the retreat of intellectuals to an isolated and insulated sphere, because academic discussions today have become so esoteric and arcane that their potential influence on public debate has dwindled to the point where shallowness has free reign.

38. Such an outlook can be understood in Nietzschean terms as accepting a "tragic" element in politics, in that politicians should affirm the fact that their best efforts can still be undone in the electoral process. In this way we can also find room to foster commitment in the face of shifting poll data and electoral outcomes, rather than the tendency among politicians to identify their policies with whatever the majority will happens to be. I was dismayed by Bill Clinton's snivelling performance after the Republican victory in the 1994 Congressional elections, when he claimed to have "gotten the message" that his policies were not received well and may need revising—as though sticking with his beliefs and fighting for them, come what may in the next election,

never occurred to him.

39. An academic department can serve as an impressive example of a competent democratic community, whose collective decisions could reflect high-level deliberations about essential matters of concern, rather than mediocre, debased, or inappropriate results. At the same time, I wonder how many academics would really favor assigning the offices of chair or dean by lot, which would mean that all members would get their turn.

40. See Iain McLean, *Democracy and New Technology* (Oxford: Basil Blackwell, 1989).

41. Moreover, if bargaining and compromise are at all valuable, such things are far less likely in direct democracy than in representative institutional milieus.

42. See W. Russell Neuman, *The Paradox of Mass Politics: Knowledge and Opinion in the American Electorate* (Cambridge, MA: Harvard University Press, 1986).

43. If this is true, we do not have to agree with Dahl that elitist tendencies violate democratic criteria (*Democracy and Its Critics*, p. 279). Along these lines, for a general discussion of the role of political parties and how they compensate for limitations in direct democracy and populist principles, see Pennock, *Democratic Political Theory*, chap. 7. For a work that is much more optimistic about, and supportive of, direct and expansive citizen participation, see Benjamin Barber, *Strong Democracy: Participatory Politics for a New Age* (Berkeley: University of California Press, 1984).

44. For a discussion of historical, socio-economic, cultural, attitudinal, and institutional conditions that foster democracy and of how these conditions relate to the question of democracy in the developing world, see Pennock, *Democratic Political Theory*, chap. 6.

45. Nietzsche's warnings about the insidious effects of egalitarian mediocrity can be aimed at the so-called self-esteem movement in American education. Low self-esteem is certainly a problem in student development and performance, but the question concerns overblown pictures of self-esteem and counterproductive effects of certain assessment practices. The ubiquitous cry that

students should "feel good about themselves" has created a tendency to praise student performance indiscriminately. Such a technique not only short-changes high achievement, but students who are continually praised for simple tasks, or for simply *doing* tasks, or for tasks that were not given the appropriate effort can perhaps get an unintended message: that they must not be considered very smart and are indeed simply being praised so that they will feel good, not because they have done well. Genuine and lasting self-esteem can come from hard work and succeeding at difficult tasks, but this implies comparative judgments of performance and a challenge to student potential. Where is it written that students should not "feel bad about themselves" when they have not performed well, when they could have done better, and when the proper encouragement, resources, and opportunity to improve are provided? Coping with failure and shortcomings and developing the habits that can sustain students in efforts for improvement are necessary life lessons as well as a means for identifying and fostering high achievement in schools. See William A. Damon, *Greater Expectations: Overcoming the Culture of Indulgence in America's Homes and Schools* (New York: Free Press, 1995).

46. Consider the example of universities: I see no reason to support authoritarian, administrative oligarchies in higher education; faculty (and students in some matters) ought to be able to sustain "bottom up" decisions in academic affairs.

47. Here we are in line somewhat with Rorty's version of the liberal division between the public and the private spheres (see *Contingency, Irony, and Solidarity*, pp. 65–69, chaps. 4–6). The most important contribution Rorty makes is to keep "final vocabularies" out of political power and restrict them to the domain of self-creation, which is an effective check on political tyranny. Rorty's division may be too sharp, however, and many liberal assumptions about selfhood and social relations can be challenged in political milieus, as we will see. For a cogent analysis and critique, see Bernstein, *The New Constellation*, chaps. 8–9.

48. For a comparable recognition of the paradox of Nietzsche's

politics, see Schutte, *Beyond Nihilism*, p. 160.

49. Ansell-Pearson makes a comparable point in *Nietzsche Contra Rousseau*, pp. 211–12.

50. See *HAH* I,632, where fixed convictions are said to stimulate and strengthen innovative countermovements.

51. See also *WP* 887.

52. The return of the rabble and the small man was the great obstacle to Zarathustra's affirmation of eternal recurrence (*Z* II,6; III,13).

53. At one point Nietzsche indicates that improvisation is inferior to a carefully fashioned artistic idea (*HAH* I, 155). He also affirms the importance of convention for the purpose of communication; avoiding convention altogether means not wanting to be understood, and so one must question the intention of the "modern rage for originality" (*WS* 122).

54. White, to his credit, owns up to the problem of constraint in postmodern discourse (*Political Theory and Postmodernism*, chap. 7).

55. All right, maybe Nietzsche was a prude; and maybe I just don't get it, but it seems to me that the celebration of sexuality is way overblown. I am always reminded that the real antagonist for Kierkegaard's aesthete was not repression or social constraint, but *boredom*.

56. One writer who takes an extreme line on the question of eroticism and madness is Georges Bataille; see *Visions of Excess: Selected Writings, 1927–1939*, trans. Allan Stoekl, Carl R. Lovitt, and Donald M. Leslie, Jr. (Minneapolis: University of Minnesota Press, 1985). Foucault's analyses, it should be said, are much more subtle and sensitive to the ambiguities of freedom and control; see especially the interview recorded in *The Foucault Reader*, pp. 381–90.

Chapter Six: Perspectivism, Truth, and Politics

1. See also *BGE* 34.

2. See Warren, *Nietzsche and Political Thought*, pp. 90–99. For extended treatments, see Alan D. Schrift, *Nietzsche and the Question of Interpretation: Between Hermeneutics and Deconstruction* (New York: Routledge, 1990), especially chaps. 6 and 7, and Maudemarie Clark, *Nietzsche on Truth and Philosophy* (Cambridge: Cambridge University Press, 1990), especially chap. 5.

3. See, for example, *BT* 21–22, *TI* 3,2 and 6, and *WP* 708.

4. See also *GM* I,1.

5. Hegel and Heidegger both take up this positive sense of appearance, and a *Nachlass* entry suggests a similar move in Nietzsche's thinking: Appearance (*Erscheinung*) is countered by the word *Schein* (which could be rendered as "appearing" or "showing"), where *Schein* is a condition of reality (*Realität*) that opposes any transformation into an imagined truth-world (*KSA* 11, p. 654). See *TI* 9,32 for Nietzsche's promotion of *Realität* and real (*wirklich*) conditions over idealizations.

6. See also *WP* 853 and *GS* 107.

7. See also *HAH* I,131.

8. We might be tempted to call Nietzsche a kind of fallibilist, except that fallibilism, in my view, comes across as "greased pig veridicalism," in that truth or consensus can operate as an absent measure or source of comfort, all the while avoiding the charge of closure. Fallibilists like Peirce seem to retain a belief in a transcendent truth that can give sense to the idea of continually striving for better and better beliefs, even though our beliefs may never arrive at unvarnished truth—they simply can hold to the extent to which they survive critical scrutiny. Habermas' fallibilism shies away from the idea of transcendent truth, but his emphasis on consensus, universal validity, ideal speech conditions, and "the force of the better argument" (*The Philosophical Discourse of Modernity*, e.g., pp. 130, 322–23) is no less slippery in continuing to cash in on

traditional truth conditions without having to proffer traditional constructions that have been challenged in contemporary thought (see Dallmayr's analysis and critique in *Margins of Political Discourse*, chap. 3). Bernstein's "engaged fallibilistic pluralism" (*The New Constellation*, p. 336) is sensitive to these problems, but I am still suspicious about "flip-siding" traditional notions. Fallibilistic critique and self-correction is not an unworthy proposal, but we must ask about its criteria and scope. How would fallibilism address apparently incommensurable conflicts or differences? How would fallibilistic critique function in disciplines other than science, in art and ethics, for example? Traditional philosophy not only believed in objective truth conditions, it also saw truth crossing all the different discourses (e.g., objective criteria for measuring beauty and goodness). Attention to *conflicts* within and between different discourses remains a strength of postmodern thought that falli- bilism has not met, as I see it. A concealed or subliminal sense of decisive truth is a significant problem because it can affect the ways in which investigations are carried out and how challenges are met. As an ancient example, Aristotle's ethics was an improvement over Plato's universal conception of the good; the human good, for Aristotle, was less certain, more pluralized, more contingent. Yet, Aristotle's conception of a divine intellect, though distant from, even unattainable for, human thought, must have been the absent measure for the kind of comfortable, confident tone that resonates from Aristotle's texts, and for the uncritical stance toward many of his pronouncements that have come to be challenged (his defense of slavery, for example). The problem with many forms of "nonfoundationalism" is that they fail to heed the existential *rupture* that Nietzsche's Madman passage announces and insists we engage. Nonfoundationalism without a certain "tremble" has not gone the full way.

9. See Habermas, "The Entwinement of Myth and Enlighten- ment: Rereading *Dialectic of Enlightenment*," *New German Critique* 26 (1982). For discussions of the problem of self-reference in Nietzsche's perspectivism and engagements of the various responses to this problem, see Schrift, *Nietzsche and the Question of Inter-*

pretation, pp. 181–94, and Clark, *Nietzsche on Truth and Philosophy*, pp. 138–58. See also the group of essays by Robin Alice Roth, Babette E. Babich, and Daniel W. Conway in *International Studies in Philosophy* 22, no. 2 (1990): 67–109. From the standpoint of political philosophy, Botwinick's *Postmodernism and Democratic Theory* gives continual attention to the problem of self-reference.

10. A *Nachlass* entry from the same period reads: "The total value (*Gesamtwert*) of the world cannot be evaluated" (*WP* 708); the word "total" makes Nietzsche's point more clearly, I think.

11. See, for example, Nietzsche's positive analysis of the Christian life for those who must see the world in the mode of denial and withdrawal (*A* 34–35, 39–40).

12. See *GM* III,7.

13. Hunt, *Nietzsche and the Origin of Virtue*, p. 158.

14. To put this in current lingo, Nietzsche's propositions are utterances from a sender to an addressee, calling for certain moves in a language game (see Lyotard, *The Postmodern Condition*, pp. 9–10).

15. For a general discussion of such questions, see Barbara Herrnstein Smith, "Unloading the Self-Refutation Charge," in *Common Knowledge* 2, no. 2 (Fall 1993): 81–95. I would hope that my analysis can improve upon Rorty's claim that the only solution to the self-reference problem is to fall back on private fantasy (*Contingency, Irony, and Solidarity*, p. 125).

16. See *BGE* 61.

17. To be precise here, science, for example, has its "commands," but *being* a scientist and affirming the perspective of science do not.

18. See *HAH* I,20 for Nietzsche's comments about the importance of metaphysical structures, as against negative postures that deny them as errors.

19. Deleuze, in emphasizing the figure of the child in *Z* I,1, mistakenly assumes that affirmation eliminates struggle, war, and competition from Nietzsche's vision (*Nietzsche and Philosophy*, p. 82).

20. The literature on this topic, beginning with the work of

Thomas Kuhn, is well established and extensive; it need not be cited for our purposes.

21. In the afterword to *Limited Inc.*, Derrida indicates that he is not discrediting "objective truth," he is only insisting that such a notion has a certain context, and therefore it is not itself purely "objective" (p. 136).

22. Derrida calls the contextual oscillation of meanings "pragmatically determined" (ibid., p. 148). See Lyotard's emphasis on an agonistic pragmatics in *The Postmodern Condition*, pp. 9–11.

23. *HAH* I,281 talks of a culture that is "many-stringed." In addition, I would suggest such a musical analogy for the subtle connotations in Nietzsche's image of philosophizing "with a hammer," which he associates with a "tuning fork" (*TI* P).

24. See Lyotard, *The Postmodern Condition*, pp. 60–67.

25. My *Myth and Philosophy*, for example, is dedicated to those elements of paralogy between the mythical and the rational.

26. In this respect Hume was right about the chasm between facts and values, but since he privileged the empirical when it came to truth, normative concerns suffered a certain intellectual demotion. Kierkegaard was not only more sensitive to the existential dimension of confronting this chasm in life situations, he also proposed a more flexible notion of truth that avoids the exclusionary effects of a reductive empiricism.

27. Sam Weber, in discussing agonistics, argues that Lyotard and others overemphasize the incommensurability of language games and miss agonistic relationships *between* language games; see the afterword to *Just Gaming*, by Jean-François Lyotard and Jean-Loup Thébaud, trans. Wlad Godzich (Minneapolis: University of Minnesota Press, 1985), pp. 101–20.

28. See *HAH* I,276, where Nietzsche likens the individual to a hall of culture large enough to accommodate conflicting powers of the spirit such as art and science. Section 251 declares that a higher culture needs a "double-brain," a division of science and nonscience, where both are important and should not be confused with each other.

29. Madison, *The Federalist*, #51.

30. See Morton White, *Philosophy, The Federalist, and the Constitution*, pp. 200–203. For Rousseau's strong objections to divided government, see *The Social Contract* II,2.

31. For insightful commentary on these issues, see Kaufmann, *Nietzsche*, pp. 211–35, 391–411.

32. See Hunt, *Nietzsche and the Origin of Virtue*, p. 65. One advantage of supplementing cognition is that we open up ways around the limitations and controversies adhering to rational decision theories that have been so prominent in explaining political practice and justifying compliance with democratic principles. For a discussion of these theories, see Pennock, *Democratic Political Theory*, chaps. 9–10. For pointed criticism see Donald P. Green and Ian Shapiro, *Pathologies of Rational Choice Theories: A Critique of Applications in Political Science* (New Haven: Yale University Press, 1994).

33. See Sarah Trenholm, *Persuasion and Social Influence* (Englewood Cliffs, NJ: Prentice Hall, 1989), chap. 12.

34. See *OTL*, p. 84 and *BGE* 16. For a helpful analysis of the question of language and rhetoric in Nietzsche, see Schrift, *Nietzsche and the Question of Interpretation*, chap. 5.

35. A significant example is Derrida's essay "White Mythology: Metaphor in the Text of Philosophy," in *Margins of Philosophy*, trans. Alan Bass (Chicago: University of Chicago Press, 1982). For an overview of the issues and the various treatments of the question of rhetoric, see Schrag, *Resources of Rationality*, chap. 5.

36. See Derrida's afterword, in *Limited Inc.*, p. 134, note 9. For a study that undercuts standard dismissals of emotive "fallacies" by showing the contribution affective appeals can make to critical discussions, see Douglas Walton, *The Place of Emotion in Argument* (University Park, PA: Penn State Press, 1992). This work includes case studies of advertisements, political debates, and workplace negotiations.

37. For Nietzsche's positive remarks on the Sophists, whom he calls "realists," see *TI* 10,2 and *WP* 427–29.

38. Weber, who was influenced by Nietzsche, gives a classic analysis. See "The Nature of Charismatic Domination," in *Max*

Weber: Selections in Translation, ed. W. C. Runciman, trans. Eric Matthews (Cambridge: Cambridge University Press, 1978), pp. 226–50. See Robert Eden, *Political Leadership and Nihilism: A Study of Weber and Nietzsche* (Tampa: University Presses of Florida, 1983).

39. Athenian democracy did not need Plato to know the dangers of rhetoric. See Ober, *Mass and Elite in Democratic Athens*, pp. 156ff. The Greeks tended toward a balanced view that recognized both the importance and the drawbacks of rhetoric in politics (pp. 123–25, 177–78, 338–39).

40. In this regard, there are certainly better and worse ways of conducting political campaigns, measured by a balancing of reason and rhetoric. There are ways of improving televised debates, for example, to cut down on rhetorical excesses and evasions. I think that a single skilled moderator in conversation with candidates, in a studio with no audience, would improve things a good deal.

41. See Dahl, *Democracy and Its Critics*, pp. 24–28.

42. American politics has become increasingly obsessed with "character" questions, to the point where even foibles in the private lives of candidates can derail their careers.

43. Machiavelli, *The Prince*, trans. W. K. Marriot (London: J. M. Dent & Sons, 1908), chap. 15. Compare *BGE* 221. For Nietzsche's comments on Machiavelli, see *WP* 304. For a discussion, see Ansell-Pearson, *Nietzsche* Contra *Rousseau*, pp. 38–43.

44. Lyndon Johnson was notorious for his bullish, overbearing personality and his intimidating treatment of opponents and rivals. He is also credited with passing momentous civil rights legislation, but it is quite evident that such legislation would have failed without Johnson's relentless, combative wrangling and haggling with recalcitrant members of Congress. Should we not sing the praises of Johnson's "vices" in such a setting? Or better yet, see them as *virtues*?

45. We have already treated agonistic elements in American judicial practice, and even the Supreme Court can fit into the contours of the present discussion. There was a recent flap about the publication of Justice Thurgood Marshall's papers, which reveal some of the nuts and bolts of judicial review and especially the

deliberative wranglings among Justices that belie the mystique of the Court as a body free from the effects of political rhetoric, intrigues, and human foibles. See Bob Woodward, *The Brethren: Inside the Supreme Court* (New York: Simon and Schuster, 1979). A comparable mystique is broken when we consider the machinations that were operative behind the scenes in the formation and ratification of the Constitution. Once again, however, the context of political *practice* in the midst of a plurality of real live human beings ought to disabuse us of a moralistic regret in such matters.

46. Perhaps the detached, reflective context of intellectual practice is what leads philosophers and theorists to imagine ideal conditions of government led by people who, like themselves, are more intelligent, objective, and principled. Of course, the naivety of intellectuals and their failures in attempts to reform government are well known phenomena in political history (beginning with Plato at Syracuse). We should be cautious, however, in explaining such failures by proclaiming that the world just cannot seem to grasp or live up to the grand visions of the intelligentsia. Recalling the executive principle, putting intellectuals in the *context* of governance would perhaps lead to something less grand. Are they especially principled and objective in their own milieus of power in the academy, for instance?

Chapter Seven: Ethics and Politics Without Foundations

1. See also *GS* 107.

2. Nietzsche even employs moralistic rhetoric in calling the inhibition of creative natures by slave morality the "root of all evil" (*WP* 870).

3. Perhaps this gives us clues for understanding Nietzsche's depiction of the *self*-overcoming of morality (*EH* IV,3), which is something different from the denial of morality in that it suggests something higher made *possible* by morality.

4. Much in Nietzsche can be associated with what has been

called virtue ethics, which engages morality not in terms of rules or principles that guide our actions, but rather character traits and attitudes that are needed to generate the moral life and sustain it. Many of the existential qualities that Nietzsche recommends can be applied to ethical considerations. Consider, for example, Nietzsche's aristocratic slant on virtue:

> One should defend virtue from the preachers of virtue: they are its worst enemies. For they teach virtue as an ideal *for everyone*; they take from virtue the charm of rareness, inimitableness, exceptionalness and unaverageness—its aristocratic magic. . . .
>
> Virtue has all the instincts of the average man against it: it is unprofitable, imprudent, it isolates; it is related to passion and not very accessible to reason; it spoils the character, the head, the mind—according to the standards of mediocre men; it rouses to enmity toward order, toward the *lies* that are concealed in every order, institution, actuality—it is the worst of vices, if one judges it by its harmful effects upon others. (*WP* 317)

For an analysis of the question of virtue in Nietzsche's thought, see Hunt, *Nietzsche and the Origin of Virtue.*

5. In this respect, the pluralism I am advocating should not be confused with a vacuous pluralism that washes out the capacity to affirm a particular stance or that becomes indifferent to "differences" that might be unjust. On this point, see Louise Marcil-Lacoste, "The Paradoxes of Pluralism," in *Dimensions of Radical Democracy*, pp. 128–42.

6. On this point, see Derrida's afterword in *Limited Inc.*, p. 116. For a discussion of the ethical and political possibilities in deconstruction, see "Dialogue With Jacques Derrida," in *Dialogues With Contemporary Continental Thinkers*, ed. Richard Kearney (Manchester: Manchester University Press, 1984).

7. Consider, for instance, Platonic formalism, the Kantian categorical imperative, and the utilitarian calculus.

8. Rorty connects commitment and contingency in *Contingency, Irony, and Solidarity*, p. 61.

9. The "nomad" is a wanderer who can always pack and leave when things get too hard. In this respect we should remember

Kierkegaard's brilliant portrayal of the aesthete, who must continually flit from one stimulation to another, to avoid both the demands of commitment and the onset of boredom. I should add that I am not very impressed by the nomadic revelry of scholars with families, mortgages, and tenure.

10. Gadamer and Habermas have argued for a more positive interactive dynamic by attempting to strike a balance between consensus and dissensus. Their contribution is a detailed account of the dialogical *inter*subjective nature of selfhood, beyond an abstract, superficial sense of mere "relatedness." See Gadamer's *Truth and Method*, trans. J. Weinsheimer and D. G. Marshall (New York: Crossroad, 1989), and Habermas' *The Theory of Communicative Action*, 2 vols., trans. Thomas McCarthy (Boston: Beacon Press, 1984/87). Bernstein gives an insightful analysis and adds the perspective of pragmatism in *The New Constellation*, chap. 2. My main complaint about such projects concerns their insufficient attention to *paralogical* elements in human relations.

11. In *HAH* I,43, Nietzsche calls cruel people "retarded."

12. From a political standpoint, then, democracy can be understood as a force that can *minimize* resentment and revenge, in that it is dedicated to giving people an opportunity to pursue their self-development and to have their voices heard. Nietzsche's aristocratic cure for resentment would seem to be worse than the disease.

13. Such thinking approaches Rorty's characterization of liberal aversion to cruelty, pain, and humiliation as a nontheoretical route to human "solidarity" (*Contingency, Irony, and Solidarity*, p. 192).

14. For provocative discussions of ethics in connection with mortality and compassion, see two works by Werner Marx, *Is There a Measure on Earth? Foundations for a Nonmetaphysical Ethics*, trans. Thomas J. Nenon and Reginald Lilly (Chicago: University of Chicago Press, 1987) and *Towards a Phenomenological Ethics: Ethics and the Life-World*, trans. Stefaan Heyvaert (Albany: SUNY Press, 1992).

15. See Charles E. Scott, *The Question of Ethics: Nietzsche, Foucault, Heidegger* (Bloomington: Indiana University Press, 1990),

especially pp. 111–20.

16. Connolly, *Political Theory and Modernity*, p. 161.

17. White, *Political Theory and Postmodernism*, p. 137.

18. White's conception of "responsibility to otherness" (ibid., chap. 2), has the capacity to bridge the gaps I am posing between ethics and politics in a number of ways.

19. A good collection of sources is *Communitarianism: A New Public Ethics*, ed. Markate Daly (Belmont, CA: Wadsworth, 1994).

20. Notice too how the idea of a unified, organized self is challenged by attention to the different associations relevant to a person's life. My "self" can be in a state of *conflict* when different elements are competing with each other in certain circumstances: for instance, a white, male, college professor considering the merits of affirmative action in hiring and retaining faculty.

21. Some writers maintain that communitarianism need not obviate pluralism and diversity (e.g., Taylor, *Sources of the Self*), but it is the status of conflict that continues to worry critics. One can affirm a kind of pluralism that still is governed by an organic harmony or teleology—in such a way that dissensus in the final analysis is perceived as out of bounds. See Connolly's treatment in *Identity/Difference*, pp. 87–94. What communitarians seem to miss is that conflict is no less a "social" phenomenon than harmony.

22. For a minimalist conception of democratic community that tries to incorporate conflict and difference, see Chantal Mouffe, "Democratic Citizenship and the Political Community," in *Dimensions of Radical Democracy*, pp. 225–39. Even here, however, I think there is an uncritical association of democracy with equality that leads Mouffe to declare that a radical and plural democracy must recognize the impossibility of a "complete realization of democracy" (p. 238) or a "fully achieved democracy" (p. 14). I would worry about the tacit or overt insinuations of such claims into political philosophy.

23. There is a connection here with excesses associated with "political correctness," especially regarding harassment criteria that go beyond abusive or manipulative treatment to include speech or behavior that is perceived to be "offensive." The presumed need to

rectify the presumed power that language or gesture has to damage psyches is a dangerous extension of harassment principles that can only be ruinous once the line between treatment and perception is blurred. For instance, under such extended criteria, a professor's vigorous criticism of religious belief in a classroom might deeply offend some students and create a "hostile environment" for them. I do not see how this example could escape the charge of harassment.

24. Here again we notice a link with the liberal distinction between the right (justice) and the good (morality), wherein political obligation and compulsion attach to the former but not the latter. In line with this issue, a suspicious eye should be cast on proposals for a politics of "friendship," for example: Michael Sandel, *Liberalism and the Limits of Justice* (Cambridge: Cambridge University Press, 1982), pp. 179–83; Alasdair MacIntyre, *After Virtue* (Notre Dame: University of Notre Dame Press, 1981), pp. 116–17, 146–48, 179–80; and David Gauthier, "Constituting Democracy," in *The Idea of Democracy*, pp. 314–34. For a discussion of friendship that draws on the ambivalence in Kant's treatment—where friendship must balance the attraction of love and the distancing of respect—see Derrida, "The Politics of Friendship," *The Journal of Philosophy* 11 (November 1988): 632–44. The same nod toward liberal respect would call for caution in the face of an ethics of "care" that is meant to counter a preoccupation with individualized distance implied in the notions of justice and rights; such an ethics has been inspired by Carol Gilligan's *In a Different Voice* (Cambridge, MA: Harvard University Press, 1982). For a discussion and overview of the relevant literature, see White, *Political Theory and Postmodernism*, chap. 6; see also Honig, *Political Theory and the Displacement of Politics*, pp. 206–9.

25. In *The German Ideology*, Marx calls the state "an illusory communal life" (*Writings of the Young Marx on Philosophy and Society*, p. 425).

26. Perhaps, then, "openness" is a better baseline category for democracy than neutrality. Botwinick argues that openness should have "lexical priority" over any particular political program

(*Postmodernism and Democratic Theory*, p. 56). Neutrality, however, does carry a connotation of nonalignment that is important.

27. See Connolly's critique of liberal neutralism in *Identity/ Difference*, pp. 160ff.

28. Lefort, *Democracy and Political Theory*, p. 41.

29. Lyotard challenges the notion of rational, individual "autonomy" and emphasizes a self that is embedded in traditions and narrative contexts; see *Just Gaming*, pp. 19–43.

30. I take oscillation to mean the Derridean idea that all the meanings are continually in play and counterplay, which is a Hegelian notion stripped of systemic order or teleological consummation.

31. See, for example, Locke's *A Letter Concerning Toleration* (Oxford: Basil Blackwell, 1948).

32. Some influential works are Sandel's *Liberalism and the Limits of Justice*, MacIntyre's *After Virtue*, and Charles Taylor, *The Ethics of Authenticity* (Cambridge, MA: Harvard University Press, 1992).

33. Heidegger's affiliation with Nazism is an instructive illustration of fascism conceived as a counterstroke to modernism; it thereby also displays the dangers in a postmodern politics. For an insightful and thorough analysis of Heidegger in this regard, see Michael Zimmerman, *Heidegger's Confrontation with Modernity: Technology, Politics, Art* (Bloomington: Indiana University Press, 1990). See also Tom Rockmore and Joseph Margolis, eds., *The Heidegger Case: On Philosophy and Politics* (Philadelphia: Temple University Press, 1992).

34. See *The Communist Manifesto*.

35. In *HAH* I,473, Nietzsche calls socialism a despotic drive to annihilate the individual.

36. The rich story of feminist thought, especially its intersection with postmodernism, is something undeveloped in the present study, but only because of my inability to do it justice given my limited acquaintance with the literature. Overviews relevant to political thought can be found in Kymlicka, *Contemporary Political Philosophy*, chap. 7 and White, *Political Theory and Postmodernism*,

chap. 6. Some representative texts include Alison Jaggar, *Feminist Politics and Human Nature* (Totowa, NJ: Rowman and Allanheld, 1983), Alice Jardine, *Gynesis: Configurations of Women and Modernity* (Ithaca, NY: Cornell University Press, 1985); Seyla Benhabib and Drucilla Cornell, eds., *Feminism and Critique* (Minneapolis: University of Minnesota Press, 1987); Judith Butler, *Gender Trouble: Feminism and the Subversion of Identity* (New York: Routledge, 1990); Linda J. Nicholson, ed., *Feminism/Postmodernism* (New York: Routledge, 1990); Anne Phillips, *Engendering Democracy* (University Park, PA: Penn State Press, 1991); and Anna Yeatman, *Feminism and the Politics of Difference* (Boulder, CO: Westview Press, 1993). For discussions of the Nietzsche connection, see Paul Patton, ed., *Nietzsche, Feminism, and Political Theory* (New York: Routledge, 1993).

37. A Nietzschean maxim here might be: Every issue elicits different stories, and there are two sides to every side of every story. See *HAH* I,417.

38. See, for example, *GS* 109,360 and *WP* 666.

39. In *WP* 585A, Nietzsche indicates that strength of will is the capacity to endure a meaningless world *"because one organizes a small portion of it oneself."* This suggests the possibility of local meaning without global meaning. A Nietzschean affirmation of local *teloi* can accord with White's insistence that postmodern discourse should not confuse the denial of a *final* purpose with the denial of *any* purpose in political life (*Political Theory and Postmodernism*, p. 53).

Chapter Eight: Selfhood, Rights, and Justice

1. To a certain extent nationalism can be understood as a version of tribalism. Nietzsche's objections to nationalism are quite pointed, since it poses a setback for what he calls an "evolving European" who is adaptable and can break free from traditional identities (*BGE* 242). This together with Nietzsche's genealogical

insistence on complexity and alterity leads me to believe that he did not want to replace universalism with a clean plurality of discrete particulars. See *HAH* I,475, indicating Nietzsche's preference for a "mixed race" over nationalistic divisions. Our study has been confined to an internal discussion of democratic societies and has not taken up the question of national political identities in relation to each other. For a discussion of "territorial democracy," see Connolly, *Identity/Difference*, chap. 7.

2. Nietzsche, as we have seen, rejects both social and metaphysical individualism:

> The single one, the "individual," as hitherto understood by the people and the philosophers alike, is an error . . . (*TI* 9,33)

At one point Nietzsche affirms the notion of a social "architecture" to counter the sense of a universalized individual artistry (*GS* 356). Culture requires the inseparable combination of social order and individual creative resistances (*HAH* I,224). The problem that Nietzsche highlights in his celebration of freedom is the tendency toward *over*-socialization and the subsequent constraints on creativity; see Warren, *Nietzsche and Political Thought*, pp. 55–61.

3. Connolly's *Identity/Difference* is a sustained reflection on the tension between identity and difference, particularly concerning the transformation of difference into "otherness" that often buttresses the construction of identities. See especially pp. 64–68.

4. Dallmayr makes a comparable point in *Margins of Political Discourse*, p. 156. I agree that the disruption of universalism "cannot be confined to the level of conflict and hostility" that follows a strict separatism. Nevertheless, from a political standpoint I am not sure that social relations "must include bonds of sympathy." A respectful agonistics is a better candidate for a baseline political ethos, since political practice is animated by a certain dissensus and distance.

5. Botwinick gives an effective critical analysis of liberalism and communitarianism and attempts to negotiate their differences toward a conception of democratic participation (*Postmodernism and Democratic Theory*, chap. 3). There emerges, however, a

problematic linkage of democratic politics with equality, consensus, security, coherence, and collective rationality (p. 54) that I would want to challenge.

6. On this idea see Arthur Mann, *The One and the Many: Reflections on the American Identity* (Chicago: University of Chicago Press, 1979).

7. See also *OTL*, *GS* 354, and *BGE* 268.

8. This is why Heidegger and Wittgenstein are more consistent in not dividing language from "prelinguistic" phenomena, since any talk of phenomena cannot help being informed by language in some way. See my essay (co-author William Brenner), "Heidegger and Wittgenstein on Language and Mystery," *International Studies in Philosophy* 15, no. 3 (1984): 25–43.

9. See *BT* 1 and *Z* P,4.

10. Aristotle, for example, set up an equation between definition, being, and essence; see *Posterior Analytics* II.3.90b25–35 and 91a1; *Metaphysics* VI.1.1025b.

11. In addition to the obvious cases of collectivism in Hegel and Marx, other modernist thinkers delivered more oblique extensions of selfhood that could justify the suppression of resistance. For Hobbes, the agreement to form a commonwealth is a reduction of the many wills to the one will of the sovereign, who is appointed to "bear their person" (*Leviathan* II, chap. 17). In agreeing to the covenant, citizens "own" and "author" the actions and judgments of the sovereign, and so anyone punished for attempting to depose the sovereign is "author of his own punishment" (chap. 18, section 1); moreover, no one can complain of injury by the sovereign, since the sovereign *is* oneself (section 4). For Rousseau, the social order requires a common interest (*The Social Contract* II, chap. 1). The political contract creates "a corporate and collective body" that subordinates the individual will to the general will (I, chap. 6), which is "always upright and always tends to the public advantage" (II, chap. 3). The contract means that people who depart from the general will have departed from their own good and freedom; so whoever refuses to obey the general will can be forced to obey, which means "forced to be free" (I, chap. 7). These selections are

taken from *The Social Contract and Discourses*, trans. G. D. H. Cole (London: J. M. Dent & Sons, 1973). For a discussion of the ambiguities of freedom and control in Rousseau, see Ansell-Pearson, *Nietzsche* Contra *Rousseau*, pp. 53–94. In a more contemporary vein, even Rawls produces like effects in his discussion of limiting the freedom of the intolerant. In denying full freedom to intolerance, we are complying with a principle that intolerant people themselves would accept in the original position (*A Theory of Justice*, p. 220). Intolerance is not only unjust, it is irrational according to the conditions of the original position (p. 149). So when we suppress intolerant people, we are really respecting them as rational persons (p. 519).

12. Accordingly, we would be frustrated in following Rawls' contention that an ideal construction of the person can serve as an "archimedean point" for reflections on justice (*A Theory of Justice*, p. 584).

13. In the case of criminal behavior, obviously there is a need for punishment, but there is no justification for the unambiguous satisfaction that punishment is sanctified by uncontestable regulations and by closed conceptions of deviance—in which case we punish without any sense of tragedy or regret, and we use the "transgressor" to construct a clear outline for the "good citizen." On these points, see Honig, *Political Theory and the Displacement of Politics*, pp. 137–48.

14. The so-called culture of blame and victimization and the litigiousness rampant in American society today are perfect targets for a Nietzschean critique. Resentment against suffering and failure lies behind the excessive degree to which people must assign blame somewhere for anything that goes wrong in life. Victimization can be challenged in two ways: First, recognition of those cases where responsibility is one's own and should not be diverted (as in the various "syndromes" cited in many criminal cases and the "disease" models applied to a host of problematic behaviors); second, recognition of those cases where there is really no site of responsibility for suffering and loss (which is a kind of Nietzschean fatalism). Here we notice an oscillation between agency and

nonagency that improves upon modernist tendencies that have tended toward the uncritical extremes of autonomy and determinism. For a rich discussion of "the ambiguity of responsibility," see Connolly, *Identity/Difference*, chap. 4.

15. For an important essay that questions the polarization of the two camps, see Michael Walzer, "The Communitarian Critique of Liberalism," *Political Theory* 18, no. 1 (February 1990): 6–23. See also Connolly's negotiated construction of "civic liberalism" in *Identity/Difference*, chap. 3.

16. This point approaches a familiar notion in modern political thought expressed by Hobbes, Kant, and Hegel, among others, namely that freedom is *enhanced* by submission to political constraints.

17. See Honig, *Political Theory and the Displacement of Politics*, chap. 6, for a pointed critique of communitarianism in terms of its marginalization of conflict, resistance, and other unstable conditions that are necessary for both social and individual development.

18. The notion of an elusive singularity is central to the work of Emmanuel Levinas; see *Totality and Infinity*, trans. Alphonso Lingis (Pittsburgh: Duquesne University Press, 1969). In my use, however, I do not want to overdetermine alterity at the expense of relatedness. See Bernstein's analysis in *The New Constellation*, chap. 3. In addition, since I do not want to dismiss the role of identity in human self-understanding and especially in social and political relations, I hope to be heeding Martin's warning against turning singularity into a new, privileged "subjectivity by default" (*Matrix and Line*, p. 161).

19. Kierkegaard and Sartre have given brilliant analyses of singularity, but each has tended to overdetermine certain categories (inwardness and freedom, respectively). Nietzsche employs the image of a "wanderer" to depict the dynamics of an ungrounded self in *HAH* I,638.

20. See MacIntyre's discussion of the problems confronting Enlightenment assumptions about rights in *After Virtue*, chap. 6.

21. In this sense I agree with Botwinick that rights can emerge

from an "agnostic seedbed" (*Postmodernism and Democratic Theory*, p. 56).

22. Rights might be called "amendments" to democracy, to mirror the relationship between the Bill of Rights and the Constitution.

23. See Joel Feinberg, *Social Philosophy* (Englewood Cliffs, NJ: Prentice Hall, 1973), pp. 56ff. As Dahl points out, the issue of rights would probably not arise in a completely homogeneous society, and so it is diversity and conflicts of interest that render rights meaningful and important (*Democracy and Its Critics*, p. 220). Incidentally, a "claim" in an agonistic setting can satisfy a minimal sense that rights "belong" to people, without slipping into talk of "possessions" that are intrinsic to "human nature."

24. Feinberg, *Social Philosophy*, p. 80.

25. See Lefort's critical examination of Marxist and socialist abridgements of rights in "Politics and Human Rights," in *The Political Forms of Modern Society: Bureaucracy, Democracy, Totalitarianism* (Cambridge, MA: MIT Press, 1986), pp. 239–72.

26. For a discussion that bypasses the modernist "subject of rights" and thematizes a social network of intersecting and conflicting identities, see Kirstie McClure, "On the Subject of Rights: Pluralism, Plurality, and Political Identity," in *Dimensions of Radical Democracy*, pp. 108–27.

27. As Derrida remarks, "there is no racism without a language," in "Racism's Last Word," *Critical Inquiry* 12 (Autumn 1985): 292.

28. Indeed, contextual apportionment allows occasions where certain identities can be the locus of a distribution of rights that departs from the formal principle of sheer equality and impartiality, for example in affirmative action policies or gender differentiations. Elizabeth Wolgast, in *The Grammar of Justice* (Ithaca, NY: Cornell University Press, 1987), makes this point in the context of maternity leave.

> The argument that a right to a maternity leave is a special and unfair right of women unless it is extended and adapted to men is a consequence of individualism and the language of equal rights. In this case it puts men in the position of jealous siblings, watching for any

sign of partiality shown to others. They are in the position of competing with pregnant women for favorable treatment, and in this stance they show a blind disregard for the realities of childbirth. (p. 41)

Along these lines, there is room for "identity politics" when certain groups have been excluded and oppressed, but the political affirmation of identity should be limited to a context of *contesting* exclusion and oppression, so as to avoid the danger of tribalistic or selective compressions that only relocate the original problem of confinement-by-identification.

29. For a provocative discussion of rights that aims to bridge the differences between modernism and postmodernism, see Agnes Heller, "Rights, Modernity, Democracy," in *Deconstruction and the Possibility of Justice*, pp. 346–60.

30. On this point, see Honig, *Political Theory and the Displacement of Politics*, chap. 2.

31. See Lyotard's discussion of justice as a "rule of divergence" as opposed to a Kantian convergence; language games have to face their own limits and avoid committing "terror," or the consumption of opponents (*Just Gaming*, pp. 93–100).

32. For a discussion, see Feinberg, *Social Philosophy*, chaps. 2–3.

33. Mill, *On Liberty*, in *Three Essays*, p. 15.

34. Ibid., p. 18.

35. Contemporary censors of "offensive" speech might therefore find a loophole in Mill's liberty principle. Mill seems to limit harm to "perceptible hurt" (p. 101); his answer to the prospect of psychological harm begins on p. 103.

36. The American First Amendment seems closest to Mill's principle, and it goes farther than other democracies (e.g., Canada, Great Britain, Germany, and Israel) that put restrictions on certain forms of political expression.

37. Mill, *On Liberty*, pp. 24ff.

38. Ibid., p. 24.

39. Ibid., p. 70.

40. Ibid., p. 50.

41. Democracy, then, is "ungrounded" in the sense that it emerges out of the "abyss" of a convened *decision*. In this regard,

Arendt and Derrida have reflected on the American Declaration of Independence as a performative utterance as contrasted with a constative utterance—i.e., the Declaration as a sheer creative act as contrasted with its appeal to "self-evident truths." For a discussion, see Honig, *Political Theory and the Displacement of Politics*, pp. 104–15.

42. To cite a specific example, I think there is a deep tragic beauty in permitting someone to burn the American flag. For a discussion of the connection between democracy and tragedy, see Castoriadis, "The Greek *Polis* and the Creation of Democracy," pp. 114–20.

43. Arendt stands somewhere between a substantive and a tragic approach when she defines the authority of the American Constitution in terms of its "inherent capacity to be amended and augmented" (*On Revolution*, p. 202). This contrasts with Rawls' position that the decision concerning principles of justice in the original position is "final" (*A Theory of Justice*, p. 135); politics, then, is limited to administrative, legislative, and judicial reasoning on the basis of primal, uncontestable rules (pp. 196–201). I prefer Lefort's contention that

> modern democracy invites us to replace the notion of a regime governed by laws, of a legitimate power, by the notion of a regime founded upon *the legitimacy of a debate as to what is legitimate and what is illegitimate*—a debate which is necessarily without any guarantor and without any end. (*Democracy and Political Theory*, p. 39)

44. An important study is Amy Gutman, *Democratic Education* (Princeton: Princeton University Press, 1987).

45. See Lyotard, *The Postmodern Condition*, p. 67. For a more critical analysis of telecommunications media, see Martin, *Matrix and Line*, pp. 185–94.

46. Again, the C-SPAN channel represents a significant improvement in political journalism. Not only coverage of House and Senate proceedings, but also long discussion formats, call-in shows, and unedited transmission of various interest group meetings provide more direct access to political discourse relatively

free of distortion. In its deliberate refusal of network gloss, C-SPAN demonstrates television's potential to simply *expose* the political process to as many people as possible to a much greater extent, without many of the interpolations of commercial interests, without the intercession of media devices and ornamentations—such as dramatic musical and visual overlays, and the personalities of reporters seeking to hype their appeal—and without the time constraints that have created rhetorical opportunities to avoid sustained discussion and criticism by means of the sound bite and sensational flourish.

47. See *GS* 40 for Nietzsche's low opinion of bourgeois industrialists, for example. In *WS* 280, Nietzsche opposes a competitive market on the grounds that a mediocrity of tastes rules in such a setting.

48. *WS* 285 argues against both the equal distribution of wealth and excessive concentrations of wealth; section 286 speaks against the exploitation of workers.

49. See Lefort's analysis in "The Logic of Totalitarianism," in *The Political Forms of Modern Society*, pp. 273–91. For a post-Marxist refiguration of socialism that emphasizes democratic agonistics and a release from modernist traps in socialist theory, see Ernesto Laclau and Chantal Mouffe, *Hegemony and Socialist Strategy: Towards a Radical Democratic Politics*, trans. Winston Moore and Paul Cammack (London: Verso, 1985); see Dallmayr's discussion in *Margins of Political Discourse*, chap. 6. For an overview of the ambiguities of Marxism and capitalism from a post-modern standpoint, see White, *Political Theory and Postmodernism*, chap. 1.

50. This would not go as far as concurring with Robert Nozick, in *Anarchy, State, and Utopia* (New York: Basic Books, 1974), that taxation, for example, is akin to forced labor (pp. 169ff.), an association that can only follow from a hyperindividualism:

[T]here is no *social entity* with a good that undergoes some sacrifice for its own good. There are only individual people, different individual people, with their own individual lives. Using one of these people for the benefit of others, uses him and benefits the others. Nothing more.

> What happens is that something is done to him for the sake of others. Talk of an overall social good covers this up. (Intentionally?) To use a person in this way does not sufficiently respect and take account of the fact that he is a separate person, that his is the only life he has. (pp. 32–33)

The idea that taxation for a social purpose might be just is completely sabotaged by such a reductive paradigm. Nozick does, however, show how extensive redistribution would have to cancel basic human freedoms (pp. 160–64).

51. See, for example, Robert Dahl, *A Preface to Economic Democracy* (Berkeley: University of California Press, 1985) and Peter Bachrach and Aryeh Botwinick, *Power and Empowerment: A Radical Theory of Participatory Democracy* (Philadelphia: Temple University Press, 1992).

52. Yack, *The Longing for Total Revolution*, p. 9.

53. Yack, perhaps without realizing it, takes the Nietzschean line on resentment by tracing revolutionary doctrines less to positive visions of reform and more to discontent and hatred of existing conditions (ibid., pp. 5–31).

54. Bernstein discusses such charges in *The New Constellation*, chaps. 6 and 9.

55. Two studies deserve mention. Philip Green, ed., *Key Concepts in Critical Theory: Democracy* is a collection of essays that focuses on "critical theories," or radical alternatives to liberal and conservative conceptions of democracy, alternatives that aim for sweeping change and exchange of existing power patterns—in various movements including Marxist, socialist, anarchist, feminist, gay/lesbian, ecological, utopian, and national liberation narratives. Chantal Mouffe, ed., *Dimensions of Radical Democracy* is a collection that recognizes a more ambiguous picture of radicalism.

56. On false consciousness in a Marxist sense, see Georg Lukács, *History and Class Consciousness*, trans. Rodney Livingstone (London: Merlin Press, 1971). For a discussion of different responses of Marxist intellectuals to the problem of worker resistance to Marxism, see Yack, *The Longing for Total Revolution*, pp. 286ff.

57. Lefort goes so far as to say that totalitarianism arises out of democracy, as a response to the "vertigo" that is created by democratic openness and indeterminacy; see "The Image of the Body and Totalitarianism," in *The Political Forms of Modern Society*, pp. 292–306. Lefort points out that totalitarianism is able to mask its oppression by touting the democratic idea of the People-as-One (p. 305)—a motif, however, that can and should be challenged by a postmodern approach to democracy.

58. On this point, see Samuel IJsseling, "Heidegger and Politics," in *Ethics and Danger*, ed. Arleen B. Dallery and Charles E. Scott (Albany, NY: SUNY Press, 1992), especially pp. 7–8.

59. Marx, *The German Ideology*, in *Writings of the Young Marx on Philosophy and Society*, p. 430.

60. There is suggested here an oscillation of convention and innovation, of the common and the uncommon, of order and change, which can echo somewhat Aristotle's directive of consulting the many and the wise (*Nicomachean Ethics* I.1; *Topics* 104a8–12). Social thought should neither be so revolutionary that it completely contradicts common perceptions, nor be so conventional that it casts out exceptional insights and challenges to the status quo. For an advocacy of revolutionary politics that forgoes global transformation on behalf of more internal, localized, and creative transformations, see Sheldon Wolin, "What Revolutionary Action Means Today," in *Dimensions of Radical Democracy*, pp. 240–53.

61. For a discussion see Ascheim, *The Nietzschean Legacy in Germany, 1890–1990*, chap. 6.

62. For a study of the Nietzsche-Marx connections, see Nancy S. Love, *Marx, Nietzsche, and Modernity* (New York: Columbia University Press, 1986). For a discussion of the ambivalent relationship with Nietzsche among Neomarxists and the Post-marxism of the Frankfurt School, see Martin Jay, *Marxism and Totality: The Adventure of a Concept from Lukacs to Habermas* (Berkeley: University of California Press, 1984).

63. It should be clear by now how difficult it is to label Nietzsche with any social or political classification. His atheism, radicalism, and aristocraticism made him both attractive and

repellent to standard political movements, depending on what element of Nietzsche's thought was in focus. Detwiler works with "aristocratic radicalism," a term that found favor with Nietzsche, to show why traditional conservatives would be repelled by his cultural radicalism and why radicals would be repelled by his aristocraticism (*Nietzsche and the Politics of Aristocratic Radicalism*, p. 189). Detwiler also describes Nietzsche as the first atheist of the political right (p. 77). For a discussion of the ambiguous reception of Nietzsche among the conservative right and the radical right, see Ascheim, *The Nietzsche Legacy in Germany, 1890–1990*, pp. 6–8, 117–18, 153–55, 192–200.

64. For the influence of Nietzsche on the avant-garde, see Ascheim, *The Nietzsche Legacy in Germany, 1890–1990*, chap. 3.

65. For Nietzsche's remarks about the importance of everyday conditions, see *WS* 5–6 and *EH* II,10.

66. As I indicated earlier, I say this partly as a critique of my own dismay about the lives of many of my fellow citizens.

Selected
Bibliography

Allison, David, ed. *The New Nietzsche*. New York: Dell Publishing Co., 1977.

Ansell-Pearson, Keith. *Nietzsche* Contra *Rousseau: A Study of Nietzsche's Moral and Political Thought*. Cambridge: Cambridge University Press, 1991.

———. *An Introduction to Nietzsche as Political Thinker*. Cambridge: Cambridge University Press, 1994.

———, ed. *Nietzsche and Modern German Thought*. New York: Routledge, 1991.

Arac, Jonathan. *Post-Modernism and Politics*. Minneapolis: University of Minnesota Press, 1986.

Arendt, Hannah. *The Human Condition*. Chicago: University of Chicago Press, 1958.

———. *On Revolution*. New York: Penguin Books, 1963.

Arthur, John, ed. *Democracy: Theory and Practice*. Belmont, CA: Wadsworth, 1992.

Ascheim, Steven E. *The Nietzsche Legacy in Germany, 1890–1990*. Berkeley: University of California Press, 1992.

Bataille, Georges. *Visions of Excess: Selected Writings, 1927–1939*. Translated by Allen Stoekl. Minneapolis: University of Minnesota Press, 1983.

Bergmann, Peter. *Nietzsche: "The Last Antipolitical German."* Bloomington: Indiana University Press, 1987.

Bernstein, Richard J. *The New Constellation: The Ethical-Political Horizons of Modernity/Postmodernity*. Cambridge, MA: MIT Press, 1992.

Blondel, Eric. *Nietzsche, the Body and Culture: Philosophy as a Philological Genealogy*. Translated by Seán Hand. Stanford: Stanford University Press, 1991.

Blumenberg, Hans. *The Legitimacy of the Modern Age*. Cambridge, MA: MIT Press, 1983.

Botwinick, Aryeh. *Skepticism and Political Participation*. Philadelphia: Temple University Press, 1990.

———. *Postmodernism and Democratic Theory*. Philadelphia: Temple University Press, 1993.

Castoriadis, Cornelius. *Philosophy, Politics, Autonomy: Essays in Political Philosophy*. Edited by David Ames Curtis. New York: Oxford University Press, 1991.

Clark, Maudemarie. *Nietzsche on Truth and Philosophy*. Cambridge: Cambridge University Press, 1990.

Connolly, William E. *Political Theory and Modernity*. London: Basil Blackwell, 1988.

———. *Identity/Difference: Democratic Negotiations of Political Paradox*. Ithaca, NY: Cornell University Press, 1991.

———. *The Terms of Political Discourse*. Princeton: Princeton University Press, 1993.

Copp, David, Jean Hampton, and John E. Roemer, eds. *The Idea of Democracy*. Cambridge: Cambridge University Press, 1993.

Corlett, William. *Community Without Unity: A Politics of Derridian Extravagance*. Durham: Duke University Press, 1989.

Cornell, Drucilla, Michel Rosenfeld, and David Gray Carlson, eds. *Deconstruction and the Possibility of Justice*. New York: Routledge, 1992.

Dahl, Robert A. *Democracy and Its Critics*. New Haven: Yale University Press, 1989.

Dallmayr, Fred. *Margins of Political Discourse*. Albany: SUNY Press, 1989.

Daly, Markate, ed. *Communitarianism: A New Public Ethics*. Belmont, CA: Wadsworth, 1994.

Dannhauser, Werner J. *Nietzsche's View of Socrates*. Ithaca: Cornell University Press, 1974.

Danto, Arthur C. *Nietzsche as Philosopher*. New York: Columbia University Press, 1980.

Darby, Tom, Béla Egyed, and Ben Jones, eds. *Nietzsche and the Rhetoric of Nihilism: Essays on Interpretation, Language, and Politics*. Ottowa: Carelton University Press, 1989.

Dauenhauer, Bernard P. *The Politics of Hope*. New York: Routledge and Kegan Paul, 1986.

Deleuze, Gilles. *Nietzsche and Philosophy*. Translated by Hugh Tomlinson. New York: Columbia University Press, 1983.

Derrida, Jacques. *Of Grammatology*. Translated by Gayatri Chakravorty Spivak. Baltimore: Johns Hopkins University Press, 1976.

———. *Spurs: Nietzsche's Style*. Translated by Barbara Harlow. Chicago: University of Chicago Press, 1979.

———. *Margins of Philosophy*. Translated by Alan Bass. Chicago: University of Chicago Press, 1982.

———. *The Ear of the Other: Otobiography, Transference, Translation*. Edited by Christie McDonald, translated by Peggy Kamuf. Lincoln: University of Nebraska Press, 1988.

———. *Limited Inc*. Edited by Gerald Graff. Evanston: Northwestern University Press, 1988.

Detwiler, Bruce. *Nietzsche and the Politics of Aristocratic Radicalism*. Chicago: The University of Chicago Press, 1990.

Dworkin, Ronald. *Taking Rights Seriously*. Cambridge, MA: Harvard University Press, 1977.

———. *A Matter of Principle*. Cambridge, MA: Harvard University Press, 1985.

Eagleton, Terry. *The Ideology of the Aesthetic*. Oxford: Basil Blackwell, 1990.

Eden, Robert. *Political Leadership and Nihilism: A Study of Weber and Nietzsche*. Tampa: University Presses of Florida, 1983.

Farrar, Cynthia. *The Origins of Democratic Thinking: The Invention of Politics in Classical Athens*. Cambridge: Cambridge University Press, 1988.

Feinberg, Joel. *Social Philosophy*. Englewood Cliffs, NJ: Prentice Hall, 1973.

Flynn, Bernard. *Political Philosophy at the Closure of Metaphysics*. Atlantic Highlands, NJ: Humanities Press, 1992.

Gibbons, John R., ed. *Contemporary Political Culture: Politics in a Postmodern Age*. London: Sage Publications, 1989.

Gillespie, Michael Allen and Tracy B. Strong, eds. *Nietzsche's New Seas*. Chicago: University of Chicago Press, 1988.

Green, Philip, ed. *Key Concepts in Critical Theory: Democracy*. Atlantic Highlands, NJ: Humanities Press, 1993.

Gutman, Amy. *Liberal Equality*. New York: Cambridge University Press, 1980.

―――. *Democratic Education*. Princeton: Princeton University Press, 1987.

Habermas, Jürgen. *Knowledge and Human Interests*. Translated by J.J. Shapiro. Boston: Beacon Press, 1970.

―――. *The Theory of Communicative Action*, Two Volumes. Translated by Thomas McCarthy. Boston: Beacon Press, 1984, 1987.

―――. *The Philosophical Discourse of Modernity*. Translated by Frederick G. Lawrence. Cambridge, MA: MIT Press, 1987.

Harvey, David. *The Condition of Postmodernity: An Enquiry into the Origins of Cultural Change*. Oxford: Basil Blackwell, 1987.

Hatab, Lawrence J. *Nietzsche and Eternal Recurrence: The Redemption of Time and Becoming*. Lanham, MD: University Press of America, 1978.

―――. *Myth and Philosophy: A Contest of Truths*. La Salle, Illinois: Open Court Publishing Co., 1990.

Heidegger, Martin. *Nietzsche*. 4 vols. Translated by David F. Krell and Frank Capuzzi. New York: Harper and Row, 1979–1986.

Higgens, Kathleen. *Nietzsche's Zarathustra*. Philadelphia: Temple University Press, 1987.

Hollingdale, R.J. *Nietzsche*. London: Routledge and Kegan Paul, 1973.

Honig, Bonnie. *Political Theory and the Displacement of Politics*. Ithaca, NY: Cornell University Press, 1993.

Horkheimer, Max and Theodor Adorno. *Dialectic of Enlightenment*. Translated by John Cumming. New York: Continuum, 1972.

Hunt, Lester H. *Nietzsche and the Origin of Virtue*. New York: Routledge, 1991.

Hutcheon, Linda. *A Poetics of Postmodernism: History, Theory, Fiction*. New York: Routledge, 1988.

Irigaray, Luce. *Marine Lover of Friedrich Nietzsche*. Translated by Gilliam C. Gill. New York: Columbia University Press, 1991.

Jaspers, Karl. *Nietzsche: An Introduction to the Understanding of His Philosophical Activity*. Translated by Charles Wallraft and Frederick Schmitz. Tucson: University Of Arizona Press, 1965.

Jay, Martin. *Marxism and Totality: The Adventures of a Concept from Lukacs to Habermas*. Berkeley: University of California Press, 1984.

Jencks, Charles. *What is Postmodernism?* 2d ed. London: St. Martin's Press, 1987.

Kahan, Alan S. *Aristocratic Liberalism: The Social and Political Thought of Jacob Burckhardt, John Stuart Mill, and Alexis de Tocqueville*. London: Oxford University Press, 1992.

Kammen, Michael, ed. *The Origins of the American Constitution: A Documentary History*. New York: Penguin, 1986.

Kariel, Henry S. *In Search of Authority: Twentieth Century Political Thought*. New York: Free Press, 1964.

Kaufmann, Walter. *Nietzsche: Philosopher, Psychologist, Antichrist*. Princeton: Princeton University Press, 1974.

Koelb, Clayton, ed. *Nietzsche as Postmodernist: Essays Pro and Contra*. Albany: SUNY Press, 1990.

Krell, David F. and David Woods, eds. *Exceedingly Nietzsche: Aspects of Contemporary Nietzsche Interpretation*. London: Routledge, 1988.

Kymlicka, Will. *Contemporary Political Philosophy*. London: Oxford University Press, 1990.

Laclau, Ernesto and Chantal Mouffe. *Hegemony and Socialist Strategy: Towards a Radical Democratic Politics*. Translated by Winston Moore and Paul Cammack. London: Verso, 1985.

Lampert, Laurence. *Nietzsche's Teaching: An Interpretation of Thus Spoke Zarathustra*. New Haven: Yale University Press, 1987.

Lefort, Claude. *Democracy and Political Theory*. Translated by David Macey. Minneapolis: University of Minnesota Press, 1988.

———. *The Political Forms of Modern Society: Bureaucracy, Democracy, Totalitarianism*. Cambridge, MA: MIT Press, 1986.

Love, Nancy S. *Marx, Nietzsche, and Modernity*. New York: Columbia University Press, 1986.

Löwith, Karl. *From Hegel to Nietzsche*. Translated by David E. Green. Garden City, NY: Anchor Books, 1967.

Lukács, Georg. *The Destruction of Reason*. Translated by Peter Palmer. Atlantic Highlands, NJ: Humanities Press, 1981.

Lyotard, Jean-François. *The Postmodern Condition: A Report on Knowledge*. Translated by Geoff Bennington and Brian Massumi. Minneapolis: University of Minnesota Press, 1984.

———. *The Differend: Phrases in Dispute*. Translated by Georges Van Den Abeele. Minneapolis; University of Minnesota Press, 1988.

Lyotard, Jean-François and Jean-Loup Thébaud. *Just Gaming*. Translated by Wlad Godzich. Minneapolis: University of Minnesota Press, 1985.

MacIntyre, Alasdair. *After Virtue: A Study in Moral Theory*. South Bend: University of Notre Dame Press, 1981.

Macpherson, C.B. *The Political Theory of Possessive Individualism*. London: Oxford University Press, 1962.

Magnus, Bernd. *Nietzsche's Existential Imperative*. Bloomington: Indiana University Press, 1978.

Mahon, Michael. *Foucault's Nietzschean Genealogy: Truth, Power, and the Subject*. Albany, NY: SUNY Press, 1992.

Martin, Bill. *Matrix and Line: Derrida and the Possibilities of Postmodern Social Theory*. Albany: SUNY Press, 1992.

McCarthy, Thomas. *Ideals and Illusions*. Cambridge, MA: MIT Press, 1991.

Megill, Allan. *Prophets of Extremity: Nietzsche, Heidegger, Foucault, Derrida*. Berkeley: University of California Press, 1985.

Mill, J.S. *Three Essays*. New York: Oxford University Press, 1975.

Mitchell, Joshua. *Not by Reason Alone: Religion, History, and Identity in Early Modern Political Thought*. Chicago: University of Chicago Press, 1993.

Mouffe, Chantal, ed. *Dimensions of Radical Democracy*. London: Verso, 1992.

Natoli, Joseph and Linda Hutcheon, eds. *A Postmodern Reader*. Albany: SUNY Press, 1993.

Nehamas, Alexander. *Nietzsche: Life as Literature*. Cambridge, MA: Harvard University Press, 1985.

Nielsen, Kai. *Equality and Liberty: A Defense of Radical Egalitarianism*. Totowa, NJ: Rowman and Allanheld, 1985.

Nozick, Robert. *Anarchy, State, and Utopia*. New York: Basic Books, 1974.

Oakeshott, Michael. *Rationalism in Politics and Other Essays*. Indianapolis: Liberty Press, 1991.

Ober, Josiah. *Mass and Elite in Democratic Athens*. Princeton: Princeton University Press, 1989.

O'Flaherty, James C., Timothy F. Sellner, and Robert M. Helm, eds. *Studies in Nietzsche and the Classical Tradition*. Chapel Hill: University of North Carolina Press, 1979.

———. *Studies in Nietzsche and the Judeo-Christian Tradition*. Chapel Hill: University of North Carolina Press, 1985.

O'Hara, Daniel. *Why Nietzsche Now?* Bloomington: Indiana University Press, 1985.

Okonta, Ike. *Nietzsche: The Politics of Power*. New York: Lang, 1992.

Patton, Paul, ed. *Nietzsche, Feminism, and Political Theory*. New York: Routledge, 1993.

Pennock, J. Roland. *Democratic Political Theory*. Princeton: Princeton University Press, 1979.

Pennock, J.R. and J.W. Chapman, eds. *Equality* (*Nomos* IX). New York: Atherton Press, 1967.

Phillips, Anne. *Engendering Democracy*. University Park, PA: Penn State Press, 1991.

Pippin, Robert B. *Modernity as a Philosophical Problem: Remarks on the Dissatisfaction of European High Culture*. London: Basil Blackwell, 1990.

Rabinow, Paul, ed. *The Foucault Reader*. New York: Pantheon, 1984.

Rawls, John. *A Theory of Justice*. Cambridge, MA: Harvard University Press, 1971.

Rawls, John. *Political Liberalism*. New York: Columbia University Press, 1993.

Rescher, Nicholas. *Pluralism: Against the Demand for Consensus*. New York: Oxford University Press, 1993.

Rickels, Laurence A., ed. *Looking After Nietzsche*. Albany: SUNY Press, 1990.

Rockmore, Tom and Joseph Margolis, eds. *The Heidegger Case: On Philosophy and Politics*. Philadelphia: Temple University Press, 1992.

Rorty, Richard. *Philosophy and the Mirror of Nature*. Princeton: Princeton University Press, 1980.

———. *Contingency, Irony, and Solidarity*. Cambridge: Cambridge University Press, 1989.

———. *Objectivity, Relativism, and Truth*. Cambridge: Cambridge University Press, 1991.

Rosen, Stanley. *The Ancients and the Moderns: Rethinking Modernity*. New Haven: Yale University Press, 1989.

Runciman, W.G., ed. *Max Weber: Selections in Translation*. Translated by Eric Matthews. Cambridge: Cambridge University Press, 1978.

Sallis, John C. *Crossings: Nietzsche and the Space of Tragedy*. Chicago: University of Chicago Press, 1991.

Sandel, Michael J. *Liberalism and the Limits of Justice*. Cambridge: Cambridge University Press, 1982.

Schacht, Richard. *Nietzsche*. Boston: Routledge and Kegan Paul, 1983.

———, ed. *Nietzsche, Genealogy, Morality: Essays on Nietzsche's On the Genealogy of Morals*. Berkeley: University of California Press, 1994.

Schrift, Alan D. *Nietzsche and the Question of Interpretation: Between Hermeneutics and Deconstruction*. New York: Routledge, 1990.

Schrag, Calvin O. *The Resources of Rationality: A Response to the Postmodern Challenge*. Bloomington: Indiana University Press, 1992.

Schutte, Ofelia. *Beyond Nihilism: Nietzsche Without Masks*. Chicago: University of Chicago Press, 1984.

Scott, Charles E. *The* Question *of Ethics: Nietzsche, Foucault, Heidegger*. Bloomington: Indiana University Press, 1990.

Shapiro, Gary. *Nietzschean Narratives*. Bloomington: Indiana University Press, 1989.

———. *Alcyone: Nietzsche on Gifts, Noise, and Women*. Albany: SUNY Press, 1991.

———, ed. *After the Future: Postmodern Times and Places*. Albany: SUNY Press, 1990.

Sherover, Charles M. *Time, Freedom, and the Common Good*. Albany: SUNY Press, 1989.

Silverman, Hugh J. and Donn Welton, eds. *Postmodernism and Continental Philosophy*. Albany: SUNY Press, 1988.

Singer, Peter. *Practical Ethics*. Cambridge: Cambridge University Press, 1979.

Solomon, Robert, ed. *Nietzsche: A Collection of Critical Essays*. Garden City, NY: Anchor Books, 1973.

Solomon, Robert and Kathleen M. Higgins, eds. *Reading Nietzsche*. New York: Oxford University Press, 1988.

Stambaugh, Joan. *The Problem of Time in Nietzsche*. Philadelphia: Bucknell University Press, 1987.

Stern, J.P. *A Study of Nietzsche*. Cambridge: Cambridge University Press, 1979.

Strong, Tracy B. *Friedrich Nietzsche and the Politics of Transfiguration*. Berkeley: University of California Press, 1988.

Taylor, Charles. *Sources of the Self: The Making of the Modern Identity*. Cambridge, MA: Harvard University Press, 1989.

———. *The Ethics of Authenticity*. Cambridge, MA: Harvard University Press, 1992.

———. *Multiculturalism and "The Politics of Recognition."* Princeton: Princeton University Press, 1992.

Taylor, Mark. *Altarity*. Chicago: University of Chicago Press, 1987.

Temkin, Larry S. *Inequality*. New York: Oxford University Press, 1993.

Thiele, Leslie Paul. *Friedrich Nietzsche and the Politics of the Soul:*

A Study of Heroic Individualism. Princeton: Princeton University Press, 1990.

Thomas, R. Hinton. *Nietzsche in German Politics and Society, 1890–1918*. Manchester: Manchester University Press, 1983.

Walzer, Michael. *Spheres of Justice*. New York: Basic Books, 1983.

Warren, Mark. *Nietzsche and Political Thought*. Cambridge, MA: MIT Press, 1988.

Westbrook, Robert B. *John Dewey and American Democracy*. Ithaca, NY: Cornell University Press, 1991.

Weston, Peter. *Speaking of Equality: An Analysis of the Rhetorical Force of "Equality" in Moral and Legal Discourse*. Princeton: Princeton University Press, 1990.

White, Alan. *Within Nietzsche's Labyrinth*. New York: Routledge, 1990.

White, Morton. *Philosophy, The Federalist, and the Constitution*. New York: Oxford University Press, 1987.

White, Stephen K. *Political Theory and Postmodernism*. Cambridge: Cambridge University Press, 1991.

White, Stephen R., ed. *Life-World and Politics: Between Modernity and Postmodernity*. South Bend: University of Notre Dame Press, 1989.

Wilcox, John T. *Truth and Value in Nietzsche: A Study of His Metaethics and Epistemology*. Ann Arbor: University of Michigan Press, 1974.

Wolgast, Elizabeth, H. *The Grammar of Justice*. Ithaca, NY: Cornell University Press, 1987.

Wolin, Richard. *The Terms of Cultural Criticism*. New York: Columbia University Press, 1992.

Yack, Bernard. *The Longing for Total Revolution: Philosophic Sources of Discontent from Rousseau to Marx and Nietzsche*. Princeton: Princeton University Press, 1986.

———. *The Problems of a Political Animal*. Berkeley: University of California Press, 1993.

Zimmerman, Michael. *Heidegger's Confrontation With Modernity: Technology, Politics, Art*. Bloomington: Indiana University Press, 1990.

Index

abortion, 86, 164
adversarial judicial system, 89–90
aesthetic conceptions of politics, 51, 232, 253 (n.65)
affirmative action, 274 (n.28)
agency, 209–10, 248 (n.20)
agōn, 61–62
agonarchy, 65, 73
agonistic democracy, 62–65, 81, 86, 107, 190–91, 193, 205–6, 223, 226, 229, 232, 234
agonistic ethics, 180–85
agonistic pluralism, 12, 75, 77, 83, 158–62, 171
agonistic politics, 87–89, 108, 199, 215
agonistic respect, 68–70, 189, 191, 220
agonistics, 83, 86–92, 97, 120–21, 134–36, 154–56, 157, 190, 220, 266 (n.18)
alienation, 17, 77, 193
ambiguity, 178, 194–96, 200
American presidency, 125, 171

amor fati, 38
anarchism, 51, 55
Anaximander, 62
Ansell-Pearson, Keith, 37, 239 (n.6), 242 (n.17), 250 (n.33–34), 252 (n.60), 254 (n.69), 257 (n.15)
Antifederalists, 125
antiperfectionism, 75
Apollonian, 52, 254 (n.69)
appearance, 148–49, 279 (n.5)
apportional justice, 111–16, 227; and political participation, 223–26
apportional merit, 114, 116
Arendt, Hannah, 239 (n.9), 263 (n.53), 298 (n.41), 298 (n.43)
aristocraticism, 70–72, 109, 117, 123–24, 128, 131
Aristotle, 55, 82, 112–15, 127, 168, 247 (n.10), 256 (n.14), 260 (n.36), 272 (n.20), 280 (n.8), 293 (n.10), 301 (n.60)
art, 9, 135, 149
ascetic ideal, 11, 48, 122, 180
asceticism, 160

Ascheim, Steven E., 251
(n.47)
assimilation, 206
athletics, 69, 119–21, 273
(n.26)
authoritarianism, 67, 122,
138, 196
authority, 64, 108
autonomy, 37–38, 49–50

Babich, Babette E., 236
(n.31), 281 (n.9)
balloting, 88
Barber, Benjamin, 276
(n.43)
Bataille, Georges, 278 (n.56)
becoming, 147–49, 153, 156,
201
being, 148, 156, 201
Beitz, Charles, 274 (n.29)
Bergmann, Frithjof, 255
(n.2)
Bernstein, Richard J., 277
(n.47), 280 (n.8), 287
(n.10)
Bill of Rights, 74, 296 (n.22)
binary oppositions, 5, 85
Botwinick, Aryeh, 281 (n.9),
289 (n.26), 292 (n.5), 295
(n.21)
bourgeoisie, 233
boycott, 92

C-SPAN, 126, 298 (n.46)
capitalism, 96–97, 198,
227–29; and democracy,
223–25
Castoriadis, Cornelius, 257
(n.16), 258 (n.21)
character, 168–69
charisma, 168
Christianity, 155–56, 199,
201, 261 (n.43)
citizen competence, 128, 130
citizen participation, 128
civic rights, 214–15
civil disobedience, 86, 92
civil rights laws, 92, 171
civil society, 92, 212
Clark, Maudemarie, 279
(n.2), 281 (n.9)
class, 129, 132
Clinton, Bill, 275 (n.38)
coalition, 88, 93
coercion, 135, 137, 192, 194
collectivism, 16, 80, 293
(n.11)
commitment, 181–85
common good, 76–77, 83,
107, 172, 184, 190–91,
262 (n.51)
common law tradition,
89–90, 267 (n.22)
communism, 193, 198–99,
228, 230
communitarianism, 189–90,
196–98, 203–4, 211–12,
288 (n.21)
community, 17, 189–90, 212,
258 (n.19)

compassion, 179, 186, 188
competition, 69, 86, 119–22
competitive fairness, 191,
 223
compromise, 88–89, 163–64,
 276 (n.41)
confederation, 93
conflict, 48, 76–77, 80–81,
 84–90, 160, 189–91, 196,
 263 (n.52)
conformism, 28, 54, 108–11,
 122, 135, 140, 233
Congress, U.S., 83, 126, 171
Connolly, William E., 17,
 242 (n.18), 250 (n.34),
 255 (n.73), 260 (n.32),
 263 (n.52), 263 (n.1), 268
 (n.6), 292 (n.3)
consciousness, 32–34
consensus, 83, 86, 88, 161,
 165
conservatism, 96, 100, 132,
 196, 198, 200
consociational
 arrangements, 93
Constitution, U.S., 58, 124,
 163, 222, 285 (n.45), 296
 (n.22), 298 (n.43)
consumerism, 233
contest, 63, 75–76, 86–91,
 119–23, 194–95
contextuality, 16, 112–13,
 136, 158–59, 170–71, 210
contract, 31
contractarianism, 80

conventionalism, 82, 130,
 142, 232
Conway, Daniel W., 281
 (n.9)
Copp, David, 260 (n.36)
creativity, 46–48, 111,
 135–36, 139–41, 201; and
 constraint, 142–44; and
 normalcy, 141–44
creator and herd, 7, 48,
 52–54, 95, 109, 133, 135
creators and politics, 137–41
criminals, 90, 210, 294 (n.13)
critical theories, 300 (n.55)
cruelty, 179
culture and politics, 134–37
cynicism, 172

Dahl, Robert A., 56–57, 255
 (n.4–5), 260 (n.36), 262
 (n.45), 276 (n.43), 296
 (n.23)
Dallmayr, Fred, 266 (n.18),
 292 (n.4)
death of God, 11, 59, 101,
 197
debate, 84, 86, 168, 284
 (n.40)
decision procedures, 65, 107
Declaration of Independ-
 ence, 58–59, 298 (n.41)
Deleuze, Gilles, 281 (n.19)
democracy: as the absence
 of a baseline political
 story, 200; as agonistic

pluralism, 162–63; as
agonistic praxis, 83–86;
as a blend of egalitarian
and aristocratic features,
122–29; and a citizen
army, 257 (n.16); as con-
flict, 76–77, 122–23; con-
sonant with Nietzsche's
thought, 74–76; defini-
tion, 55–57; direct, 81,
123, 125–29, 275 (n.37);
and excellence, 110–11;
as experiment, 77, 79;
extent of, 133–37; merito-
cratic, 116–19; and meta-
narratives, 193–200;
Nietzsche's critique,
22–24; and the noncogni-
tive, 167–69; as open,
196, 200; and ordinary
sensibilities, 234;
parliamentary, 266
(n.20); as a politics of
suspicion, 70–74;
procedural, 79, 81; and
radicalism, 230–34;
representative, 81,
122–29, 275 (n.37); as
risk, 122; and the tragic,
222
democratic practice, 88, 172
democratic radicalism, 231
democratic theory, decons-
truction of, 73–74
demos, 107

Derrida, Jacques, 231, 244
(n.26), 282 (n.21–22), 298
(n.41)
Descartes, René 13, 14, 16
desert, 100–102
Detwiler, Bruce, 42, 239
(n.6), 249 (n.26), 253
(n.62–63), 259 (n.29), 302
(n.63)
deviance, 192, 205, 294
(n.13)
Dewey, John, 74, 264 (n.4)
difference, 19, 77, 82–84,
86–88, 99, 111, 189–90,
205–7, 212
Dionysian, 52, 254 (n.69)
dogmatism, 65, 157
domination, 36–39, 45,
48–51, 63, 95, 143; as a
weakness, 122
Dworkin, Ronald, 270 (n.10)

economic freedom, 198
economic justice, 96, 226–29
economic redistribution:
and fair competition,
226; and resentment,
227–28
education, 100, 109, 129–32,
144, 276 (n.45); and poli-
tics, 223
egalitarianism, 98–106, 114,
117–19, 126–27; Nietz-
sche's critique, 28–29;
nonsubstantive, 98–99;

substantive, 57–61, 97, 106
elections, 63, 75, 81, 126–28
elitism, 95–96, 108, 123–28, 132–36, 169, 262 (n.47); in democratic politics, 96, 128
embodiment, 248 (n.15)
endowments, 100–102, 104
enlightened despotism, 74
Enlightenment, 13, 22–23, 29, 197, 203–4, 206, 251 (n.41); and the development of democracy, 130
equal opportunity, 100, 120–21, 223
equal regard, 60, 97–99, 107
equality, 28–31, 57–61, 96–98, 107, 112, 115–18, 231; before the law, 90; contextual, 98; as fair competition, 119–22; and freedom, 96–98; redescription, 106–8; traditional conception, 57–59
essentialism, 18
Estlund, David, 260 (n.36)
eternal recurrence, 10–11, 38, 154, 157, 234
ethics, 161, 180–85; distinguished from politics, 185–93
ethics of "care", 289 (n.24)
excellence, 40, 62, 95, 109–11, 113–18, 125–26, 131–33, 139, 142

executive principle, 170–71
existential rights, 215
experimentation, 79, 132, 143, 150, 264 (n.4)

fairness, 99, 101–2, 119–21
fallibilism, 66, 279 (n.8)
false consciousness, 226, 231
fascism, 196–97
Federalist, The, 58
Federalists, 124
feminism, 196, 199
finitism, 19–20
finitude, 66–67, 78–81, 122, 154, 188, 208
Flynn, Bernard, 246 (n.3)
Foucault, Michel, 143, 242 (n.19), 243 (n.20), 278 (n.56)
foundationalism, 73, 157
free expression, 81–82, 219–22
free market, 229
freedom, 14–16, 23, 30–31, 96–97, 141–43, 200, 218–19, 265 (n.9); in Nietzsche, 30–31, 35–38; postmodern, 217
Freud, Sigmund, 16, 32, 231, 271 (n.18)
friendship, 186, 289 (n.24)

Gadamer, Hans Georg, 287 (n.10)
gender, 116, 132, 296 (n.28)
Gendlin, Eugene, 245 (n.28)

genealogy, 7, 165
Gilligan, Carol, 289 (n.24)
God, 11, 57, 102; in political
 theory, 22–24
good and bad vs. good and
 evil, 175, 178–80
great politics, 137
Greek democracy, 59–60, 64,
 127, 275 (n.37)

Haar, Michael, 254 (n.71)
Habermas, Jürgen, 20, 42,
 237 (n.2), 266 (n.18), 279
 (n.8), 287 (n.10)
Hamilton, Alexander, 58,
 262 (n.47)
harmony, 76, 83, 86, 88, 190
Hegel, G.W.F., 13, 16, 23, 58,
 77, 82, 87, 263 (n.52)
Heidegger, Martin, 224, 237
 (n.1), 290 (n.33), 293
 (n.8)
Heller, Agnes, 297 (n.29)
Heraclitus, 62
herd mentality, 28, 95, 138,
 175, 180
Hesiod, 62
heterogeneity, 143, 160
Hitler, Adolf, 168
Hobbes, Thomas, 77, 82, 247
 (n.9), 263 (n.52), 293
 (n.11)
Holocaust, 11, 221
Homer, 62
homogeneity, 144, 160

Honig, Bonnie, 263 (n.53),
 266 (n.16), 266 (n.19),
 267 (n.22), 294 (n.13),
 295 (n.17)
House of Representatives,
 U.S., 125
human nature, 80–82; and
 politics, 203–7; in mod-
 ernism, 31
Hume, David, 188, 282
 (n.26)
Hunt, Lester H., 248 (n.19),
 253 (n.64), 257 (n.15),
 272 (n.22), 286 (n.4)

identity, 19, 31, 118, 190,
 205–7, 216
identity politics, 296 (n.28)
immigration, 206–7
impartiality, 103–4, 269 (n.8)
inclusiveness, 84, 106–7, 190
individualism, 15–16, 31–34,
 80, 83, 85, 197–99, 203–5,
 209–11, 292 (n.2), 299
 (n.50)
individuation, 52, 142, 205,
 212
inequality, 112–16
innocence of becoming, 201
inquisitorial judicial system,
 89
institutions, 130, 192
intellectuals and politics,
 275 (n.37), 285 (n.46)
intention, 245 (n.28)

interpretation, 91
irony, 20
isonomia, 90

Janaway, Christopher, 248
 (n.20)
jazz, 132
Jefferson, Thomas, 125, 256
 (n.9)
Johnson, Lyndon, 284 (n.44)
judgment, 158, 180–81, 210
justice, 101–3, 111–16,
 190–92, 271 (n.19); in
 Nietzsche, 66–67; and the
 political process, 223–26

Kahan, Alan S., 264 (n.7)
Kant, Immanuel, 13–14,
 217–18, 265 (n.9)
Kateb, George, 271 (n.16)
Kaufmann, Walter, 44
Keats, John, 66
Kennedy-Nixon television
 debate, 167
Kierkegaard, Søren, 278
 (n.55), 282 (n.26), 287
 (n.9), 295 (n.19)
kindness, 179
King, Martin Luther, 168
Kymlicka, Will, 268 (n.1)
laissez-faire, 97
language, 17–18, 20, 63, 245
 (n.28); and selfhood,
 32–34, 207–8
language game, 18, 281
 (n.14), 282 (n.27)

law, 90
leadership, 124–25, 130,
 169–71, 275 (n.36)
Lefort, Claude, 71, 195, 258
 (n.21), 298 (n.43), 301
 (n.57)
legal agonistics, 89–91
Levinas, Emmanuel, 295
 (n.18)
liberalism, 38–39, 80, 85,
 99–100, 133, 141,
 196–200; division
 between the public and
 the private, 211; Nietz-
 sche's critique, 29–39
life-affirmation, 10–11,
 152–55, 158, 235; and
 politics, 173
life-denial, 152–53, 160
life-enhancement, 152–53,
 155, 158
limit conditions, 188
linguistic turn, 17, 244 (n.23)
Locke, John, 22–23
lottery, 126–27
Loury, Glenn C., 274 (n.28)
love, 186
Luban, David, 267 (n.21)
luck, 101
Lukács, Georg, 300 (n.56)
Lyotard, Jean-François,
 17–18, 242 (n.19), 244
 (n.23, 24), 290 (n.29), 297
 (n.31)

Machiavelli, N., 169

Madison, James, 74, 163,
 262 (n.47)
madness, 143–44
majoritarianism, 81–82
majority rule, 64–65, 93, 129,
 267 (n.27)
Marcil-Lacoste, Louise, 286
 (n.5)
Martin, Bill, 244 (n.26), 295
 (n.18)
Marx, Karl, 13, 16, 23, 77,
 82, 193, 198–99, 231–32,
 246 (n.3), 263 (n.52)
Marx, Werner, 287 (n.14)
Marxism, 228–30
mass communications, 121
mass politics, 123
master-slave relation, 7,
 24–28, 39, 46–48, 138,
 175
materialism, 80, 233
McClure, Kirstie, 296 (n.26)
mediocrity, 28, 53, 94–95,
 108–11, 113–15, 123, 136,
 139–40, 233–34
melting pot, 206
merit, 108–11, 118
meritocracy, 108, 129–36
metanarratives, 17, 161,
 193–200
metaphysics, 156–57
Mill, John Stuart, 72, 110,
 218–21, 261 (n.39), 273
 (n.25), 297 (n.35)
mind-body question, 158

modernism, 13–15, 18,
 36–38, 209, 242 (n.18)
Montesquieu, 163
Mouffe, Chantal, 288 (n.22)
multiculturalism, 93,
 196–97, 204–5

narratives, 17; in political
 discourse, 194–200
nationalism, 291 (n.1)
natural law, 22
natural rights, 22, 58, 82,
 214
Nazism, 251 (n.47), 290
 (n.33)
negative capability, 66, 157
negative rights, 214
negotiation, 88
Nehamas, Alexander, 238
 (n.5)
neutrality, 69, 194, 197
Nietzsche: and affirmation,
 10–11, 27, 48; and agonis-
 tic selfhood, 50; his
 aristocraticism, 39–42,
 52–53, 115, 122, 138; on
 art, 9; and authoritarian-
 ism, 72, 137; on biology
 and race, 40; his chal-
 lenge to tradition, 5–6; on
 creator types, 9, 38,
 43–44, 47, 51–52, 137–41,
 234; and critical reason,
 150, 166; his critique of
 modernist subject, 31–39;

his critique of morality,
24–28, 165; deconstruc-
tion of his political
thought, 72–76; different
periods, 241 (n.14); and
ethics, 175–80; and
experimentalism, 68; on
freedom, 38, 141–42; and
genealogy, 42–43; on
great politics, 41; influ-
ence on radical theories,
232–33; interpreting his
politics, 43–54; on lan-
guage, 207; and masks,
12, 49; his naturalism, 6,
102, 104, 240 (n.2); and
Nazism, 44–45; his oppo-
sition to teleology, 201;
on overcoming, 9, 48,
177, 227–28; his own
metanarratives, 234; on
passion, 166–67; and
political philosophy, 235;
and politics, 51–54; as
postmodern thinker, 21;
and self-creation, 234–35;
on sovereign individual,
37–38; his style, 11; on
weakness and strength,
43–44
nihilism, 7–8, 155, 173, 228,
230
normalization, 141–44, 224
nostalgia, 190, 258 (n.19)
Nozick, Robert, 299 (n.50)

Ober, Josiah, 259 (n.22), 284
(n.39)
objectivity, 106, 146–47, 158,
182; in Nietzsche, 160
oligarchy, 123
optimism, 15
ostracism, 273 (n.27), 274
(n.30)

pacifism, 46
Pangle, Thomas L., 255 (n.6)
partiality, 103
paternalism, 143, 232
Pennock, J. Roland, 255
(n.4), 276 (n.43–44)
people, the, 81, 107, 191,
195, 301 (n.57)
perfectionism, 172, 181
performance, 31–32, 114–18,
142
performative contradiction,
20–21, 151
person, 117–18, 217; in post-
modern terms, 213
perspectivism, 8, 12, 145–62,
165, 182–84; and democ-
racy, 64–70, 162–64; and
political practice, 164–73
pessimism, 152
physis and *nomos*, 82
Plato, 70–72, 77, 109, 168,
260 (n.34)
Platonic idealism, 169
pluralism, 75, 85, 157–62,
194, 206–7, 286 (n.5)

poiēsis, 232

political campaigns, 167

political correctness, 288
(n.23)

political participation,
130–31, 195, 214–15

political practice, 119–29,
169–73, 194–95, 235, 285
(n.45)

political procedures, 79,
82–84, 86–88, 90–92, 200

polyarchy, 57, 72

positive rights, 215

postmodern democracy, 39,
65, 70, 73, 76–77, 80–85,
206, 222

postmodern selfhood,
117–18, 204–13

postmodernism, 1–2, 13,
15–19, 87, 242 (n.19)

power, 49–50, 187, 252
(n.61)

pragmatic phenomenology,
78, 239 (n.9)

private property, 223, 228

private sphere, 85, 195, 197,
211–12

procedural politics, 129, 192,
194, 223, 230, 234, 264
(n.5)

progressivism, 201–2

proportional representation,
93, 267 (n.27)

protest, 92

public sphere, 85, 195, 197,
212

punishment, 294 (n.13)

purpose, 201, 291 (n.39)

race, 116, 129, 132

racism, 221

radicalism, 230–36

rational decision theory, 74,
80, 283 (n.32)

Rawls, John, 85, 266 (n.17),
268 (n.7), 269 (n.9), 294
(n.11–12), 298 (n.43)

realism, 149; in politics,
169–71

reason, 14–15, 18; and politi-
cal practice, 164–69

rebellion, 92

recognition, 186

relativism, 69, 182–83

religion, 85–86, 197

resentment, 27, 94–95, 99,
102–4, 108–10, 113–14,
122, 294 (n.14)

respect, 66–69, 107, 122,
186, 191–92; and anti-
democratic convictions,
220–22; and freedom,
217–22

responsibility, 102, 185,
209–11, 294 (n.14)

revolution, 230, 267 (n.24)

rhetoric, 91, 167–69

right and the good, 85, 289
(n.24)

rights, 79, 81–82, 108,

213–17, 296 (n.22–23),
296 (n.28); as agonistic,
215–16; and the denial of
essences, 216–17; and
freedom, 217; in Nietz-
sche, 215; and selfhood,
216–17
risk, 220, 270 (n.9)
romanticism, 80
Rorty, Richard, 79, 85, 231,
237 (n.3), 271 (n.18), 277
(n.47), 281 (n.15), 287
(n.13)
Rosenfeld, Michel, 267
(n.22)
Roth, Robin Alice, 281 (n.9)
Rousseau, Jean-Jacques, 77,
82, 226, 263 (n.52), 293
(n.11)

Sartre, Jean-Paul, 295 (n.19)
scarcity, 262 (n.45)
Schacht, Richard, 240 (n.6)
Schopenhauer, Arthur, 32,
152, 188
Schrag, Calvin O., 245
(n.27), 283 (n.35)
Schrift, Alan D., 279 (n.2),
280 (n.9), 283 (n.34)
Schumpeter, Joseph A., 274
(n.34)
Schutte, Ofelia, 250 (n.32),
251 (n.51), 252 (n.56),
254 (n.68), 259 (n.30),
261 (n.40), 274 (n.31–32)

science, 15, 18, 158
scientific rationalism, 57–59
Scott, Charles E., 252 (n.57),
287 (n.15)
secular humanism, 198
secularization, 85
self-creation, 111, 141–43,
187, 277 (n.47)
self-esteem movement, 276
(n.45)
self-evident truth, 262 (n.47)
selfhood, 118, 207–13, 264
(n.6)
self-reference, 150–56
Senate, U.S., 125
separation of church and
state, 197
separation of powers, 90,
125, 163
sexuality, 143, 278 (n.55)
Shapiro, Gary, 241 (n.12)
Shapiro, Ian, 264 (n.5)
Shapiro, Michael J., 262
(n.48)
Singer, Peter, 270 (n.12)
singularity, 212, 295 (n.19)
skepticism, 157, 183
social programs, 121
socialism, 96, 193, 198–99,
229; Nietzsche's critique,
228
sociality, 34, 83, 85, 211–12
socialization, 52, 82, 142,
205, 292 (n.2)
Socrates, 169, 260 (n.34)

Sophists, 82, 168–69
special interests, 83
state of nature, 55, 82, 255
(n.2), 263 (n.52)
state, the, 83
stratification, 111–13,
116–17, 129, 132, 142
stratified pluralism, 128, 226
Strong, Tracy B., 253 (n.62,
67), 257 (n.15), 261 (n.40)
subgroups, 92–93
subject, 18, 31
subjectism, 14–17, 102
suffering, 188
Supreme Court, U.S., 125,
284 (n.45)
suspicion, 70–74, 89, 134,
206, 235; and equality,
262 (n.47)

talent, 99–101, 103, 114, 120,
131, 268 (n.7)
taxation, 299 (n.50)
technology, 15, 121, 127,
224–26
teleology, 87, 102–3, 196;
and politics, 201–2
television, 224
terror, 193, 297 (n.31)
tolerance, 69
totalitarianism, 301 (n.57)
totalization, 17, 224
town meetings, 87
tragic, the, 6, 7, 275 (n.38),
298 (n.42)

tribalism, 93, 197, 205
truth, 11, 73, 91, 129,
134–35; as agonistic plu-
ralism, 158–62; and au-
thoritarianism, 67, 70–71;
in Nietzsche, 145–58; in
question in democracy,
64–74, 85, 134
tyranny, 67, 163

Übermensch, 9, 234
undecidability, 84, 91, 136,
184–85
universal education, 131–32
universalism, 17, 181, 197,
203–4

values, 175–80
via negativa, 4, 39, 78–79, 84
vice in politics, 169–71
victimization, 294 (n.14)
victor principle, 140
violence, 92, 187
virtue, 169
virtue ethics, 286 (n.4)
voting, 72, 88, 91, 116, 128,
134

Waldenfels, Bernhard, 266
(n.18)
Walton, Douglas, 283 (n.36)
Walzer, Michael, 271 (n.19)
Warren, Mark, 36–37, 39, 49,
249 (n.22–24), 254 (n.72),
258 (n.17), 259 (n.32),

264 (n.6)

wealth and poverty, 223

Weber, Max, 283 (n.38)

Weber, Sam, 282 (n.27)

welfare capitalism, 96

welfare programs, 229

White, Morton, 163

White, Stephen K., 278
(n.54), 288 (n.18), 291
(n.39)

will to power, 8–9, 27, 36–39,
45–46, 63, 68–69, 75, 139,
151, 157, 182, 251 (n.51)

Wittgenstein, Ludwig, 293
(n.8)

Wolgast, Elizabeth, 296
(n.28)

Wolin, Sheldon, 301 (n.60)

workplace democracy, 229

Yack, Bernard, 242 (n.16),
265 (n.9), 300 (n.53)

Young, Iris, 269 (n.8)

Zimmerman, Michael, 290
(n.33)